très petite et je serai d'avoir

en échange un tableau de 5000 frs (don ...

... perds 10,000 frs). Mais si les

Bernheim trouve cette demande trop

grande, qu'il fasse leur offre et je

consens à diminuer.

Je regrette certainement la perte de 15,000

Mais en même temps cette ... leçon pour

... . Les grands tableaux sont si difficiles

à placer et leur valeur est si petite

COLLECTING MATISSE

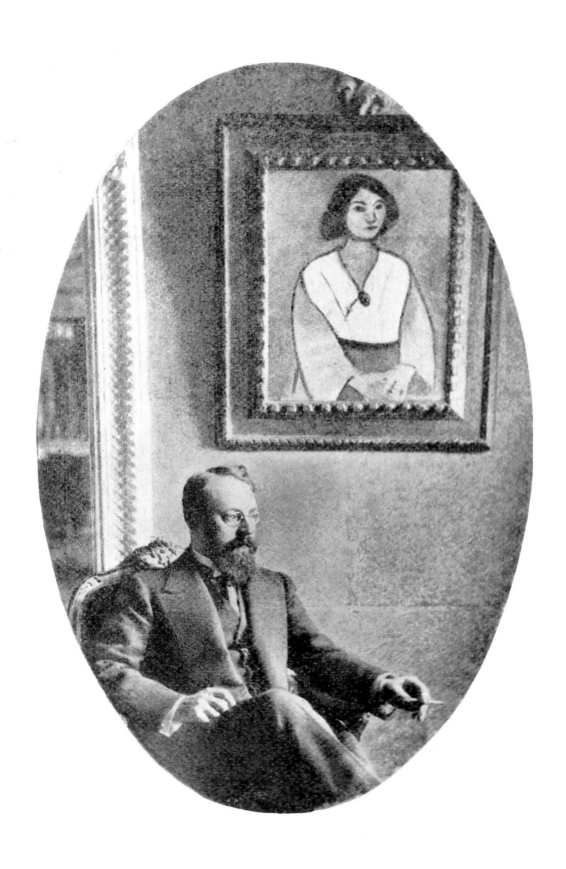

COLLECTING MATISSE

ALBERT KOSTENEVICH
NATALIA SEMYONOVA

Flammarion

FLAMMARION

26, RUE RACINE

75006 PARIS

THE TEXT WAS TRANSLATED FROM THE RUSSIAN BY ANDREW BROMFIELD

COPYEDITING BY MIRIAM ROSEN

DESIGN BY KONSTANTIN JOURAVLIOV

TYPESETTING BY ATELIER D'ÉDITION EUROPÉEN

PRINTED BY IMPRIMERIE CLERC S.A., SAINT-AMAND-MONTROND

BOUND BY ATELIERS BRUN, MALESHERBES

ISBN: 2-08013-541-4

DÉPÔT LÉGAL: FEBRUARY 1993

N° D'ÉDITION: 0535

PRINTED IN FRANCE

CONTENTS

THE STORY OF AN ENCOUNTER

NATALYA SEMYONOVA

THE RUSSIAN PRESS ON MATISSE'S VISIT

MATISSE IN RUSSIAN COLLECTIONS

ALBERT KOSTENEVICH

MATISSE'S CORRESPONDENCE
WITH HIS RUSSIAN COLLECTORS

(CATALOGUED AND ANNOTATED BY A. KOSTENEVICH)

MALAYA LUBYANKA STREET, MOSCOW, 1910

THE STORY OF AN ENCOUNTER

NATALYA SEMYONOVA

1. THE CITY OF GAUGUIN, CÉZANNE, AND MATISSE

The late autumn of 1911 offered a field day to the journalists of Moscow and St. Petersburg with the arrival of the famous painter Henri Matisse in Russia. Comment in the press was extensive, ranging from eulogy to forthright deprecation. Matisse's name was just as well known to the public in Russia as it was in Europe, for the simple reason that more than thirty of the artist's finest paintings were hanging in Moscow, in the private collections of Ivan Morozov and Sergei Shchukin. The exceptional quality of the body of works assembled by these two men prompted the Russian artist and critic Alexandre Benois to dub Moscow "the city of Gauguin, Cézanne, and Matisse."[1] However, only those who were aware of the true breadth and depth of the Moscow collections could fully appreciate the aptness of this remark.

Shchukin and Morozov, who made it possible for Russia to follow the new movements in European art virtually at first hand, played an important part in the life and career of Henri Matisse. Of the two, it was Shchukin who first discovered Matisse. It seems most likely that the Russian collector, who was generally recognized as a knowledgeable connoisseur of modern art, made his first appearance in the artist's studio in the autumn of 1906, but he certainly knew of Matisse much earlier, from the time of his 1904 one-man show at Vollard's gallery and the 1905 Salon des Indépendants, which had made Matisse famous throughout Europe. In any case, Matisse regarded Shchukin's arrival as a memorable event.

"[Shchukin], a Moscow importer of Eastern textiles was about fifty years old, a vegetarian, extremely sober. He spent four months of each year in Europe traveling just about everywhere. He loved the profound and tranquil pleasures. In Paris his favorite pastime was visiting the Egyptian antiquities in the Louvre, where he discovered parallels to Cézanne's peasants. He thought the lions of Mycenae were the incontestable masterpiece of all art. One day he dropped by the Quai St.-Michel to see my paintings. He noticed a still life hanging on the wall and said: 'I buy it [*sic*], but I'll have to keep it at home for several days, and if I can bear it, and keep interested in it, I'll keep it.'"[2] This was typical of Shchukin, who always felt the need to "get to know" a painting. Matisse passed the test, and his *Nature morte, vaisselle à table* (Still Life, Dishes on a Table) became the first of his works to enter a Russian collection.

The Russian public had been introduced to Matisse two years earlier, in late 1904, when the St. Petersburg journal *Mir iskusstva* (World of art) published the first reproduction of one of his paintings, the impressionist work *La Desserte* (Dinner Table).[3] As Matisse's fame grew, his paintings were in ever greater demand for exhibitions. In the spring of 1908, three of them were shown in the French section of the first Salon of the Golden Fleece in Moscow. The following year, the second Salon of the Golden Fleece included four of his paintings and nine drawings.[4] Between late 1909 and the spring of 1910, two of Matisse's canvases (one of them the second version of the famous *Jeune marin* [Young Sailor]) toured Odessa, Kiev, St. Petersburg, and Riga with an exhibition organized by the Odessa sculptor Vladimir Izdebsky.[5] Matisse's work was also included in an exhibition of contemporary French graphics held in the editorial offices of the St. Petersburg journal *Apollon* (Apollo).[6]

The Russian public found Matisse's work hard to accept, but in young artists' circles he was the constant topic of excited discussion, and the appearance of new works in the Moscow collections was followed with keen interest. As for

1. Alexandre Benois, "Khudozhestvennye pis'ma" (Letters on the arts), *Rech* 20 (21 January 1911).

2. "Matisse Speaks," *Art News Annual* 21 (1952) reprinted in Jack Flam, *Matisse on Art* (London, 1973), p. 133.
It was always assumed that Shchukin first met Matisse in the autumn of 1906, but it is in fact more probable that the meeting took place immediately after the Salon des Indépendants, at which *La Joie de vivre* made such a great impression on the Russian collector. This supposition is supported by a letter from Matisse to Manguin, dated late May/early June, in which he wrote that Shchukin had purchased a large still life he found in the attic of Matisse's studio, and also a drawing and two lithographs. See Judi Freeman, *Les Paysages fauves* (Paris, 1991), p. 138.

3. During a trip to Paris in 1904, Igor Grabar, at Sergei Diaghilev's request, collected photographs of the latest examples of French painting for publication in the journal *Mir iskusstva*. Grabar was subsequently responsible for the reproduction of Matisse's *Dinner Table* (*Mir iskusstva* 2/8-9 [1904], p. 243), the first work by the artist to be shown in Russia.

4. The first Salon of the Golden Fleece, Moscow, April-May 1908. In the section devoted to French art, Matisse's work was shown alongside that of Cézanne, Degas, Gauguin, and Van Gogh. The exhibition was the subject of the journal *Zolotoe runo* (The golden fleece) nos. 7, 8, and 10 (1908). The French artists who participated in the second Salon of the Golden Fleece in January-February 1909 included Braque, Derain, Marquet, Matisse, and Rouault.

5. The First International Exhibition of Paintings, Sculpture, Graphic Art and Drawings, 4 December 1909-7 July 1910. In addition to Matisse, the exhibition included works by Braque, Vlaminck Gleizes, Marquet, Metzinger, Rousseau, Signac, Le Fauconnier, and Van Dongen.

6. An exhibition of Drawings, Lithographs and Watercolors by Contemporary French Artists, St. Petersburg, February-March 1910. The exhibition included works by Van Dongen, Gauguin, Degas, Redon, Rousseau, and Signac.

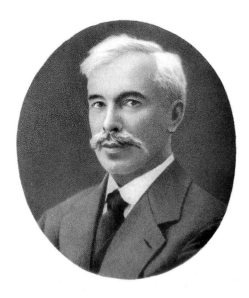

SERGEI SHCHUKIN, 1890s

7. B. N. Ternovets, *Pisma. Dnevniki. Stati* (Letters. Diaries. Articles), compiled and annotated by L. S. Alyoshina and N. B. Yavorskaya (Moscow,1977), p. 121.

8. Sergei Ivanovich Shchukin was born in Moscow on 27 June 1854 (according to the old calendar) and died in Paris on 10 January 1936. (In Soviet publications the date of his death has often been given wrongly as 1937.) He is buried in the Montmartre cemetery.

9. The Shchukin family included four daughters and six sons: Nikolai (1851-1910), Pyotr (1853-1912), Sergei (1854-1936), Dmitry (1855-1932), Vladimir (1867-1895), and Ivan (1869-1908).

Shchukin, the collector became engrossed in Matisse; as time was to demonstrate, this enthusiasm was deeper and more powerful than his feelings for any of the other artists whose works he bought. In the words of the future director of the Moscow Museum of Modern Western Art, Boris Ternovets, Matisse not only "took possession of his [Shchukin's] mind," but he proved to be Shchukin's "most enduring passion, unexhausted to the very end."[7] The outcome was the purchase of no less than thirty-seven of Matisse's paintings. If the course of history had not taken a tragic turn, there would undoubtedly have been still more.

Sergei Shchukin was the third son of the founder of the Shchukin merchant dynasty.[8] His father, Ivan Vassilievich Shchukin, had his own business in Moscow, trading in manufactured goods that he dispatched to the farthest corners of the Russian Empire and beyond, notably to Persia. Sergei's mother, Ekaterina Petrovna, came from even more notable merchant stock: she was the daughter of Pyotr Kononovich Botkin, the founder of a major trading house dealing in tea and sugar. At his birth in 1854, Sergei's future was already planned out for him: following studies at home with tutors from France and Germany, he and his brothers were to attend the German boarding school in St. Petersburg and then go to Europe to continue their education and study advanced methods of textile production. Because of a weak constitution and a strong stammer, however, Sergei was kept at home and educated with his sisters until the age of nineteen. It was only after considerable effort that he persuaded his father to send him abroad and, in the spring of 1873, finally arrived in the small German town of Burgsteinfurt. There he underwent treatment for his stammer (in fact, he was never to rid himself completely of this disability), and the following autumn, he entered the Academy of Commerce in the small Thuringian town of Gera for three years of study.

Sergei Shchukin ascended the ladder of commerce with exceptional rapidity. In 1883, he and his two older brothers, Pyotr and Dmitry, became partners in their father's firm, which was renamed "I. V. Shchukin and Sons." When the father died in 1890, the other brothers attempted to reduce their involvement in the business.[9] Sergei, by contrast, was seeking to prove himself and seized the opportunity to take over the running of the firm, which through his efforts quickly became the leading buyer of cotton and wool goods in Russia. Sergei Shchukin's success was so remarkable that before long the ministry of finance awarded him the title of "commercial counselor" (which brought with it entry into the nobility). Sergei Ivanovich Shchukin's passion for business —he was respectfully referred to in Moscow as "the minister of commerce"—was matched by his brothers' enthusiasm for collecting. Although their parents had never taken any interest in art, the younger generation of Shchukins had an outstanding model to follow in their uncle Dmitry Petrovich Botkin's fine picture gallery on Petrovka Street. Through the Botkin family, which included collectors of antiquities, Byzantine enamels, silver, and drawings, the Shchukins were also related to the brothers Pavel and Sergei Tretyakov, the famous collectors immortalized by the Tretyakov Gallery that they founded in Moscow.

During this period, educated merchants were obsessed with art, and this was particularly true among the merchantile bourgeoisie of Moscow, so unlike the aristocratic and court circles of St. Petersburg. By dint of sheer hard work, the Russian merchants had accumulated immense amounts of capital, which gave them a dominant position in society. In both education and lifestyle, they had little in common with their grandfathers, often former serfs who had made the move to Moscow from distant villages and small provincial towns. Believing that wealth brought its own obligations, the merchants engaged in a wide range of philanthropic activities and supported all of the arts, including theater, music, and painting. Collecting became a passionate cult among this new breed of businessmen, and Pyotr and Dmitry Shchukin followed the example of their friends and relatives.

Pyotr Shchukin began in dilettante fashion with photographs of actors and writers, then turned to Persian carpets and Japanese screens at the fair in Nizhny

Novgorod, books and manuscripts at Moscow's Sukharev market, and occasionally, modern paintings in Paris. Over a period of twenty years, Pyotr accumulated an immense collection for which he undertook construction of a special museum in the old Russian terem or "tower" style in 1892. Three years later, the Shchukin Museum of Russian Antiquities opened its doors to the public, with the owner himself greeting visitors and showing them around the collection.[10]

Although not as active as Sergei, Pyotr nonetheless remained involved in the family business, whereas the other brother, Dmitry, who had a strong predilection for the humanities, never took any interest in commerce. He was a mild and retiring individual who lived alone, managing quite well indeed on his inherited capital, which was sufficient to allow him a prosperous lifestyle. His twenty-room apartment on Starokonnyushenny Lane close by the central Arbat Street was more like a museum than a home, with solid antique furniture, Dutch paintings hanging on the walls, Italian majolica and English porcelain sparkling in the sideboards and carved cupboards, dozens of clocks keeping melodic track of time, and lovely ladies of yesteryear gazing from the tops of tiny snuff boxes and portrait miniatures.[11]

Sergei Shchukin developed the collector's passion much later than his brothers, when he was already past the age of forty. By that time, he was the head of the firm, the father of three sons and a daughter, and the owner of a mansion on Bolshoi Znamensky Lane close to the old Kremlin. The eighteenth-century mansion with its garden and secondary buildings (the previous owners were the aristocratic Trubetskoi family) had been a present from his father to mark the birth of the latter's grandson Ivan.[12] In addition to its moulded plasterwork and murals, the Shchukin residence, like any rich Moscow mansion, was decorated with pictures that formed an integral part of the interior. First there had been landscapes and genre paintings by the Russian Itinerants who were popular in the 1870s and 1880s, and works by exhibitors in the Paris Salon. These were followed by landscapes by the Norwegian Fritz Thaulow and the paintings of the French artists Simon and Cottet, who worked in Brittany. As fashions changed, so did Sergei Shchukin's artistic enthusiasms, and he began buying with a greater sense of purpose. His clear preference was for the French school, as demonstrated by the acquisition of pictures by Fernand Maglin, Emile Ménard, Henri Moret, Henri Fantin-Latour, Eugène Carrière, and Jean-Louis Forin. The novice collector's most important purchases, made in the late 1890s, were Puvis de Chavannes's sketch for *The Poor Fisherman* and a tapestry of *The Adoration of the Magi,* woven in

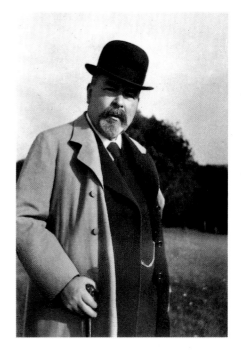

DMITRY SHCHUKIN, 1910s
ARCHIVES OF THE STATE PUSHKIN MUSEUM OF
FINE ARTS

10. In 1905 Pyotr Shchukin donated his museum on Malaya Gruzhinskaya Street—23,911 works of art—to the Historical Museum, retaining lifelong ownership of all the buildings and collections, which included Russian and foreign objects, collections of oriental art, the painting gallery, the collections of drawings and prints, the library, and the manuscript depository.

11. After the Revolution, Dmitry Shchukin's collection of 146 paintings and pastels, mainly by artists from the Netherlands and Germany, was transformed into the first Museum of Old Western Painting. In 1924 it became part of the collection at the State Pushkin Museum of Fine Arts.

12. Ivan Sergeievich Shchukin (1887-1975), the eldest son of the famous collector, emigrated with his father in 1918. He was a specialist in medieval Islamic art and worked in the French Archaeological Museum in Beirut.

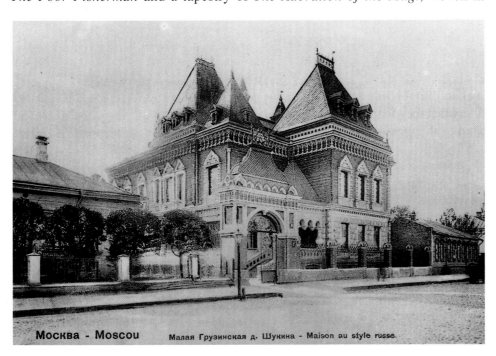

Москва - Moscou Малая Грузинская д. Шукина - Maison au style russe.

PYOTR SHCHUKIN MUSEUM ON MALAYA GRUZHINSKAYA STREET, MOSCOW

13. It was always thought that Sergei Shchukin's first purchase was Claude Monet's *Lilac in the Sun*. However, his son Ivan claimed that it was a different work by Monet, *Cliffs on the Belle-Isle*. Letter from Ivan Shchukin to A. A. Demskaya. Pushkin Museum, archive 13, inventory no. XI/II, no. 145/3.
This painting is discussed in detail in one catalogue of Claude Monet's work. See Daniel Wildenstein, *Claude Monet* (Lausanne-Paris, 1979), vol. 1, no. 204, p. 61; vol. 2, no. 1084, p. 198.

14. Having run up large debts that he was unable to repay from the sale of his paintings at auction (most of his collection proved to consist of copies of old Spanish masters), Ivan Shchukin shot himself on 2 January 1908.

William Morris's workshops from a sketch by Burne-Jones (a rare example of the English school in a Russian collection).

Shchukin's first really serious passion, however, was impressionist painting. It began in 1898 with the purchase of Claude Monet's *Cliffs* and Camille Pissarro's *Opera Passage in Paris* from the Durand-Ruel Gallery in Paris.[13] Nor was Shchukin alone in his new enthusiasm: in the autumn of the same year his brother Pyotr bought Monet's *Cliffs at Etretat* and Pissarro's *Place du Théâtre-Français* at a gallery on the rue Lafitte. In April 1899 a Paris dealer sold the rich Russians two other works by Claude Monet: *Lilac in the Sun* to Sergei, and *Woman in a Garden* to Pyotr. That same year, Sergei also bought two of Monet's *Haystacks* from Durand-Ruel, while Pyotr, through the good offices of Ivan Shchukin, acquired a nude by Auguste Renoir. Ivan, the youngest of the Shchukins, was undoubtedly responsible for introducing his brothers to impressionist painting. It was he who directed their attention to this new art, still unrepresented in Russian collections; he took them to the most interesting galleries, which were almost unknown to Russian collectors, and introduced them to the owners. Fifteen years younger than Sergei, Ivan had been educated differently from his brothers (graduating first from a privileged Moscow lycée and then from the law school), and his life was quite different. In 1894, he went to Paris, where he remained until his tragic death fourteen years later.[14] In addition to lecturing on the history of philosophy at the School of Oriental Languages there, he wrote for Russian newspapers and journals, sending their art departments articles and reviews in a distinctively polished, laconic style. This Parisian Shchukin astounded everyone who knew him with his vast erudition in the fields of philosophy and literature, and even more so with his knowledge of modern art and remarkable familiarity with the art market. The renowned "Tuesdays" at Ivan Shchukin's apartment on the avenue Wagram attracted Russian professors of philosophy and history, publishers, journalists, writers, actors and artists: the regular guests included Rodin, Degas, Renoir, Redon, Huysmans, and Durand-Ruel.

In the company of famous artists and the artistic elite of Paris, Ivan Shchukin developed expensive tastes, and his inheritance gradually dwindled. At the turn of the century, a new enthusiasm for early Spanish paintings, acquired from his artist friend Ignazio Zuloaga, impelled this impassioned bibliophile and collector to take the drastic step of selling off pictures by Díaz de la Peña, Manet, Monet, Renoir and Degas that he had bought during the 1890s. The eldest Shchukin brother, Pyotr, also parted with canvases by Degas, Renoir, Monet, Pissarro, and Maurice Denis, but only much later, in 1912, just a few months before his death, when he was obliged to set his financial affairs in order. Fortunately, the serious threat that these pictures might be lost to Russia was averted: Sergei Shchukin, well aware of the value of the pictures his brother was selling, bought them all for 100,000 francs, even though at the time he was himself caught up in the work of Matisse and Picasso. As a collector, Sergei Shchukin was always attracted to unrecognized artists, to art with an "element of risk." For him, the purchase of works by acknowledged impressionist masters was a distinct exception to the rule—he was not in the habit of retracing his steps. The last of his Monets, the famous *Déjeuner sur l'herbe*, had been acquired in 1904, and from that time on, impressionism was a closed chapter for him.

His subsequent enthusiasms were for Van Gogh, Gauguin, and Cézanne, with a clear preference for Gauguin. After acquiring the early *Fruits*, he bought several more Gauguins painted during the artist's stay in Tahiti from the posthumous exhibition arranged by Vollard in 1903. Following the 1906 retrospective, several Gauguins from Gustave Faillet's collection also found their way to Znamensky Lane, including the key work *Rupe-Rupe*.

According to several accounts, Shchukin personally supervised not only the choice of the fabrics he dealt in but also the creation of new designs and patterns

by the team of artists employed by his firm. This work must surely have developed the professional appreciation of color, form, and decoration that made him so exceptionally receptive to the new developments in painting.[15]

The painter and art critic Igor Grabar noted Shchukin's essential ability to keep ahead of his time: "By nature and temperament, Sergei Shchukin was a collector of art that was active and vitally alive, today's art, or rather, tomorrow's—not yesterday's." [16] At first, to be sure, he seemed to lack confidence in his own unusual choices. For a long time he could not bring himself to display several paintings, such as the Gauguins, and he kept them in small, dimly lit rooms on the first floor. "Sergei Ivanovich spared the merchants the immediate shock of his unrestrained artistic passion. I remember that when he brought the series of Gauguins from Paris, he kept them out of sight for a long time," recalled the painter Sergei Vinogradov. [17]

His indecisiveness was short-lived, however, and the paintings soon emerged from the twilight into the sunlit main dining room. Hung so close that they touched each other, the sixteen canvases in rich gilded frames were a blinding display of "flaming yellow-orange "," sweet pink," and "luxuriant deep blue"—the renowned Gauguin "iconostasis" that astounded all visitors with the calm magnificence of the primitive Tahitian paradise. "Russia, and snowy Moscow, may be proud of having offered refuge to these exotic blossoms of eternal summer that their step-mother, French officialdom, has failed to gather to herself," wrote the critic Yakov Tugendhold. "This Moscow residence contains not only the largest collection of works by Gauguin, but possibly also the finest and most representative."[18]

Shchukin's enthusiasm for Gauguin was at its height during a period marred by a string of family tragedies in the space of a few years: his youngest son's suicide in 1905 was followed by the sudden death of his wife in 1907 and the suicides of his brother Ivan in 1908 and his middle son, Grigory, in 1910.

His wife's unexpected death prompted Shchukin to make proper provision for the future of his collection of modern French painting. According to the will he wrote on the night of 3 January 1907, in the case of his death the entire collection was to be transferred to the Tretyakov Gallery, which was the national museum of Russian art but also possessed a good—if rather small—section of nineteenth-century European paintings collected by Sergei Tretyakov. [19]

The idea of converting his collection into a public museum required renovation of the mansion, which Shchukin began immediately, before leaving for Egypt in hopes of restoring his shaken health and shattered nerves. Arriving in Cairo in September 1907, he hired an immense caravan of thirty camels and twenty attendants and set off across the Sinai desert to the Holy Land. He wanted "to escape temporarily from the circumstances of normal civilized life . . . live in a tent . . . live like a real Bedouin on dates, bread, and plain water. . . ," Shchukin wrote in the diary that he began to keep for the first time in his life during this journey. "In a short time I have suffered a great deal and borne irreplaceable losses. I felt I didn't have the strength to begin a new life. My religious feelings were weak. I dashed from one thing to another in the attempt to fill my life with something. For a time I plunged into private philanthropy. . . . Then I became passionately involved in my business. . . . For a while, this filled my life, but only for a while."[20]

The journey with which Shchukin attempted to fill the "void" that appeared in his life following his wife's death nonetheless proved to be a difficult one. Far from the comforts of civilization, the fifty-three-year-old merchant was forced to admit that he was no longer strong enough to endure such an exhausting pilgrimage. He rushed back to Europe, to his own "cultured, subtle, elegant world," the world of Scriabin's music, Briussov's poetry, and Denis's painting.

The events of 1907 thus determined the mood in which Shchukin arrived in Paris in December. At that point, the Moscow collector's interest in Matisse was

15. Memoirs of G. O. Gordon. Archives of the State Pushkin Museum of Fine Arts, archive 13, collection XI, no. 26/19.

16. Igor Grabar, *Moia jizn. Avtomonografia* (My life. An automonograph) (Moscow/Leningrad, 1937), p. 245.

17. S. A. Vinogradov. "S. I. Shchukin. Pamiati primetchatelnogo moskovskogo kollektsionera (Iz moikh vospominany)" (S. I. Shchukin. In memory of the remarkable Moscow collector. [From my memoirs]), *Segodnya* (Riga),19 January 1936.

18. Y. Tugendhold, *Pervy muzei novoi zapadnoi jivopissi* (The first museum of modern western painting) (Moscow/Petrograd,1923), p. 48.

19. Sergei Mikhailovich Tretyakov's collection of eighty-four works was formerly a closed private gallery. The earliest pieces were by Ingres, David, and Delacroix, and there were also works by the Barbizon school—Courbet and Bastien-Lepage, Fortuny, and Alma-Tadema—and the German painters Menzel and Knauss. In 1910, thirty paintings by European artists were added from Mikhail Morozov's collection, which was donated to the Tretyakov Gallery by his widow, Margarita Morozova.

20. Sergei Ivanovich Shchukin's diary, 1907. Private collection, Moscow.

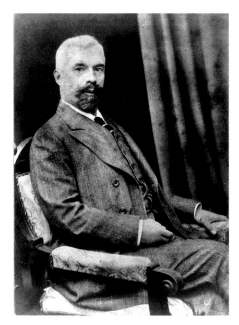

SERGEI SHCHUKIN, 1900s
ARCHIVES OF COUNT RUPERT KELLER

21. Ivan Shchukin discussed this topic with Beverly Kean. See her *All the Empty Palaces, The Merchant Patrons of Modern Art in Pre-Revolutionary Russia* (London, 1983), p. 193.

22. Seven students from Russia studied at the Académie Matisse. Olga Markusovna Merson (Meerson) (1878-1934 or later—she committed suicide after the Nazis came to power in Germany), a former extramural student at the Moscow School of Painting, Sculpture, and Architecture, studied

stimulated by a visit to the apartment of Leo and Gertrude Stein on the rue de Fleurus, probably at the suggestion of Ambroise Vollard. The Steins' collection of modern paintings, which included Matisse's best works of recent years, was rightfully considered one of the finest in Paris. Many people came to the Saturday "open house" at this Montparnasse apartment in order to see the works by Cézanne, Matisse, and later, Picasso. The Steins' numerous Matisses included the small *Musique* acquired at the previous Salon d'Automne and the large *Joie de vivre* that Shchukin had first seen in the spring of 1906 at the Salon des Indépendants. According to his son Ivan, who visited the exhibition with him, this canvas made a very deep impression on Shchukin. [21] The huge idyllic landscape with figures dancing, making music, and making love, represented a turning point in Matisse's career: it was certainly powerful enough to make Shchukin wish to meet the leader of the Fauves.

By 1907 the fauvist grouping had, in fact, begun to disintegrate, and Matisse was already engaged in his own search for inner harmony achieved "by simplifying ideas and plastic forms." Some were attracted by the change in Matisse's style, while others were repelled. His professional relationship with Leo Stein became much less close, and Stein, who had purchased his first Matisse—the fauvist *Femme au chapeau* (Woman with the Hat)—in 1905, gradually stopped buying the artist's work. Nonetheless, Matisse remained on friendly terms with Leo and Gertrude, whose support meant a great deal to him. It was Matisse's good fortune at this time to find a new patron in the person of Sergei Shchukin, who immediately accepted the new path that the artist had chosen.

Matisse and Shchukin met again in the spring of 1908, when the collector paid his traditional visit to the Salon des Indépendants, although that year Matisse did not exhibit a single work. The artist was on the brink of worldwide fame; his name would soon be one to conjure with. In January Matisse had opened his own school in the old monastery on the rue de Sèvres, a step he had been persuaded to take by two of his devoted admirers, the German artist Hans Purrmann and Sarah Stein. Sarah and her husband, Michael (the elder brother of Leo and Gertrude Stein), had been buying Matisse's work for many years, and Michael also helped to finance the "Académie Matisse," which brought students from America, Germany, Scandinavia, and Russia to study with the artist whom they idolized. [22]

Sergei Shchukin's recent enthusiasms, first for Cézanne, and then for Gauguin, were now things of the past. The place of these recognized masters was gradually taken over by less well-known, living artists, and primarily by Matisse. The Moscow collector's ambition to become a "participant in the artistic process" was

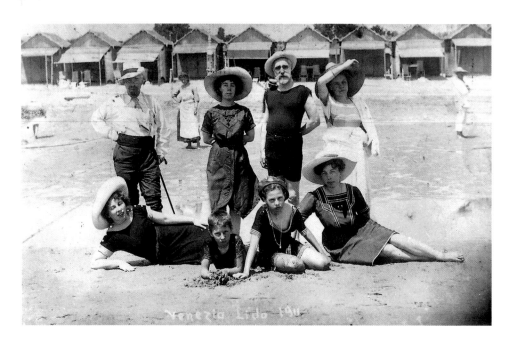

VENICE, LIDO, SUMMER 1911
FROM LEFT TO RIGHT: SERGEI SHCHUKIN, SHCHUKIN'S NIECE, EKATERINA MYASNOVO, ALEXANDR MYASNOVO
SEATED: VERA MIROTVORTSEVA AND NADEZHDA KONIUS WITH HER CHILDREN NATALIA AND ADRIAN
PRIVATE ARCHIVES, MOSCOW

finally realized. He had found a painter whose art he admired and whose victory he never doubted. Rumors immediately spread to Moscow about Sergei Shchukin's new passion and the fact that he and Morozov had returned from Paris with "a heap of Gauguins, Matisses, and such."[23]

When he visited Matisse's studio in the spring, Shchukin bought several works directly from the artist.[24] Bypassing the dealers, he chose the newly completed *Joueurs de boules* (Game of Bowls) and reserved two unfinished landscapes, *Nature morte en rouge de Venise* (Still Life in Venetian Red), and the large *Desserte rouge* (Harmony in Red), better known as *The Red Room*. A still life offered to him by Druet, *Plats et fruits sur un tapis rouge et noir* (Dishes and Fruit on a Red and Black Carpet), was acquired shortly afterward. Another painting from Druet's extensive collection of early works by Matisse, *Nature morte au pot bleu et citron* (Still Life with Blue Pot and Lemon), was acquired by the other Moscow collector, Ivan Morozov, who had already purchased one Matisse—*Le Bouquet* (The Bouquet)—at the Bernheim-Jeune Gallery in October 1907.

Ivan Abramovich Morozov was a figure of considerable note in Russian commerce and art.[25] He did not make the move to Moscow from the provincial town of Tver, where he was a director of the Tver Manufacturing Association, until 1901. And he began his collecting career by acquiring works by Russian artists. In 1903, when Sergei Shchukin was about to abandon the well-established impressionists, Morozov bought his first work by a foreign painter, *Gel à Louveciennes* (Frost at Louveciennes) by Alfred Sisley. It is widely accepted that Ivan Morozov was continuing the tradition of collecting established by his older brother, Mikhail, who was born in 1870, one year before him. The example of Mikhail Abramovich Morozov's brilliant and extravagant personality must certainly have been infectious. Having acquired the taste for collecting only a few years before his sudden death in 1903, he rapidly transformed the winter garden of his large and sumptuous mansion on Smolensky Boulevard into a picture gallery containing icons and works by Barbizon artists, the impressionists, and contemporary Russian painters. Mikhail Morozov owned a fine Gauguin, a Van Gogh and a Toulouse-Lautrec, but the pride and joy of his collection was Renoir's full-length portrait of the young actress Jeanne Samary.

The phlegmatic Ivan showed little resemblance to his high-spirited, reckless elder brother, Mikhail, or his madcap younger brother, Arseny, who built himself a Moorish castle on Vozdvizhenka Street in the center of Moscow, firmly convinced that this was a much better legacy to leave for posterity than any collection of paintings. Indeed, there was a remarkable similarity in the various roles played by the brothers in the very different Shchukin and Morozov families. Just like Sergei Shchukin's brothers, Mikhail and Arseny Morozov preferred to withdraw from the family business and enjoy themselves by spending their huge inheritances. When he took over the management of the Morozov textile factories—an entire town of about twenty thousand workers not far from Tver—Ivan was obliged to devote himself almost entirely to trade and industry. "We possess the means for an easy life in abundance," he once said in a newspaper interview, "but despite that, most of us work nine or twelve hours a day, devoting our rare free time partly to improving our education, partly to private life, partly to art."

These two passionate enthusiasts of modern painting, Shchukin and Morozov, were quite different in their approaches to collecting. As Boris Ternovets, the future curator of Morozov's collection, wrote: " Constantly cautious and restrained in his choices, fearful of conflict and of everything still struggling to establish iself, Morozov preferred the calm search, in contrast with Shchukin's wandering spirit."[26] Unlike Shchukin, Morozov never disregarded the advice of the popular Moscow artists Valentin Serov, Konstantin Korovin, and Sergei Vinogradov (former adviser to his deceased brother Mikhail), whose works also hung in his collection. (Morozov's parallel buying of works by Russian and foreign artists also served to emphasize the continuity of his own collection and his brother's.) Ivan

longest with Matisse, from 1908 to 1911. The painter and sculptor Maria Ivanovna Vasilieva (1884-1953) shared a studio with Merson. Matisse accepted three other students on Shchukin's recommendation: Anna Ivanovna Troyanovskaya (1885-1977), graphic artist and singing teacher who was the daughter of a well-known Moscow doctor and collector; her friend Ekaterina Vladimirovna Sapozhnikova, and Leopold Sturzwage (1879-1968), the son of a Moscow musical instrument maker and student at the Moscow School of Painting, Sculpture, and Architecture. Sturzwage lived in Paris from 1908 and is better known as a painter and graphic artist under the name of Léopold Survage. Some accounts also indicate that the Moscow sculptor Militsa Nikolaevna Curie studied at the Académie Matisse, while the seventh student could well have been Sergei Shchukin's niece, Zoya Aristionovna Myasnovo. On Sapozhnikova, see P. D. Ettinger, "Articles. Correspondence. Memoirs" (in Russian), compiled and annotated by A. A. Demskaya and N. Y. Semyonova (Moscow,1989), p. 113.

23. Letter from I. S. Ostroukhov to A. P. Botkina, 28 April 1908. Manuscript Department of the State Tretyakov Gallery, archive 48, no. 525.

24. Since Sergei Shchukin's archive has not survived, we have no documentary record of where and when any particular purchase took place, nor have we any information about purchases made directly from artists (with the exception of Shchukin's regular acquisitions in Matisse's studio and a small number of purchases from Picasso). On the other hand, we do know the names of the Paris dealers who numbered Sergei Shchukin among their clients: Durand-Ruel, Druet, Bernheim-Jeune, Berthe Weill, Clovis Sagot, Vollard, and Kahnweiler.

25. The Morozov family was one of the most famous Russian merchant dynasties, founded by the peasant craftsman Savva Vasilievich Morozov (1770-1862), who initiated four distinct branches of the Morozov textile business. Under the management of Abram and David Abramovich Morozov, the Tver Paper Goods Factory broke away to become an independent firm, of which the last directors were Varvara Morozova and her son Ivan Abramovich. "[Morozov], a Russian colossus, twenty years younger than [Shchukin], owned a factory employing three thousand workers and was married to a dancer," recalled Matisse in a 1951 statement to the critic Tériade published in *Art News Annual* 21 (1952) and reprinted in Flam, p. 133.

26. Ternovets, p. 119.

Morozov was particularly fond of landscape painting. Its clear dominance in his collection can be traced to the influence of the landscape artists who advised him and the lessons that he and his brother had taken from Konstantin Korovin in their youth, when Ivan would relax from his studies at the Zurich Higher Polytechnical School by painting landscapes in oils. His brother's widow believed that the collecting habit in which Ivan invested so much energy and resources was also primarily "a way of relaxing from business and the monotony of life."

Ivan Morozov never actively sought the attention of the press or the critics. The idea of playing a public role in the art world repulsed him, and he made no effort to do so. He admitted visitors to the house on Prechistenka Street with reluctance and never organized anything in the manner of Shchukin's regular Sunday showings with virtual lecture tours of the collection. Nonetheless, Morozov quickly won fame as a collector outside Russia, beginning in 1906, when he showed several pictures from his collection in Sergei Diaghilev's exhibition of "Two Centuries of Russian Art" at the Salon d'Automne. At the close of the exhibition he was elected an honorary member of the salon and awarded the French Legion of Honor, which spurred him on to still greater efforts. From then on, every year saw the appearance of at least thirty new canvases in the mansion on Prechistenka Street. Ivan Morozov, whom Ambroise Vollard called "the Russian who doesn't haggle," was considered a desirable client in the galleries, auction rooms, and exhibition halls of Paris. He was known to be able to spend two or three hundred thousand francs a year on buying pictures, something that few, if any, of the museums of Europe could possibly afford to do. The paintings he bought at the Durand-Ruel Gallery alone cost a quarter of a million francs.

Although the two men collected the same artists, Sergei Shchukin never regarded Ivan Morozov as a rival: Morozov acted too methodically, with steady, almost museum-like consistency; his aspiration was a collection that would comprehensively represent the main stages of development of modern painting and of individual artists. He approached the construction of a picture gallery in his mansion with the same thorough attention to detail: in 1905, when he refurbished the main house of the 1840s estate on Prechistenka Street (which he had bought in 1899), Morozov requested the architect, Lev Kekushev, to arrange the enfilade of rooms on the second floor to present a severe, museum-style vista. He had all the

VALENTIN SEROV, **PORTRAIT OF I. A. MOROZOV WITH PAINTING BY MATISSE**, 1910
STATE TRETYAKOV GALLERY, MOSCOW

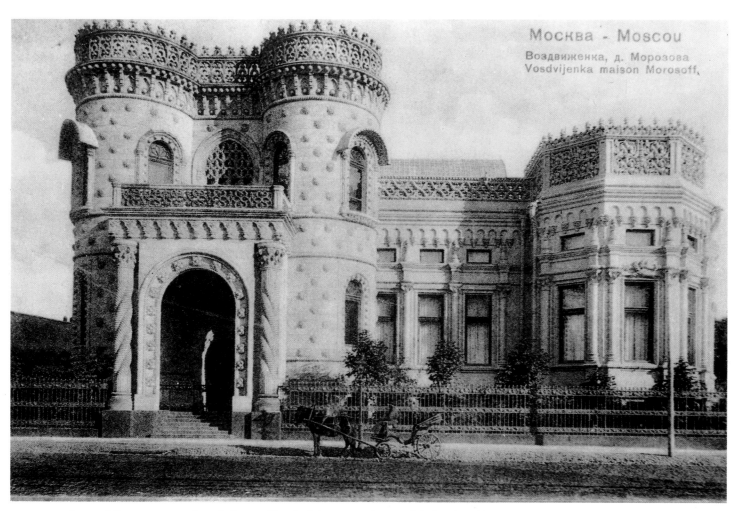

Москва - Moscou
Воздвиженка, д. Морозова
Vosdvijenka maison Morosoff,

ornamental mouldings removed and the walls clad in neutral gray fabric. A tall glass skylight was built into the roof to admit the sunlight that a genuine museum required. Morozov conceived of the collection that he was trying to assemble as a collection "of works, not names." He was capable of waiting for years to acquire the precise picture that he wanted to represent each artist. He had fifty impressionist paintings—by Monet, Renoir, Pissarro, and Degas. The painters of the next generation who were best represented in his collection were Van Gogh, Gauguin, and Cézanne. Gauguin's canvases first appeared in the Prechistenka Street mansion following his retrospective in the 1906 Salon d'Automne, and by 1911, the purchase of one of the artist's finest late works brought Morozov's total to eleven. The collector could pride himself on all seven of his Van Goghs, including *The Prisoners' Walk*, *Red Vineyards*, and *Landscape in Duver after Rain* (which he bought on the advice of Maurice Denis). Real pride of place in Morozov's collection, however, was held by his Cézannes—eighteen canvases covering almost every period of the artist's work, beginning with *Girl at a Piano* and ending with *Blue Landscape*. His own favorite was the still life *Peaches and Pears*. Morozov also had a particular liking for Maurice Denis, who was a fervent admirer of Cézanne. Morozov knew about Denis from his brother Mikhail's collection and the canvases acquired by Pyotr and Sergei Shchukin, but it was the 1906 Salon des Indépendants that first gave him the idea of collecting the artist's work himself. The following year, Morozov commissioned Denis to paint the decorative panels for the concert hall in his house on Prechistenka Street.

The five panels that Denis painted for Morozov on the theme of "The History of Psyche" were exhibited in the 1908 Salon d'Automne, where Matisse had arranged a virtual retrospective of his own work in a definite bid for a leading role in the modern art world. The Moscow collectors were already among Matisse's regular buyers, but of the several dozen canvases that Ivan Morozov shipped back to

ARSENY MOROZOV'S MANSION ON
VOZDVIZHENKA STREET, MOSCOW

Moscow from the Salon, only one, *Nu assis* (Seated Nude), was bought from Matisse. Sergei Shchukin's passion for Matisse was not so evident at this time either: he bought only two of the painter's works at the 1908 Salon. Indeed, between 1908 and 1911 Shchukin expanded his collection with works by the Fauves —Manguin, Vlaminck, Van Dongen, and Marquet—and his clear preference was for Marquet, from whom he bought nine landscapes.

With every year that passed, the gallery on Znamensky Lane attracted more and more attention. The first serious publication about it appeared in the summer of 1908, when the popular art historian and critic Pavel Muratov wrote in the journal *Russkaya mysl* (Russian Thought) that in recent times Shchukin's gallery had "exerted the most decisive influence on the course of Russian painting" and become "the most powerful channel in Russia for Western artistic trends." [27]

27. Pavel Muratov, "Shchukin's Gallery" (in Russian), *Russkaya mysl* 8 (1908), p. 116.

As Prince Sergei Shcherbatov recalled: "The effect of Shchukin's lectures and rapturous accounts of the latest trends in Parisian art was to shake all the academic foundations of the School of Painting, and in fact, of teaching in general, as well as the authority of the teachers. They provoked stormy debate, revolutionized the youth, and immediately give rise to fanatical imitation." [28] With the appearance of Matisse's canvases, followed almost immediately by those of Picasso and Derain, the "contagion" spread rapidly throughout Moscow. "Even for us specialists, Matisse, Picasso, and Van Gogh came as a surprise, and we struggled hard and complained loudly in the attempt to gain some understanding of them," confessed the artist Kuzma Petrov-Vodkin, who was himself often accused of blindly imitating Matisse.[29] As for those who had no understanding whatever of questions of modern art, Prince Shcherbatov noted acerbically that they reacted to these strange and incomprehensible canvases "like Eskimos to a gramophone."[30]

28. Sergei Shcherbatov, *Khudojnik uchedchei Rossii* (The artist in vanished Russia) (New York, 1955), p. 38.

29. K. S. Petrov-Vodkin, *Khlynovsk. Prostranstvo Evklida. Samaarkandia* (Khlynovsk. Euclidean space. Samarkandia) (Leningrad,1982), p. 366.

30. Shcherbatov, p. 39.

Many people in Russia accused Sergei Shchukin of corrupting the youth and undermining the foundations of society, while Morozov, who did not open his collection for viewing, provoked no such censure. In addition to the differences in artistic enthusiasms, the collections were also distinguished by the collectors' different attitudes to the public. Morozov always behaved like a genuine collector, totally absorbed in his own collection: he never actively sought the approval of public taste, whereas such approval was extremely important for Shchukin, who wished to take an active part in the artistic life of his country.

Although Sergei Shchukin, unlike Ivan Morozov, did not buy works by Russian artists, he played a unique role in the national cultural life of Russia, not only by virtue of his collection—which shaped and educated an entire generation of Russian avant-garde artists—but also by his personal involvement in the establishment of artistic societies and associations.[31] In addition to the immense resources that he invested in the paintings for his Museum of Modern French Art, intended as a gift to the city of Moscow, Shchukin was also obliged to expend considerable energy in the struggle with conservative public taste. The most serious test faced by the collector undoubtedly came with the two large decorative panels commissioned and purchased from Matisse: these major culprits in "disturbing the peace" of Russia's young artists in the early 1910s made Shchukin's gallery a revered site of pilgrimage for lovers of modern art.

31. The decision to form the Union of Russian Artists was actually taken in Shchukin's home in 1909, and in 1911 Shchukin was the first person to accept honorary membership in the Moscow artist's association Jack of Diamonds.

2. A SPECIAL COMMISSION

Matisse had already received the commission for a large panel for the main staircase of the mansion on Znamensky Lane when an article about the French painter appeared in the July issue of the journal *Zolotoe runo* (Golden fleece).[1] The study by Alexandre Mercereau, the French correspondent of Nikolai Ryabushinsky's sumptuous journal of the arts, was printed together with Henri Matisse's own recently written "Notes of a Painter" and illustrated with seventeen reproductions.[2] One of these showed the sketch for *La Danse* (The Dance), and the

1. *Zolotoe runo* 6 (1909), illustrations pp. 3-14, text pp. I-X.
2. Nikolai Pavlovich Ryabushinsky (1876-1951), one of eight brothers in a wealthy family of Moscow entrepreneurs and bankers, was a notable patron of the arts. Founder of the journal *The Golden Fleece* in 1906, he championed the idea of a Palace of the Arts in Moscow. His collection, which consisted mostly of works by Russian

article mentioned that it was the first of two panels commissioned by Shchukin. However, it was another year before this daring step by the impassioned Moscow collector provoked serious comment. Alexandre Benois prophesied a great future for Matisse's new creation: "Rumor has spread recently that Matisse has been commissioned to paint a mural for the staircase of a certain rich Moscow patron of the arts. It is quite possible that I myself will derive no great joy from these frescoes, for my preferences lie with other systems and other tastes. But I think that in the history of art this work by Matisse could well serve as the starting point for an entire movement that, in time, will produce something great and beautiful."[3] Shchukin's idea of commissioning the decorative panels from Matisse finally materialized in January or February 1909. The seed had been planted a long time before by two pictures hanging in the apartment of Leo and Gertrude Stein on the rue de Fleurus—the large painting *Joie de vivre* and the small sketch *Music*. No doubt Shchukin informed Matisse of his intention of offering him an important commission over breakfast at the luxurious Paris restaurant Larue. The artist apparently agreed then and there to embark on this major decorative work and stated his basic conditions.[4]

When Matisse gave an interview to Charles Estienne of the Paris newspaper *Les Nouvelles*, he described his task in approximately the following terms: 'I have to decorate a staircase. It has three flights. I imagine a visitor entering. He reaches the first floor. I have to give him strength and a sense of relief. My first panel represents a whirling circle dance on a hilltop. On the second floor we are already inside the house. In this quiet atmosphere I see a musical scene with attentive listeners. Finally, on the top floor there's calm, and I paint a scene of rest, with people stretched out on the grass, engrossed in daydreams and meditative thought. I shall achieve this through the greatest simplicity and economy of means, which allow the artist to give the most accurate form to his inner vision." [5]

Matisse made two ink and watercolor sketches of the proposed panels and sent them to Moscow for his client's comments with his letters of 11 and 12 March 1909. These were *Composition No. 1 (Danse)* and *Composition No. 2 (Demoiselles à la rivière* [Bathers by a River]), both depicting nude figures. Thanking the artist for the sketches, Shchukin informed Matisse—whose hopes of using the mansion as the setting for a triptych of panels resulted from his ignorance of its interior construction—that the staircase had only two flights, and consequently only two panels were required.[6]

In addition, however, a decision to display nude figures several meters high on the staircase of a house in which little girls had recently taken up residence would have flown in the face of Russian tradition.[7] Sergei Shchukin wrestled with his conscience for two weeks in the search for a compromise.[8] It was only on 31 March that he finally summoned up the resolve to write to Matisse that he was willing to accept all his terms: "I find so much nobility in your panel 'The Dance' that I have decided to ignore our bourgeois opinion and hang a subject with nude figures on my staircase. At the same time I shall need a second panel, the theme of which could be music."[9]

No longer insisting on the exclusion of nude figures from the composition, Shchukin merely requested that *Music* should in some way indicate the character of the house, in which there was "a great deal of music-making." Indeed, the choice of subject for the second panel was by no means fortuitous. The artist Leonid Pasternak (father of the poet Boris) recalled that for many years the former Trubetskoi palace was the venue for "brilliant evenings of chamber music, with an abundance of fine food and drink, and also marvelous bouquets of red roses" that were given at the end of the concerts to the ladies among the two hundred or so invited guests. This custom, established during the lifetime of Shchukin's first wife, Lydia Grigorievna, was continued after her death, with the very finest musicians performing on the wonderful Steinway in the white salon, where the walls were hung with canvases by Monet and other impressionists.

artists, also included paintings by Georges Rouault and Kees Van Dongen.

Matisse's "Notes of a Painter" first appeared in *La Grande Revue* 52 (25 December 1908). Shchukin owned seven of the works that were reproduced: *The Red Room (Harmony in Red), Statuette and Vases on an Oriental Carpet, Game of Bowls, Nude (Black and Gold), The Dance,* a study for the panel *Nymph and Satyr,* and *The Spanish Woman.* Morozov owned *Seated Nude.* None of these works was exhibited at the Salon of the Golden Fleece, because Shchukin and Morozov refused to make them available. They were planning to show works from their collections at a specially organized exhibition (an intention that was never realized). The only Russian collector of Western paintings who showed works at the Salon was Ryabushinsky.

3. A. Benois, "Khudojestvennye pisma. Salon i shkola Baksta" (Letters on the arts. The Salon and the Bakst school), *Rech*, 14 May 1910.

4. Alfred H. Barr confirmed that such a meeting took place in *Matisse: His Art and His Public* (New York, 1951), p. 133. His remarks are based on Matisse's own comments from "Questionnaire VI from Alfred Barr," Archives of the Museum of Modern Art, New York, March-April 1951.

5. Charles Estienne. "Des tendances de la peinture moderne" (Trends in modern painting), *Les Nouvelles*, 12 April 1909.

6. Letter from S. Shchukin to H. Matisse, 16 March 1909.

7. Following the death of his younger brother, Shchukin took in three peasant orphans, Anya, Varya, and Marusya (the latter left after a brief stay). Their tutor was Elizaveta Aristionovna Myasnovo, Shchukin's sister-in-law and former director of the grammar school in Tula. The girls were taught languages, dancing, and music.

8. Letter from S. Shchukin to H. Matisse, 27 March 1909 (letter XII in "Correspondence" below).

9. Letter from S. Shchukin to H. Matisse, 31 March 1909 (letter XIV below). Published in a corrected form in Kean, pp. 296-299. Kean discovered a confusion between letters of 31 March 1910 and 22 August 1910 as published Barr, p. 555.

Music fascinated Shchukin in the same way as painting, and he found as much inspiration in the world of sound as he did in the world of colors and images. After his wife's death, he often attended musical evenings at the Free Aesthetics Society; when the famous Polish harpsichordist Wanda Landowska gave concerts there during her Russian tour, her playing brought tears of ecstasy to Shchukin's eyes. Vera Scriabina, the wife of the famous composer, and a very fine pianist in her own right, often played at the Free Aesthetics evenings. Shchukin was very enamored of Scriabina, who was separated from her husband, and in 1908 he formally proposed to her, but she refused. Even after the parting with Scriabina, however, music continued to occupy an important place in his life. The evening concerts on Znamensky Lane continued with Mozart concertos, Bach preludes and Scarlatti sonatas. Meanwhile, in his studio at Issy-les-Moulineaux, Matisse was just beginning work on his *Music* panel, with composition and colors following quite different melodies and rhythms.

Shchukin had very high hopes for the future panels. In January 1909 Maurice Denis came to Moscow to finish the decoration of the music salon in Ivan Morozov's mansion.[10] Many people later expressed the opinion that Denis's panels were boring and compared their colors to "pink caramel." But at the time, the restricted and select public who had the opportunity to visit Morozov on Prechistenka Street considered the panels a great success, and this ruffled Shchukin's pride. He encouraged Matisse to continue, although he knew perfectly well how difficult it would be to come out ahead. Yet Matisse's victory would at the same time be his own.

From the moment that Matisse began work on the panels, Shchukin relentlessly strove to convince everyone around him of "Matisse's greatness" as "a born decorative artist" who was "in love with gaiety and the appearance of things." It was extremely important to Shchukin to convert people who understood and loved art to his own faith. He thought about it constantly, even during one of his regular trips to Egypt. From faraway Cairo he wrote to Ilya Ostroukhov, a trustee of the Tretyakov Gallery in Moscow, that his enthusiasm for Matisse was "shared by people sincerely devoted to art," such as Hugo von Tschudi, the director of the museum in Munich, who had commissioned a painting by Matisse and called him

10. The five panels arrived in Moscow in November 1908, but during his visit there in 1909, Denis decided that they did not adequately complement the architectural style of the house, and he painted an additional eight panels. Denis considered the Moscow panels to be among his best works. They are now part of the Hermitage collection.

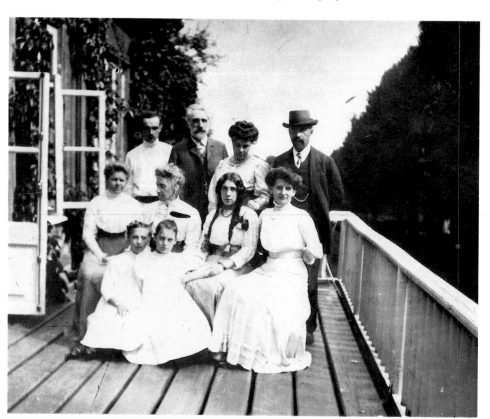

SERGEI SHCHUKIN WITH THE FAMILY OF HIS SISTER, NADEZHDA MYASNOVO, 1910. FRONT ROW: THE ORPHANS ANYA AND VARYA
PRIVATE ARCHIVES, MOSCOW

"one of the most significant artists of our century," or Bernard Berenson, the authoritative connoisseur of ancient art, who had dubbed Matisse "the artist of the epoch."[11]

Shchukin's final visit to Egypt in the autumn of 1909 ended unhappily: he injured his eyes in a fall from a horse, and as a result he had to spend late November and the whole of December in Paris under the constant supervision of some of the finest oculists in Europe. A new tragedy forced his sudden return to Moscow when his twenty-two-year-old son Grigory committed suicide.

In May 1910, following months in which he and Matisse had hardly exchanged a single letter, Shchukin set out to spend the entire summer in Italy, accompanied by his children and Nadezhda Afanasievna Konius. A teacher at the music school run by her husband, the well-known pianist and teacher Lev Konius (Shchukin's adopted daughters, Anya and Varya, attended the school on the advice of Vera Scriabina), Nadezhda Konius would later become Shchukin's wife.

The summer completely restored Shchukin's health, so that he was able to maintain his custom of many years and travel to the Salon d'Automne, where Matisse intended to exhibit the finished panels. The Salon opened on 1 October; Matisse returned to Paris from Munich two weeks later, and Shchukin, who had been vacationing on the French Riviera with Nadezhda Konius, left Menton for Paris on 31 October.[12]

The 1910 Salon d'Automne was dominated by decorative painting. The tone of the entire show was set by the huge canvases of Maurice Denis and José María Sert, and dozens of similarly oriented painters were represented by paintings of every possible size. In these surroundings Henri Matisse's panels, listed in the catalogue as numbers 536 and 537, appeared frankly provocative. "This time simplification has reached its extreme limits," wrote the *Gazette des Beaux-Arts,* and the Paris newspapers responded to the artistic sensation of the autumn with caustic caricatures.[13]

Instead of the long-anticipated success, there was suddenly scandal. Shchukin, forgetting the courage he had mustered to place such a commission, lost his control and backed down. Having seen with his own eyes the reaction of the Parisian public, he could imagine only too clearly what an uproar the sight of the new "masterpieces" would provoke in Moscow, where he had long been considered "a crazy collector of decadent trash." The year 1910 had already provided rich pickings for the society columnists and their readers: first there was Grigory's mysterious suicide, then his eldest son Ivan's loudly publicized divorce, (which took place only a few months after the wedding and cost Shchukin a million roubles), and now his daughter's divorce was pending. Shchukin could see no other option but to decline the panels.

It was also a very difficult time for Matisse. Just as the public and the critics began pouring scorn on his works in the Salon, his father died, and he had scarcely returned from the funeral when he learned of Shchukin's decision not to take the panels.

On 8 November, the last day of the Salon, Shchukin left for Moscow. The next day, Matisse received a telegram sent by the collector from Warsaw, requesting him to dispatch the panels "by express delivery." A letter followed a week later to explain what had happened in greater detail.[14] Alexandre Benois, who by no means shared all of Shchukin's views, called his most recent purchase a feat of heroism. "What has this man had to put up with for his 'caprices'? For years he has been regarded as a madman, a maniac who throws his money out of the window and allows himself to be 'fiddled' by Parisian swindlers. But Shchukin, ignoring the howling and the laughter, carried on in simple good faith along his chosen path. Still worse than all these external jibes is the suffering he has had to bear from his own doubts and disappointments. . . . Every one of his purchases was in its own way a feat of heroism, fraught with the torment of fundamental uncertainty. . . .

11. Letter from S. Shchukin to I. Ostroukhov, 10 November 1909. Manuscript Department of the State Tretyakov Gallery, archive 10, section 7276.

12. Postcard from S. Shchukin to N. Myasnovo, 31 October 1910. Archives of the Pushkin Museum, archive 13, collection XI/II, no. 132.

13. "Le Salon d'Automne," *Gazette des Beaux-Arts,* November, 1910, p. 370: "In the depths of the hall hung two large paintings by M. Henri Matisse. On this occasion simplification has reached its extreme limits: flat, thinly colored figures drawn in red on a background that is half green, half blue. The drawing is no less synthetic: each figure is not modeled, but surrounded by a unifying brushstroke—a calm line on the panel to the left, which represents Music, and an arabesque woven into a treble clef on the right-hand panel, representing Dance."
The French reviewer's opinion was shared by a Russian colleague: "Entering the Salon d'Automne, we halt before two panels by Matisse (owned by the Moscow merchant Shchukin). The panels evoke constant outbursts of indignation, rage, and ridicule from the people standing before them. Indeed, the provocative, poisonous colors create an impression of diabolical cacophony; the drawing is simplified almost to the point of nonexistence, and the unexpected deformations of the figures express the idea in a bold and imperious fashion. The world created by Matisse in these cannibalistically naive panels is, I must confess, a very unpleasant one. Matisse strives to convey not one impression, but an entire sequence of impressions, yet the unpleasant feeling remains from the first moment of viewing these panels to the last. In my opinion they are a complete failure and demonstrate once again the uneven quality of the work done by Matisse, one of the most celebrated artists of our time. . . .
"Simplification is increasingly seducing the contemporary artist, leading him into extremes that may not necessarily be bad for art, since they prevent one from becoming satiated with the routine. Harm is done, however, by legions of sportsmen claiming the rights of primitive decadents to produce vulgarity; simplification produces arbitrary and schematic blocks of forms. What business do these gentlemen have engaging in art, tormenting the nerves of artists who were fashioned by the grace of God! . . ." (P. Skrotsky, "Iz Parija" [From Paris], *Odessky listok* 267, [20 November 1910]).

14. Letter from S. Shchukin to H. Matisse, 11 November 1910 (letter XXIII below).

"Shchukin has used a kind of ascetic method . . . to train himself through his acquisitions, and he has drawn on his own force to break through the barriers that arose between himself and the worldview of the artists who interested him. Perhaps he has been mistaken on occasion, but in overall terms he now emerges victorious. He has surrounded himself with objects that, through their slow and constant influence, have enlightened him as to the true state of affairs in modern art and taught him to rejoice in those things of our time that are genuinely capable of bringing joy. His latest feat of heroism is the acquisition of two decorative panels by Matisse, which outraged the whole of Paris last autumn. . . . Shchukin has suffered greatly for this decision. He very nearly declined to purchase them, but then, on his return to Moscow, to his own surprise, he began to "miss" these pictures and hastened to send for them. He no longer regrets this bold step, but his friends and the connoisseurs now regard him with still greater suspicion, and even many of his usual supporters can only shrug their shoulders in amazement."[15]

Despite the favorable outcome of this incident, it took Matisse a long time to recover from the shock. Hans Purrmann, who helped Matisse to pack the panels, recalled that from time to time the artist would panic. He was afraid (and not without reason) of the Russian public's reaction to his works. Shattered nerves and chronic insomnia forced Matisse to seek a change of scene by going to Spain. Before his departure, however, he found time to act as intermediary between Shchukin and the Bernheims, whose firm had recently begun to represent his own interests. In one of his rare changes of mind, Shchukin had decided to decline a huge panel by Puvis de Chavannes that he had bought from the Bernheims—an allegorical work entitled *The Muses Greet Genius, the Herald of Light,* which was a sketch for one of the monumental decorative pieces produced by Puvis for the Boston Public Library. [16]

Matisse first became unwittingly involved when he gave up his studio at Issy for a few days so that Shchukin could examine the work, which measured several meters and would not fit into the Bernheim-Jeune Gallery on the avenue Matignon. Marguerite Duthuit recalled how her father cleared a place for the pictures, painted in uncommonly soft, muted tones and combining illusory naturalism with academic convention.[17]

15. A. Benois, "Khudojestvennye pisma. Moskovskie vpechatlenia" (Letters on the Arts. Moscow Impressions), *Rech*, 17 February 1911.

16. The work referred to is Puvis de Chavannes's study for the central section of the series on the theme of enlightenment. The drawing was exhibited at the salon as Bernheim-Jeune's property; it is now housed at the Opéra Comique in Paris.
Shchukin apparently bought the drawing, consisting of five parts, before he canceled his order for Matisse's panels, as Puvis's work was already in Paris on 11 November. It is possible that the collector bought the work while in Paris at the end of September, before departing for Menton, which might be explained by a desire to have a replacement available for Matisse's panels *The Dance* and *Music*, which Shchukin was not sure he would be able to display for public viewing.

17. Kean, p. 198.

When Puvis de Chavannes's panel arrived in Moscow, it became apparent that the room in which Shchukin proposed to hang this grandiose decoration (more appropriate for the adornment of a public building) would require fundamental reconstruction to accommodate the work. When he learned that the expenditure on the small vaulted room would be ten times the cost of the *Muses* themselves, Shchukin thought it more reasonable to cancel the purchase, but the only way he could extricate himself from the situation and minimize his loss was to arrange a mutually advantageous exchange with Bernheim. Through the good offices of Matisse, the Moscow collector was able to exchange Puvis's gigantic panel for Matisse's small *Jeune fille aux tulipes* (Girl with Tulips), which Bernheim had bought at the Salon des Indépendants in 1910, and thus reduce his losses on the deal to ten thousand francs.[18]

During the month it took to transport Matisse's panels to Moscow, Shchukin could think of little else. Having set everything that happened in Paris behind him, he was more convinced than ever that Matisse had chosen the right path. However, his faith alone was not enough to make the Moscow public accept the artist.

Shchukin made no attempt to shield Matisse from the fact that the struggle for the recognition of *The Dance* and *Music* would be hard. He felt that a more accessible still life would provide useful ammunition in his mission of enlightenment as he systematically attempted to prepare the Russian viewer for the unfamiliar forms and color combinations. He hoped that having dispatched the panels that had caused him so much stress to Moscow, Matisse would find the time in Spain to paint him a few still lifes.[19]

Shchukin bought works by many artists, but people had the impression that he never thought about anyone except Matisse. The idea of creating a genuine Matisse museum probably came to him quite early on. He wanted it to include every genre of painting. In December 1910, before the panels had arrived, Shchukin asked Matisse several times for "a composition with clothed figures."[20] As a possible subject, the collector suggested that Matisse might paint a family portrait showing Madame Matisse and his three children. Matisse liked Shchukin's idea, and he very quickly produced a sketch for the picture, which Shchukin praised enthusiastically, writing that he sensed nobility in the work and definitely wished to have it.[21]

Meanwhile, on 4 December 1910, *The Dance* and *Music* arrived safely in Moscow. "Tomorrow we are going to a Beethoven concert, a very interesting one, at Mr. Shchukin's. His Matisse panels arrived yesterday—they're awful! Sergei Ivanovich himself is of the same opinion, and he told me yesterday at our house that the gallery might not take them when he dies. We should make an official record of that opinion," wrote Ilya Ostroukhov to Pavel Tretyakov's daughter Anna Botkina, who was his colleague on the board of the Tretyakov Gallery.[22]

Shchukin hung Matisse's panels on the staircase leading from the entrance hall to the second floor. The beginning of the staircase was hidden by a massive arch (all the ceilings in the old house were vaulted). *The Dance,* which drew the viewer's eyes upward, was positioned on the narrow landing after the first flight of steps, but it was hard to get a good view of the painting because there was no space to step back, and the staircase continued around a right-angle bend to the right.

18. Letter from S. Shchukin to H. Matisse, 11 November 1910 (letter XXIII below).

19. Letter from S. Shchukin to H. Matisse, 27 November 1910 (letter XXIV below).

20. Letter from S. Shchukin to H. Matisse, before 17 December 1910 (letter XXV below).

21. Letter from S. Shchukin to H. Matisse, 23 December, 1910-5 January, 1911 (letter XXVII below).

22. Letter from I. Ostroukhov to A. Botkina, 5 December 1910 (all of Ostroukhov's letters are dated according to the old style). Manuscript Department of the State Tretyakov Gallery, archive 48, no. 634.
Anna Pavlovna Botkina (1867-1952) was the daughter of the founder of the Tretyakov Gallery in Moscow and widow of the well-known doctor and collector S. S. Botkin.

 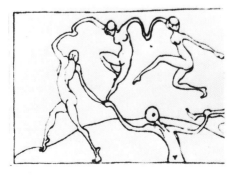

"BEFORE" AND "AFTER." CARICATURE OF MATISSE'S PANELS, WHICH WERE EXHIBITED AT THE SALON D'AUTOMNE IN 1910
DRAWING FROM *LA VIE PARISIENNE*, 8 OCTOBER 1910

Music, which was hung on the way up to the second floor, seemed to provide a calming pause in the ascent. Only from the landing on the second floor was it finally possible to view the two panels, placed at right angles to each other. Because of the dim lighting on the staircase (especially in the evening, when the electric light was turned on), the pictures produced the impression of tapestries or frescoes.

Shchukin's letter informing Matisse of the paintings' arrival was restrained in tone. He wrote that "the effect is not bad" and that he found the panels "interesting."[23] The main thing, however, was that despite the protests of the public, despite all the jibes and accusations of corrupting the youth by buying such pictures, he continued to believe in Matisse.

Indeed, Shchukin was quite deliberately educating the Russian public to appreciate Matisse's art. After his purchases from Denis, Morozov had turned to another member of the Nabis, Pierre Bonnard, for a triptych entitled *The Mediterranean* painted over the main staircase of the mansion-museum on Prechistenka Street.[24] Shchukin, however, could not envision a painter other than Matisse for the decoration of the room where the Puvis de Chavannes panels were to have been hung. Without attempting to impose his own opinion concerning the subject of the paintings (although he did suggest that a traditional treatment of the ages of man might be suitable), Shchukin made only one request—that there should be no nude bodies. [25]

"I am beginning to enjoy looking at your panel 'Dance,' and as for 'Music,' that will come in time," wrote the collector, who was gradually becoming accustomed to the panels that had caused him so much trouble.[26] His daughter, Ekaterina Sergeievna, used to speak about her father's own special way of deciding whether or not a particular work was really worth buying. The most reliable indicator was his own response—that inexplicable excitement he felt when he saw a canvas for the first time.[27] When he sensed that familiar tingling of the nerves, Shchukin took a picture without a moment's thought. Only some time later, when he was alone face to face with the painting, did he attempt to understand what had prompted his choice.

If we are to believe the reminiscences of Prince Shcherbatov (who was one of the outspoken critics of *The Dance* and *Music*), Shchukin complained at first that when he was left alone with the panels, he hated them, had to struggle to overcome his response, almost wept, and abused himself for having bought them, but as each day passed he could feel them "overpowering" him more and more.[28]

"'You have to live with a picture in order to understand it. Live with it for a year at least. It happens to me as well—sometimes you can't accept an artist for several years, then your eyes are opened. You have to get used to it. Very often you don't like a picture at first sight, it repels you. But a month goes by, then another, and you remember it despite yourself, keep looking at it again and again. And it reveals itself to you. You understand it and start to love it. . . .'

"Our host became animated, his eyes began to sparkle, he pointed impatiently first at one picture, then the other and said: 'Don't look at them as pictures. See them as a porcelain plate or a tile. It's a spot of color that pleases the eye. Look, now! Isn't that remarkable? Magnificent? What a subtle color combination, what taste, what boldness!'

"'For me Matisse is above all the rest, better than them all, closest to my heart. . . . His work is a festival of exultant colors.

"'Let's go! Come on,' he exclaimed, and ran off through the rooms. . . . He flung open a door on to the inner staircase and withdrew into the depths of a dark room.

"'Look! Look at them from here, from the darkness!'

"We viewed the Matisse panel hanging above the staircase. On a bright green ground, beneath a bright blue sky, the bright red naked figures with their hands clasped together swirled round and round. 'Just look!' our host exclaimed, inspired. 'What colors! The staircase is lit up by this panel, isn't it?'"[29]

Matisse's *The Dance* and *Music* panels were indeed a staggering sight. Once seen, they could never be forgotten. "For those times, this was so unusual that even

23. Letter from S. Shchukin to H. Matisse, 20 December 1910 (letter XXVI below).

24. Pierre Bonnard. *The Mediterranean. A Triptych* (1911, The Hermitage). In 1912 he added two more large panels to the triptych: *Early Spring in the Country* and *Autumn. Fruit Picking* (State Pushkin Museum of Fine Arts).

25. Letter from S. Shchukin to H. Matisse, 20 December 1910 (letter XXVI below).

26. Letter from S. Shchukin to H. Matisse, 23 December 1910-5 January 1911(letter XXVII below).

27. Kean, p. 157.

28. Shcherbatov, p. 37.

29. I. Zhilkin, "V Moskvie" (In Moscow), *Russkoe slovo*, 22 September 1911.

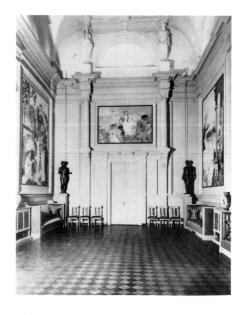

SALON WITH MAURICE DENIS'S **L'HISTOIRE DE PSYCHE** IN MOROZOV'S MANSION

people of the milieu like us were excited, Matisse's panels were so bold and unusual. . . . And of course, the forms of these naked bodies were very far from 'academic,'" recalled the artist Sergei Vinogradov. "Nowadays this has all become rather ordinary and sometimes even a bit boring, but then, in wealthy, frosty, beautiful Moscow with those marvelous Friday lunches at Shchukin's and the liveried footman—Matisse was a peppery contrast."[30]

Very few were capable of appreciating Shchukin's gift of foresight and therefore conceding Matisse's victory immediately after the panels appeared, not ten years later. Boris Ternovets described the shock he experienced with characteristic insight: "I was at Shchukin's today. . . . Need I say that the finest things do not suffer in the least from frequent visits; on the contrary, you want to go on looking at them forever—as with Monet's *Breakfast* or Cézanne's *Still Life*, or Gauguin's works. But the thing that astounded, attracted, and captivated us, the thing that resounded like a triumphant final chord, was Matisse's new fresco, *The Dance*. I was literally intoxicated by it: on a blue ground, women dancing round in a circle. They have just stopped, but the movement is so powerful that the circle will close again, and the dance will continue with renewed energy. The figures are red, outlined here and there in black. There is no way to convey in words the absolute finality, the inner focus, the conclusiveness of the composition. The distorted and dislocated limbs do not for one moment shock the eye: everything is so necessary to the whole, so inherently necessary. If you stand in the half light of the next room and squint just a bit, the result is fantastic, fabulous, unreal. Everything comes to life and bursts into wild, irrepressible movement. This is the best thing that Matisse has created, and perhaps the best that the twentieth century has given us. This is not painting (for there is no form), not a picture—this is some other kind of monumental decorative art, a thousand times more forceful and astounding. Never have I felt the ennobling power of art so strongly. My soul seemed to be purged by the fire of beauty; I felt its fleeting, artificial veils fall away. . . ."[31]

Shchukin's commitment to Matisse was indeed exceptional. Not only did the Moscow collector provide the artist with support and encouragement by letter, but he also guaranteed his financial security through constant purchases and commissions. Even before he had grown accustomed to the panels, Shchukin was full of new plans and ideas. He insistently requested Matisse to complete the family portrait and pressed him to accept his next large commission.

At the end of March 1911, two still lifes that Matisse had painted in Spain arrived in Moscow. The proposal that Matisse decorate a room in the Shchukin mansion was accepted and the price agreed upon. The room, small and poorly lit, was a difficult one for hanging pictures, and Shchukin thought it wise for the artist to come to Moscow and examine the room for himself. In September it was finally decided that the two would go to Paris at the same time, Matisse from Collioure and Shchukin from Moscow. Following the Salon d'Automne, in which Matisse planned to exhibit the finished portrait of his family, they were to travel to Russia together.

On 19 October (1 November according to the Gregorian calendar), Sergei Shchukin and Henri Matisse set out from Paris on the Northern Express.

3. A VISIT TO RUSSIA, AUTUMN 1911

The first Russian city that Matisse visited in the company of Sergei Shchukin was St. Petersburg, but their stay in the imperial capital was both brief and unsuccessful, for they were unable to follow the program they had planned.

Communicating the latest news to Anna Botkina, Ilya Ostroukhov wrote that "22 October, the first day in Russia, was a 'flop' for Matisse. He had dreamed excitedly of seeing the Hermitage (this was their reason for going to St. Petersburg) . . . but Ser[gei] Iv[anovich] Shchukin, having learned from the doormen that the Hermitage was closed for the winter, was too shy to bother the

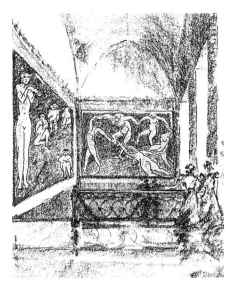

THE DANSE AND **MUSIC**: RECONSTRUCTION OF THEIR PLACEMENT ON THE STAIRCASE IN SHCHUKIN'S HOME DRAWING BY IVAN SAVELIEV

30. Vinogradov, "S. I. Shchukin."

31. Ternovets, p. 10.

HENRI MATISSE WITH SERGEI SHCHUKIN'S GRANDSON,
ILYA KHRISTOFOROV, NOVEMBER 1911

HENRI MATISSE WITH SERGEI SHCHUKIN'S GRANDSON,
ILYA KHRISTOFOROV, NOVEMBER 1911

1. The exhibit referred to is the Sixth Autumn Exhibition, at which the majority of works on show were by Russian salon painters. The Emperor Alexander III Museum is now known as the Russian Museum.

2. According to the program drawn up by Ostroukhov, 23 October should have included a visit to the Cathedral of the Assumption in the Kremlin, and the Patriarch's Vestry, which housed objects from the religious life of the patriarchs and metropolitans of Moscow.

3. *Sadko*, an opera by Rimsky-Korsakov, was being performed at the Bolshoi Theater.

4. Konstantin Nikolaevich Igumnov (1873-1948) was a pianist and professor at the Moscow Conservatory.

5. The Bat was a cabaret theater in Moscow from 1908-1918. It was founded by Nikolai Tarasov, a patron of the arts, and Nikita Baliev (1877-1936), a member of the Moscow Arts Theater company and the first Russian "master of ceremonies."

6. Letter from I. Ostroukhov to A. Botkina, 25 October 1911. Manuscript Department of the State Tretyakov Gallery, archive 48/672.

7. Letter from I. Ostroukhov to A. Botkina, 19 October 1911. Manuscript Department of the State Tretyakov Gallery, archive 48/669.

8. Letter from I. Ostroukhov to A. Botkina, 30 October 1911. Manuscript Department of the State Tretyakov Gallery, archive 48/674.

9. Pavel Ivanovich Kharitonenko (1852-1914), a sugar refiner, was a patron of the arts and collector; his wife was Vera Andreievna. (See note 16 below.)

10. The Rogozhskoe cemetery was the spiritual and administrative center of the Russian Old Believers' church.
The Monastery of St. Nicholas of the Single Faith, located beyond the Preobrazhensky Gate, belonged to a different branch of schismatics.

director. So now Matisse will probably never ever see the Hermitage. He fled in horror from the Autumn Exhibition and the Alexander III Museum. [1] He liked St. Petersburg a lot as a city. The day before yesterday they arrived in Moscow, and Matisse went to stay with Mr. Shchukin. On the first day he looked at Shchukin's collection and that of Ivan Abramovich [Morozov]. Yesterday evening he was our guest. You should have seen how he was delighted by the icons! He literally spent the whole evening with them, savoring and admiring each one. And with such finesse! . . . Finally he announced that for these icons it was worth his while to come from a city even farther away than Paris, that he valued them more than Fra Beato. . . . Today Ser Iv phoned me to say that M[atisse] literally could not get to sleep all night, so keen was the impression made. . . . Tomorrow I am taking him to the cathedral, the vestry, and a chapel of the Old Believers.[2] In the evening we are going to Sadko.[3] (Yesterday at our house he heard Igumnov and liked him very much.)[4] Then over the next few days I am arranging a concert of the Synodal Choir for him, a banquet of honor at the Bat on 1 November, etc.[5] I hope he will be pleased. . . . I find Matisse extraordinarily likeable, and I regret most terribly that you are not here—he is a remarkably subtle, well bred, and original gentleman. And absolutely everyone who talked with him yesterday had the same impression."[6]

Ilya Ostroukhov, whom Shchukin had been trying for several years to convince of "Matisse's greatness and significance," had made friends with the artist at the previous Salon d'Automne, where they met several times. In his letters to Russia Ostroukhov wrote that Matisse was "a fine, highly intelligent, and cultured person," who shared his exceptional "enthusiasm for the Egyptians," and with whom he found it "extremely interesting" to spend time.[7] In Moscow Ostroukhov postponed many business commitments in order to give Matisse as much of his attention as possible. "I continue to devote almost all my free time to Matisse, whom I find more and more charming," he wrote to Botkina.[8] Indeed, it is to Ostroukhov's credit that, having volunteered to arrange Matisse's program in Moscow, he managed to organize his guest's time to the maximum benefit. Here, for instance, is the program Ostroukhov proposed to Shchukin for just three days:

"29. Saturday. At 11 I call for you and we go to the Novodevichy Convent; from there we can go to lunch at Kharitonenko's (he wants to sketch a view of the Kremlin, and they have several interesting icons).[9] 30. (Sunday). I call for you in the car about 1-1:30, to go to the Rogozhskoe cemetery and the Dissenters' monastery.[10]

"1. (Tuesday). At 3 I call for you to go to a concert by the Synodal Singers, specially arranged for us. . . . At 12 midnight I expect Matisse at my house to go to the Bat, where they want to receive him.

"That's for the next few days. We'll see about the rest later."[11]

The sightseeing in Moscow was focused primarily on old Russian painting and architecture, a choice determined by Ostroukhov's own personality: he was a figure of considerable note in the art world of early twentieth-century Moscow, a gifted artist, an energetic museum administrator, and a collector endowed with equal measures of passion and refined taste.[12]

Ilya Ostroukhov had taken up painting rather late, after the age of twenty, but he became one of the finest Russian landscape painters of the 1880s. His marriage to Nadezhda Botkina (the niece of Sergei Shchukin's mother) made him co-owner of the Botkin Tea Trading Company. Although Ostroukhov never possessed large capital, since he took almost no part in the business, he enjoyed enough financial security to collect works of art. Having stopped exhibiting his own works early on, Ostroukhov devoted himself entirely to public cultural activities and collecting. At first he bought German artists—Achenbach, Menzel, Lenbach—and the Scandinavians Thaulow and Zorn, then the French Daubigny, Degas, and Renoir. Ostroukhov was the first to bring one of Edouard Manet's paintings to Moscow, when he bought the *Portrait of Antonin Proust* from its previous owner, Ivan Shchukin (who served for many years as his intermediary with the Paris dealers).

Ilya Ostroukhov was an artist-collector of a kind rare in Russia. He approached works from a purely artistic point of view, and probably for this reason, his collection contained more studies than actual paintings. His first interest was the work of late nineteenth-century painters, followed by that of contemporary Russian artists; then, in 1902, he turned to old Russian icon painting. While the museums collected icons only, if at all, as historical rarities, he was attracted by their artistic qualities. An unusually keen artistic instinct told him that the layers of later overpainting concealed the original surfaces.

In other words, if not for Ostroukhov, who was dubbed "the Columbus of old Russian painting," and was, in the opinion of his contemporaries, the most competent authority in Moscow on all matters of art, Matisse's trip would scarcely have provided him with such a great wealth of impressions. Nor were Ostroukhov's efforts made in vain, for his Parisian guest proved to be most attentive, and grateful for all that he learned and saw.

"The Russians do not even suspect what artistic wealth they possess. I am familiar with the religious art of several countries, and nowhere have I ever seen such a complete expression of the mystic mood, at times even of religious fear . . . ,"

MAK (P. IVANOV), **PORTRAIT OF HENRI MATISSE**
ZERKALO (THE MIRROR) NO. 45, 1911

11. Letter from I. Ostroukhov to S. Shchukin, 27 October 1911. Manuscript Department of the State Tretyakov Gallery, archive 10/680.

12. The artist Ilya Semyonovich Ostroukhov (1858-1929) was a member of the board (and from 1905 to 1913, curator) of the Tretyakov Gallery. He was the owner of a small but selective collection of works of Russian and European paintings, both old and modern. In 1918 his collection was transformed into a branch of the Tretyakov Gallery as the Ostroukhov Museum of Icons and Painting; it was liquidated in 1929.

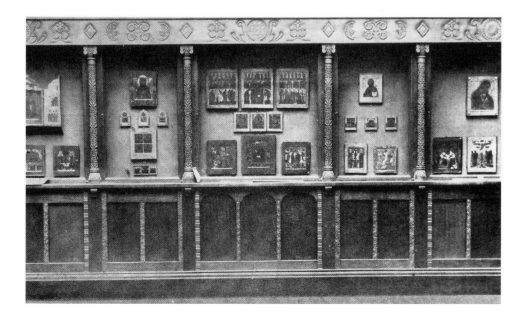

EXHIBITION OF ICONS AT THE TRETYAKOV GALLERY, 1906
ARCHIVES OF THE STATE TRETYAKOV GALLERY

13. Extract of an interview with Matisse, *Russkie vedomosti* (The Russian chronicle), 27 October 1911.

14. Maurice Denis arrived in January 1909 at the invitation of Morozov. In his diary the artist noted the event as follows: "Arrival in Moscow, at the small square in front of the station, low buildings, snow, mild weather, sleds with drivers dressed for the most part in blue, moving sluggishly around their light carriages. In Berlin and Warsaw, which we passed through quickly, it was dirty and very wet. Here everything is white and silent, there is little movement on the streets. Straight to the Kremlin, time: half past three, evening closing in fast. Overcast, the first lights, flocks of crows, the chiming of bells, but nothing particularly impressive, with the possible exception of the city itself, with its countless bell towers, as far as the eye can see from the terrace in front of the memorial to Alexander" (Maurice Denis, *Journal*, vol. 2 [1905-1920] [Paris, 1957], p. 99).

15. Letter from I. Ostroukhov to A. Botkina, 28 October 1911. Manuscript Department of the State Tretyakov Gallery, archive 48/673.

16. The Kharitonenko mansion on the former Sofiiskaya Embankment is now occupied by the British Embassy. Kharitonenko's collection of western European painting is part of the collection of the State Pushkin Museum, and the whereabouts of the icons, which subsequently hung in the Church of Our Savior of Natalievka close to Kharkov, is not known.

17. "G. Matiss v Moskvie" (Mr. Matisse in Moscow), *Utro rossii*, 3 November 1911.

remarked Matisse in an interview with the correspondent of the *Russkie vedomosti* (Russian chronicle). "Your cathedrals are wonderful, magnificent. Such monumental style! The Kremlin, several corners of Moscow, the remnants of ancient art—these have a rare beauty. . . . The icons are a supremely interesting example of primitive painting. . . .

"Such wealth and purity of color, such spontaneity of expression I have never seen anywhere. This is Moscow's finest heritage. People should come here to learn, for inspiration should be sought from the primitives."[13]

Matisse's response to what he saw in Moscow was different from that of Maurice Denis two years previously, although the two artists' programs were very similar: the Kremlin with the majestic Cathedral of the Assumption covered with frescoes from floor to ceiling; the Cathedral of the Annunciation that served as the royal court's private church; the New Virgin Convent in the bend of the Moscow River.[14] In the Tretyakov Gallery, for example, which Denis had seen as "one immense ensemble of Russian painting," Ostroukhov reported that Matisse "walked through the first floor without showing any particular interest but began to tremble with delight in the icon room, where he and I spent an hour and a half, opening every one of the glass cases."[15]

Attempting to cater to Matisse's interests, Ostroukhov showed him only the old Russian art. Even when he took him to the home of Pavel Kharitonenko, it was not for the sake of the superb collection of works by the Barbizon painters, but for the unique fifteenth- and sixteenth-century Novgorod icons. Many artists had been attracted to the wealthy sugar-refiner's mansion by its fine view of the towers and cathedrals of the Kremlin.[16] Matisse too wished to take advantage of his host's generosity and make a few studies of the Kremlin, but we do not know whether he actually did so: when the newspapers reported his intention, they indicated that the French artist was waiting for a little more snow to fall.[17]

Unfortunately, Matisse's hopes of seeing a genuine, snowy Russian winter were thwarted: the cold weather came late that year, and little snow fell. However, Matisse had the privilege of seeing something rarely shown to visitors—the churches of the Old Believers, the branch of the Orthodox Church that had rejected the reform of the seventeenth century and remained faithful to the ancient rites. Situated on the outskirts of the city, the Old Believer churches were virtual museums of fourteenth- to seventeenth-century Russian icons, which, undefaced by later overpainting, had preserved their original appearances. Ostroukhov also

ILYA OSTROUKHOV IN HIS STUDY

ILYA OSTROUKHOV, VALENTIN SEROV, AND ANNA BOTKINA ON THE PORCH OF OSTROUKHOV'S HOME ON TRUBNIKOVSKI LANE, MOSCOW, c. 1910
ARCHIVES OF THE STATE TRETYAKOV GALLERY

DRAWING FROM THE ALBUM OF SERGEI ZIMIN, 1911
GRAY PAPER, GOUACHE, 26 X 33 CM.
CENTRAL STATE ARCHIVE OF LITERATURE AND ART,
MOSCOW

treated his guest to the singing of the choir of the Synodal College on Nikitskaya Street, the only place where one could hear "unison chanting" and see the choristers dressed like ancient deacons in their long surplices with upright collars. And at Pyotr Shchukin's Museum of Russian Antiquities, Matisse also learned about Russian history while viewing a wide range of items from the daily life of the distant past.

But all this was only the first half of the program arranged for the artist. The second half was intended to acquaint him with the contemporary cultural life of the city via theater outings, visits to clubs and societies, social gatherings, and receptions at which the "leader of the Paris modernists" was a most welcome guest.

It would be an understatement to say that Matisse's appearance in Moscow did not pass unnoticed. The French visitor was the focus of intense interest throughout the two and a half weeks of his stay in the city. Reporters dogged his every step and interviews with him appeared in a number of newspapers. Nothing similar had occurred during Denis's visit to Moscow—and not simply because the Morozov family was in mourning when he stayed at the closed and inaccessible mansion on Prechistenka Street.

The house on Znamensky Lane was always a focus of "noisy" activity. Thanks to Sergei Shchukin and his extremely popular collection, Matisse was the main topic of interest in literary and artistic circles. Indeed, following the departure of Paul Poiret, the Parisian "legislator of fashion," Matisse and his painting became the main topic of conversation in all of Moscow. People wrote letters to each other about the French artist's arrival; they noted it in their diaries. Young artists were particularly excited. As the amateur sculptor Ludmila Goltz, who moved freely among the artistic elite of Moscow, wrote: "But of course, Matisse himself has arrived, Matisse, whom they have been trying to outdo for years and cannot, whom they adore and whose efforts they use as the justification for their own ignorance, elevating his calculatedly careless drawing into a principle and quite overlooking his (marvelous!) drawing. . . . So now they have celebrated their holiday and feted their idol. The reception was on Wednesday at the Aesthetics."[18]

Only a select public was invited to the reception for Matisse at the Free Aesthetics Society. The young philosopher Fyodor Stepun read an essay on "The Landscape from the Point of View of Philosophy," after which the symbolist poet Andrei Bely spoke in his usual fashion, "obscurely and aphoristically, so that even a Russian would have difficulty understanding him."[19] Out of respect for Matisse, who did not understand a word of Russian, the discussions that followed were held in French. Matisse was asked all sorts of deep questions: what was his opinion of the relationship between drawing and color in painting, how could beauty of color be attained, should the experience of color be immanent to form, and so on. The event was mockingly reported in the *Vechernyaya gazeta* (Evening news) under the rubric "Rustling Newsprint":

"MUSCOVITES MOLLYCODDLE MATISSE, WHOSE TALENT IS:
RIEN, TROIS FOIS RIEN [Zero, three times zero]

18. Diary of L. V. Goltz. Private collection. Moscow.

19. Andrei Bely recalled the event as follows in his memoirs:
"They even brought Matisse here; they regarded him as a 'Moscow' artist, since he lived at Shchukin's house and hung his own canvases all around the place. Gold-bearded, wiry, tall, with pince-nez and slick, smoothly parted hair, he tried to make himself out to be a *camarade*, but he looked like a *maître*. A crowd of overdressed merchants' wives came straggling in and goggled idiotically at him. Matisse was astonished at their bright, motley garb, the height of the pale toques rising from their coiffures, the size of the pearls and the expanses of naked skin: Venice, Genoa, Honolulu! All that was missing were the rings in their noses. There weren't any Russian 'Frenchmen'; the artists didn't speak French. They pushed me out to the front: I began with 'cher maître'. Matisse leapt to his feet and flung one hand out in front of him, pressing the palm of the other against his starched shirtfront, and interrupted me with false pathos: 'Seulement camarade!' 'Cher camarade!'
"He screwed up his eyes like a cat and listened, tilting back his head and thrusting out his golden beard" (A. Bely, *Mejdu dvukh revolyutsy* [Between two revolutions] [Moscow,1990], p. 198).

ZIMIN'S OPERA HOUSE ON
BOLSHAYA DMITROVKA STREET, MOSCOW

SERGEI ZIMIN, OWNER OF THE PRIVATE OPERA HOUSE

MOSCOW THEATER OF THE ARTS

FOYER AT THE MOSCOW THEATER OF THE ARTS

227. Москва. Б.-Дмитровка, Театръ Солодовникова.

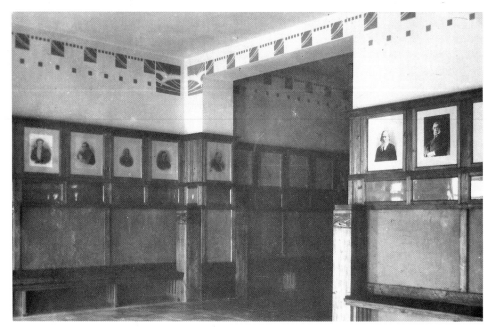

BOLSHOI THEATER, MOSCOW

NIKITA BALIEV

FEDOR KORSH

VALERY BRIUSSOV

ANDREI BELY

20. *Vechernyaya gazeta*, 28 October 1911.

21. "Khudojestvennaya letopiss Moskvy" (Moscow arts chronicle), *Protiv techeniya*, 18 November 1911.

22. Letter from B. A. Sadovsky to his father, 28 October, 1911. Central State Archive of Literature and Art, archive 464, inventory no. 11, storage no. 277. In another letter to his father the writer Boris Sadovsky wrote: "The French painter Matisse. . . wanted to visit the Free Aesthetics Society. Before the readings began, a radiantly excited Briussov came running in with the visitor's book for important guests; the secretary minced along behind him with a pen and an inkwell. Matisse turned up, a big redheaded fellow with debauched, typically French features. They sat him down where everyone could see him. Matisse listened to a speech without understanding a single word. Someone read some verse. Matisse thoughtfully tapped out the rhythm with his fingers, trying to give the impression that he was counting the meter" (Ibid.).

23. "Ou rampy" (Under the footlights), *Vechernyaya gazeta*, 26 October 1911.

24. Idem, 6 November 1911.

25. Matisse's quick sketches in Zimin's guest book, in which all the famous visitors to his opera left their autographs, were discovered by Grits and Khardzhiev. See T. R. Grits and N. I. Khardzhiev, "Matiss v Moskvie" (Matisse in Moscow), *Matisse* (Moscow, 1958).
Teodor Grits and Nikolai Khardzhiev were the first researchers whose work threw some light on the circumstances of Matisse's visit to Moscow, previously somewhat of a mystery to historians of art. Eleven years later, Yury Rusakov addressed this question in a paper he read at a conference at the Hermitage for the hundredth anniversary of Henri Matisse's birth. His text was the basis for the article "Matisse in Russia in the Autumn of 1911" (*Burlington Magazine* 117, no. 866 [May 1975], pp. 284-291, which is the most comprehensive and detailed account in print of Matisse's visit to Russia. Sergei Ivanovich Zimin (1875-1942) was the founder and owner of a private opera company that existed in Moscow from 1904 to 1917. Fyodor Fyodorovich Fedorovsky (1883-1955) was a set designer.

26. *Vechernyaya gazeta*, 31 October 1911.

While he could, he rode high on the hollow tires of inflated fame in Paris.
Now he is riding high in America and Russia.
In Paris he's washed up, old hat.
But here people hang on his every word like a revelation."[20]

The newspaper *Protiv techeniya* (Against the current) was equally categorical in its judgment: "paintings by 'Matisses' cannot in any sense be called works of art. . . . Anyone attempting to convince the public that these canvases daubed with paint are capable of establishing any kind of mood or conveying any kind of image must either himself be so hypnotized by his art that he can no longer actually see it, or else deliberately leading the public astray by relying on the enchantment of the words *artist* and *new*."[21]

Despite these correspondents' disinterested attacks on "the brilliant artist who is regarded in Europe as the modern Raphael," the newspapers continued to inform their readers of Matisse's every appearance in the "social world."[22]

"Matisse, the leader of the French modernists, visited the Arts Theater yesterday. . . . Matisse enjoyed the play—it was *In Life's Clutches*—very much, and he was delighted with the scenery and the actors, but when asked whether the theater would be a success in Paris, Matisse said that with plays like this one of Hamsun's it was unlikely: there was too much philosophy in it for Paris."[23]

"Matisse continues to be the toast of Moscow. Yesterday the artist attended *The Queen of Spades* in Zimin's theater. He very much liked Fedorovsky's stage sets.

"During the interval Matisse took tea with Zimin in his office and at the entrepreneur's request, covered four pages of the visitor's book with drawings."[24] As Fedorovsky later recalled, Zimin asked Matisse to draw the pot of flowers standing on his desk—apparently they were primulas—which Matisse did, rendering them in tempera on thick gray paper.[25]

"Yesterday *La Bayadère,* playing for the second season at the Bolshoi Theater, drew a completely full house. The performance was a great success. . . .

"The audience included many popular Moscow personalities.

"One of the boxes on the right was occupied by the well-known patron of the arts Shchukin, with his family and their current guest, the artist Matisse."[26]

Matisse also visited the Bat, the popular artistic cabaret-theater run by the

DRAWING FROM THE ALBUM OF SERGEI ZIMIN, 1911
GRAY PAPER, GOUACHE, 26 X 33 CM.
CENTRAL STATE ARCHIVE OF LITERATURE AND ART,
MOSCOW

DRAWING FROM THE ALBUM OF SERGEI ZIMIN, 1911
GRAY PAPER, GOUACHE, 26 X 33 CM.
CENTRAL STATE ARCHIVE OF LITERATURE AND ART,
MOSCOW

incomparable merrymaker and wit Nikita Baliev. In addition to the traditional notice stating that all guests were considered to be old acquaintances, the Bat was decorated for the occasion of his visit with a caricature of the Parisian artist in the company of "decadent-looking ladies in scanty attire."[27] Other posters and notices hung around the walls were dedicated to the actress Blumenthal-Tamarina, who was celebrating her jubilee that day.[28]

"The session started immediately after midnight. Everyone who is anyone was at the Bat yesterday: actors, artists, businessmen, dandies, all of them mingling in one smart, elegant, lively crowd. . . . The artist Matisse arrived with Ostroukhov. . . . Baliev amused everyone by talking to Matisse the whole time in his funny French and asking Ostroukhov to translate. Matisse was presented with the aforementioned picture. . . . The part of the program that Baliev calls *Les artistes chez soi* kept everyone loudly and happily entertained until morning."[29]

On 1 November, the day following the social reception in the French artist's honor at the Bat, Matisse sent Manguin a postcard with a view of the Church of the Nativity of the Virgin on which he wrote: "Life in Moscow is great with parties from night to morning, this is the life—the grand life—and with it, the town has character and the primitive pictures are really beautiful and even a little fauvist."[30] In a postcard sent the same day to the Steins, Matisse wrote that the weather was rainy and awful, that he had not managed to see "le Czar" but was pleased with his trip, that he had seen and studied icons in Moscow and that he would be back in a week at the latest.[31]

Although the Moscow newspapers literally followed the Parisian celebrity everywhere he went, we know very little about Matisse's stay in Shchukin's home. Most of our information comes from later reminiscences, and their accuracy can only be confirmed by the testimony of eyewitnesses.

Thus, the writer and philosopher Emilii Metner related the latest news as follows: "Henri Matisse was here in Moscow, and he enslaved Shchukin's entire household and ordered him to hang only his own works and banish the rest to the attic. Shchukin could at least have left Pi-pi-ca-so-so, but Ma-ma-ma-tisse won't allow it."[32] Metner's account was echoed by Andrei Bely in his memoirs, where he described Shchukin as "stammering slightly" as he told how Matisse had abused

27. *Rampa i zhizn* (Footlights and life) 45 (1911), p. 10.

28 Maria Mikhailovna Blumenthal-Tamarina (1859-1938) was an actress at Korsh's theater in Moscow.

29. "V Letutshei myshi (Nabroski s naturi)" (At the Bat [Sketches from life], *Vechernyaya gazeta*, 2 November, 1911.

30. Concerning the reception in Matisse's honor, see *Vechernyaya gazeta*, 30 October 1911, section 4 (below p. 50). Postcard to Manguin quoted in Pierre Schneider, *Matisse* (Paris, 1984), p. 309, note 101.

31. The postcard that Matisse sent to Gertrude, Sarah, and Michael Stein (now in the Yale University Library, G. Stein Collection) is mentioned by Barr (Barr, p. 143). Later accounts report that Moscow seemed to Matisse like "a huge asiatic village." See Alison Hilton, "Matisse in Moscow," *Art Journal* 29 (Winter 1969/70), p. 173.

32. Letter from E. K. Metner to Ellis (L. L. Kobylinsky), 12 November 1911. Manuscript Department of the Saltykov-Shchedrin State Public Library, archive 190, Musaget Publishers section.

MATISSE DRAWING ROOM IN SHCHUKIN'S HOME, 1912

GAUGUIN DINING ROOM IN SHCHUKIN'S HOME, 1912

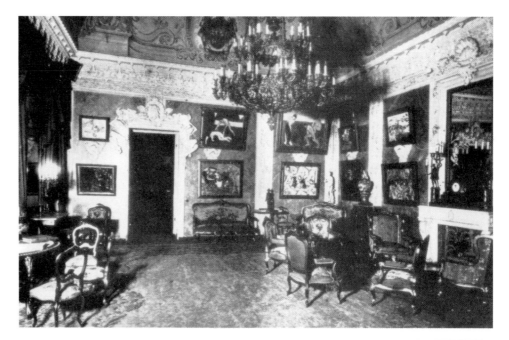

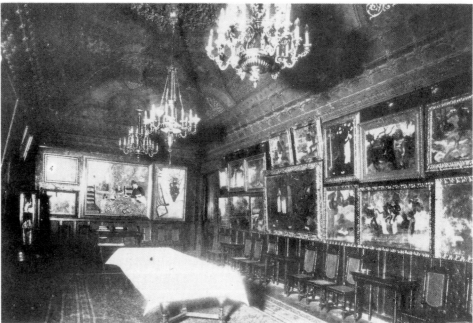

33. A. Bely, *Natchalo vieka* (Beginning of the century) (Moscow, 1990), p. 443.

34. Ibid., p. 667, n. 113

35. Letter from H. Matisse to A. Romm, November 1934. Archives of the State Pushkin Museum of Fine Arts, archive 13, no. 127/10.
Restorers at the Hermitage eventually (in 1988) followed Matisse's advice and removed the patch of paint, which proved to be simply gouache.

his welcome: "He drinks champagne, eats sturgeon, and praises icons. He just will not go back to Paris; he charmed everyone at the Aesthetics Society with his orange beard, smoothly parted coiffure, and pince-nez".[33] Bely's memoirs also contain the following passage: "They do say that at home he touched up a painting by Matisse that he himself ordered (and that Matisse pretended he hadn't noticed)." The first version read a little differently, however: "Shchukin made Matisse's reputation and fed him champagne; he even touched up one of Matisse's canvases." [34]

Andrei Bely's grotesquely ironic narrative style cloaks a reference to an actual incident that Matisse himself mentioned in a letter to the Soviet art historian Alexandr Romm: "Concerning the decorative works in Moscow, allow me to inform you that the owner of the panel *Music* wanted a little paint applied to the second figure, depicting a small flute player with crossed legs. He had this paint applied in order to conceal the sex of the figure, which was, however, indicated in a very modest fashion. . . . It is quite sufficient for the restorer to take a liquid solvent, such as mineral oil or petrol, and rub the spot a little for the concealed features to reemerge."[35]

As far as we can judge, when the panel arrived, Shchukin permitted himself the liberty, without asking the artist's permission, of having the small flute-player's disturbing "sexual characteristics" painted over. On the journey to Moscow with Matisse, Shchukin did not dare to tell him what he had done, fearing unpleasantness. Beverly Kean has recorded the account of Shchukin's eldest son, Ivan, the last living witness to the dumb show that took place in the Znamensky Lane mansion. He recalled his father's unusual state of embarrassment as Matisse climbed the stairs. However, the incident was effectively closed by a single remark from the artist to the effect that "in essence, what has been done changes nothing."[36]

36. Kean, p. 216.

The only thing that genuinely displeased Matisse was the way his pictures were hung. Many years later he told the story of how he expressed his dissatisfaction to Shchukin, who had covered the canvases with glass and hung them on a sharply sloping surface.[37] Matisse has even been reported as saying that artistic display of this kind would kill an elephant, let alone his works. Various memoirs also contain numerous references to the fact that Matisse's pictures were scattered throughout various rooms in the mansion, but this assertion is probably without

37. Barr was the first to write about this incident. He cited a conversation between John Rewald and Matisse that took place in March/April 1951 (Barr, pp. 143, 539).

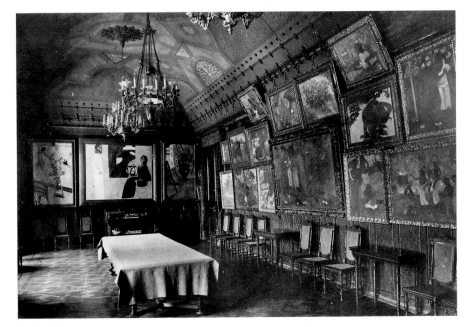

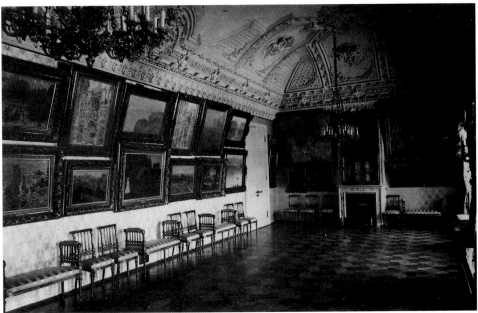

DINING ROOM IN SHCHUKIN'S HOME, 1912

MUSIC ROOM IN SHCHUKIN'S HOME, 1913

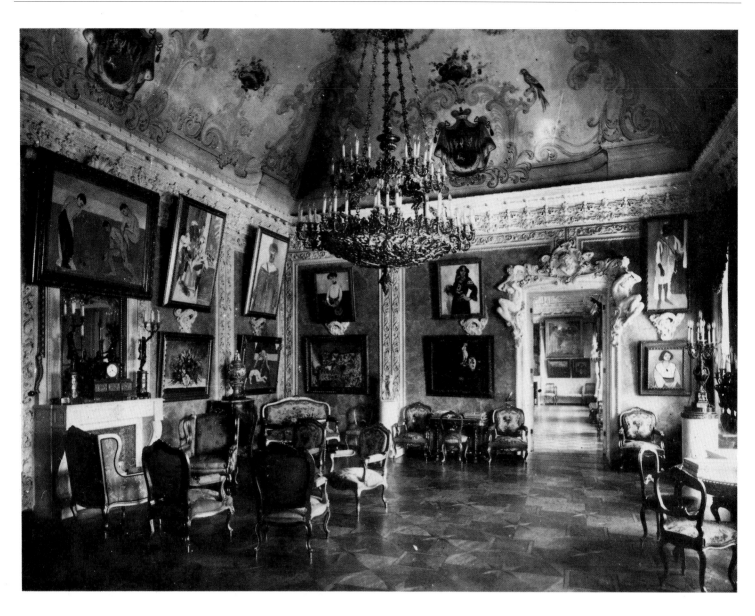

MATISSE DRAWING ROOM IN SHCHUKIN'S HOME, 1913

38. I. Zhilkin, for instance, mentions the Matisse hall in the article cited above (n. 29), which was published in September 1911.

39. Letter from V. Shamshina to B. Ternovets, 5 February 1911. Cited in Ternovets, p. 129.

foundation: by the time of the artist's arrival the greater part of his paintings were already hanging in the drawing room.[38] Matisse undoubtedly insisted that his twenty or so works should be gathered together, so that he could hang them as he thought appropriate.

"Matisse . . . decided to hang his works in the beautiful pink eighteenth-century drawing room, which had previously provided such a lovely setting for Cézanne and Degas. Although all of Matisse's works are large and do not fit into the spaces between the moulded medallions on the walls, Matisse, unabashed, hung them directly over the medallions, and the tops of the frames cover the sculptured cornices. To be sure, certain still lifes, as objects—blue porcelain pieces and others in pink and green tones—are a very good match for the pink sofas; some paintings practically repeat the tones of the material."[39]

Matisse chose the middle of the three reception halls that lined the facade of the mansion. The first hall, with its bright silvery wallpaper and gilt chairs upholstered in gray silk, contained works by Monet, Sisley, and Pissarro—silvery green, pearly pink, and icy blue. The elegant gilded chandeliers and huge mirror lent this music salon a certain festive elegance. The dining room at the other end was the same size. The dark silk wallpaper and oak-paneled walls made the hall a rather somber setting, in which Gauguin's canvases blazed as bright as "exotic blooms of eternal summer." In the center of the end wall hung Matisse's *Red Room*, his decorative panel for a dining room where large numbers of guests gathered at the immense table for sumptuous luncheons.

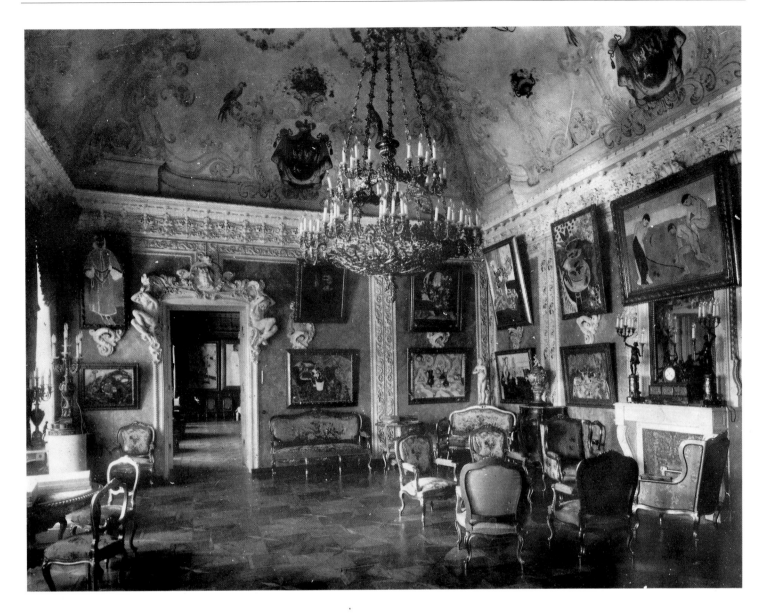

MATISSE DRAWING ROOM IN SHCHUKIN'S HOME, 1913

The drawing room in which Matisse's "fragrant garden" blossomed so profusely was not only smaller but quite different in atmosphere. It was the only room in the mansion to have a vaulted ceiling decorated with frescoes—garlands of flowers, fantastic birds, and heraldic insignia; the walls were sumptuously decorated with mouldings and the doors framed with medallions and cupids. The magnificence of the pink drawing room was emphasized by candelabras, heavy chandeliers, and expensive gilt furniture in the Louis XV style.

The addition of Matisse's own paintings to the decor of this hall was the major achievement of his trip to Moscow. For many years afterward the critics would refer to the visual discoveries of that autumn 1911 installation.

"It is impossible to say with certainty what 'helps' what here: whether the room helps Matisse or Matisse helps the room," wrote Yakov Tugendhold several years later in an attempt to understand the enchantment of the pink drawing room. "But the overall impression is that everything—the wallpaper, the carpet, the ceiling, and the pictures—is all Matisse's work, his decorative stage set."[40] Tugendhold was remarkably knowledgeable about the Paris art world; he had seen Matisse's works in salons and at exhibitions and even visited the artist's studio several times, but the Moscow critic was not exaggerating when he said he had not really known Matisse until he visited Shchukin's mansion. It was not the number of pictures, but the astounding surroundings in which the canvases were displayed that led Yakov Tugendhold, the author of the most subtle description of

40. Y. Tugendhold, "Frantsuzkoie sobranie S. I. Shchukina" (S. I. Shchukin's French collection), *Apollon* 1-2 (1914), p. 24.

41. Ibid., pp. 24-25.

42. Ternovets, p. 129.

43. This date is supported by the "Daily Schedule" in the I. S. Ostroukhov collection of the Central State Archive of Literature and Art (archive 822, inventory 1, no. 53):
"9 January, evening: Matisse with Shchukin." On another page: "Wednesday 9: Cathedral of the Assumption, Kremlin. Evening—S. Shchukin, Matisse, Shcherbatov, Igumnov." Matisse's name does not appear in any further entries.

44. "Khronika iskusstv. Matiss v Moskvie" ("Arts chronicles. Matisse in Moscow") *Utro rossii*, 3 November 1911.

45. "Moskovskie shtriki" (Moscow features), *Rul*, 7 November 1911.

46. Memoirs of N. M. Rudin. Central State Archive of Literature and Art, archive 2850, inventory 1, no. 9.

47. Letter from I. Ostroukhov to A. Botkina, 1 November 1912. Manuscript Department of the State Tretyakov Gallery, archive 48/689.

48. G. P. Fedotov, "Tri stolitsi" (Three capitals), quoted from *Novy mir* 4 (1989), p. 213.

49. Ivan Sergeievich Shchukin gave different versions of the reasons for the appearance of this ex-libris. In the interview with Beverly Kean he said that Matisse lived in his rooms in the Znamensky Lane mansion, and the drawing was made as a gesture of thanks (Kean, p. 216). In a letter to A. A. Demskaya, he stated that he did not know which room Matisse stayed in, since he himself "did not live in the big house," and only met the artist in the drawing room where his paintings were hung (Archives of the State Pushkin Museum of Fine Arts, archive 13, collection XI/II, no. 145/9).
The second account seems more probable, since Sergei Shchukin's foster daughters recalled that Matisse lived in the children's room, or the "classroom," as Varvara Vasina called it, which was located by tradition in the former domestic chapel of the Trubetskoi mansion (ibid., no. 146/2). Whatever the case, following his visit to Moscow, Matisse sent Ivan Sergeievich Shchukin two sketches for an ex-libris, of which the collector's son chose the one on which Matisse had written in French, "The one I prefer." (See the letter from I. S. Shchukin to Matisse below, p. 178). Ivan Shchukin later gave the second design to the well-known Moscow bibliophile Count M. P. Keller, who had married his sister, Ekaterina. The two ex-libris were first published in "Novy knijnie znaki" (New book marks), *Vestnik literatury* 11 (1914).

Shchukin's gallery, to call the Znamensky Lane mansion "the breeding ground and apotheosis of Matisse's painting."

"It may not be possible to philosophize in Shchukin's pink drawing room, but it is not possible to succumb to a Chekhovian mood there either. The chiming colors resounding from the walls, the dissonances between the predominantly torrid hues and the glacial ones, the purples and blues, absolutely exclude apathy. Surrounding you in luxuriant heat and brisk cold, they have the effect of laughing gas, and ultimately, give you a feeling of life's plenitude. Here, without leaving your armchair, you can journey to the poles and the tropics of feeling. . . ."[41]

Even after the revolution, when it became fashionable to criticize the old museums that had been liquidated, Boris Ternovets, who had abandoned his former enthusiasms, felt obliged to single out the Matisse hall for positive mention. "Shchukin's collection was displayed in a state of 'ideal disorder,'" wrote the director of the State Museum of Modern Western Art. "With the exception of the Matisse reception hall and the Gauguin hall, everything else was hung about the walls without a trace of logical order—pictures with no space between them, their intimate proximity dictated by the inexplicable whim of the former owner's personal taste."[42] As for Shchukin, the pink drawing room was his favorite—he frequently said that the Matisse hall was his "aromatic hothouse, sometimes poisonous, but always filled with beautiful orchids."

Matisse left Russia on 10 November.[43] A week earlier, the newspapers were still writing that he was the sole topic of conversation in the artistic circles of Moscow and that, having received commissions "from certain individuals who remain anonymous," he was "intending to prolong his stay." As souvenirs of Moscow, it was reported, "Matisse will take away with him the albums he has been given containing photographs of old icons, two ancient icons, samples of Russian porcelain, and a (good-natured) caricature of himself painted collectively by Mr. Baliev et al."[44] The final note in the press was a brief comment on 7 November to the effect that "during his stay with us," the famous artist Matisse was "making an intense study of Moscow life, visiting the churches and theaters, and yesterday he attended Sunday mass at the Uspensky Cathedral in the Kremlin."[45]

The trip to Moscow made a profound impression on Matisse—old Russian art in particular was a revelation to him. Shchukin loved to tell visitors to his gallery how absolutely astounded Matisse was by the icons. "I spent ten years searching for something your artists discovered in the fourteenth century. You should not be coming to us to study, we should be learning from you," Matisse reportedly said during their visit to the Tretyakov Gallery.[46]

Be that as it may, on his return to Paris Matisse began advising his artist friends to visit Moscow, apparently with such persistent energy that many were convinced. Otherwise, how could Ostroukhov have informed Botkina in January 1912 that "Picasso, Van Dongen, and a number of other artists seduced by his stories of Russian icon-painting are arriving in Moscow any day now?"[47] The newspaper articles that appeared at the time added the names of Derain, Le Fauconnier, Braque, Metzinger, and Delaunay. In fact, not one of these artists ever visited Russia. Apart from Denis and Vallotton, Matisse was the only one to see the palaces, the cathedrals, and the "multicolored architectural garments" of this city, in which a European "feels the breath of Asia so keenly."[48]

As a sign of his gratitude, Matisse sent his Moscow guide Ostroukhov a painting of a nude, with the inscription: "A Monsieur I. Ostrooukoff, hommage respectueux, Henri Matisse." At the same time, Shchukin's son Ivan received the drawing for an ex-libris, characterized in certain accounts as an expression of thanks for the hospitality he had shown Matisse in Moscow.[49] As for the idea that Matisse should decorate one of the rooms in the Shchukin mansion (reported in the newspapers as the reason for Matisse's appearance in Moscow), it was never raised again.

4. IDEAL COLLECTORS

In view of Shchukin's demonstrated ability to become cool toward one of his artistic passions when he discovered new idols, it was reasonable to expect that Matisse might eventually forfeit his patron's adoration as well. Indeed, the appearance of serious rivals in the persons of Picasso and Derain lent weighty support to such a supposition. Following his introduction to Picasso (thanks to Matisse, who brought his Moscow patron to the artist's studios at the Bateau-Lavoir in 1908) and his purchase of the cubist *Woman with a Fan* in the autumn of 1909, Shchukin acquired fifty-one of Picasso's works before the start of the war; from 1912 to 1914 he bought sixteen of Derain's paintings from Kahnweiler.

Shchukin had in fact waited some time before acquiring any Picassos, and when he finally did, they clashed so badly with the rest of his collection that he could not bring himself to hang them. Ultimately, however, they conquered his resistance. While assuring his friends and associates that Picasso, this "destroyer of the foundations," was "the future," Shchukin admitted that he derived no pleasure from his works, but that the artist simply possessed him "as if through hypnosis or magic."[1] Matisse and Picasso were both major figures in Shchukin's collection, but the principles they represented for him were quite different: gaiety on the one hand, somber intensity on the other. "Matisse should paint palaces and Picasso, cathedrals," was the way the collector defined the contrast between them. Shchukin loved to explain to people who visited his gallery on Sundays that "Matisse is joyful, exuberant, accepting of life," while Picasso "is morbid, infected with some evil, demonic principle."[2]

Shchukin's small, vaulted study was quickly filled with paintings by the great destroyer of the "old beauty," and transformed into the "Picasso cell." It was reached by going through Matisse's pink drawing room and Gauguin's dining room, where, in the words of the great philosopher Nikolai Berdyaev, "one seemed to experience the ultimate joy of the natural life." In the study, surrounded by pictures that seemed to some to be nothing but "a heap of cubes, cones, and cylinders," and to others, "philosophical tracts expounded in paint on canvas," visitors to the gallery experienced quite different sensations from those in Matisse's "fragrant garden."

And yet, despite the fact that Picasso, and later Derain, usurped the focus of Shchukin's attention as a collector, he remained faithful to Matisse, the third leading figure of the Paris avant-garde. Shchukin's love of Matisse's work lent their relationship a unique quality: it was a friendship between two outstanding

1. Rudin, memoirs, no. 9.

2. Ternovets, p. 12.

PLAN FOR SHCHUKIN'S PAINTING GALLERY

1. LIBRARY
2. VESTIBULE CONTAINING THREE OF MATISSE'S PAINTINGS
3. THE MONET HALL
4. THE MATISSE HALL
5. THE PICASSO HALL
6. THE GAUGUIN DINING ROOM
7. FAMILY CHAPEL
8. WINTER GARDEN
9. STUDY

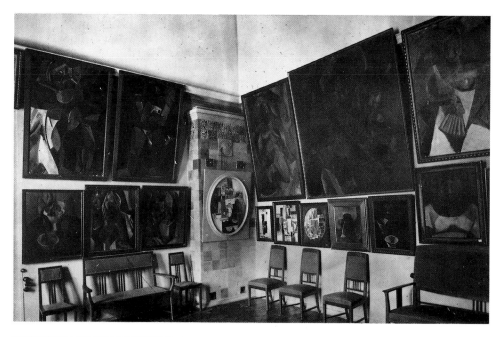

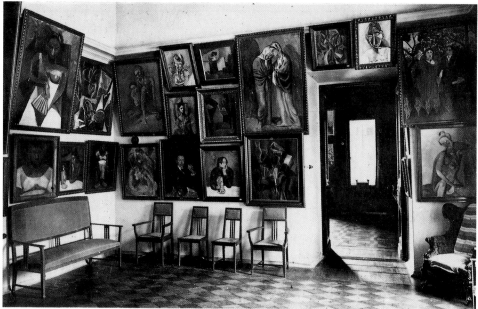

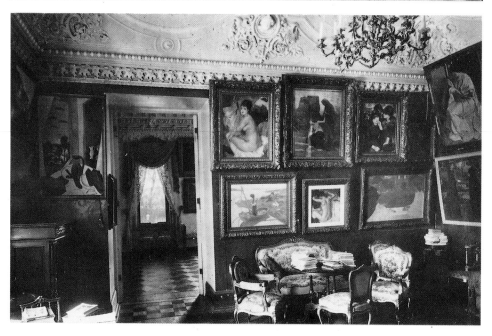

PICASSO ROOM IN SHCHUKIN'S HOME, 1913

PICASSO ROOM IN SHCHUKIN'S HOME, 1913

ROOM IN SHCHUKIN'S HOME, 1913

personalities, collector and artist. There can be no doubt that knowing such a patron existed in Russia—a man endowed with rare taste, insight, and a great deal of money, and who infected others with his enthusiasm—gave Matisse much more confidence. Shchukin, for his part, tried not to miss seeing a single canvas by Matisse, choosing the very best for his collection so that the pink drawing room was ultimately transformed into the definitive museum of his favorite artist's work.

Shortly after his return from Russia, Matisse undertook another, much more protracted journey, this time to Morocco. Before departing for Tangier, he informed Shchukin that he could offer him a large canvas, *L'Atelier du peintre* (The Artist's Studio) and, at the collector's request, forwarded a sketch. Shchukin liked the watercolor, as he liked everything by Matisse, and although he was at the time most interested in having "pictures with figures"—compositions like the *Family Portrait*—he did buy an *Artist's Studio*. This was not, however, the red version shown in the sketch, but *L'Atelier rose* (The Pink Studio), showing the right half of Matisse's work space at Issy-les-Moulineaux.[3]

Another purchase followed when Matisse, on his return from Morocco in June 1912, informed Shchukin that he had saved several works that would be suitable for the Moscow collector's drawing room and dining room.[4] When he arrived in Paris in July, Shchukin visited the studio at Issy and selected the paintings he liked. He bought *Amido le Marocain* (Amido the Moor), painted in Morocco (the "souvenir of Tangier" he had requested from Matisse), and *Les Poissons rouges* (Goldfish), which, although painted after his return, was not simply a still life with a glass jar of fish standing on a garden table but a reminiscence of the recent journey to a southern paradise. In addition, Shchukin selected *Les Capucines à "La Danse"* (Nasturtiums and "La Danse") and its companion piece, *Coin d'atelier* (Corner of the Studio). During this visit he probably also saw *La Conversation* (The Conversation) for the first time.

"I am thinking a lot about your blue painting (with two figures)," Shchukin wrote to Matisse a month later. "It seems to me like a Byzantine enamel, with such rich, deep colors. This is one of the most beautiful paintings that has remained in my memory."[5] Shchukin had to wait an unusually long time for *The Conversation*—more than a year. Sent to the Second Exhibition of Post-Impressionist Art held in London from October to December 1912, the picture only reached Moscow late in the autumn of 1913. Upon its arrival, *The Red Room* was removed from the dining room and replaced by *The Conversation*, in a broad, simple frame, with *Corner of the Studio* on the right, and its companion-piece, *Nasturtiums and "La Danse,"* on the left.[6] These last two paintings had been exhibited at the 1912 Salon d'Automne. Filling the end wall, which had no mouldings or wooden panels, the three new paintings appeared like one large decorative panel. Clearly, Shchukin was thinking of more than just harmonious color combinations: there was a definite meaning in the way he placed the pictures.

The central painting, *The Conversation*, showed Matisse in conversation with his wife, Amélie. Visible through a window overlooking the garden were beds of nasturtiums and a small building—the artist's studio. Like the wings of a triptych, the pictures hung to the right and left narrated events inside the studio. The scene of peaceful conversation between husband and wife called to mind Matisse's words in an interview with a woman journalist from New York who had been shocked by the artist's anti-bohemian lifestyle at Issy-les-Moulineaux: "Oh, do tell the American people that I am a normal man, that I am a devoted husband and father, that I have three children, that I go to the theater, ride horseback, have a comfortable home, a fine garden that I love, flowers, etc. . . ."[7]

In mid February 1913 Matisse returned from his second visit to Morocco. In his own words, the two winters spent far away from home had led him to discover "a closer contact with nature." During this period Matisse painted twenty-three pictures, of which he showed eleven in his six-day exhibition "Paintings and

HENRI MATISSE, **PORTRAIT OF SERGEI SHCHUKIN**, 1912, CHARCOAL
PRIVATE COLLECTION, NEW YORK

3. The watercolor was later sold by its owner and eventually found its way into the collection of the State Pushkin Museum of Fine Arts.

4. Letter from S. Shchukin to H. Matisse, 2 July 1912 (letter XXXV below).

5. Letter from S. Shchukin to H. Matisse, 22 August 1912 (letter XXXVII below).

6. *The Red Room* was hung in a small room behind the second floor vestibule. It was later joined by *The Painter's Family* and *Corner of the Studio*.

7. Clara T. MacChesney. "A Talk with Matisse, Leader of Post-Impressionists," *New York Times*, 9 March 1913.

MATISSE HALL IN THE FIRST MUSEUM OF MODERN
WESTERN PAINTING (FORMER SHCHUKIN MANSION)

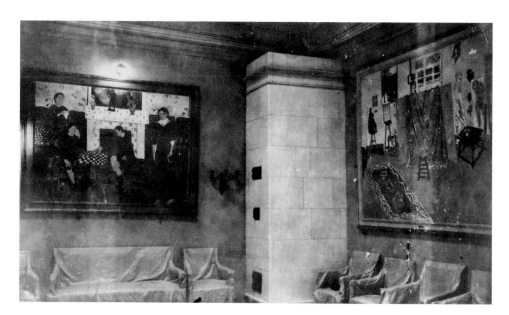

Sculptures from Morocco," which opened on 14 April at the Bernheim-Jeune Gallery. Seven of the works were purchased before the exhibition opened, but the catalogue gave only the owners' initials: "M.S.S." and "M.I.M."

Shchukin now owned four pictures that Matisse had painted specially for his drawing room—the artist had not forgotten his client's request to make *Goldfish* and *Amido the Moor* a pair, to which he himself added two still lifes with white calla lilies. When the pictures arrived in Moscow, the pink drawing room was rehung yet again. *Game of Bowls* was moved to the center, half covering the large mirror over the fireplace. The place on its left was taken by *Goldfish*, coupled with *Arums, iris et mimosas* (Arum, Iris and Mimosa). To the right were *Bouquet d'arums sur la véranda* (Bouquet of Arum Lilies on the Veranda) and *Fatmah la mulâtresse* (Fatmah the Mulatto). The erect, elongated figures of *Zorah debout* (Zorah Standing) and *Amido the Moor* faced each other along the full length of the drawing room, which now held more than twenty of Matisse's paintings.

Three pictures at the exhibition—*Fenêtre ouverte à Tanger* (Open Window at Tangier), *Zorah sur la terrasse* (Zorah on the Terrace), and *La Porte de la Casbah* (Entrance to the Casbah), subsequently known as the "Moroccan triptych"—had become the property of Ivan Morozov, but he had to wait more than two years for them. Relations between Matisse and Morozov never involved anything like the close contact there was between the artist and Shchukin. Despite the seriousness of Morozov's intentions toward Matisse—he made several attempts to commission "a large decorative work" from him—something interfered with his plans each time.[8]

In 1910 Morozov bought three Matisse canvases: the early still life *Fruits et cafetière* (Fruit and Coffeepot) from Druet, *Nature morte à "La Danse"* (Still Life with "La Danse") (with a pink version of Shchukin's *The Dance*) from Bernheim, and the newly completed *Bronze et fruits* (Fruit and Bronze), showing a carpet hanging on a wall and Matisse's sculpture *Les Deux négresses* (Two Negresses). This last painting acquired a place in the history of Russian art when it was used as the background for a portrait of Ivan Morozov painted by Valentin Serov immediately after the work arrived in Moscow.

In this portrait, wrote the art critic Abram Efros, Serov moulded Morozov out of matter quite different from that which "nature had bestowed on him." Against the exotic background of Matisse's still life, the large, flabby Morozov with his characteristic goatee appeared like a "smart, extremely well-groomed European who is interested in art and follows confidential advice to buy things that are the latest fashion."[9] Serov himself, who served as one of his sitter's advisors, was ambiguous in his attitude toward Matisse. "Although I sense talent and nobility in Matisse, he brings me no joy, and yet, strangely enough, he makes everything else seem boring somehow—a fact worth pondering. It all looks harsh, twisted,

8. Letters from S. Shchukin to H. Matisse,
27 March 1909, 10 January and 10 October 1913
(see letters XII, XXXIX, and XLIV below).

9. Abram Efros."Cheloviek s popravkoi" (A man
with a correction), *Sredi kollektsionerov* 10 (1921),
p. 2.

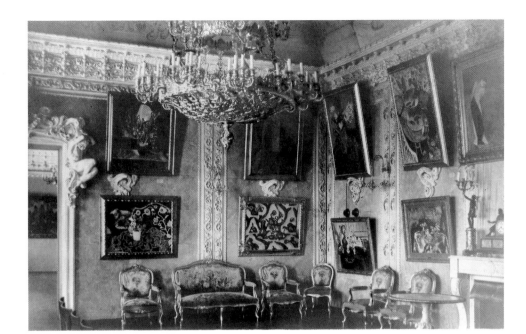

MATISSE HALL IN THE FIRST MUSEUM OF MODERN
WESTERN PAINTING (FORMER SHCHUKIN MANSION)

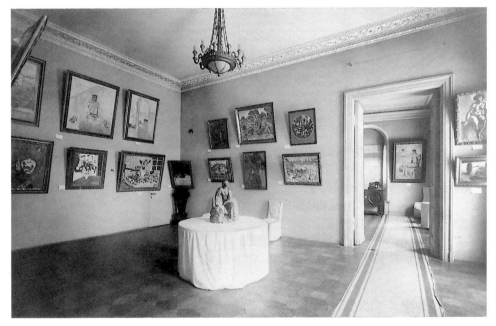

MATISSE ROOMS IN THE STATE MUSEUM OF MODERN
WESTERN PAINTING (FORMER MOROZOV MANSION),
1930s

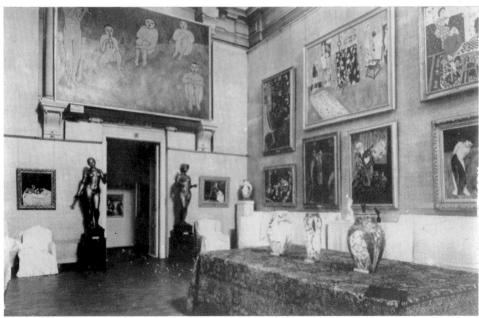

10. *Valentin Serov v perepske, dokumentakh i interviu* (Valentin Serov in correspondence, documents, and interviews), compiled and annotated by I. S. Zilberstein and V. A. Samkov (Leningrad, 1985), vol. 2, p. 184.
"I like a few things about Matisse, but only a few; in general I don't understand him," remarked Serov in 1910 (*Valentin Serov in the Memoirs, Diaries and Correspondence of Contemporaries,* compiled and annotated by I. S. Zilberstein and V. A. Samkov [Leningrad, 1971], vol 2, p. 236).

11. Mikhail Osipovich Zetlin (1882-1945) was the son of one of the owners of the large Vysotsky tea-trading firm; a poet and prose writer (under the pen name of Amari), he was later the founder and editor of the *New Journal* in New York. His wife, Maria Samoilovna Zetlin, née Tumarkina (1882-1976), was the daughter of a Moscow jeweler and a member of the left-wing Socialist Revolutionary Party. From 1908 the Zetlins lived abroad; they owned a villa in Biarritz (Villa des Mouettes), where they received many painters, including Diego Rivera, Max Voloshin, Marievna (M. B. Stebelskaya), and Valentin Serov. Maria Zetlin was the model for paintings and sculptures by a number of artists, including Emile Bourdelle and Valentin Serov. The Zetlin's home in Paris was visited by Picasso, Braque, Goncharova, and Larionov. They collected old porcelain, prints and works by contemporary Parisian artists. The Moscow collection they owned in their house on Povarskaya Street consisted mostly of old paintings but also included one work each by Vlaminck and Matisse, a drawing by Van Gogh, and two statuettes and a marble bust of Maria Zetlin by Bourdelle.

12. Efros, p. 3.

13. Nothing is known of the relations between Matisse and Ivan Morozov prior to the beginning of their correspondence in 1911, although the Soviet art-historical literature contains frequent assertions (without documentary substantiation) that at the 1910 Salon d'Automne, on the advice of Matisse and Serov, Morozov bought the painting *Blue Plums* by the "Moscow Matisse," Ivan Mashkov.

14. Letter from H. Matisse to I. Morozov, 1911. Archives of the State Pushkin Museum of Fine Arts, archive 13, collection 6, storage no. 127/2 (letter X below).

15. Letter from H. Matisse to I. Morozov, 19 September 1912. Archives of the State Pushkin Museum of Fine Arts, archive 13, collection 6, storage no. 27/1 (letter IX below).

16. Letter from H. Matisse to I. Morozov, 29 September 1912. Archives of the State Pushkin Museum of Fine Arts, archive 13, collection 6, storage no. 27/3 (letter XII below).

17. Letter from H. Matisse to I. Morozov, 19 April 1913. Archives of the State Pushkin Museum of Fine Arts, archive 13, collection 6, storage no. 26/5 (letter XIV below).

18. Letter from S. Shchukin to H. Matisse, 11 April 1913 (letter XLI below).

19. Letter from H. Matisse to I. Morozov, 25 May 1913. Archives of the State Pushkin Museum of Fine Arts, archive 13, collection 6, storage no. 27/61 (letter XV below).

crooked, yet at the same time, one has no wish to look at the works by other artists hanging close by, painted in such a familiar manner. Technically they are good, but still, something is missing; they're insipid."[10] It is interesting to note that Serov's portrait subjects included another buyer of Matisse's work, Mikhail Osipovich Zetlin, who owned the still life *Tournesols dans un vase* (Sunflowers in a Vase). [11]

Whereas "Parisian celebrities of the brush" always appeared at Shchukin's "as though on stage, in full costume and make-up, they arrived at Morozov's more quietly, intimately, and simply."[12] Shchukin bought only new paintings, but Morozov was quite willing to buy old works. In 1911 Matisse learned that Morozov had bought from Bernheim one of the artist's own favorite still lifes. *Still Life with Gin Bottle*, painted in 1896, thus became the earliest Matisse in a Russian collection, and this purchase provided the pretext for a correspondence between artist and collector, who had known each other for several years.[13] Matisse, who, as already noted, attached great importance to the way in which his works were presented, offered to find an antique frame to replace the "ordinary" one in which the still life had arrived in Moscow.[14]

Matisse's letter prompted Morozov to meet the artist again in the summer of 1911, when Matisse received a commission for two landscapes. However, work on these paintings proceeded quite slowly. In September 1911 Matisse wrote to Morozov from Collioure that although he had been thinking of the landscapes since he arrived, he would scarcely be able to finish them.[15] A whole year later Matisse apologized once again for the fact that the promised landscapes were still not ready, but he informed Morozov that he was counting on working on them in Morocco, where he was to go in October 1912.[16] In the event, the two commissioned landscapes and a still life, painted at the request of Morozov's wife, were only finished during Matisse's second trip to Morocco.

"The three paintings . . . are still on show at Bernheim's," Matisse wrote in April 1913. "They have been a great success, and I feel sure that you will be satisfied, even though you have waited for so long. . . . The three paintings have been combined with the intention that they should be hung together in a particular order. . . . I hope that these three canvases will make you want to visit my studio if you come to Paris this summer, in order to see two large canvases of about 2 meters by 1.7, showing a tall man from the Rif [*Riffain assis*] and an Arab café. I could send you photographs of them if you are interested." [17]

Matisse also wrote to Shchukin about the two works exhibited for sale at Bernheim's. Shchukin replied that he was very interested and hoped to see them when he visited Paris in July.[18] While awaiting Shchukin's arrival, Matisse nonetheless wrote to remind Morozov about *Le Café arabe* (The Arab Café).[19] Hoping to nudge the collector into decisive action, he also sent Morozov a copy of the journal *Les Cahiers d'aujourd'hui* containing an enthusiastic article by his critic friend Marcel Sembat: "Do you remember the large picture called *The Arab Café*? Take a good look at it: all of Matisse is in it! Study it closely and you will see the very essence of the artist."[20] Matisse thought this article the best thing to be written about him at the time.

Ultimately, the painting, which Sembat described as "inducing a serene sensation of meditative drowsiness," was bought by Shchukin, not Morozov. When he was in Paris in early August 1913, Shchukin visited Issy, and in Matisse's absence the artist's wife showed him the picture. Madame Matisse later recalled that *The Arab Café* immediately captivated the Moscow collector.[21] "Did you know that I sold *The Arab Café* to Shchukin? The picture should already have arrived in Moscow," Matisse wrote on 15 September to Charles Camoin, who had traveled to Morocco with him.[22]

Matisse miscalculated by only a few days; despite his apprehensions, the canvas arrived in Moscow in good condition, and Shchukin hung it in his dressing room.[23] "It's a painting that I now like more than the others, and I spend at least an hour each day looking at it."[24] In the East, Matisse had been astounded by the Arabs'

ability to spend hours contemplating a beautiful flower or fish gliding across the surface of water. Shchukin, who had developed an intuitive understanding of Matisse's language, grasped the essence of the artist's message—*The Arab Café* became an object of meditation for him.

In October 1913, after Matisse's new painting had arrived in Moscow, the city received an impressive delegation of directors of major European museums, and the program prepared for them naturally included the Morozov and Shchukin collections. In a letter to Matisse, Shchukin listed the names of all the important gentlemen he had received and joyfully informed the artist that after studying his painting "with the greatest of interest," every one of them had called him "a great master." To these compliments Shchukin then added the news that Morozov was absolutely delighted with the pictures from Morocco. "I have seen them, and I share his admiration. All three are magnificent. Now he is thinking of commissioning three large panels for one of his rooms. . . ."[25]

Once again, however, circumstances conspired to prevent Morozov from placing a commission with Matisse. Meanwhile, the Shchukin collection acquired its thirty-seventh work by the artist—*Madame Matisse*—which Guillaume Apollinaire called the finest piece in the 1913 Salon d'Automne. Painted in a dark, refined range of blue-gray tones, the portrait of Matisse's wife hung very well together with the earthy gray canvases of Derain and the works by Le Fauconnier that had been added to the collection in recent years.

The fact that the Znamensky Lane mansion housed portraits of Matisse's wife and children demonstrated the unusually close relationship that existed between Matisse and his Russian patron. Works of this kind—icons of his family—must have meant a great deal to Matisse, and he would hardly have allowed them to go to someone he regarded as a stranger. The high prices that his paintings fetched at this time were no longer a decisive factor; the artist had not suffered any financial difficulties since 1910 (thanks in large part to his Russian buyers, and notably Shchukin).

Like most collectors, Sergei Shchukin cared little for having his own image immortalized, and he never commissioned a portrait from any French painter. With the exception of a single caricature by Picasso, Matisse was the only French artist to attempt to capture the image of the Moscow collector.[26] Marguerite Duthuit, Matisse's daughter, recalled that the idea was to paint a picturesque portrait, and Matisse had gotten past the stage of the rough sketch to a largish, fully developed easel drawing when the work was interrupted by news from Moscow of the death of Sergei Shchukin's brother Pyotr.[27]

In 1912 Shchukin had bought six paintings from Matisse; in 1913 he bought five, at a total cost of forty thousand francs, and 1914 promised to be an equally fruitful year. While vacationing in Venice in June, Shchukin was hoping that Matisse would not forget about his drawing room, which, he felt, still required a few more paintings for the upper row.[28] When Shchukin was in Paris in mid July he reserved *La Femme au tabouret* (Woman on a High Stool).[29] Matisse was still searching and experimenting, and his new works expressed the precise structure of objects with ever greater force. This new style impressed Shchukin at a time when he was obsessed with the discoveries made by Picasso and Derain.

A week before the outbreak of war, Shchukin sent Matisse a letter that was to be the last in their correspondence of many years. The collector was still expecting to receive new works—in this particular instance a picture of a boat, which he had been requesting for a long time.[30] In November 1914 Matisse received a telegram from Shchukin in response to his request for permission to exhibit *Woman on a High Stool* in New York.[31] The painting was thus destined to cross the ocean to a haven of peace on a distant shore. Indeed, Shchukin had never objected to works he owned being exhibited before they were sent to Moscow.

Shchukin's telegram was to be the final news Matisse received from faraway Russia. But on that day Matisse could hardly have surmised that the war that

20. Marcel Sembat. "Henri Matisse," *Les Cahiers d'aujourd'hui*, April 1914, pp. 191-192.

21. Schneider, p. 307.

22. Daniele Giraudy, "Correspondance Henri Matisse-Charles Camoin," *Revue de l'art* 12 (1971), p. 16.

23. Owing to illness, Matisse was unable to supervise the dispatch of the paintings. This was such a rare occurence that he considered it necessary to notify Shchukin. His letter of 21 August 1913 is now in the archives of Pierre Matisse; some researchers believe the artist never sent it. See *Matisse in Morocco: Paintings and Drawings 1912-1913* (National Gallery of Art, Washington, D.C., 1990), pp. 266, 268, n. 75.

24. Letter from S. Shchukin to H. Matisse, 10 October 1913 (letter XLIV below).

25. Ibid.

26. H. Matisse, *Portrait of Sergei Shchukin*, 1912. Charcoal on paper, 49.5 x 30.5 cm. Private collection, New York.

27. It seems most likely that an error has crept into Duthuit's memoirs on this point: Pyotr Shchukin died on 25 October 1912, two weeks after Matisse's departure on 8 October. The sketch was probably made during the summer of 1912.

28. Letter from S. Shchukin to H. Matisse, 18 June 1914 (letter XLVII below).

29. H. Matisse, *Woman on a High Stool*, 1913-1914. Oil on canvas, 147 x 95,5 cm. The Museum of Modern Art, New York.
Matisse in the Collection of the Museum of Modern Art. Catalogue. (New York, 1978), p. 202, n. 5.

30. Letter from S. Shchukin to H. Matisse, 7 August 1914 (letter XLVIII below).

31. "Content exposer New-York Amitiés, Stschoukine, 21 novembre 1914" (Glad to exhibit New York Regards. Shchukin. 21 November 1914), Pierre Matisse archives. First published in Kean, p. 243.

would bring about the fall of empires would also deprive him of his Russian patron, nor could Shchukin anticipate that he would never receive another new painting from Matisse.

World War I isolated Russia from Europe. The western art market was denied its Russian buyers, and it soon became clear that the loss would be permanent. Ivan Morozov, who had never stopped acquiring the work of Russian artists for his collection, switched over completely to the Russian avant-garde. Sergei Shchukin simply stopped collecting. Modern Russian art was never one of his interests as a collector, and he saw no reason to change anything now.

Shchukin's gallery continued to receive visitors throughout the war and the revolution—every Sunday from eleven until two. The pictures all remained hanging in their places. At first, nothing changed in Morozov's mansion either, but during the early months of the revolution he took his pictures down and transferred them to a fireproof storeroom. In December 1917 Shchukin donated the sketch for *The Artist's Studio* to a charity auction in aid of war victims, where it sold for five hundred roubles. On the reverse he wrote: "I certify that this is an original drawing by Henri Matisse. Sergei Iv. Shchukin. Moscow, 16 December 1917. His first idea for the picture *Studio*." Shchukin never valued Matisse's sketches very highly—he gave the sketch for *The Dance* to Ilya Ostroukhov and *Composition No. 1* to Pavel Muratov. The only sketch he did keep was *Le Pêcheur* (The Fisherman), which Matisse had given him when they met. Legend has it that in this large pen drawing, the figure with the fishing rod is a self-portrait, and the swimmer is Derain.

In 1918 it became clear from the course of events in Soviet Russia that members of the former property-owning class had no choice but to emigrate if they wished to save their lives. In August 1918, three months before his collection was nationalized, Shchukin left Russia with his son.[32] His wife, Nadezhda, and their three year-old daughter had left a month earlier. The Shchukins stayed for a short while in Germany (where Morozov also arrived in the spring of 1919, after only a short period working in the post assigned to him by the new authorities: assistant curator of the collection that no longer belonged to him, which consisted of leading guided tours of the gallery). The Shchukins then moved on to Nice, where, in 1919, the collector and the artist met once again after an interval of five years.

The meeting took place on Matisse's initiative, since Shchukin made no attempt to see the artist, who was living nearby in Collioure. Without a proper grasp of what had happened in Russia, it was impossible for Matisse to understand Shchukin's changed circumstances. The power and respect that had been his only yesterday were now gone, and he had been transformed into an emigrant obliged to live out his days in a foreign land. The painful fact of the matter was that Shchukin could no longer afford to buy paintings, especially paintings by Matisse, which, as Shchukin had anticipated, were constantly increasing in value.

For a while, unable to understand the cause of Shchukin's indifference to him, Matisse attempted to reestablish the old relationship between them. He recalled that he once persuaded Shchukin to visit Renoir, who was now very old and living at the villa Le Colette in Cannes. By force of habit Matisse looked for Shchukin in the first-class railway carriage, only to find the former collector calmly waiting for him in the second-class. Underlying this amusing anecdote was a serious message: Shchukin was deliberately demonstrating his withdrawal from the role of the "ideal patron" that he had played so brilliantly for so many years.

Meanwhile, the Shchukin and Morozov collections had been nationalized and in 1919 became the First and Second Museums of Modern Western Painting.[33] The new museum administration introduced relatively insignificant changes in the way the works, including the Matisses, were hung, but the general reorganization and consolidation of museum collections in the mid 1920s had a greater effect. In 1928, it was decided to give the former Shchukin mansion on Bolshoi Znamensky Lane to the Museum of Porcelain, and Shchukin's entire collection of paintings was transferred to Morozov's former house on Prechistenka Street. The Trubetskoi

32. Following the decision to nationalize the largest private collections, the first to be made government property, by decree of 5 November 1918, was Sergei Shchukin's gallery. The decree nationalizing Ivan Morozov's collection was passed on 19 December.

33. In April 1922, the First and Second Museums of Modern Western Painting were combined into one museum with the title of State Museum of Modern Western Art. The first director of the new museum was Boris Ternovets, who held the post until 1938.

mansion then made the rounds of various organizations until it was finally occupied by a military department, and by the mid 1930s, not a trace was left of the former glory of the pink drawing room.

Although Matisse's works were all collected together in the Museum of Modern Western Art on Prechistenka Street, the Matisse hall had none of the charm of the drawing room on Znamensky Lane. The *Dance* and *Music* panels, removed from the staircase, also looked different: they now hung on opposite walls of the large hall, the center of which was occupied by a large table bearing a display of Matisse's ceramics. In fact, the hall allocated to Matisse had until recently been the music salon decorated with Maurice Denis's panels, now cruelly boarded over.

In the late 1930s, the State Museum of Modern Western Art began coming under constant attack from the controllers of Soviet cultural policy, who considered it harmful to show such art to the Soviet public. During the Second World War, the museum's collection, including all the Matisses, was evacuated to Novosibirsk. This move, made in difficult circumstances, was far from good for the paintings, and when the collection was returned to Moscow, the works were left sitting in their crates, with Matisse's panels wound on a roller. Not far away was 1948, the year of tragedy for Soviet culture and art that saw the beginning of the struggle against "cosmopolitanism" and every manifestation of "formalism," which was held to include impressionism and all that came after it.

Neither Ivan Morozov, who died in Karlsbad in 1921, nor Sergei Shchukin, who died in Paris in 1936, lived to see the liquidation of the museum that was established on the basis of their collections. The employees of the doomed museum were simply ordered to bring out the entire collection overnight. They managed to hang some of the paintings, and they removed Matisse's panels from the roller and spread them out on the floor. Alexandr Gerasimov, president of the Academy of Arts, who hated the museum with all his heart, knew exactly what he was doing when he suggested that Marshall Kliment Voroshilov—sent by the government to deliver judgment on the Museum of Modern Western Art—should begin his inspection with the Matisse panels.[34] Shortly afterward, Stalin signed the decree liquidating the museum.[35]

It was only by chance that the plan proposed by the museum's department of the Committee for Artistic Affairs was not implemented, which would have involved scattering the works from the disbanded museum around the provincial galleries, with several of them destroyed altogether and only the very best (as they thought) retained for the museums of Moscow. In the circumstances of the time, however, the optimal solution, and the only acceptable one, was felt to be the division of the collection between the Hermitage and the State Pushkin Museum of Fine Arts.[36] The Hermitage took everything that the conservative Pushkin Museum found unacceptable. Consequently, Matisse's most challenging works, including the famous panels, left Moscow (as did those of Picasso). The paintings were divided up in a most irrational fashion—for instance, according to size, which meant that the Hermitage took all the large works for which there was no space in the Moscow museum. Even the "Moroccan triptych" was split up, with *Entrance to the Casbah* going to the Hermitage, and not until 1962, following a long exchange of letters, were the canvases reunited. *Zorah Standing* remained in the State Museum, however, even though *Amido the Moor* had gone to the Hermitage in 1934.

From the beginning of the 1940s, the former Shchukin and Morozov collections were not shown to the public. Only the impact of large French art exhibitions in Moscow in 1955 and Leningrad in 1956 made it possible to leave some of the paintings on permanent display, and in the mid 1960s to show almost all the Matisses (but without naming their former owners). The pictures collected at the beginning of the century by the Moscow merchants Sergei Shchukin and Ivan Morozov could now embark on a triumphant tour of the world. Time has confirmed Henri Matisse's place as one of the great artists of the twentieth century. The Russian collectors played no small part in his achievement.

34. "Voroshilov looked and gave a sound like a laugh:
'He, he,' and all of his retinue joined in: 'He, he, he.' Many years have passed since then, but that chorus of mocking laughter still rings in my ears" (Nina Yavorskaya, "Rasskaz ochevidtsa o tom, kak byl zakryt Muzei novogo zapadnogo iskusstva" [An eyewitness account of the closure of the Museum of Modern Western Art], *Dekorativnoe iskusstvo SSSR 7* [1988], p. 13).

35. The Morozov mansion on Prechistenka Street was transferred to the control of the newly organized USSR Academy of Art, and the Academy's conservative leaders proposed that the museum should be closed down and its premises used by the Academy. The Academy remains there to this day.

36. After the State Museum of Modern Western Art was liquidated, fifteen paintings by Matisse went to the Pushkin Museum, and twenty-three went to the Hermitage, bringing the Hermitage's collection of Matisses up to a total of thirty-six. The pictures were divided up in a rather hasty and ignorant fashion. As the legal successor to the State Museum of Modern Western Art, the State Pushkin Museum of Fine Arts was in a position to make its own choice, but it willingly parted with all of Matisse's programmatic works, considering them the "most formalist".

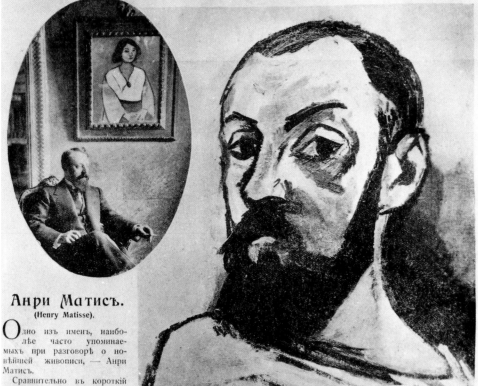

Анри Матисъ.
(Henry Matisse).

Одно изъ именъ, наиболѣе часто упоминаемыхъ при разговорѣ о новѣйшей живописи, — Анри Матисъ.

Сравнительно въ короткій срокъ Матисъ заставилъ о себѣ говорить, какъ о смѣломъ новаторѣ въ области живописи, нашелъ себѣ подражателей и сталъ, такимъ образомъ, во главѣ опредѣленнаго теченія.

Онъ родился въ 1869 году. Окончивъ École des beaux Arts въ Парижѣ и не мало поработавъ самостоятельно, Матисъ не сразу пріобрѣлъ извѣстность. Учителемъ его (такъ же, какъ и Марке, одного изъ самыхъ обѣщающихъ современныхъ французскихъ художниковъ) былъ Густавъ Моро, чрезвычайно бережно относившійся къ индивидуальности своихъ учениковъ. Владѣя недюжиннымъ рисункомъ, Матисъ, тѣмъ не менѣе, не могъ овладѣть вниманіемъ общества.

А. МАТИСЪ. Автопортретъ (1906 г.). Вверху и внизу — снимки съ А. Матиса въ домѣ С. И. Щукина: 1) у портрета его работы, 2) съ внукомъ С. И. Щукина.

THE RUSSIAN PRESS ON MATISSE'S VISIT

RANNIEIE UTRO (EARLY MORNING), 25 OCTOBER 1911, NO. 245

The famous French artist Henri Matisse has just arrived in Moscow. He has caused a sensation not only in France but also here in Russia, where he has given rise to an entire school of imitators.

Last year's "Jack of Diamonds" exhibition, with the endless controversy and ridicule it provoked, is still fresh in our minds, but it would be unfair to reproach Matisse with the excesses committed in the works of his imitators.

Matisse is a great and serious artist who has initiated a new epoch in the history of French painting.

We may not agree with his art, but we cannot ignore it—it is too bright a spot on the canvas of artistic life in modern France.

Matisse is staying with our famous collector S. I. Shchukin, a great admirer of his art and the owner of perhaps the very richest collection of works by this innovative artist.

Sadko

RANNIEIE UTRO (EARLY MORNING), 26 OCTOBER 1911, NO. 246

"WITH MATISSE"

A sumptuous living room in the style of the eighteenth century. The gilt gleams gently and the pale tones of the silk are softly iridescent. Dazzlingly colorful paintings cover the walls.

By the window, bent over a book, sits the man whose mighty brush created these paintings: Matisse. His face is more that of a scholar than of an artist. A serious, inquisitive gaze, slow measured movements, a sober, laconic manner of speaking.

A calm, even voice breaks the silence: "I know that many attack me because they consider my work sick or even deliberately 'original.' But that does not bother me. I know what I want to do. In my view, the artist should not represent nature as it is in reality. We have photography for that. Nor should the artist regard a painting as an opportunity to demonstrate the brilliance of his technique. In the final analysis, paint is only a means, not the goal. I believe that art is a mirror that reflects the soul of the artist. In his paintings, the artist must express only himself. And everything that serves as a subject for his art must be merely a pretext for the constant and repeated baring of his own soul. Therefore what I demand from the artist above all is sincerity and modesty. If he is really an artist he must avoid posturing and reveal himself as he really is, without embarrassment at the limitations of his inner world; it may be small, but it is his, and only his.

"Yesterday I saw a collection of old Russian icons. This is truly great art. I am in love with their touching simplicity, which is dearer and more precious to me than the paintings of Fra Angelico. In these icons, the souls of the artists who painted them unfold like some mystical flower. We should study them in order to understand art.

PAGE FROM THE JOURNAL *ZERKALO* (THE MIRROR) NO. 45, 1911

"I am glad to be here in Russia at long last. I expect a great deal from Russian art, because I sense incalculable riches stored in the soul of the Russian people; the Russian nation is still a young one that has not yet lost the fire in its soul."

I walked down the staircase of Shchukin's quiet mansion. On the wall before me blazed the colors of a gigantic fresco by Matisse. Naked youths whirled in a frenzied dance and in their wild impulse of passion I seemed to sense the majestic passion of a soul with a strict faith.

M. V. Shevlyakov

UTRO ROSSII (RUSSIAN MORNING), 27 OCTOBER 1911, NO. 247

"MATISSE ON MOSCOW"

When that exponent of a well-known trend in painting, Henri Matisse, arrived for his visit to Russia, his first impression was disappointment. He had expected to see snow, Russian snow, without which foreigners cannot imagine Russia. But there is no snow, and Moscow looks "underdressed."

. . . The earliest capital city holds a special interest for Matisse. "In Gascony," he says, "I became acquainted with Spain; in France I became acquainted with Germany; in Moscow, I have made the acquaintance of Asia."

Moscow is the threshold of Asia. European strata deposited on eastern foundations, European culture against a background of provincial disorder (luxurious stores and slovenly, neglected roadways); it all creates a curious and colorful picture.

Matisse has seen the Kremlin, the palaces, the cathedrals, admired the moonlit landscape by the Zmoskvoretsky Bridge, and so on. He approaches everything he has seen from the viewpoint of style.

Old Moscow, especially the cathedrals and the old icons, have made a great impression on him. The monumental forms of the Kremlin cathedrals, the magnificence of the Byzantine style, the originality of the Iverskaya Chapel—these have all drawn sincere praise from Matisse.

The rich, pure colors of the old Russian icon, their emotional directness were a genuine discovery for him: "This is primitive art, authentic folk art. This is the original source of the artistic quest. The modern artist must draw his inspiration from these primitive works."

Matisse has noted our Empire style. . . .While acknowledging its fine artistry, he feels that the Empire style is more rigorous in French architecture.

The modern architecture of Moscow left Matisse with a most unfavorable impression.

RUSSKIE VEDOMOSTI (RUSSIAN CHRONICLE), 27 OCTOBER 1911, NO. 247

"A CONVERSATION WITH MATISSE"

Gauguin and Matisse. In modern painting these are the two most famous names, names associated with the most lively of innovations.

Strange as it may seem at first sight, in order to study Gauguin and Matisse one must travel not to Paris, but to Moscow. On quiet Znamensky Lane there is a typical old Moscow mansion belonging to Sergei Ivanovich Shchukin. And this mansion houses a large collection of works—the finest—by two of the major figures of modern painting.

A few days ago, one of them, Matisse, arrived in the city that has shown such hospitality to his art. The famous artistic innovator, who has had considerable influence on the younger generation of Russian artists, shared his views on the latest trends in painting.

The new school, Matisse said, is a direct continuation, a consequence as it were, of impressionism. As we know, the impressionists strove to achieve the most direct expression possible of their visual impressions, without attempting to analyze them, but rather, surrendering to them totally. Thus the works of the impressionists were nothing other than sketches registering visual impressions. By contrast, the modern school in painting regards impressions of color and line as a means for expressing the artist's own personality. Just as any melody can be constructed from seven simple musical tones, paint should be used in the manner that expresses feeling most harmoniously. The modern school takes a more conscious attitude toward "impressions." The artist no longer surrenders

totally to his impressions; he does not simply record them on the canvas as they arise, but uses them as material for expressing his own personality. The link between the impressionists and the new school is provided by Gauguin's painting.

In Matisse's opinion, modern society provides extremely favorable conditions for painting to flourish: nowadays everyone is a collector, everyone would like to buy a good painting. It is not unusual to find excellent collections of works of art in some modest bourgeois home, whereas previously only monarchs and the most noble aristocrats bought paintings. But novelty in art always shocks at first. This was the case with the paintings of the new school—Matisse's own, and those of the other artists who worked along the same lines, Picasso and Marquet. Matisse's view is that only genuine connoisseurs were capable of taking an immediate interest in these unusual paintings. Such connoisseurs, it turned out, were to be found not in his own country but in Moscow. As a result, a significant number of his and Gauguin's works found their way to Moscow. Now France has also acknowledged the new trend, and, as Matisse says, there is no longer any shortage of people who wish to acquire the paintings of this school. "But," says Matisse, "I work entirely for America, England, and Russia."

In contrast with the flourishing condition of painting, sculpture is in a state of deep crisis. This is explained by the general decline of the decorative arts, especially architecture. Sculpture has always depended intimately on architecture, and when mansions and churches were built in large numbers, works of sculpture were required to decorate them. But now? Works of sculpture are hardly required except as figures for paperweights. A revival of the decorative arts, led by architecture, will have to occur if sculpture is to flourish once again.

Going on to discuss the public's opinions of modern art, Matisse did not discern any great difference between present-day visitors of exhibitions and those of previous years: the general public is the same now as it always was. Very few people understand the artist, and the majority totally misinterprets his intentions.

Art criticism, when practiced by artists themselves, is always biased, and when practiced by men of letters, it is always inept. In general, Matisse recognizes only passionate criticism, when a person defends his views and preferences and advocates his ideas with the heat of conviction (unjustly, of course, in the majority of cases).

Matisse will be in Moscow for a few more days.

Nikolai G.

MOSKOVSKAYA GAZETA (MOSCOW NEWS), 28 OCTOBER 1911, NO. 144

"WITH THE BARBARIANS IN RUSSIA"

When one considers the invasion of "foreign tribes" that Moscow has been suffering recently, one involuntarily recalls Chatsky and his pithy aphorism: "One should borrow from the Chinese the wise ignorance of foreigners."

Poiret and his mannequins.

Casadesus and his ancient instruments.

Paquin and his models.

And finally, the hero of more recent days, Henri Matisse, who has come to paint the walls in Mr. Shchukin's house.

These "Frenchies from Bordeaux" have not merely turned the heads of the jaded Moscow ladies; they have fascinated the press and, through it, the broadest strata of Moscow society.

Conversation everywhere is limited to the cut of the latest fashions and French painting of the new school.

Matisse has been shipped into Moscow from the other end of the world, no doubt for an immense fee, to execute his paintings in a merchant's mansion.

Borobykin wrote a curious story that is called simply "Matisse."

A rich merchant's wife feels that this name, casually dropped in a conversation about her collection, will be her passport to the most subtle and refined understanding of art. This observation is peculiarly apt with regard to the patronizing merchants and merchants' wives, who simplemindedly assume that Gauguin and Matisse have spoken the final word in art.

Matisse himself admits that he enjoys his greatest success in Russia and America, where, of course, all kinds of "pork (or anthracite) kings" have even less idea of what genuine art is than the shareholders of the Danilov Manufacturing Company.

It is worth noting that during the construction of the very mansion that Matisse is now decorating, and receiving plenty of money for decorating, the builder—one of our most talented architects, L. N. Kekushev—took the owners to court over the settlement of accounts.

Of course, haggling over money with a Russian architect is one thing, but when it comes to a barefoot Parisian artist, one has to demonstrate one's expansive industrialist generosity.

It makes no difference if the artist paints repulsively ugly women: in Moscow they will pass for Venus or Diana.

One recalls the extremely interesting manifesto of the Italian "futurists," who have had enough of the ugly deformities of modernity:

"Today's artists," says the poet Marinetti, the author of the manifesto, "exhibit the bodies of their mistresses and transform the salons into pork markets."

On Moscow's Bolshoi Znamensky Lane thousands are "forked out" for these knuckles of pork.

Fate is playing a malicious joke on the tastes of the Shchukins.

A few years ago in Paris, Ivan Shchukin, the brother of the Moscow millionaires, shot himself.

He was a passionate collector of paintings, and exhausted his entire fortune in acquiring works of art.

His Moscow brothers could not match him in terms of aesthetic education and artistic taste.

His dispatches from Paris, printed in *New Times*, and his critical articles, printed in *The Scales*, were read with the greatest interest.

Nonetheless, when an auction of the paintings he owned was arranged following his suicide, it turned out that most of them were forgeries or pieces of very questionable value.

The outcome of the auction was paltry for such a collection.

The Paris print dealers had foisted junk on the rich Russian nobleman in the guise of masterpieces of art.

Time will show the value of Matisse's works in the history of art to be equally paltry. In Paris his works are no longer regarded as precious gems of painting.

The French school of painting has genuine masters of the palette, subtle artistic virtuosos who have spoken a new word in the interpretation of the female body.

There are the charming, pearly portraits of Puvis de Chavannes.

The colorful, gentle plasticity of Cézanne's girls.

The bright, bold drawing of Maurice Denis.

The magical lines of Le Fauconnier.

But in no way can Matisse's works be set on the same level as these inspired creations of genuine art.

Matisse's art is a dry algebraic schema, harsh and lifeless anatomy, not the beauty of nature in all of its sparkling colors.

Bumler

VECHERNYAYA GAZETA (EVENING GAZETTE), 30 OCTOBER 1911, NO. 67

"ROUT IN HONOR OF MATISSE"

A rout was held yesterday at the home of the popular benefactress S. M. Adel in honor of a guest from Paris, the artist Matisse.

A large and interesting company assembled in the elegant drawing room decorated in the purest Russian Empire style.

There were many artists and writers.

The leader of Russian modernism, Valery Briussov, Mr. Sergei Mamontov, and a whole group of Moscow Matisses—young artists from Jack of Diamonds for the most part.[1]

These include Konchalovsky, the landscape painter Larionov, Mashkov, Matisse's pupil Mme Curie, and the most "leftist" of all the Jacks, Burliuk, whose lorgnette is so out of keeping with his Little Russian accent and all of his mannerisms.[2]

1. The Jack of Diamonds Society was established in Moscow on 1 November 1911, the day after the rout described in this article. It was based on a group of artists who, by their own admission, worked "in the new tendency of Post-Impressionism, with an orientation toward French culture." The society's first chairman was Pyotr Konchalovsky. In January 1912, the Jack of Diamonds group organized an exhibition of the same name, where works by Russian and French artists were shown. Three drawings by Matisse were exhibited: no. 142 (property of Tamara Adel), no. 143 (property of Militsa Curie), and no. 144 (property of Nikita Baliev). He could well have done these drawings while in Moscow as presents for his new Russian friends.

The evening passed in a very lively fashion.

Matisse spent a great deal of time in conversation with the artists, who listened reverently to their "maître."

He told them that apart from the icons, the Tretyakov Gallery had not impressed him at all.

Matisse showed great interest in his Moscow followers.

He promised to visit the studio of Konchalovsky and Mashkov during the next few days.[3]

The pianist Focht-Sudarskaya rendered several pieces at the rout, and one young artist sketched Matisse and Briussov.

The rout continued long past midnight.

2. The outrageous Jacks loved to parade themselves in public in the most extravagant of appearances. David Burliuk, who was raised in provincial Ukraine ("Little Russia") usually sported a top hat, kid gloves, and lorgnette.

3. As Yury Rusakov remarked, Matisse probably did not visit the studio of Pyotr Konchalovsky and Ilya Mashkov, since it was not reported in the press, and there is no mention of it in these artists' published memoirs. Such a visit could not possibly have gone unnoted.

ZHIVOE SLOVO (LIVING WORD), 31 OCTOBER 1911, NO. 35

"HENRI MATISSE"

Henri Matisse, a member of a significant movement in modern French painting, has arrived in Moscow. Matisse is by no means the innovator he is taken for. His work is a synthesis of Cézanne, Signac, the early Italians, Etruscan vases, and the ancient Greek archaics, rearranged in a popular fashion to suit the modern public. But the years spent in the academy have left their mark on him: for all his efforts to achieve simplicity in a few basic lines and tones, he cannot rid himself of academic precision: emphasizing a muscle, detailing a foot, and instead of the generalized simplicity of the ancients, which conveyed the very idea of an object, giving only an impression of deliberate clumsiness. He does not deal with his material in that free manner that in Mexican art, for instance, transforms the human body into sheer patternwork, or the melodious elegance of flowing lines found in Japanese painting. He is almost an academic artist: of course, he does not render the bone structure, but that is probably only because it is not there on the Etruscan vases, and Matisse happily repeats the forms and movements of the Etruscan figures (*Recreation, Boys Playing Ball*, and especially a *Dance* of cinnabar-red girls flying above a hilltop against a blue background). Matisse has also been tremendously influenced by religious *vitraux peints*, [stained-glass window] with their colors of bright green, scarlet, and azure, separated by the black lines of the lead framing. Matisse is a purely receptive artist. It is highly likely that his newly developed interest in old Russian icon painting, undiscovered masterpieces of which are still scattered throughout the Old Believers' cottages and mossy forests along the Vetluga, will mark a new stage in Matisse's art. Matisse is an excellent ornamental painter whose works are a pleasant decoration in drawing rooms (Shchukin's pink drawing room), who adapts skillfully to the dimensions of the surface he is working and achieves great beauty in the arrangement of sharp, brilliant tones, which in his work always emphasize and complement one another. But in the final analysis, Matisse is a *cravate*, a colored necktie, in the words of Pablo Picasso, his opposite. He is beautiful but not profound. He has not created a genuine school. The most original and talented artists among his first followers—Picasso, Delaunay, Friesz—have not continued to follow him, or have abandoned Matisse altogether and gone back to Cézanne.

Matisse's main contribution is that he has popularized the ideas of Cézanne and made them acceptable to the masses.

PROTIV TECHENIYA (AGAINST THE CURRENT), 5 NOVEMBER 1911

"MOSCOW ARTS CHRONICLE: A WEEK OF MATISSE"

Henri Matisse is visiting Moscow, where the well-known collector of modern French painting Sergei Shchukin has a large collection of his works (twenty-five pieces).

Moscow gave its guest a cordial welcome. He was introduced to Moscow and shown our antiquities and artistic treasures; interviews with him were arranged (at the Free Aesthetes);

PARISIAN GUEST HENRI. CARICATURE FROM *RAMPA I ZHIZN* (FOOTLIGHTS AND LIFE), NO. 45, 1911

the newspapers have devoted a number of articles to him, in which they have mentioned the artistic preoccupations of contemporary French painting.

Matisse, not expecting to receive so much attention, is very happy with Moscow and has readily shared his impressions of the city. The rumor that Matisse was invited by Mr. Shchukin in order to decorate his new home is untrue. Matisse came simply to get to know Moscow. New works of his and several paintings by Marquet are arriving in Moscow shortly for Shchukin's collection.

B. P. Lopatin-Shuisky, Arts Editor

PROTIV TECHENIYA (AGAINST THE CURRENT), 5-18 NOVEMBER 1911, NO. 8/32

"MOSCOW ARTS CHRONICLE: CONVERSATIONS WITH MR. MATISSE"

. . . Under the gaze of his own works in the pink drawing room of Sergei Shchukin's luxurious mansion, Henri Matisse kindly shared his views on art and his impressions of Moscow with our correspondent.

"Moscow has made an extraordinary impression on me. It has many distinctive points of beauty.

"Your cathedrals are beautiful, majestic. Such monumental style. The Kremlin, certain corners of Moscow, the relics of ancient art—these are all of a rare beauty. I especially liked the decoration of the Iverskaya Chapel and the old icons.[1]

"The icons are a supremely interesting example of primitive painting. Such a wealth of pure color, such spontaneity of expression I have never seen anywhere else. This is Moscow's finest heritage. People should come here to study, for one should seek inspiration from the primitives.

"An understanding of color, simplicity—it's all in the primitives. The modern artist has to add his own sense of balance in order to create a lofty work of art."

"Have you paid any attention to our monuments?"

"I remember the monument to Alexander II in the Kremlin.[2] But it is too harsh, too truncated. It does not harmonize with the surrounding landscape.

"I do not like the Great Palace either; it lacks elegance. Its interior is overdecorated; there is too much gold. It hurts the eyes."[3]

"What about the Church of Christ the Savior?"

"That is beautiful. The monumentality of the Byzantine style is impressive."

"The Church of Christ the Savior? But it's an example of stylistic perversion!"[4]

"Really? Perhaps. I saw it at night. It seemed a fine, rich patch of color. Perhaps I did not look at it properly."

"And the Moscow Empire style?"

"There are fine buildings in very good taste, very good style. But the French Empire style is more rigorous. The new buildings, attempting to be modern, made a bad impression on me. They are pure barbarism. Barbarism underscored by the artistic quality of old Moscow. In this respect, modernism, as often happens, falls into grievous error in thinking *plus c'est grand, plus c'est beau.*[5]

In short, it's the story of the Eiffel Tower all over again.

"Moscow is interesting as the threshold of Asia. There is much that is oriental in the old painting, and the city itself. In the moonlight, the landscape by the Zamoskvoretsky Bridge is pure Chinese, with the whimsical silhouettes of the towers against a dark blue sky."

"What was your impression of the Tretyakov Gallery?"

"Russian painting is extraordinarily rich; the icons made an immense impression on me."

"What about Serov or Vrubel?"

"I knew almost nothing about Russian painting before this. As you will understand, I find it awkward to mention names."

"Which of your works in here are the earliest?"

Matisse pointed to a landscape rendered in dark tones, which was richer and more expressive in its colors than the others.

"This is a kind of study. I took great care with the colors, looking for the genuine tones. And afterward, by selected the main ones, the most typical, and generalizing and simplifying them, I arrived at my most recent pictures." (Matisse gestured broadly at the "primitivized" pictures on the walls.)

1. The small Iverskaya Chapel, erected in 1792 alongside the walls of the main Voskresensky Gate in the Kitai-gorod district of Moscow, was considered one of the most popular in Moscow. It housed an especially revered miraculous icon, the Virgin Mary of Iverskaya.

2. The bronze memorial to the emperor Alexander II was unveiled in 1892 on the upper bank of the Moscow River opposite the Kremlin Palace. It was surrounded by a colonnade with abundant gilt-work and Venetian mosaics. Contemporaries thought it in pompous bad taste.

3. The Kremlin Great Palace, built in 1837-1850, was the czar's residence. Its facade was in a pseudo-Russian style.

4. The Church of Christ the Savior was a grandiose cathedral in the pseudo-Byzantine style, built in 1837-1882 to commemorate the victory over Napoleon in 1812. It could hold up to ten thousand worshipers. The church was sited so that its mighty golden cupolas could be seen from the most distant parts of the city.

5. "The bigger, the more beautiful" (in French in the text).

"The artist's major task is to pursue harmony of color. It is not at all a matter of their strength or violence, but a matter of harmonious combination. *Tout est dans la mesure.*[6]

"Conviction is achieved by other means. I would put it this way," he added with a smile, "*il faut peindre les choses délicates avec la force.*"[7]

6. "Everything in moderation" (in French in the text).

7. "Subtle things should be painted forcefully" (in French in the text).

ZERKALO (THE MIRROR), 1911, NO. 45.

"HENRI MATISSE"

One of the names most frequently mentioned in conversations about modern art is Henri Matisse.

In a comparatively short period of time, Matisse has won himself the reputation of a bold innovator in the area of painting and attracted imitators, so that he has become the leader of a distinct trend.

He was born in 1869. After graduating from the Ecole des Beaux-Arts in Paris, he worked independently for quite some time before becoming famous.

His teacher was Gustave Moreau (also the teacher of Marquet, one of the most promising of modern French artists), who took great care to preserve the individuality of his pupils. Even with a remarkable mastery of drawing, Matisse was unable to attract the public's attention.

He did not join the impressionists, but sought his own way in the expression of artistic ideas. In his colors he followed oriental motifs to a certain degree and became absorbed in producing ornamental pictures verging on the style of the poster.

His experiments in this direction attracted the attention of younger artists. In the process of simplifying his drawing and moving from complex to more simple color tones, Matisse gradually "discovered" himself.

He became the leader of a famous group of young artists whom society christened with the semihumorous nickname "fauves" [wild beasts]. Matisse's name carried more and more weight. In Paris, the banker Stein proved to be a passionate supporter of modern art. He became Matisse's main buyer and thereby made his salon fashionable in the best circles.

At the same time the Moscow patron of the arts S. I. Shchukin also began to collect Matisse.

Matisse began to appear in the most progressive exhibitions in Europe, in the Salon des Indépendants in Paris, in the Secession in Berlin. His paintings do not find their way into museums; they are borne away by a small number of private collectors.

Imitators of Matisse have appeared, and the greatest number of his followers are to be found in Russia, America, and Hungary.

Infatuated with the spirit of innovation, Matisse opened his own school in France. His name attracted a large number of pupils (more than 150), including a good many Russians.

But Matisse closed his school after two years, claiming that teaching interfered with his creative work. Malicious tongues assert that the school was closed because of the threat of competition to Matisse himself: this modern art proved so easy to assimilate that the pupils caught up with their teacher with remarkable speed. This reference to the primitive technical level of Matisse's painting—which is far from unjustified—applies, of course, to his latest works, which express his aims and goals more fully.

In S. I. Shchukin's precious collection of modern French painting Matisse has been given an entire room to himself; it contains twenty-six of his works.

The drawing by Matisse in our photograph shows him to be to some extent an impressionist who is not devoid of expressive vitality. Matisse's earlier pictures (landscapes) also betray a certain affinity with impressionism. Their colors possess undoubted merits, being rather rich and well controlled in their range.

Matisse gradually went on to reject complex tones and simplify his drawing to the total exclusion of chiaroscuro. His still lifes are still richly colored, and their pure tones and inventive harmonies are of interest for the artist. But the striving for ornamental effect has gradually flattened out the forms.

In his genre paintings and portraits, the total absence of form and expression is blindingly obvious. Though their colors may be interesting, this is so quite apart from the

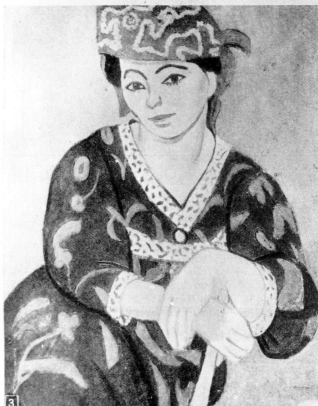

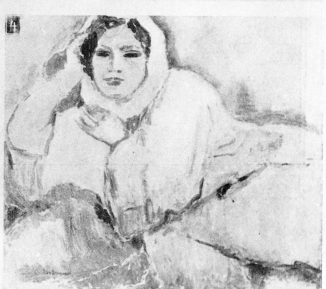

1) А. МАТИСЪ. „Пастораль“. 2) А. МАТИСЪ. Рисунокъ перомъ (собраніе С. И. Щукина). 3) А. МАТИСЪ. „Выразительная головка“ (Tête d'expression) (собраніе С. И. Щукина). 4) ВАНЪ-ДОНЖЕНЪ. „Альмея“. 5) Розовая гостиная въ домѣ С. И. Щукина, занятая картинами А. Матиса. На-право отъ дверей: вверху—„Фавнъ и Нимфа“; внизу—Nature morte se-villane. Правѣе по стѣнѣ: вверху—„Игроки въ мячъ“; внизу—Nature morte. 6) В. ВАНЪ-ГОГЪ. „Молодая дѣвушка“ (Ванъ-Донженъ и Ванъ-Гогъ—представители новой французской живописи).

question of whether these colors cover a triangle, a square, or the contours of a human figure. The color combination of two pieces of bright fabric dropped onto a chair is interesting in the same way.

Matisse's painting has thus arrived at total absence of meaning and content.

This is what the pictures tell us, but not what he himself tells us about the goals of his painting.

He feels the need to provide a theoretical justification for them. He defines the aim of painting as the expression of the artist's personality. His source of inspiration is primitive art, with its wealth of expressive power and refreshing approach to color.

In speaking of his own goals, Matisse has said that the human being is the most worthy of subjects; in drawing the human being he expresses his own religious feeling for life. Where then is there a hint of the expression of the artist's individual experience? A stooping figure with arms outstretched and a face expressing nothing, a group of strange pink figures hurtling around a green field—what can these suggest to the viewer? They are faceless, dumb; their outlines tell us only of a certain physical motion, and no more.

Matisse's portraits are faceless. We do not even suspect that the figures have faces, and we cannot tell what the artist thought about them. These are artist's mannequins, differing from each other only in the dimensions of their various parts.

Matisse's public declaration that without drawing there can be no work of art is fatal to his own painting, where even linear drawing is absent, for not every line made possesses the power of expression.

Matisse, it is true, began from the impressionists, and he left them behind—to move beyond the bounds of what is acceptable in art, to come close to abolishing art.

In its present form Matisse's painting should not be mentioned alongside any of the impressionists, who are too sincere, and understand nature too well, to be compared with him.

The juxtaposition of the names of Gauguin, Claude Monet, and Matisse is an insult to greatness. The first two, France's most richly expressive artists, have nothing in common with Matisse's ideas, with his "simplicity."

The pseudo-primitivism that Matisse represents is either a degenerate artistic phenomenon or, if it is sincere, an incomprehensible error.

B. Shuisky

PAGE FROM THE JOURNAL *ZERKALO* (THE MIRROR)
NO. 45, 1911

MATISSE IN RUSSIAN COLLECTIONS

ALBERT KOSTENEVICH

1. IN THE BEGINNING WAS THE STILL LIFE

In the beginning was the still life, and the still life came from the Dutch masters. The small canvas that was the start of it all—"my first painting"—depicts a pile of law books with tattered leather bindings, a burnt-out candle, streaks of candle wax on a gleaming candlestick: the vivid reminders of a job in a lawyer's office in St. Quentin—not onerous work, but not very interesting either. The wayward clerk clearly found more amusement in capturing the appurtenances of the office on canvas than in studying the provisions of the law, and he still regarded his pastime as a game, signing his *Nature morte aux livres* (Still Life with Books, 1890) with the anagram "Essitam." This first attempt betrays the painstaking zeal of the apprentice, but the precision with which every texture is captured, from the thick pile of the carpet to the gleam of polished metal, is truly astonishing. Its emphatic verisimilitude is in effect the hallmark of a waning era, the era of the realism that Matisse was to reject so decisively at the turn of the century. When Matisse was already a renowned artist, he would include this first opus in his Paris retrospective.[1] Although the painting is certainly rather naive, it already offers a glimpse of qualities fundamental to the artist's nature—a spontaneous striving for equilibrium and an attitude of studious yet loving attention to material objects.

The still life is a very specific genre: here, rather than drawing on nature ready-made, the artist arranges it beforehand and then reproduces it on canvas. Why does *Still Life with Books* contain these particular details? What influenced the novice's choice? Surely there was more to it than the influence of his everyday surroundings. Genuine art is always nourished not only by impressions of real life, but also by the memory of what previous artists have done. This "first painting" has a genealogy that reaches back to the *vanitas* genre of the Leyden masters, works filled with reminders of the impermanence of human existence, in which books and candles formed an integral part of the pictorial symbolism. Living as he did in the provincial town of St. Quentin, Matisse could hardly have known the distinctive features of the Leyden school of still life painting, but he did know some of the links in the chain leading to the eighteenth-century Dutch masters whose work still contained lingering traces of the *vanitas* theme. In Matisse's later still lifes, however, there would be no more books, candles, or other attributes of the Leyden school's philosophy: no more reminders of death, only a constant emphasis on the joys of life. In most cases, flowers and fruit would provide the content of the works and define the key accents of the composition.

In the center of the earliest work by Matisse to be found in a Russian collection, *La Bouteille de Schiedam* (Still Life with Gin Bottle), there stands a small pyramid

1. Henri Matisse. Exposition. Galerie Bernheim-Jeune, Paris, 1919.

NATURE MORTE AUX LIVRES, 1890
(STILL LIFE WITH BOOKS)
PRIVATE COLLECTION

2. This painting was acquired by Morozov in 1911, from the Bernheim-Jeune Gallery in Paris.

3. Jacques Guenne, "Entretien avec Henri Matisse" (Conversation with Henri Matisse), *L'Art vivant* 18 (15 September 1925).

constructed of peaches.[2] If not for them, the painting would produce a dismal impression, dominated as it is by a tall black bottle of Schiedam gin that towers up behind the fruit. The unrelievedly dark background—a concession to the tradition of museum art—provides a deliberate contrast to the brightly lit objects. The largest of these—from which the picture takes its name—is yet another reminder of Holland, but there can no longer be any suspicion of imitating Dutch models: the old masters did not paint bottles in their still lifes; they limited their treatment of such motifs to the depiction of an elegant glass goblet filled with wine. Matisse was working with different reference points here. *Still Life with Gin Bottle* was painted by a man who had left behind the small towns of Cambrai where he spent his childhood and youth and had already known several years in the French capital studying art under the guidance of Gustave Moreau, who at that time was the finest teacher not only at the Ecole des Beaux-Arts, but in the whole of Paris. Moreau, admittedly, did not paint still lifes, but while he was drawn by his romantic muse to themes of legend, mystery, and fancy, he made no attempt to persuade his pupils to imitate his own subjects or his own style. Moreau had an exceptional respect for each individual's personality, no matter how much it might differ from his own. He encouraged Rouault to work on his religious compositions, and yet he found no fault with Marquet for the impulse that drew him out on to the streets and embankments of Paris. Moreau invited Matisse to become his pupil after the latter had failed the competitive entrance examination for the Ecole des Beaux-Arts. He immediately sensed the serious intent that underlay Matisse's rather clumsy works of the time. It was also Moreau who first recognized in Matisse the artist who would transform the very basis of European painting and told him: "It is your destiny to simplify painting."[3]

In the *Still Life with Books*, the desire to represent objects faithfully was already accompanied by an urge to organize them into a pyramidal arrangement, and Matisse resorts to this same reliable formula for stability in *The Gin Bottle*. This time, however, aware of the importance of compositional clarity, he attempts a less complex solution. Every element is subordinated to precise geometric calculation. The upper half of the canvas is occupied by a dark gray ground, and the lower half by a small table covered with a white tablecloth. The bottle that crowns the pyramid thus links together two distinct spaces: the sharply delineated foreground, which is a realm of light, and the seemingly veiled background, a realm of shadow. While not yet rejecting three-dimensional representation, Matisse limits the depth of his compositional structure in the interests of clarity. The tablecloth falls from the table almost precisely along the picture plane, and the handle of the knife even extends beyond it. The shallow pictorial space is delimited by the two peaches at the left of the picture, and a similar purpose is fulfilled by several diagonals—the edge of the table, the fold in the tablecloth, the knife pointing toward the center. For all of the composition's immutable geometrical construction, the effect is not the least bit stiff because the objects are depicted with such vitality and nobility in a pictorial interdependence stemming from a series of subtle juxtapositions (glass and silver, bone and cloth, the coldness of metal and the velvet texture of a peach, and so on). Even the blank pall of the dark ground is made to interact with the objects by setting the dark bottle in the center, where it almost merges with the background. With its carefully constructed composition, restrained color range, and painstakingly rendered halftones, reflections, and shadows, there is nothing in *The Gin Bottle* to presage the advent of the rebel who would set the artistic circles of Europe talking a few years later. But then, in his later rejection of shadows and halftones in order to allow the beauty of color its maximum impact, the "subversive" would not in any way transgress the fundamental principles of art. Whatever the language he chose to express himself, each work was always born from a relentless search for harmonious relationships, rhythmic vitality, and organic, living form.

Every element in this still life is easy to read at the first glance. The objects form

a unified whole without in any way diminishing each other. The tablecloth, with its downward folds, confidently "attached" to the picture plane, serves as the "platform" on which the three-dimensional space is constructed. The other objects recede from the picture plane, and only the handle of the knife, protruding slightly over the edge of the table, seems to penetrate the extrapictorial space in which the viewer stands. At the same time, the blade of the knife leads the eye into the very center of the composition, dominated by the enigmatic bottle of Schiedam. The philosophy expressed in this work seems to be that the world, for all the riddles it contains, is arranged in a regular and rational fashion. Insofar as the beautiful and the sublime are revealed in the everyday, the world of real objects is worthy of our consideration and love.

The objects that the young Matisse loved to paint are neither exotic nor commonplace but, in their own way, precious. The artist was so attached to such objects that they reappeared in painting after painting, as in the case of the bottle of Dutch gin, in which Matisse was able to reveal a beauty that, far from being gaudy, was actually noble. The external appearance of these ordinary objects is subordinated to a more intense focus on their hidden inner meaning.

Quite clearly, Matisse's point of departure was the painterly practice of the old masters, who investigated the world around them without opposing themselves to it. But Matisse could not hold to this position for any length of time. The visible

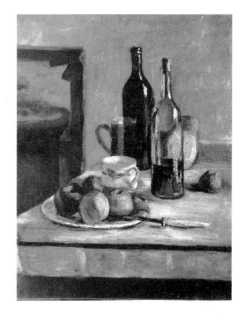

NATURE MORTE AUX DEUX BOUTEILLES, 1896
(STILL LIFE WITH TWO BOTTLES)
PRIVATE COLLECTION

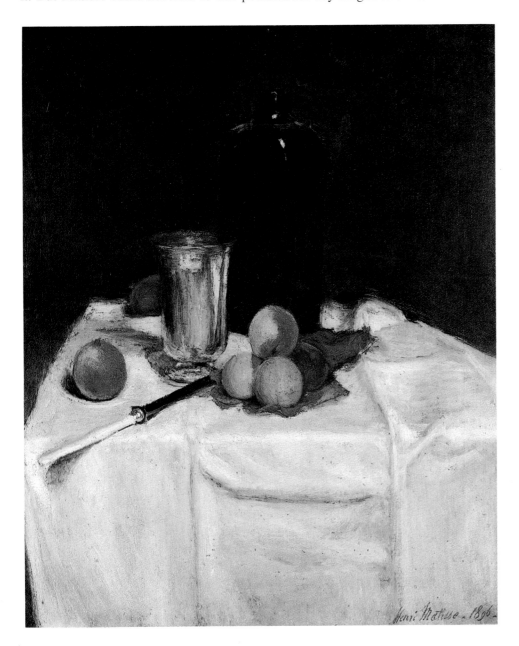

LA BOUTEILLE DE SCHIEDAM, 1896
(STILL LIFE WITH GIN BOTTLE)
OIL ON CANVAS, 73 x 60 CM.
STATE PUSHKIN MUSEUM OF FINE ARTS, MOSCOW
ACQUIRED BY IVAN MOROZOV IN 1911 FROM
BERNHEIM-JEUNE.

59

world had been investigated thoroughly enough, and neither perspective nor chiaroscuro offered the prospect of any important new discoveries. In addition, the objective aspects of reality could be studied more cheaply—and dependably—by photography. By the close of the nineteenth century, the simple fact that photography had been perfected to such a high degree was sufficient to compel the visual artist to turn his attention elsewhere, toward those aspects of reality that, eluding mechanical reproduction, reflect personal and individual concerns. Matisse must have realized this during his days at the Ecole des Beaux-Arts, at some point before *The Gin Bottle* was painted. But what really happened during the six years that separate this painting from the *Still Life with Books*?

In October 1891 Matisse returned to Paris, where he had previously (1887-1888) been a student in the faculty of law. But this time it was something other than jurisprudence that drew him there. At long last he had convinced his father, who disapproved of his artistic inclinations, to allow him to study art. He presented himself to none other than the renowned Bouguereau, but there was no basis for mutual understanding between the young provincial and the great artistic luminary of the French capital who was so accustomed to adulation. For Matisse, as for Cézanne before him, Bouguereau became the living embodiment of the official salons. The maestro's mechanical and self-enamored method of obliging the beginner to repeat the same subject over and over again failed to arouse his enthusiasm. Bouguereau, for his part, failed to detect any artistic gift in Matisse. Escholier, reporting Matisse's own comments, informs us that Bouguereau, not finding the cold perfection he required in his pupil's drawing of a plaster cast, exclaimed in exasperation that Matisse would never learn to draw.[4]

In the final years of the nineteenth century, Bouguereau and Ferrier at the Académie Julien, where Matisse began his studies, and, somewhat later, Bonnat and Gérôme at the Ecole des Beaux-Arts, which Matisse visited on a regular basis (despite having failed the entrance examination), were officially recognized as stars of the first magnitude in the firmament of French art. In fact, they were only capable of destroying the very desire to study art in anyone who was seeking his own way. It is difficult to say what would have become of Matisse if he had not met Gustave Moreau.[5]

Very few of Matisse's works from the early 1890s have been preserved, yet one can see very clearly just how much he matured during this period. The time spent in Moreau's studio was immensely important for various reasons: it was first of all a meeting ground for a group of individuals who were to have a profound influence on the course of European painting—Rouault, Marquet, Manguin, Camoin, Piot, Desvallières, Bonhomme, Evenpoel. In addition, the atmosphere was one of genuine respect for each artist's individual creative impulse, with Moreau himself setting the tone. He was three times Matisse's age when they first met, but he had been a professor for less than a year: in effect, the novice painter fell into the hands of a novice teacher.

It seems almost paradoxical that Gustave Moreau's studio should have become a seedbed for young talents, but in fact Moreau was endowed with two distinct artistic personalities: in his first persona he painted works for the salon in a style that was distinctly mannered but nonetheless demonstrated a magnificent grasp of the old masters and a serious artistic intent; in his second persona, he was a stubborn and unrelenting researcher, almost an alchemist, whose experiments, particularly his free sketches, semi-abstract watercolors, and picturesque sculptures, constitute a separate, subterranean stratum in his work. This second Moreau was well ahead of his time. Almost alone among his peers in seeing rigid inflexibility as art's worst enemy, the acknowledged master had his answer for the zealous academic proponents of "good form": far from being finished, he said, painting was only just beginning. He told his students that they could compare themselves with him when they began to repudiate him, and it was through this process of repudiation that the best of Moreau's students advanced to maturity.[6]

4. Raymond Escholier, *Henri Matisse* (Paris, 1937), p. 30.

5. This meeting most probably took place in 1892.

6. Marcel Brion, *Georges Rouault* (Paris, 1953).

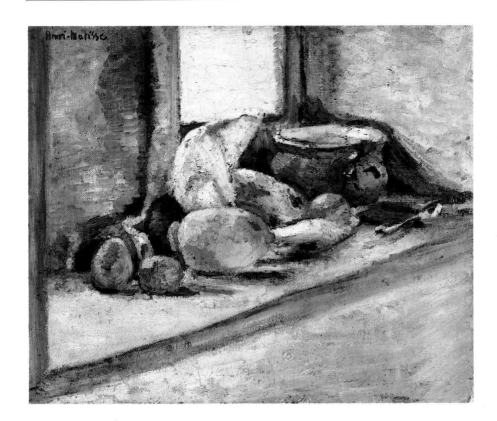

POT BLEU ET CITRON, 1897
(BLUE POT AND LEMON)
OIL ON CANVAS, 39 x 46.5 CM.
THE STATE HERMITAGE MUSEUM, ST. PETERSBURG
ACQUIRED BY IVAN MOROZOV IN 1908 FROM DRUET

While Bouguereau detected more of "life" in his stubborn student's work than the arbitrary canons of the salon could countenance, Moreau found Matisse's life drawings genuinely interesting, although he used to say that, for the artist, drawing from life is merely a pretext for self-expression. [7] Moreau never told Matisse or his other pupils what they must draw, but life drawing was always supplemented by trips to the Louvre. Paul Baignières, one of Matisse's studio companions, tells us that during the summer the entire class spent from noon till evening copying in the Louvre. Moreau, he indicates, was incomparable in his manner of explaining the great works of the past. Without contact with the old masters, Moreau insisted, the artist was in danger of falling into the slavish imitation of nature, and likewise, without a living knowledge of the objects of the real world, he was condemned to fruitless repetition.

Such truths are now regarded as axiomatic, but they were not easily accepted in the late nineteenth century, and Matisse and Rouault had good reason to emphasize the point in their reminiscences of Moreau. "By acting in this way," Matisse later wrote of the trips to the Louvre, "he was able to direct us away from the dominant trends at the Beaux-Arts, where their attention was fixed exclusively on the salon. To direct us to the museum at a time when official art, faithful to imitations of the worst possible kind, and avant-garde art, under the sway of plein-air painting, seemed to have joined forces to divert us from this, was almost revolutionary on his part." [8]

"What a charming teacher he was!" Matisse reminisced. "At least he was capable of enthusiasm, and even passion. One fine day he would declare his admiration for Raphael, and the next, for Veronese. One morning he came in and declared that there was no greater master than Chardin. Moreau knew how to appreciate art, and he knew how to present the really great artists to us, whereas Bouguereau exhorted us to admire Giulio Romano." [9]

Matisse certainly applied himself to Raphael, but he was attracted most of all to Chardin and copied all five of his works in the Louvre. In fact, the very first picture that Matisse copied was Chardin's *The Pipe*, followed by "reproductions" of *The Skate* and *Pyramid of Fruit*. These works involuntarily come to mind when viewing still lifes such as *The Gin Bottle*: the choice of the goblet, for instance, was clearly "prompted" by Chardin, who depicted one exactly the same in another

7. Jean-Paul Crespelle, *Les Fauves* (Neuchâtel, 1962), p. 43.

8. Gaston Diehl, *Henri Matisse* (Paris, 1954), p. 11.

9. Jacques Guenne, *Portraits d'artistes* (Paris, 1927), p. 214.

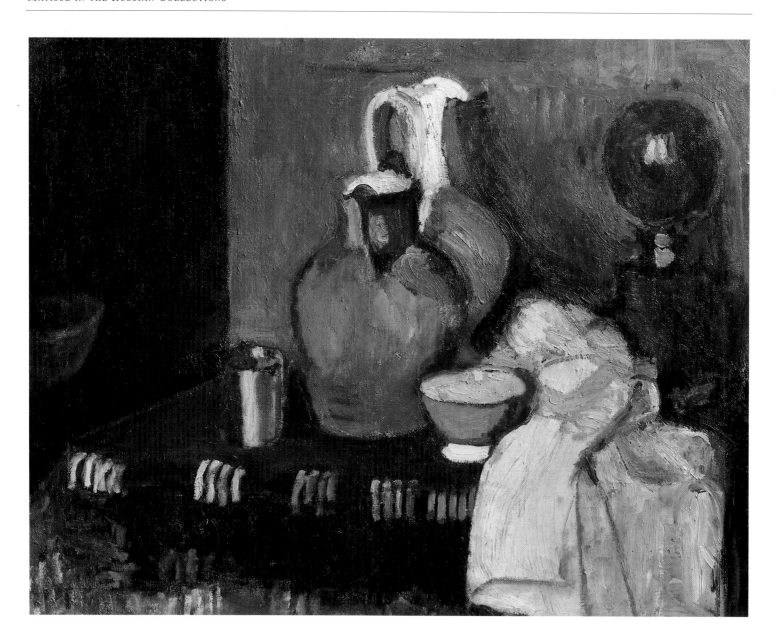

NATURE MORTE À LA CRUCHE BLEUE, C. 1900
(STILL LIFE WITH BLUE POT)
OIL ON CANVAS, 66 x 74 CM.
STATE PUSHKIN MUSEUM OF FINE ARTS, MOSCOW
ACQUIRED BY IVAN MOROZOV IN 1909 FROM VOLLARD

Louvre painting, *The Silver Wine Glass*, and Chardin's still life repertoire also included black bottles. Most important of all, however, was the example of balance and measure that he offered. Matisse's study of Chardin developed his predilection for pyramidal compositions, in order to induce the viewer to contemplate the painting at length. And it was from Chardin that Matisse learned certain means of defining the picture space, such as, in *The Gin Bottle*, setting a knife on the very edge of a table, so that the handle protrudes noticeably from the picture plane. Chardin attempted to expand the set spatial formulae of the still life, not by means of additional depth (the space is usually cut short by a wall) but by means of an apparent shift forward, toward the viewer.

Though he soon abandoned Chardin's delicacy, Matisse would long remember his way of structuring a still life. The *Nature morte à la cruche bleue* (Still Life with a Blue Jug), for instance, may be regarded as a more or less free quotation of the right-hand section of *The Skate*.

Copying was preceded by a detailed study of the old masters' canvases. Matisse recalled that at the Louvre, Moreau's students attempted every possible means to penetrate to the very essence of a picture. They had to feel the grain of the canvas, study the way the paint was applied, the means used to differentiate the objects, the highlights, the transitions from light to shade, even resorting to the use of a magnifying glass if need be.[10] The purpose of the exercise was not to produce a

10. Pierre Courthion, *Georges Rouault* (New York, 1961), p. 412.

copy as nearly as possible identical to the original, but to gain an understanding of the fundamentals of the picture in question. Not one of Matisse's nineteen copies is a facsimile reproduction; they are always more free and less "finished" than the originals, even when they were intended for sale.

One of the most important studies Matisse made in the Louvre was his copy of de Heem's *Still Life*. Matisse himself acknowledged just how much he learned from studying de Heem's gradations of silver and grey, and this particular tonal range dominated his work for a long time, as we can see not only from *The Gin Bottle*, but also from the impressionistic *Pot bleu et citron* (Blue Pot and Lemon).

Nonetheless, his general direction of development was to shift, in Matisse's own words, from the Dutch masters to Chardin who provided rich food for thought concerning both composition and color. As he later wrote in "Notes of a Painter," "I like Chardin's way of expressing it: 'I apply color until there is a resemblance.'"[11]

At the same time, we can detect the first signs of Matisse's interest in the masters of the modern period: The Bottle of Gin brings to mind Manet as well as de Heem and Chardin. It is hard to tell whether he had seen Manet's *Breakfast in the Studio* (1868), and his *Still Life with Lemon and Peaches* (1866), but Matisse's very choice of objects and the way he incorporates them into the composition ally him closely to his predecessor. Perhaps Matisse had seen other works by Manet, such as *Fruit* (1864), with its small pile of peaches and a knife on a white tablecloth. Such combinations of detail were typical of others as well: a black bottle and a knife, for example, were important elements of *Still Life with Ham* (c. 1870), by Philippe Rousseau, a fashionable painter of this genre during the Second Empire. It is more probable, however, that Matisse's point of reference was Manet, who was already one of his favorite painters. He was impressed (as we can infer from *The Gin Bottle*) by Manet's bold brushwork, his tendency to simplification of form, and his accentuation of color.

The year of *The Gin Bottle*, 1896, in effect marks the first significant landmark in Matisse's career as a painter. He remained in Gustave Moreau's class, but the initial period of apprenticeship was over. For the first time he exhibited his works—not without success—in the salon of the Association Nationale des Beaux-Arts. He became a member of the association, thereby acquiring the right to exhibit his works without submitting them to the jury. Matisse's manner became more assured, and his scope expanded correspondingly. As before, the still life remained his preferred genre, but in addition to composing pure still lifes, he also produced more heterogeneous works: *Intérieur au chapeau haut-de-forme* (Interior with a Top Hat, 1896) is, as the title suggests, a still life in an interior. Somewhat earlier, Matisse had attempted a rather more difficult combination by introducing a human figure into an interior for *La Liseuse* (Woman Reading, 1895). This tendency was continued by *La Serveuse bretonne* (The Breton Serving Girl, 1896), the first step along the road that would eventually lead the artist to *La Desserte rouge* (The Red Room). In 1896 Matisse also produced several bold landscapes clearly demonstrating a familiarity with the principles of impressionism.

We know only too well how desperately "seditious" professors of the time thought impressionism to be. In the spring of 1897 an exhibition at the Luxembourg Museum, made up of paintings from the Caillebotte collection—including several masterpieces of impressionist painting—was the occasion for lively dispute. Gérôme, Moreau's colleague at the Beaux-Arts, attacked the pictures with greater fury than anyone else. Moreau, on the other hand, knew something about impressionism: his friend Degas called him a hermit who still knew the train schedule. For himself, Moreau accepted neither impressionism nor its subsequent developments in postimpressionism, for he believed that art was an expression of personal fantasies, dreams, fears, and longings. He would never have painted like Toulouse-Lautrec, but he could enthuse rapturously over Lautrec's posters and exhort his students to look at them. Thus it was Moreau who proved

11. Henri Matisse, "Notes d'un peintre", *La Grande Revue* 52/24 (25 December 1908), pp. 731-745, translated as "Notes of a Painter" in Jack D. Flam, ed., *Matisse on Art* (London, 1973), p. 39.

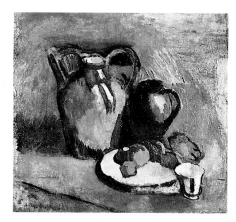

NATURE MORTE AU PICHET BLEU, 1900
(STILL LIFE WITH A BLUE PITCHER)
PRIVATE COLLECTION

FRUITS ET CAFETIÈRE, 1898
(FRUIT AND COFFEEPOT)
OIL ON CANVAS, 38.5 x 48,7 CM.
THE STATE HERMITAGE MUSEUM, ST. PETERSBURG
ACQUIRED BY IVAN MOROZOV IN 1910 FROM DRUET

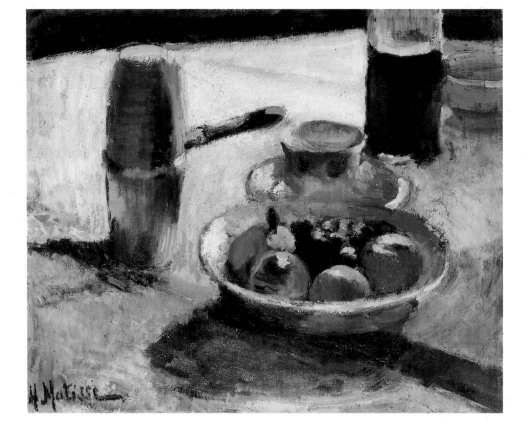

12. Alfred H. Barr Jr., *Matisse: His Art and His Public* (New York, 1951), p. 35.

13. Henri Evenepoel, *Lettres à son père* (Paris, 1923), p. 14.

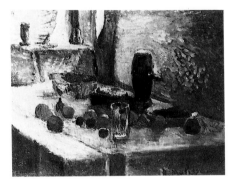

PREMIÈRE NATURE MORTE AUX ORANGES, 1899
(FIRST STILL LIFE WITH ORANGES)
OIL ON CANVAS, 56 x 73 CM.
MUSÉE NATIONAL D'ART MODERNE, PARIS

14. Henri Matisse, "Notes d'un peintre sur son dessin" (A painter's notes on his drawing), *Le Point* 21 (July 1939).

the most passionate defender of Matisse's *La Desserte* (Dinner Table, 1897)—a work infinitely far removed from Moreau's own imaginative approach—in which the theme of *The Breton Servant Girl* is developed further in the spirit of impressionism. Matisse's teacher was filled with admiration for the way in which his pupil conveyed spatial depth; he said the carafes were painted so convincingly that you could hang your hat on the glass stoppers.[12] Although the impressionist obsession with light was alien to Moreau, there was still one element that reconciled him to the new style his pupil had mastered: color.

Indeed, Moreau exhorted his pupils to think constantly about color and keep a special place for it in their imagination.[13] His own understanding of color was romantic rather than impressionist, but his subtle color sense nonetheless obliged him to acknowledge impressionism's achievements in this area. In contrast to the other professors at the Beaux-Arts, he did not regard color as secondary, but as the most valuable element of art. Moreau knew the magic power of color, and he had sought out the means to penetrate this enchanted kingdom. Having broken with the academic tradition incarnated at the Beaux-Arts by Ingres and the classic painters, he was no advocate of the absolute domination of drawing.

Moreau, in fact, frequently gave his pupils exercises not with drawing but with color. In order to preserve the freshness of color, he even encouraged them to paint without any preliminary drawing. He got them to paint quickly—very quickly—a technique comparable with the impressionists "cursive" approach, and he taught them not to destroy a work's vitality with endless corrections. Many years later, Matisse was merely repeating Moreau's precepts when he wrote: "The page is written: no corrections are possible. And if it is a failure, one must start afresh, just as in acrobatics."[14]

In the context of the late nineteenth century, the desire for pure, living color could only lead to a break with the academic routine. Thus, color became the rallying point of painters seeking to escape from official art, while those artists who set the tone at the salons and presented themselves as guardians of tradition waged unrelenting war on color and those who championed it. In an educational institution supported by the state and entangled in the obsolete academic

conceptions of the salons, it seemed quite unthinkable to combine tradition with experiment in the area of color, but this is precisely what Gustave Moreau did.

If we compare three still lifes of the 1897-1900 period—*Blue Pot and Lemon*, *Fruit and Coffeepot*, and *The Blue Jug*—we can see how much Moreau's support and the discovery of impressionism assisted Matisse in acquiring his mastery of color. While in the first of these canvases, color is still subordinate to light, it assumes equal importance in the second and ultimately comes to dominate in the third.

Blue Pot and Lemon is in effect the study where Matisse finally trained his eye before beginning work on *Dinner Table* and what a startling contrast it provides with his earlier works! Light is no longer used to determine the form of the objects and lend them three-dimensional solidity; rather the objects themselves become a pretext for the affirmation of light, allowing us to join the artist in admiring its play across form. There is no underdrawing. The brushwork conveys an impetuous energy, with the brushstrokes conforming less to the shape of the object than to a unified rhythm derived from the artist's attempt to capture the very flow of the light.

In *Nature morte, fruits et cafetière* (Still Life with Fruit and Coffeepot), Matisse is still obsessed with the problem of reproducing light, but his approach has changed. In pursuit of a saturated luminosity, he makes more decisive use of contrasts, following the play of highlights and reflections, and the penetration of light into shadow. This marks a distinct step forward, insofar as color no longer plays a subordinate role. The colored reflections on the tablecloth are the key to the whole painting: they serve to unite the various objects. *Fruit and Coffeepot* is closely related to two still lifes painted in Toulouse in early 1899, *Première nature morte aux oranges* (First Still Life with Oranges) and *Nature morte à contre-jour* (Still Life Against the Light), which show the same coffeepot and tablecloth. *Fruit and Coffeepot*, which appears to be a transitional work, was probably painted before the other two, toward the end of 1898, when Matisse was still occupied with the choice between light and color. In the Toulouse works, the choice has been made, in favor of color. The same applies to *Nature morte à la cruche bleue*

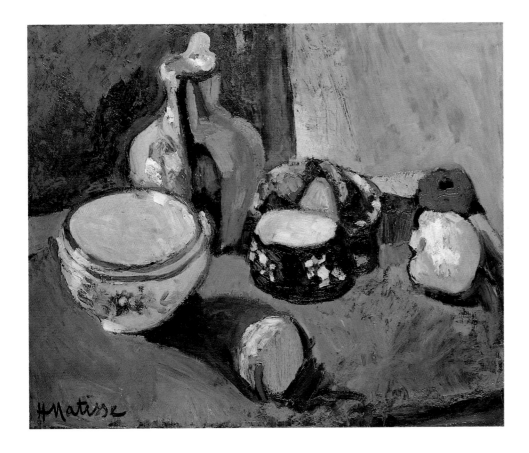

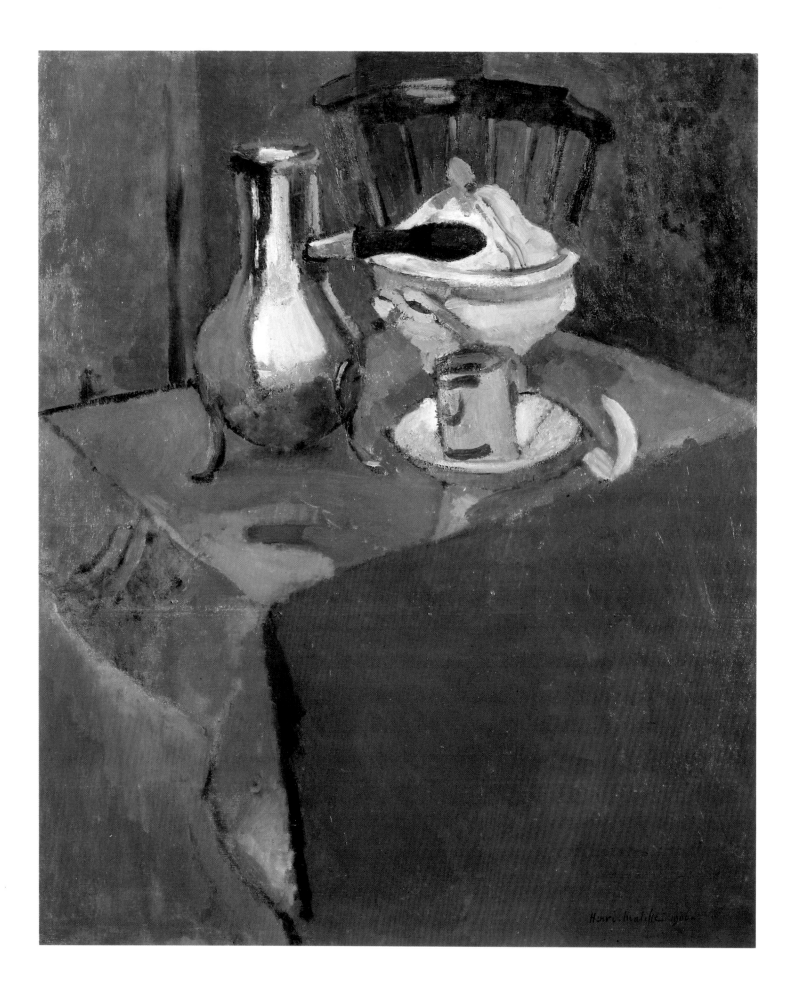

(Still Life with a Blue Jug) and the more significant *Nature morte, vaisselle à table* (Dishes on a Table), in both of which, although there are still highlights, reflections, and shadows, color is unconditionally dominant.

The evolution of Matisse's early work can easily be followed through the developing treatment of one and the same object, for instance, the lemon. In the 1897 painting, the lemon is simply one shiny surface among others; the effect of the painting is somewhat washed out, and the color of the fruit itself lacks intensity. Nine years later, in *Plats et fruits sur tapis rouge et noir* (Dishes and Fruit on a Red and Black Carpet), the details that could convey an impression of the lemon's three-dimensional form are simply omitted. What remains is a flat spot of color, and in order to maximize the color's impact and intensity, the yellow lemon bursts forth from a black ground, which itself acquires added depth from this intimate interaction. Harmony has come to presuppose the symbiosis of colors.

Several decades later Matisse wrote to Courthion: "What do I get out of copying this lemon—why does it interest me? Is it a very beautiful lemon? The most beautiful of lemons? Why give myself so much trouble to more or less eternalize it on a canvas when I could always renew my admiration before the actual fruit, which, when I get tired of contemplating it, can also make an excellent drink? What interested me was the relationship that my contemplation created between the objects: the yellow of the lemon rind on the shiny black marble of the mantelpiece. And I had to invent something that would render the equivalent of my sensation—a kind of communion of feeling between the objects placed in front of me."[15]

What matters, in other words, is not the object itself but only its capacity for expressing sensations, and this can only come about by ignoring certain concrete features. "What possible interest could there be in copying an object which nature provides in unlimited quantities, and which one can always conceive more beautiful. What is significant is the relation of the object to the artist, to his personality, and his power to arrange his sensations and emotions."[16]

This aesthetic position was formed in Gustave Moreau's class. There was a great deal in the older man's views that Matisse was to pick up and develop further. In composing a painting, Moreau was guided by the principles of an artist who lived entirely for his art, constantly discovering in it the inspiration for renewed creative effort. One of his most important aesthetic principles was what he called "beautiful inertia." Once he took a subject to his heart, Moreau was capable of producing variation after variation without wearying of it, delighting in the succession of different aspects of the same theme: Salome begins her dance in Herod's palace in one painting, and she concludes it in another. The principle of "beautiful inertia" was closely related to the principle of "reproduction": Moreau's obsession with his own previous works drove him to reproduce parts of them in his new canvases and watercolors.

Matisse, much closer to nature than Moreau, could not accept accept these principles unconditionally. Most of Matisse's works are based on the direct experience of the natural world, whereas his teacher's impulse to create was normally stimulated by a work of literature or another work of art, most frequently one of his own paintings. The most important thing in Moreau's works was not the subject, but the expression of personal feeling by means of arabesques and the careful play of patches of color. Matisse's goal was essentially the same, but whereas Moreau guarded the sublimity of his inner world against the encroachment of nature, Matisse was unafraid of the external world, and he elevated it to the level of poetry. Insofar as the pupil, like the teacher, also laid the greatest emphasis on personal feeling—though for other reasons—he resembles his mentor in turning repeatedly to the same themes. He does not seek new subjects for every picture; like Moreau, Matisse is content to weave his arabesques indefinitely around a single motif. This love of ornamentation is already noticeable in early works such as *Fruit and Coffeepot* or *Dishes on a Table*.

NATURE MORTE À LA CAFETIÈRE
ET LA SOUPIÈRE, 1899
(STILL LIFE WITH COFFEEPOT
AND SOUP TUREEN)
PEN, BRUSH, AND INK
PRIVATE COLLECTION

15. Jack Flam, *Matisse. The Man and His Art, 1869-1918* (London, 1986), pp. 40-41.

16. Henri Matisse, "On Modernism and Tradition," *The Studio* 9/50 (May 1935), p. 238.

VAISSELLE À TABLE, 1900.
(DISHES ON A TABLE)
OIL ON CANVAS, 97 x 82 CM.
THE STATE HERMITAGE MUSEUM, ST. PETERSBURG
ACQUIRED BY SERGEI SHCHUKIN IN 1906 FROM
THE ARTIST

17. Ari Renan, *Gustave Moreau* (Paris, 1900), p. 43.

Another fundamental principle of Moreau's art was "indispensable luxury," which required that the ornamental effect should not be transformed into a geometrical abstraction if it was to retain its sensual attraction. Moreau appealed to the authority of the old masters when he exhorted his pupils "not to make meager art." He used to say that the old masters always put into their pictures everything they felt was most magnificent and precious—the richest, brightest, rarest, indeed, the strangest things that they knew.[17] Even a swift glance at Matisse's paintings demonstrates that he too was by no means indifferent to the rare and the precious, with the result that the major "roles" in his paintings are frequently played by decorative fabrics and splendid ceramics.

Matisse, of course, did not crowd his canvases with precious objects; they are in no way comparable with Moreau's displays of sparkling gems. While Moreau was wary of everyday objects, Matisse learned to perceive their precious qualities. He found his teacher's aristocratic, artificially nurtured world too cramped. For Matisse, every object was potentially precious, and he revealed this potential by penetrating to the objects' inner artistic significance. The precious objects in his paintings are the simple coffeepot that appears in one canvas after another, or the simple cup in *Fruit and Coffeepot*, and later the balustrade in *La Conversation* (The Conversation) or the checkerboard in *La Famille du peintre* (The Painter's Family). He delights in the dialogue of form between the pot-bellied coffeepot and the massive porcelain tureen in *Dishes on a Table*.

Above all, Matisse transforms color into a precious object. This is why associations with gemstones come to mind so readily—sapphires when we look at *Vase d'iris* (Vase of Irises), and chalcedony when we see the greenness of the water in *Les Poissons rouges* (Goldfish), and this is why the fruits in *Fruit and Coffeepot* seem to sparkle like jewels. In Matisse's art, the principle of indispensable luxury takes on universal significance.

The three years that separate *Blue Pot and Lemon* from *The Blue Jug* and *Dishes on a Table* were devoted to an unrelenting struggle for the mastery of color, a struggle that would have been quite unthinkable without the achievements of the impressionists and their immediate successors. In 1897 Matisse met the patriarch of impressionism, Camille Pissarro, who gave him important advice on a series of questions. The next year he went to London to study Turner's work. Matisse's new interests can be gauged from his acquisition of Cézanne's *The Bathers* (c. 1879-1882), Gauguin's *Head of a Boy*, and a drawing by Van Gogh.

Matisse found himself more and more attracted to Cézanne. However, when the master of Aix came to Paris, their paths did not cross. Possibly it was Pissarro who first drew Matisse's attention to Cézanne. Many years later Matisse recalled a conversation with Pissarro: "'Cézanne is not an impressionist,' said Pissarro, and in answer to my question, 'Then what is an impressionist?' he said: 'An impressionist is someone who paints with grays. Above all, all his life he has painted the same painting. He does not create sunlight. He only creates gray weather. He has always sought the same thing.'"[18]

18. Flam, *Matisse. The Man and His Art*, p. 51.

The *Blue Jug* and *Dishes on a Table* summon up associations with Cezanne's still lifes, such as *Green Pot and Tin Jug* (c. 1870). This painting was in Ambroise Vollard's gallery when Matisse began going there. Sergei Shchukin bought it from Vollard and sold it again soon afterward (in the 1890s he had not yet learned to appreciate Cézanne), and in 1900, the year that Matisse painted *Dishes on a Table*, it was auctioned at Drouot's. Several years later, the Matisse that Shchukin acquired was precisely *Dishes on a Table*, a work that clearly expresses respect for Cézanne without in any sense imitating him, for the use of color and the generalized treatment of broad areas are already distinctively Matisse's, and the work is executed with the confidence of a true master.

Matisse recalled that in selecting this particular still life, Shchukin told him he would need to get used to the painting. Reserving a work for a few days was then a quite common condition of purchase. "I was lucky enough that he was able to bear

this first ordeal easily, and that my still life didn't fatigue him too much," observed Matisse.[19] Indeed, Shchukin selected a picture that is not tiresome, either in its subject (virtually an invitation to dine) or, more important, in its style, which has led the artist to omit all fine detail. The painting is already pure Matisse.

This art, however, was the outcome of considerable effort in order to come to terms with the new values that had fundamentally moulded the art of the great postimpressionist painters. Matisse's paintings of 1898-1900 clearly reflect the coexistence of two different tendencies: a taste for calm and contemplation, which was evident from the very beginning (*viz.* his preference for the still life), coupled with an emotional discomfort, expressed in the deliberate use of bright color, sharply differentiated brush strokes, and sketchy treatment of form. This turmoil, which Matisse later learned to curb, was an expression of youthful impatience. The recent student of the Ecole des Beaux-Arts would not have dared to paint in such an uninhibited fashion without the examples of Van Gogh and Gauguin.

During the summer of 1897, Matisse received a Van Gogh drawing from John Russell, apparently as a gift, and two years later he bought the second one.[20] In 1898, when he traveled to Corsica for several months, Matisse was clearly under the influence of Van Gogh. Modern scholars have repeatedly emphasized that this trip held almost the same significance for Matisse as the journey to Arles did for Van Gogh. It is possible that the very idea of working in the south was prompted

19. "Matisse Speaks," *Art News Annual* 21 (1952), reprinted in Flam, *Matisse. The Man and His Art*, p. 133.

20. Flam, *Matisse. The Man and His Art*, pp. 485-486.

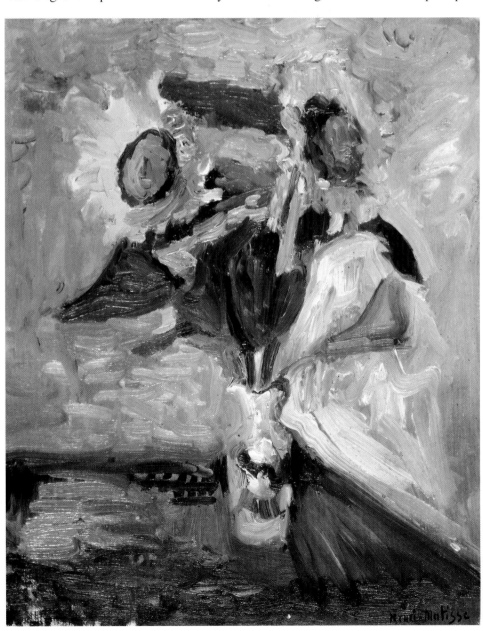

TOURNESOLS DANS UN VASE, 1898
(SUNFLOWERS IN A VASE)
OIL ON CANVAS, 46 x 38 CM.
THE STATE HERMITAGE MUSEUM, ST. PETERSBURG
PRIOR TO 1918 IN THE ZETLIN COLLECTION, MOSCOW

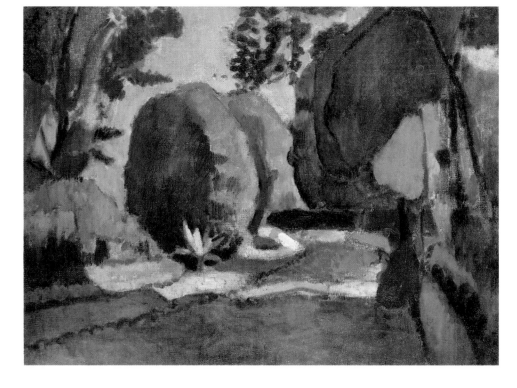

21. For the influence of Van Gogh on Matisse, see Isabelle Monod-Fontaine's article in the exhibition catalogue *Vincent Van Gogh and the Modern Movement*, Museum Folkwang, Essen; Van Gogh Museum, Amsterdam (1990), pp. 296-302.

22. This work, painted in 1898, was presented to the State Museum of Fine Arts in 1970 by the artist's secretary, L. N. Delektorskaya.

by the Dutch painter's example. Just like Van Gogh in Arles a decade earlier, Matisse's paintings in Corsica reflected the reaction of a northern artist to southern light and color.[21]

Paysage corse. Les Oliviers (Corsican Landscape. Olive Trees)[22] is reminiscent of Van Gogh both in its energetic brushwork and brilliant colors and in the choice of subject. Matisse followed in his predecessor's footsteps, but in his pursuit of color in Corsica he paid little attention to drawing, and his paintings often give the impression of sketches.

No less sketchy and even more expressive is another Corsican canvas of the same size, *Tournesols dans un vase* (Sunflowers in a Vase). In his desire to capture the intensity of the colors, Matisse resorted to veritable speed-painting and apparently did not test all the color combinations, with the result that the paint has darkened over time.

The motif of sunflowers has come to be associated with Van Gogh, although Claude Monet had treated it successfully even earlier. It is difficult to tell whether Matisse had seen Monet's painting, but there is no doubt that he was acquainted with some of Van Gogh's variations on this theme. For Van Gogh, the sunflower was the incarnation of the sun, and a remnant of this idea lingers on in Matisse's work. In *Coucher de soleil en Corse* (Sunset in Corsica, 1898), for example, he painted the sun almost like the head of a sunflower. Nonetheless, there are significant differences between the two artists. Matisse employed symbols far less frequently, and those symbolic meanings that are present in his work remain much more in the background. The comparable still lifes by Van Gogh are deliberately decorative, and he himself used to speak of his sunflowers as "decorations for a madhouse." That Matisse's aims were different can be seen even from the fact that he chose a more modest format. His *Sunflowers in a Vase* is a variation on Van Gogh's theme, but he is primarily seeking to resolve pictorial problems.

A period of about three years separates this work from *Dishes and Fruit*, another painting that is reminiscent of Van Gogh in its dynamism and brightness. But here we are dealing with art that is more complex and mature, with a canvas painted by an artist who has studied the works of Gauguin, Bernard, and Cézanne but has retained his own independence. In its own way, *Dishes and Fruit* is a quintessential postimpressionist painting of the final stage, when many of the major figures were still alive. Gauguin's influence was on the increase—young artists who had settled in Paris told stories about this Frenchman lost somewhere in the South Seas.

Matisse himself later emphasized that "the influence of Gauguin was more immediate than the influence of Van Gogh."[23] Flam has called *Dishes and Fruit* a reminiscence of Gauguin, but that would be a rather one-sided definition: Matisse followed Gauguin and Bernard in his use of formal simplification and flat surfaces, but he endowed these effects with a dynamism more typical of Van Gogh and Cézanne.[24] Matisse was impressed by the impasto effects of Van Gogh and Cézanne, a feature quite alien to Gauguin and Bernard. At this stage, he already owned the Cézanne *Bathers* that was to become his talisman and which was painted with an emphatic relief technique.

Cézanne provided Matisse with the key to compositional clarity. Later, in his "Notes of a Painter," Matisse wrote of Cezanne's paintings that "all is so well arranged that no matter at what distance you stand or how many figures are represented you will always be able to distinguish each figure clearly and to know which limb belongs to which body. If there is order and clarity in the picture, it means that from the outset this same order and clarity existed in the mind of the painter, or that the artist was conscious of their necessity."[25]

The sequence of still lifes from 1897-1901 clearly demonstrates the search for a style that would allow the most effective expression of personal feeling. This search was to lead Matisse from the impressionists to Van Gogh, Gauguin, and Cézanne, who provided more distinct and promising reference points. The objects in his paintings, only recently so peaceful, now become disturbing; they are defined with large strokes of pure color, glittering provocatively in response to the pressure of powerful feelings. Matisse quickly understood that the stronger the emotion, the more urgent the need to control its flow with the "dam" of reason. He was also convinced that the finest intermediary in communicating the artist's emotions to other people was the outside world in all its forms.

In a painting of 1901, the trees of the Luxembourg Garden are nothing more than simplified patches, silhouettes of color. The colors are more intense than in nature, but Matisse's impulse to intensify them derived from his impressions of nature, and his trees convey a particular sense of early spring, with that unmistakable coolness in the shadows, that startling combination of flaming crimson with yellow glades and greenery that is still moist.

23. Henri Matisse, "De la couleur" (On color), *Verve* 4/13 (November 1945).

24. Flam, *Matisse. The Man and His Art*, p. 103.

25. Matisse, "Notes of a Painter," p. 38.

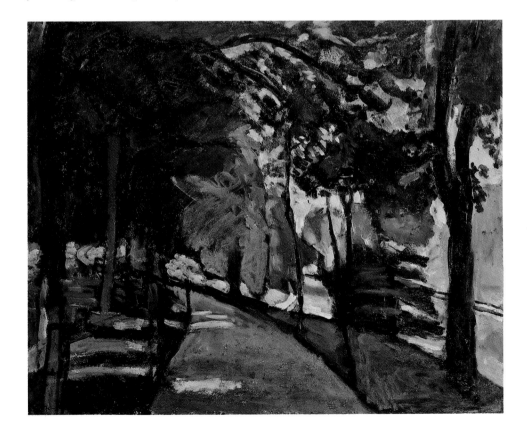

LE BOIS DE BOULOGNE, 1902
OIL ON CANVAS, 63 x 80 CM.
STATE PUSHKIN MUSEUM OF FINE ARTS, MOSCOW
ACQUIRED BY SERGEI SHCHUKIN IN 1904 (?) FROM
DRUET

Le Jardin du Luxembourg and other Parisian landscapes of 1901-1902 were the first paintings linking Matisse to Gauguin. Matisse's sensibility is visible even in his choice of a very coarse-grained canvas, reminiscent of the jute sacking preferred by Gauguin. The example of Gauguin has encouraged Matisse to exclude fine detail, and also to produce a calmer picture surface. The excitation of Corsica has been overcome. The entire composition now consists of several large, active zones of color. Although Matisse did not have the colors of the tropics for inspiration, his canvases are brighter than Gauguin's. Matisse was later to say that Gauguin lacked the ability to construct space with color.

The tendencies common to their styles and the elements that separate them become quite clear from a comparison of *Le Jardin du Luxembourg* with Gauguin's *Fatata te Moua* (At the Foot of the Mountain, 1892), a painting that Matisse quite probably knew. Each of these works employs decorative effect and generalization of form in order to emphasize the impact of color, but since the reproduction of light remained highly important for Matisse, in his work the color carries the authority to define space, and the alternating planes of cool and warm tones lend the picture space added depth. Gauguin also employed the juxtaposition of complementaries, especially green and red, but he had to slip them into the composition, and hence he could write of his own *Tahitian Pastorales* (1892) that despite his use of pure Veronese green and raw vermilion, the picture had turned out to resemble an old Dutch painting or a faded tapestry.[26]

26. *Lettres de Paul Gauguin à Georges-Daniel de Monfreid* (Paris, 1950), letter IX.

2. TESTING THE METHOD: FAUVISM

The pursuit of color ended in the fauvist explosion that reverberated so loudly at the 1905 Salon d'Automne, but which had been heralded by a number of canvases that preceded it—the still life *Dishes and Fruit*, for instance, has quite justifiably been described as a proto-fauvist painting.[1]

Major changes in Matisse's art were presaged in the work he did in Collioure in the summer of 1905 and again in the spring and summer of 1906. This was the place and the time when color was liberated in all its intensity.

In the quest for the utmost saturation of color, Matisse inevitably had to take into account the experience of the neo-impressionists. This example prompted the separate spots of color and distinct brushstrokes of *Vue de Collioure* (View of Collioure), one of those canvases that laid the foundations of Matisse's color system and thus remain immensely important, not only in Matisse's development, but in the development of French painting as a whole. The separation of the brushstrokes is not as methodical as in the paintings of Signac and Cross, nor does it mark an attempt to create luminosity by means of optical interference. In the first place, the color separation is subordinate to representational goals: it renders the gleaming of the tiles in the sunlight, the sparkling of the waves on the sea, and also the way the walls of houses or mountains appear as flat patches of color. Moreover, the units this separation produces are so large that they cannot be accommodated by the neo-impressionist theory of light. They acquire an autonomy that is emphasized by the exclusion of shadows and defined volumes, as prompted in large part by the glittering reality of the Midi.

"The artist's means of expression," Matisse wrote three years later in his "Notes of a Painter," "must derive almost of necessity from his temperament. He must have the humility of mind to believe that he has painted only what he has seen. . . . Those who work in a preconceived style, deliberately turning their backs on nature, miss the truth. An artist must recognize, when he is reasoning, that his picture is an artifice; but when he is painting, he should feel that he has copied

1. cf. Antonina N. Izergina, in *Matiss. Jivopiss. Skulptura. Grafika. Pisma* (Matisse. Painting. Sculpture. Graphics. Letters) (Leningrad, 1969, p. 62).

VIEW OF COLLIOURE
PHOTOGRAPH
MATISSE ARCHIVES, PARIS

72

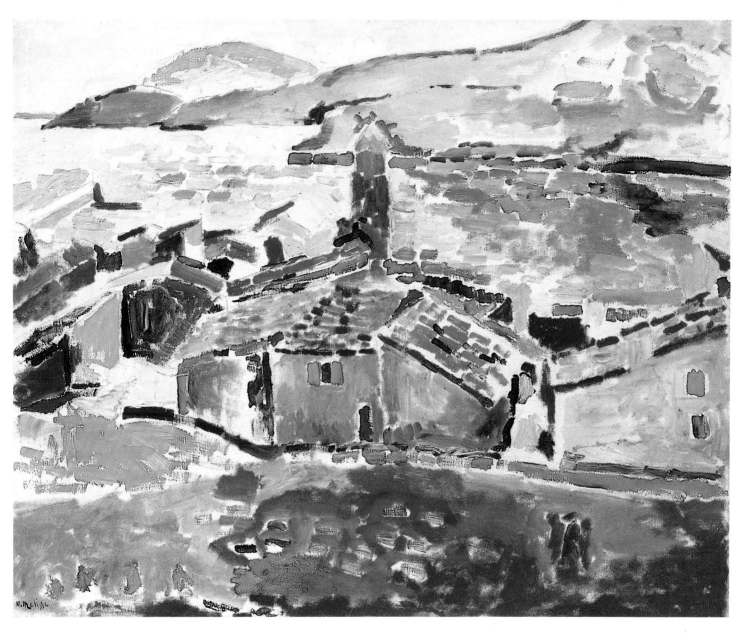

VUE DE COLLIOURE, 1905
(VIEW OF COLLIOURE)
OIL ON CANVAS, 59.5 x 75 CM.
THE STATE HERMITAGE MUSEUM, ST. PETERSBURG
ACQUIRED BY SERGEI SHCHUKIN IN 1908 FROM
BERNHEIM-JEUNE

nature. And even when he departs from nature, he must do it with the conviction that it is only to interpret her more fully."[2]

The bright colors and the way they were applied to the canvas were not merely for decorative effect; they served to express a simple, even naive feeling for nature. However, granting such total freedom to color did not solve all the problems of creating a picture: the colors had to be harmonized without reducing their impact. During the summer of 1905, Matisse found the key to this problem. "At that time in Collioure," he told Courthion many years later, "I started with an idea that had been expressed by Vuillard as the concept of the 'final brushstroke.'. . . This helped me a great deal because I had a feeling of how an object was colored: I applied this color, and it was the first color on my canvas. I added a second color, and then, since the second color did not harmonize with the first, instead of removing it, I added a third that reconciled them. Then I had to carry on in this way until I felt that I had created a completely harmonious canvas and exhausted the emotion that had forced me to begin it."[3]

The first two colors in *View of Collioure* were the red-orange of the roofs and the blue of the sea. The role of arbitrator between them was played by the green, strokes of which separate the orange and blue and weave their way into the zone of the sea. The other harmonizing color is the pink.

The Collioure landscapes of 1905 represent a great step forward for Matisse as

2. Matisse, "Notes of a Painter," p. 39.

3. Jean Guichard-Meili, *Matisse* (Paris, 1967), p. 48.

LE PORT DE COLLIOURE, 1905
(THE HARBOR AT COLLIOURE)
INK
PRIVATE COLLECTION

colorist, even in comparison with such radical canvases as *Dishes and Fruit*, where he discovered, in defining objects with unmixed colors, that these colors by no means always went well together. Thus he took care to separate the fruits and the cups in this still life, while unifying them within a surrounding area of pale purple calculated to allow the color patches of the objects to retain their full expressive intensity. However, the very principle of this harmonizing ground already muted somewhat the brightness of the colors.

In order to find color like this, as resonant as the note of a trumpet, resistent to any encroachment by chiaroscuro, Matisse would have had to look beyond the boundaries of modern Europe. The transformation of nature that he achieved through color and drawing brings to mind not the painters of the preceding century, or even the sixteenth to eighteenth centuries, so much as the masters of medieval Europe and the East. For Matisse, color was now such a great and magical power that he would not sacrifice it for all the obvious achievements of the Renaissance. Of course, in returning to a long-interrupted colorist tradition, Matisse had no idea of reestablishing the authority of medieval artistic principles, nor of imitating the style of the East. On the contrary, his art is steeped in impressions of the real world and obsessed by the passions of its time.

View of Collioure and the other spirited canvases of 1905–1907 embody the exultant and rebellious energy of the new century, its uncompromising confidence and hopes. What seemed to most of the public no more than an act of defiance designed to shock was in fact the genuinely sincere expression of a pure and youthful, if somewhat naive, lust for life. *View of Collioure* is a triumphant hymn to the sun-soaked Mediterranean, almost childishly ingenuous. Yet, at the same time, it could not have been created without a thorough grasp of the experience of those who, like Cézanne, Van Gogh, and Gauguin, had taken their start from impressionism and arrived at a new understanding of color, drawing, and composition, a new awareness of artistic form.

The connection with Cézanne, whom Matisse respected most of all, is perhaps the least obvious. The blazing colors of the Collioure landscape make it easy to forget the underlying drawing in the manner of Cézanne. But the impression of a spontaneous, slap-dash sketch created without any preparation is deceptive. The colors have indeed been applied rapidly to the canvas, but there was the prior stage of thinking with pencil in hand, when the place of each detail was determined in a subtle framework of contours that was later almost obliterated by an avalanche of colors. This was the way Matisse would continue to work on his paintings for years to come.

In following Van Gogh and Gauguin in the pursuit of the most dynamic possible color, Matisse made decisive use of contrasting tonal effects. There is hardly any need to demonstrate that he went beyond the others in the autonomy he granted to color. Less obvious, however, is the fact that his very boldest color experiments all sprang from his insights into nature, which were perhaps even more essential to him than to Gauguin or Van Gogh. Suffice it to consider the role of the brushstroke in *View of Collioure* and similar pictures. Gauguin's synthetism sacrificed the brushstroke in favor of broad, soothing zones of color. At the other extreme, Van Gogh's brushstroke was sinuous and forceful, above all the expression of an emotional impulse. In combining flat surfaces of color with individual brushstrokes, Matisse occupied, as it were, an intermediate position, but one that was in fact closer to Van Gogh, since at that time he indeed sought high-tension color effects.

With his constant use of individual brushstrokes in the Collioure paintings of 1905, Matisse might still seem to be basing himself on neo-impressionism, but it is no accident that these works irritated Signac, for he and Matisse used the brushstroke for entirely different ends. Signac's mosaiclike method of applying paint, intended to simulate the play of light, reduced each brushstroke to the same level. Matisse's brushstroke performed a more complex function than that of

Signac, or even Van Gogh: while expressing emotion, it still faithfully serves an entirely concrete representational function. Thus, for instance, brushstrokes separated by gaps of unpainted ground are intended to convey the impression of roof tiles glittering in the midday sun or the rippling waves of the sea.

The colors of *View of Collioure* are as intense and pure as the artist's feeling. These are not the real hues of the Mediterranean noon, for the scorching sun drains them of strength and they become faded out, but Matisse the color-worshiper could not allow this in his painting. He had not the slightest intention of producing an illusion of real lighting, which would reduce color to a secondary role. For Matisse, color in and of itself was capable of expressing anything and everything. Indeed, his colors magnificently convey the sultry southern heat, not literally, of course, but metaphorically: the heat is not exhausting (what poetry would there be in that?) but sumptuous.

When the canvases of 1905 were exhibited in the Salon d'Automne that year, it was precisely their extreme intensity of color that provoked one of the major shocks of early twentieth-century European art. The unaccustomed brilliance of the colors and their immense scope, the liberated brushstroke, and the totally uninhibited technique reduced the public to near stupefaction. Society readily seized upon the inspired term coined by the critic Louis Vauxcelles: the Fauves (wild beasts).

Fauvism did not appear out of nowhere. There are palpable signs of it in pre-1905 works by many artists who were to become members of the movement, including Vlaminck, Derain, and Puy. As for Matisse, who was quickly recognized by the critics as the leader of the movement, he and his friend Marquet were already showing signs of the new trend at the end of the 1890s.

In the eyes of a stunned Paris, fauvism seemed like a fully formed artistic movement, but it proved to be short-lived. Only two years after the uproar of 1905, it was already losing its adherents. The reason was in part the constantly accelerating development of art, but above all, the group's own insistence on the expression of individual feelings, which could only encourage the differences in the artists' temperaments and push them in different directions.

Fauvism brought together a group of brilliantly talented colorists and allowed their talents to unfold in a quite startling fashion. It is highly significant that painters such as Friesz, Puy, and Manguin painted their finest works during the fauvist period, when they were caught up in the furious pace of events: gripped by the most powerful enthusiasm they were ever to experience, they rejected outright

LE PÊCHEUR, 1905
(FISHERMAN)
PEN AND INK, 30.3 x 48.7 CM.
STATE PUSHKIN MUSEUM OF FINE ARTS, MOSCOW
GIFT FROM MATISSE TO SHCHUKIN IN 1906

all the old, arbitrary academic restrictions. The Fauves' discoveries, primarily in the area of color, would also prove decisive for the expressionist movement and for painters of other tendencies, not only in Europe, but around the globe. Fauvism simplified and redefined the act of creation itself. As one of the first art movements of the twentieth century, it played a key role in determining certain basic features of those that followed: a pronounced emphasis on materials and technique and a heightened attention to the formal aspects of art.

Both of these features derived, not from any deliberate sensationalism, but from the very nature of the Fauves' art. As they continued the liberation of color initiated by the impressionists and postimpressionists, Matisse and his friends discovered that a picture could be based entirely on very simple but dynamically enhanced color harmonies.

"For me," Matisse later observed, "fauvism was a test of means—putting blue, red, and green side by side, combining them into an expressive structure. This was less the result of deliberately conceived intention than of inner necessity."[4] Matisse frequently emphasized the intuitive, rather than rational, nature of fauvist painting. Its simplified use of color resulted from the desire to express feeling powerfully and directly.

The simpler the means used in art, the more powerful the expression of feelings—this was what Gustave Moreau told his students, although he himself did not follow this maxim. Matisse acted as he did because he was convinced that art must convey unique feelings with absolute sincerity.

View of Collioure belongs to the initial stage of fauvism. *Femme à la terrasse* (Woman on a Terrace), painted two years later, also in Collioure, already represents its final phase, and one more step along the path of resolute simplification. The outstanding feature of the painting is the insistent use of color outlining, which was only just beginning to emerge in *View of Collioure*. These contours served to redirect the artist's thought to the organizing role of drawing (temporarily obscured by the fauvist torrent of color) and thus clearly foretokened the approaching end of fauvism. In this work, the contours are patches of color in their own right, rather than boundaries of other patches. The outlining is executed in specific tones complementary to the patches it encircles in order to intensify their effect: it not only delimits and separates; it also reconciles neighboring colors. Van Gogh had employed similar effects, but Matisse emphatically highlighted them.

Even more than the canvases of Van Gogh, this painting evokes the drawings of children, through its recklessly thick outlines, the general flatness of its images, and its selective use of detail—a bright green hill, a house by the sea, sails. Picasso later explained that the development of this style was influenced by the fact that the artist's sons, Jean and Pierre, had just begun to draw, and their crude outlines and clumsy, childish scribbling demonstrated to their highly sophisticated father how he could simplify a picture without sacrificing what was most important. We might even conjecture that he was amused by some drawings they made of their mother, for the figure in the picture is Matisse's wife, Amélie.

In itself, the picture's subject is banal. Matisse had earlier painted a woman on a terrace (*La Terrasse de Signac, Saint-Tropez,* 1904) in a restrained style that seemed to indicate an interest in impressionism, Bonnard, and Vuillard and gave no hint of Matisse's role in subverting impressionism's basic precepts. By this time, the subject had gradually become more or less a commonplace in French painting. One of Matisse's closest colleagues, Manguin, made free use of it, and it was a vehicle used by salon painters for imitations of the impressionists. Matisse evidently knew some impressionist works in this genre, such as Renoir's canvas *By the Sea* (1882) or *Behind the Blinds* by Berthe Morisot (1878-1879), in which the female figure is presented in profile, turning to the right, in precisely the same pose.

There are clear elements of mimicry in *Woman on a Terrace,* but they can hardly

4. Henri Matisse, "Rôle et modalité de la couleur" (Role and modality of color), in *Écrits et propos sur l'art*, éd. Dominique Fourcade (Paris, 1972), p. 199.

VUE DE LA FENÊTRE. COLLIOURE, 1905
(VIEW FROM THE WINDOW. COLLIOURE)
PEN AND INK
PRIVATE COLLECTION

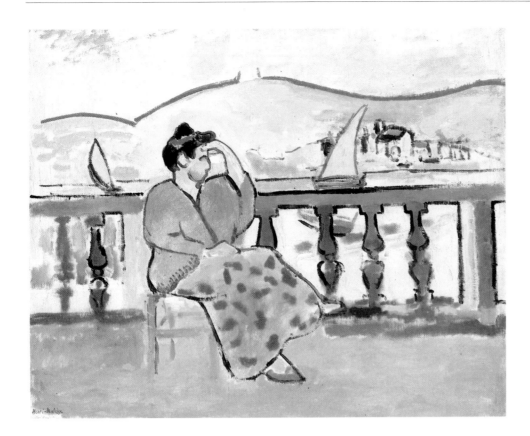

FEMME À LA TERRASSE, 1906-1907
(WOMAN ON A TERRACE)
OIL ON CANVAS, 65 x 80.5 CM.
THE STATE HERMITAGE MUSEUM, ST. PETERSBURG
ACQUIRED BY SERGEI SHCHUKIN IN 1908 FROM DRUET

be interpreted as deliberate ridicule, despite the suggestively close parallels with certain impressionist works. There is a sense of parody in the details of the picture's composition, especially of pseudo-childish art. Elements of parody are present in fauvism—they can be detected, in particular, in *La Joie de vivre* (1905-1906), a programmatic work of the fauvist period, but this is a parody so serious in its intent that irony is excluded before it can develop, leaving no place for the ridicule of similar treatments of the same theme. The implied object of ironic imitation is at best the sterotype of the subject, and not one specific embodiment of it.

The finest product of Matisse's fauvist period among the still lifes is *Nature morte, vaisselle à table* (Dishes on a Table), also known as *Vase, bouteille et fruits* (Vase, Bottle, Fruit).[5] The handling of color is in sharp contrast with the still lifes of previous periods, and the work is unusual in its very conception, insofar as Matisse painted over an old composition, the details of which still show through the background.[6] The entire structure of the picture announces a new era in painting. The dark ground of the earlier work is half overlaid with a sparse wash applied in swift strokes, which in combination with the bright patches of the fruits and colored patterns produces an almost pastel effect. However, Matisse shows little inclination to exploit the unusually soft, delicate tonal effects of pastel. His brushstrokes are applied to the canvas with a swift vigor, in a single touch that presages "action painting" in the literal sense of the word.

To paint in this manner, you have to "work yourself up," but this picture is not the product of some trancelike state. As always with Matisse, feeling and reason work hand in hand. The magical play of color is grounded on a firmly structured composition reminiscent of the copies Matisse made in the Louvre, especially of Chardin's *Pyramid of Fruit* and de Heem's *Still Life*. The composition is carefully thought out—the gleaming top of the milk jug defines the precise center; in spite of its haphazard appearance, the arrangement of the vases and dishes is in fact finely balanced, and the table with its cloth covering provides a stable, and quite beautiful base for the overall pyramidal composition.

During the fauvist years, which marked a break with previous artistic principles, Matisse treated the various genres differently. He was most daring in his approach

5. The dating of this painting remained controversial for a long time. Matisse's daughter, Marguerite Duthuit, claimed that the still life was already in her father's apartment in 1903, as a result of which several publications dated it to 1902-1903. The style of the work quite definitely suggests a date of 1906-1907, however, and it seems clear that it must have been painted in early 1906, since it was exhibited that March at Druet's gallery as *Nature morte. Camaïeu bleu* (Still Life. Blue Tablecloth). Furthermore, it has recently become clear that Matisse himself described the still life as "fauvist."

6. X-ray photography has revealed that *Dishes on a Table* was painted over a still life of Matisse's early, academic period showing a cup and fruit.

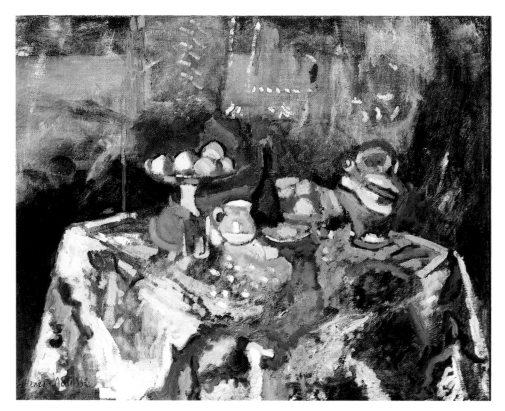

to landscapes and figure compositions, whereas in his still lifes, as a rule, he remained more faithful to the appearance of his subject. The compositions of his landscapes are usually more freely constructed, in the manner of the impressionists: almost as if by chance, the vanishing point is outside the field of view, so that it could be extended quite easily in any desired direction. Only rarely does Matisse employ fixed markers for the eye, such as the belltower of the church of St. Vincent that serves as the central axis in *View of Collioure*. The still lifes of this period are different: everything has been worked out beforehand.

To a greater or lesser degree these still lifes retain the imprint of lessons learned from Cézanne. The spatial structure of *Dishes and Fruit on a Red and Black Carpet* is quite definitely cézannesque, and the master of Aix also quite clearly inspired the picture's treatment of the so-called plunging perspective (*perspective plongeante*). At the same time, the structure of the composition is articulated by means of broad areas of color much in the spirit of Gauguin. For the first time, Matisse takes an oriental artefact as his subject—the "hero" of the painting is clearly the carpet rather than the dish or the fruit. It is so colorful in itself that there seems no need for emphatically decorative treatment. The dense red of the carpet provides the dominant note that dictates the inclusion of complementary emerald-green tones, for which Matisse used the lemons and banana, and also the glass *porrón*, an exotic Spanish wine pitcher that he had used in earlier paintings. In addition to complementing the oriental ceramic and fabric, the *porrón* also plays an important role in the spatial composition: its neck firmly locates the middle ground and provides a vertical element that gives stability to the whole structure, while its spout echoes the foreshortening of the carpet. Here Matisse has used a red-green color scale in the way that Delacroix did before him, but unlike the great romantic painter, he intensifies the colors to such an extreme that a third color is needed to achieve harmony. This is not difficult to locate: the black of the central section of the carpet, which gains extra depth from a sprinkling of lemon yellow. Thus the carpet assumes a central role in the color scheme. As such, it is far more than a simple background for the other objects, which in fact serve as foils for its sumptuous, exultant beauty.

Dish and Fruit on a Red and Black Carpet was painted in Matisse's beloved Collioure in 1906. In the spring of that year the artist had made his first trip to

Africa, to Biskra (Algeria), and brought back oriental fabrics and ceramics that he immediately began to include in his still lifes. The small Algerian prayer carpet is depicted in two other works painted in Collioure at this time: *Les Tapis rouges* (Oriental Rugs) and *Nature morte au putto de plâtre* (Still Life with a Plaster Statuette). It was in Biskra that he acquired the two-handled vase that figures in *Le Bouquet* (Bouquet) and the later *Nature morte à "La Danse"* (Still Life with "La Danse"), both of which were acquired by Morozov.

In the still lifes of 1906-1908, the objects brought back from Algeria are more than simple subjects: they are a source of inspiration that set the fundamental tone of the works. But while Matisse could not fail to be attracted by the artistic qualities of the utensils of the East, with their whimsical shapes, rich colors, and lively ornamentation, he nonetheless remained a French artist, never attempting to paint in an "Oriental style." The structural dynamics of Matisse's "oriental" still lifes are entirely western: *Nature morte en rouge de Venise* (Still Life in Venetian Red), a work saturated with eastern elements, is in the highly expressive manner of a Parisian avant-garde artist with a profound admiration for Cézanne. Just like Cézanne in his *Still Life with a Plaster Putto* of about 1895, Matisse plays on the juxtaposition of a white statuette and other objects. While tending toward flatness, he ultimately does not reject three-dimensionality. A profound respect for the master of Aix is detectable in the cézannesque development of the composition, which brings the middle and foreground planes into intense interaction, "collapsing" the foreground and thus precluding any smooth transition into deep space.

In the years following Cézanne's death, his influence in the unofficial art circles of Paris was immense. He had many followers who borrowed his manner in a literal—and therefore superficial—fashion, while the cubists tended to a merely formal or abstract understanding of his visual ideas. Clearly, Matisse could not become a member of either group. In the school that he created in 1908-1909, he often spoke to his students about the artistic and cultural significance of the work of Cézanne, "the father of us all" (as reported by Max Weber, the most talented American student in the school's genuinely international community). [7]

7. Barr, p. 87.

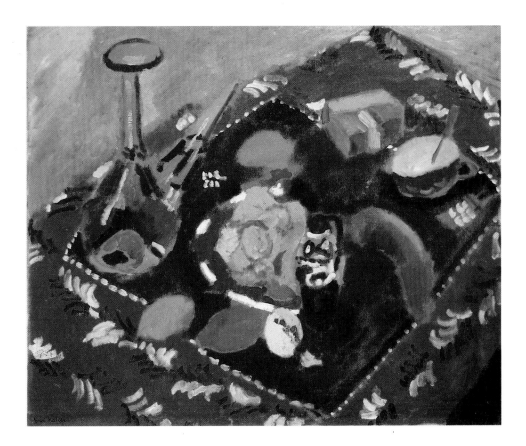

PLATS ET FRUITS SUR TAPIS ROUGE ET NOIR, 1906
(DISHES AND FRUIT ON A RED AND BLACK CARPET)
OIL ON CANVAS, 61 x 75 CM.
THE STATE HERMITAGE MUSEUM, ST. PETERSBURG
ACQUIRED BY SERGEI SHCHUKIN IN 1908 FROM DRUET

BOUQUET (VASE À DEUX ANSES), 1907
(BOUQUET [VASE WITH TWO HANDLES])
OIL ON CANVAS, 74 x 61 CM.
THE STATE HERMITAGE MUSEUM, ST. PETERSBURG
ACQUIRED BY IVAN MOROZOV IN 1907 FROM
BERNHEIM-JEUNE

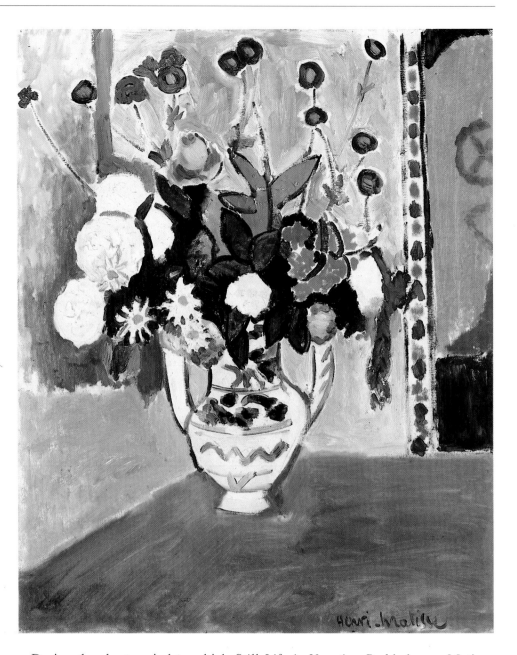

During the short period to which *Still Life in Venetian Red* belongs, Matisse became the acknowledged leader of the Paris avant-garde, attracting a stream of students from various countries and publishing his theoretical article "Notes of a Painter," one of the finest statements made by any artist in the twentieth century. People paid attention to what Matisse said, but he was still under attack from every side: his former allies, seduced by cubism, deserted him, while most of the critics and almost all of the public remained as hostile as ever. For the critics, Matisse was not radical enough, and for the public, he was too radical.

Nonetheless, it was during this period that Matisse extended his scope to reveal previously undiscovered aspects of a wide range of genres: still life, interior, landscape, portrait, nude. He undertook a number of programmatic works, culminating in *The Red Room.* He also devoted more energy to sculpture, and the switch from painting to sculpture and back again enriched both activities. According to Matisse, sculpture gave him a clearer understanding of what it was that excited him in painting. [8]

8. Guichard-Meili, p. 168.

In addition to the problem of recreating volume, sculpture attracted Matisse by its use of artistic means to convey the vital energy of the human body and to fix what is most difficult of all to capture: movement. As an example of a remarkable solution to this problem, he used to cite the sculptors of ancient Egypt: "Look at an Egyptian statue," he wrote in "Notes of a Painter." "To us it seems rigid, and yet

we perceive it as a representation of a body endowed with movement and life, for all its immobility."[9] Matisse's sculpture *Madeleine I* (1901), which occupies the place of honor in the *Still Life in Venetian Red,* incarnates an integral movement involving the entire figure from head to feet. This "twisting" movement gives the body a lively outline that allows the artist to exploit certain formal parallels with the vases. The inclusion of this sculpture with the oriental objects provides the painting with a specific counterpoint. The vases are placed around the statuette like some fantastic retinue for a beautiful woman. The contours of the vases and the statuette echo each other's rhythms in a way that emphasizes the beauty of the movement still further. In addition, the contrast between the objects brings out the beauty of their materials from which they are made, and each of the objects is presented in a way that contributes to the creation of a dense, structured space.

"What interests me most is neither still life nor landscape, but the human figure," wrote Matisse in 1908, and these words marked the advent of a new stage in his work, one in which figure compositions and portraits were to acquire much greater significance.[10] Since the Ecole des Beaux-Arts, Matisse had turned from time to time to the theme of the nude female body, most significantly in *La Joie de vivre,* a virtual hymn to the sensual beauty of nakedness. Each figure in this large composition is captured with a purity of line reminiscent of Ingres; indeed, for all its intensity of color, *La Joie de vivre* is an apotheosis of contour drawing. In several later canvases of 1906, the drawing disappears, and the body is transformed into a patch of color surrounded by other, brighter patches. In these fauvist canvases the artist was satisfied with the color effect of a gleaming pink body on a green background and made no attempt to introduce any clear detail. As he emerged from fauvism in the works of 1907, Matisse attempted a new synthesis of drawing. In *Le Nu bleu* (Blue Nude, 1907), the structure of the body is conveyed with powerful simplicity. In another painting of that year, *La Coiffure* (Coiffure), the color is restrained, but the modeling is almost "sculptural."

"Suppose I want to paint a woman's body," wrote Matisse in "Notes of a Painter." "First of all I imbue it with grace and charm, but I know I must give something more. I will condense the meaning of this body by seeking its essential lines. The charm will be less apparent at first glance, but it must eventually emerge from the new image which will have a broader meaning, one more fully human. The charm will be less striking since it will not be the sole quality of the painting, but it will not exist less for its being contained within the general conception of the figure."[11] In the original edition of the text, Matisse included reproductions of several of his paintings, including *Nu assis* (Seated Nude) and *Nu, noir et or* (Nude, Black and Gold) better known under the title *Black and Gold.*[12]

Black and Gold develops stylistic features that made their first appearance in *Coiffure* and can also be compared with sculptures such as *Les Deux négresses* (Two Negresses, 1908), with their massive, solidly assembled forms. This was the same period that Matisse made the small bas-relief *Nu debout* (Standing Nude, 1908), which reproduces in reverse the pose of *Black and Gold.*

If, at the beginning of the fauvist period, Matisse seemed intoxicated with color and was frequently willing to abandon all caution in its use, he soon became convinced that the wealth and power of color in a painting did not depend on the copious application of various undiluted tones, but on the very opposite: economy in their use. In *Black and Gold,* the painter essentially restricts himself to the combination of two dominant colors that are modulated and supported by only one or two other subordinate colors.

The comparison of naked flesh with gold was not Matisse's discovery: suffice it to recall Gauguin's painting of nude Tahitian women, appropriately titled *And the Gold of Their Bodies.* Like Gauguin, Matisse approaches this subject in an exalted and poetic manner, with color as the main vehicle for achieving his goal. The difference is that Matisse employs exaggeration without needing to justify it by exoticism, and he arrives at a bolder and more laconic solution. Ochre and black—

9. Matisse, "Notes of a Painter," p. 38.

10. Ibid., p. 38.

11. Ibid., p. 36.

12. The date of this painting has never been agreed upon in the literature. Alfred H. Barr proposed 1905, but the organizers of the 1970 Matisse centennial exhibition indicated 1909. The latter date is entirely improbable, since the painting was used as one of the illustrations to "Notes of a Painter," published in *La Grande Revue* on 25 December 1908. The picture was undoubtedly painted in 1908, given the two related works in the Hermitage depicting the same model and bearing the date 1908.

VASE DE NARCISSES, 1911
(VASE OF NARCISSUS)
PRIVATE COLLECTION

81

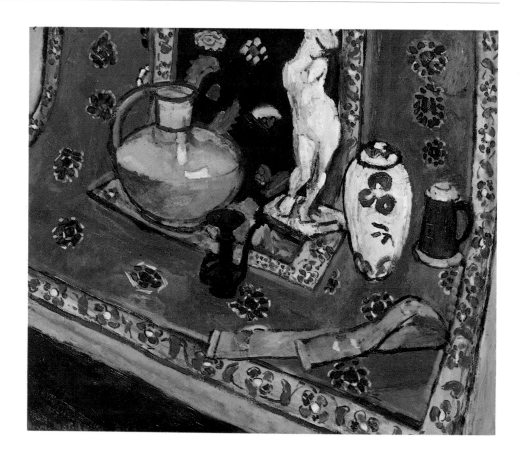

aren't these two colors enough to paint the human body? In Matisse's hands, ordinary ochre becomes a precious substance, glittering like gold against a black that also has a profound and precious gemlike quality. It is hard to name another painter whose black is so boldly expressive.

The painting has a special frame with large gold scrolls in relief on a black ground. It corresponds so precisely to the treatment of the masses of the figure that it was undoubtedly made for this work from a sketch by Matisse himself. The lively ornamentation of the frame is not merely a boundary but in effect, an element of the work itself.

The possibilities offered by a style that takes its impetus from nature and yet subordinates nature to itself can be clearly seen in a comparison of *Black and Gold* with *Nude*. The connection between the two paintings is explicit: the same model in the same pose. *Nude*, which Matisse gave to Ilya Ostroukhov, was a study for *Black and Gold*, although, somewhat dry and rigid in its treatment, it is rather different from other studies. The date on it is 1908, but that might have been added later, by way of a postscript to *Black and Gold*.

The task addressed in *Black and Gold* is extremely simple. It is not a programmatic work on some preconceived theme or idea, but merely an attempt to depict the nude model in the most banal of poses. Nonetheless, Matisse's intensive work on this theme extended his expressive range and the structural force of his drawing, and he clearly had good reason to select this work to illustrate "Notes of a Painter." More than just one study among others, this painting of a professional model posing for money raises the subject to its highest power, liberating it entirely from the bonds of the present moment and transforming it into the object of some unknown cult, exalted and yet entirely earthly.

The model for *Black and Gold*, *Nude Woman*, and *Seated Nude* can also be recognized in two 1908 drawings of nudes: one in the Musée de Peinture et de Sculpture, Grenoble, the other in the Metropolitan Museum, New York, both of which, according to Matisse's daughter, were made in Munich. In the summer of 1908 Matisse was in fact working in the Munich studio of his friend and student

Hans Purrmann, where a German model was posing. However, Marcel Sembat, the author of the first book about Matisse, called *Black and Gold* the "Italian nude."[13] The possibility cannot be excluded that the entire cycle was painted by Matisse in Paris in 1908, when both his studio and his school were located on the boulevard des Invalides. Matisse could well have worked alongside his students when he set them to figure drawing. In the least, there would seem to be little doubt about the Parisian origins of *Black and Gold*, which consolidated stylistic features that had only just made their appearance in *Seated Nude*.

There is a sharp contrast between the sculptural three-dimensionality of *Black and Gold* and the flatness of another work of the same year, *Les Joueurs de boules* (Game of Bowls), in which the nude body is plotted rather than actually

NU ASSIS, 1908
(SEATED NUDE)
PENCIL
MATISSE ARCHIVES, PARIS

13. Marcel Sembat, *Matisse et son oeuvre* (Paris, 1920), p. 19.

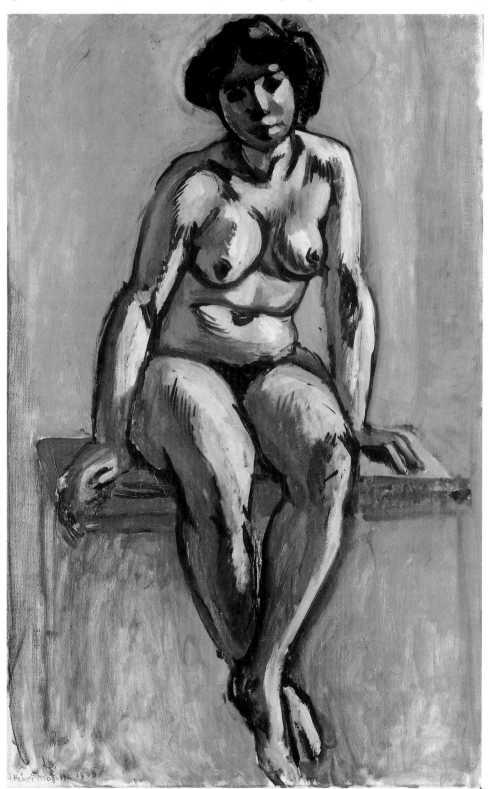

NU ASSIS, 1908
(SEATED NUDE)
OIL ON CANVAS, 80.5 x 52 CM.
THE STATE HERMITAGE MUSEUM, ST. PETERSBURG
ACQUIRED BY IVAN MOROZOV IN 1908 AT THE
SALON D'AUTOMNE IN PARIS

represented. Beyond stylistic differences, the works seem to be statements of quite distinct philosophies. The first is inseparably linked to the appearances of the real world that it attempts to reproduce, while the second is an unambiguous expression of primitivism in the broader sense.

For several years before Matisse began to work on *Game of Bowls* he had been taking a serious interest in art outside the sphere of the European culture that began with the Renaissance and seemed to have exhausted its resources at the end of the nineteenth century. The seeds planted during the "dark" period of doubt and seeking, when Matisse visited exhibitions of Islamic art (1903) and of French primitive painters of the late Middle Ages (1904), sprouted only later, in 1906-1908. Many years afterward, his comment on the Barnes collection in Merion, where old pictures are hung alongside contemporary works, with the Douanier Rousseau next to some late medieval artist, was that this comparative approach made clear a great many things that are not studied in the academies.[14]

In 1907 Matisse also remarked to Apollinaire that an artist can be helped in developing his individual style by contact with various methods of artistic expression, whether the work of the hieratic Egyptians and the sophisticated Greeks, the Cambodians and the ancient Peruvians, or the blacks of Africa.[15] In studying the expressive languages of artistic cultures far removed from his own, Matisse hoped to approach the root system of all art and grasp its spiritual fundamentals. This is why he was attracted by the magic of primitive ritual, the meditative culture of the East, and the spiritual culture of medieval Christianity. Exotic art and children's drawings were important to him insofar as they served to pry open the door to the primordial mystery of art. Matisse was one of the first—certainly before Picasso—to appreciate the artistic virtues of black African sculpture.[16]

The "primitivism" of Matisse's pictures derives above all from the theme of the Golden Age, as conceived in his imagination, that mythical time when art itself was also conceived. *Game of Bowls* should also be included in Matisse's Golden Age cycle, although the picture has none of the idyllic quality usually associated with the genre.

The cycle began with *La Joie de vivre* and continued with the two versions of *Le Luxe* (Luxury, 1907, Pompidou Center, Paris; Statens Museum for Kunst, Copenhagen). The next step came with compositions involving three figures, as in *Game of Bowls* and *Les Baigneuses à la tortue* (Bathers with a Turtle, 1908). The poses of the figures in *Luxury* and *Game of Bowls* are similar in many respects; *Bathers* and *Game of Bowls* are equally closely related by their generalized treatment of landscape and the spatial arrangement of the figures.

The figures in *Game of Bowls*, like those in the later *La Danse* (The Dance) and *La Musique* (Music), are simultaneously like and unlike real people. The youths are as absorbed in their game as any modern teenagers, yet their poses and gestures are almost ritualistic. Matisse's characters are not amusing themselves; they are engrossed in the "game of life." An extremely simplified landscape background thus becomes the only fully appropriate setting for the severe and mysterious symbolism of the action: the body of water seen on the horizon, be it sea or river, is perceived not so much as an element of the countryside as a symbolic milieu—since time immemorial both river and sea have figured in human consciousness as metaphors for the dialectical unity of life and death. The more symbolic such painting becomes, the more deeply it is drawn into the sphere of primitivism, where stylistic norms are generated by content.

The picture has a clearly stated subject, but the general simplification of formal means and the absence of any psychological basis for the action or any explanatory details transform it into an allegory. The entire scene is perceived as an interrogation of fate with the number of figures, like that of the bowls, the symbolic three so often found in folklore. A theme that might appear to be frivolous is explored solemnly, even dramatically. The color range, so devoid of

NU DEBOUT ET TÊTE, 1908
(STANDING NUDE AND HEAD)
PENCIL
MATISSE ARCHIVES, PARIS

14. "Le tour du monde d'Henri Matisse. Entretien avec Tériade," *L'Intransigeant*, 27 October 1930.

15. Guillaume Apollinaire, "Henri Matisse," *La Phalange 2* (15-18 December 1907).

16. It is possible that Matisse might have drawn Sergei Shchukin's attention to black African sculpture, of which the Moscow collector acquired several significant examples.

NU, NOIR ET OR, 1908
(NUDE, BLACK AND GOLD)
OIL ON CANVAS, 100 x 65 CM.
THE STATE HERMITAGE MUSEUM, ST. PETERSBURG
ACQUIRED BY SERGEI SHCHUKIN IN 1908 FROM DRUET

joy, at first seems unexpected, but on second thought entirely appropriate. The green of the meadow symbolizes life—the life given by the earth—but something else as well: for the ancient Egyptians, green was the color of Osiris, the god of nature's productive forces and lord of the afterlife. The symbolism of colors is never unambiguous, because its force is not literary in origin but intuitive.

The symbolic setting of *Game of Bowls*—a boundless green meadow and blue water—had already appeared in *Bathers with a Turtle*, a canvas of the same scale and significance as *La Joie de vivre* before it and the later *Red Room*. The intentional symbolism of *Bathers with a Turtle* is expressed in every component of its style and content. Nudity is taken to express humanity's primal state, and in this context, the use of a turtle as the element uniting the characters could not be more logical. The animal is of course a symbol of slowness and stability, but in primitive cultures it also incarnated vital energy and fertility—thus its presence alongside female figures is entirely appropriate. When Matisse later wished to produce a "male" version of these *Bathers*, the result was *Game of Bowls*. It is not known whether Matisse made any preparatory drawings or sketches for the latter picture. Painted very quickly in Collioure at the beginning of the summer of 1908, it was already in Moscow by midsummer.[17]

The rich and contradictory scope of Matisse's vision of the Golden Age is demonstrated by yet another composition in the cycle, *La Nymphe et le satyre* (Nymph and Satyr, exhibited at the Bernheim-Jeune Gallery as *Satyre poursuivant une Bacchante* [Satyr Pursuing a Bacchante]). In the spring of 1907 Matisse produced a ceramic triptych for the Osthaus villa in Hagen. On the side panels he depicted a dancing nymph, and on the central panel, a satyr and a nymph. In contrast with the later version in the Hermitage, the satyr here has thick fur, goat's hooves, and so forth. The nymph's legs are half covered over with cloth, and her pose is reminiscent of the *Blue Nude* in Baltimore, which had been painted immediately before. The prototype for the satyr and nymph is Correggio's *Jupiter and Antiope*, a painting that Matisse knew quite well from his days as one of Gustave Moreau's students, when he visited the Louvre repeatedly to copy the old masters. The fact that Matisse reversed the structure of Corregio's composition suggests that he worked from an engraving rather than the painting itself. He also knew other variants of this motif, in particular Watteau's *Nymph and Faun* (*Jupiter and Antiope*) in the Louvre.

˘ The ceramic triptych is a purely decorative piece: it has no landscape background and is bordered with bunches of grapes. When he returned to this composition for a painting, Matisse omitted all the mythological references and altered the poses of the figures. Most important of all, he gave the scene a unified symbolic meaning that fused the concepts of fate, life, and sex, which thus placed it in the series with *Game of Bowls*, *Bathers with a Turtle*, and the paired *Dance* and *Music*. The painted *Nymph and Satyr* is larger than the ceramic version and has a much stronger impact on the viewer as a result of its exceptionally intense color, which has always required that it be given a space of its own in any exhibition. The ceramic panel, in contrast, is very restrained, since Matisse had to take into account its function as architectural decoration.

The theme of the nymph and satyr seems to have fascinated Matisse at this time. It was probably in 1909 that he painted another canvas, *La Nymphe et le Faune* (Nymph and Faun), in which the entire scene is rendered in a more peaceful fashion: the faun is staring thoughtfully at the sleeping nymph rather than pursuing her.

Nymph and Satyr was painted in response to a commission from Sergei Shchukin, who must have been familiar with the Hagen ceramic triptych (he knew Osthaus, who had stayed at Shchukin's house in Moscow). Matisse worked on the painting in Cassis in January 1909. On 7 February the artist informed Fénéon that he had finished a canvas for Shchukin that he called "Faun Catching a Nymph Unawares." This was begun in 1908 (Matisse mentions it in a letter of

17. Flam dates *Game of Bowls* to the spring of 1908, when Matisse moved to the new studio on the boulevard des Invalides. In fact it was painted in the summer, when Matisse continued the practice of previous years and went to Collioure. The inventory card of the Moscow Museum of Modern Western Art notes a label (subsequently lost) on the stretcher, bearing the word "Collioure." Flam quite justifiably compares this painting to a very large watercolor. (Flam, *Matisse. The Man and His Art*, p. 226).

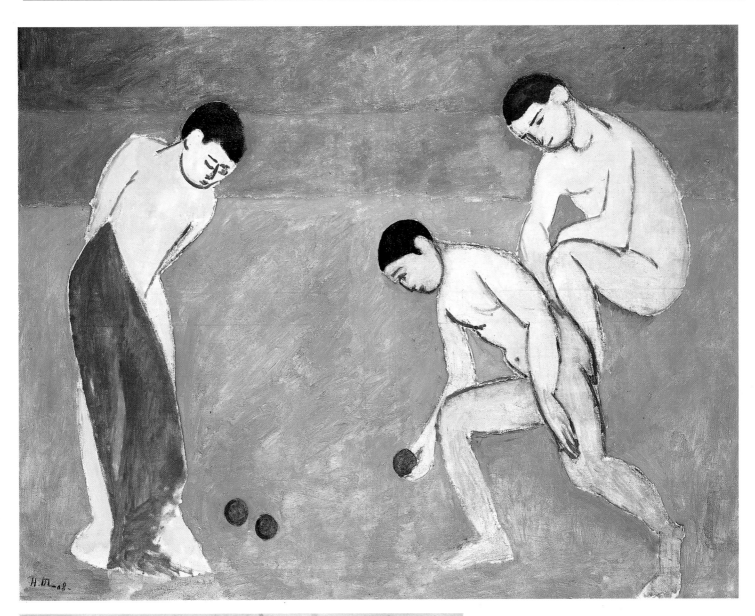

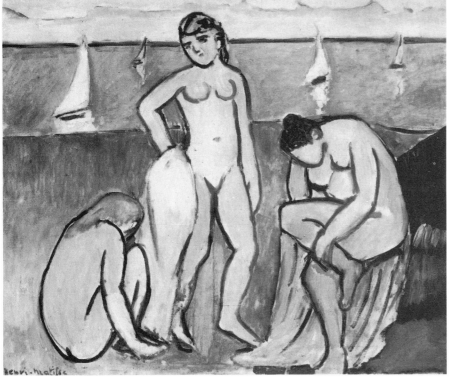

LES JOUEURS DE BOULES, 1908
(GAME OF BOWLS)
OIL ON CANVAS, 113.5 x 145 CM.
THE STATE HERMITAGE MUSEUM, ST. PETERSBURG
ACQUIRED BY SERGEI SHCHUKIN IN 1908 FROM
THE ARTIST

TROIS BAIGNEUSES, 1907
(THREE BATHERS)
THE MINNEAPOLIS INSTITUTE OF ARTS

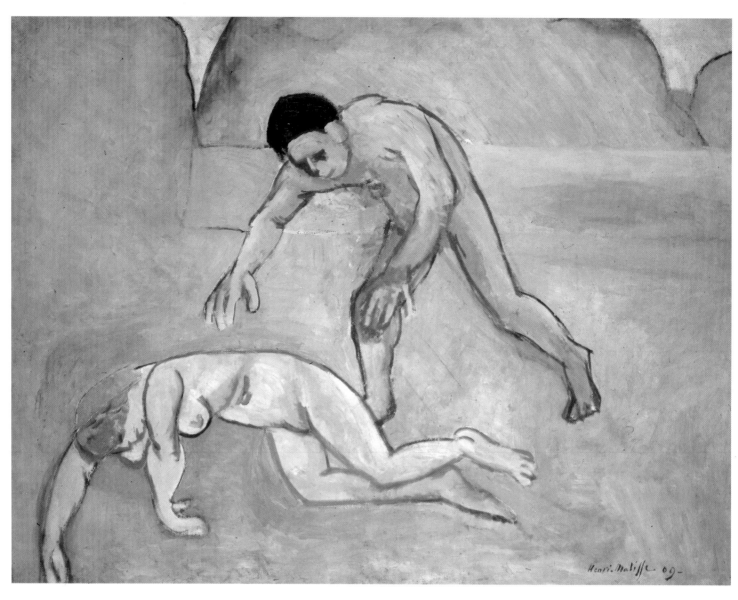

LA NYMPHE ET LE SATYRE, 1909
(NYMPH AND SATYR)
OIL ON CANVAS, 89 x 117 CM.
THE STATE HERMITAGE MUSEUM, ST. PETERSBURG
ACQUIRED BY SERGEI SHCHUKIN IN 1909 FROM
THE ARTIST

LA NYMPHE ET LE SATYRE, 1907-1908
(NYMPH AND SATYR)
CENTRAL SECTION OF A TRIPTYCH
CERAMIC
OSTHAUS VILLA, HAGEN

26 November to Fénéon), and the photograph of the first state was probably taken at about the same time.[18] Even without the use of X-rays it is possible to make out the original contours beneath the layer of green paint and sense that in the first state the movements of the figures were even more dynamic.

Both the expressionistic brilliance of the colors and the distinctly sensual character make this painting unique in Matisse's oeuvre. Flam explained this by Matisse's infatuation with his Russian student Olga Merson (Meerson)—despite the exaggerated rendering of her features, the red-headed nymph is indeed very like the model for the 1910 *Portrait of Olga Merson*.[19]

3. A DECORATIVE PANEL FOR A DINING ROOM

Sergei Shchukin's acquisition of such fundamental works as *Game of Bowls* and *Nymph and Satyr* demonstrates the closeness of his relations with Matisse. Even more significant was his purchase of *The Red Room*, one of the most important works in the whole of twentieth-century art. From this point on, Shchukin was no longer merely a collector of Matisse's paintings: he became, in essence, the artist's patron. It is no exaggeration to say that their alliance provided the conditions for the appearance of a whole series of important works. The strengthening of his ties with Shchukin was all the more important for Matisse given that Leo and Gertrude Stein, who had taken him under their wings and bought several of his more radical paintings, began to distance themselves from him in 1908.

In the summer of that year, Shchukin apparently reserved *Harmonie bleue* (Harmony in Blue), Matisse's third key work (after *La Joie de vivre* and *Bathers with a Turtle*), and the most significant to date in artistic terms. *Harmony in Blue* was intended for the large dining room in Shchukin's mansion—"decorative panel for a dining room" was the way in which Matisse himself described the work, although he originally referred to it as the "large still life" (*grande nature morte*, or simply *G. N. M.*).

In 1942, Louis Aragon wrote down what Matisse had told him about painting still lifes, starting when he was studying in Gustave Moreau's studio: "I thought that I would never paint faces, then I began to include faces in my still lifes. . . . My faces are alive for the same reasons that my still lifes were alive . . . an atmosphere of love, the feeling that I am making my objects beautiful."[1] Indeed, *Harmony in Blue* owes a great deal to the still life, even if, in formal terms, it is closer to an interior and also includes elements of landscape and figure composition. Matisse employed a narrative compositional approach derived from his early still lifes. He had first applied it in the realistic *Breton Serving Girl* of 1896 (which the artist kept in his own collection), and the following year in the impressionistic *Dinner Table*. In both cases, a woman—a servant or the mistress of the house—has been introduced into a still life and is laying the table. This role was given to Caroline Joblaud, Matisse's constant model and companion of the time. A schematic rendition of her features appears again over ten years later in the "decorative panel for a dining room."

The point of departure for *Harmony in Blue* was a decorative fabric with a blue design of pastoral motifs known as Jouy cloth. Matisse loved this fabric so much that he kept it among the accessories in his studio till the end of his life. He painted it again and again, using it, for instance, in *Dishes on a Table* and later in *Nature morte, camaïeu bleu* (Still Life with a Blue Tablecloth). Also in 1908 the fabric served as the background for the *Portrait de Madame Greta Moll* (Portrait of Greta Moll).

The entire structure of *Harmony in Blue* is subordinated to the flat surface of the canvas. The basic rhythms are defined and emphasized in such a way that the outlines of the trees, the fruit on the table and the woman's figure provide

LE SATYRE ET LA NYMPHE, 1909
(SATYR AND NYMPH)
PENCIL SKETCH
PRIVATE COLLECTION

18. Flam, pp. 246, 494.

19. Ibid., p. 248.

1. Louis Aragon, *Henri Matisse, Roman* (Paris, 1971), vol. 1, p. 142.

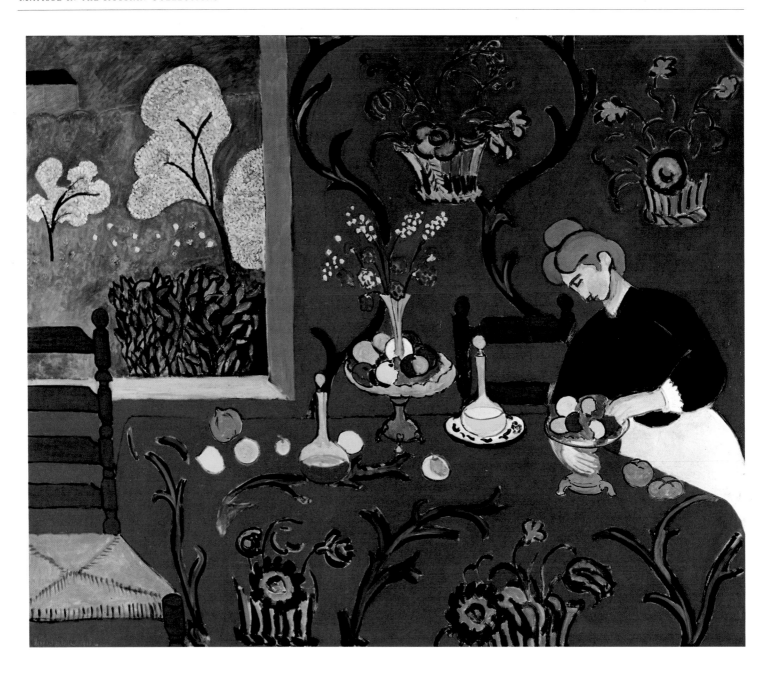

LA DESSERTE ROUGE (HARMONIE ROUGE), 1908
(THE RED ROOM [HARMONY IN RED])
OIL ON CANVAS, 180 x 220 CM.
THE STATE HERMITAGE MUSEUM, ST. PETERSBURG
ACQUIRED BY SERGEI SHCHUKIN IN 1908 FROM
THE ARTIST

accompanying chords to the S-shaped ornamental motifs of the fabric's design, which in real life are less laconic than the artist's brush has made them. But for all this, the picture is closely related to *Dinner Table* in many ways. In the earlier work, the lower section of the canvas is given over to the table with compote bowls, fruits and rounded carafes; above them there is the form of a window, on the left the chairs, and on the right, the woman. With the new organizational logic of the later picture, there are fewer objects on the table; instead of two chairs there is only one, and the sketchy indication of a window now becomes an opening leading into a garden: Matisse now needed to expand the limits of the whole scene. The intimate mood is replaced with a quite different note. When viewing *Dinner Table,* the viewer can easily imagine being involved in what is happening, but the "decorative panel" is already a thing apart, a work combining the real and the absolutely conventional and one that leads Matisse to address cosmic themes. The nineteenth century has given way to the twentieth.

All that is left of *Harmony in Blue* is the now-faded colored slide that was made when it was completed, and the narrow strips of the old painting at the edges of *The Red Room*—for in 1908 *Harmony in Blue* was transformed into *Harmony in Red*, better known as *The Red Room*.[2]

Retracing the genesis of the painting, Alfred Barr identified three stages: originally, he indicated, there was a "*Harmony in Green,*" dominated by cold green tones (Barr referred to a description used by Matisse himself), then *Harmony in Blue*, and finally the *Harmony in Red* that we have today.[3] Flam subsequently disputed this idea, claiming that the painting had only two states—blue and red. He based this claim on the reminiscences of the artist's daughter and son, Marguerite Duthuit and Pierre Matisse, and also on the colored slide. This unique slide, made using the newly invented autochrome method, cannot in itself serve as proof that the original version of the picture was not painted in rather different tones. We must also treat with caution recollections coming several decades after the facts. If the tonal ranges of the first and second stages were relatively close and if, in addition, one followed immediately upon the other, the first might easily be forgotten.

The remaining strips of the picture's original state show no trace of a transition from green to blue. Most likely Matisse had, from the very beginning, chosen an intermediate hue that could be called either green or blue. The actual color of the Jouy fabric is close to sky blue, which Matisse accentuated in the later *Still Life with a Blue Tablecloth*. It is difficult to imagine that in working on *Harmony in Blue* he initially departed from the actual color, only to move back toward it afterward. His usual way of working was just the opposite: his original impulse came from external reality.[4] There is, however, another point to be considered in favor of a green stage: the transition to red would be more likely if the artist were starting not with light blue, but with a hue dominated by green, insofar as this color would "provoke" the transition toward its complementary, red.

When Barr asked him why he had repainted this canvas, Matisse replied that he did it to achieve a better balance of color.[5] The change was made on his own initiative, but not in any way to use *Harmony* as a demonstration of the theories to be expounded in part at the end of the year in "Notes of a Painter." Before the repainting Matisse cleaned the surface with turpentine, as he always did when reworking a canvas, but left the blue motifs and the objects on the table untouched.

When a visitor to Matisse's studio saw what had happened to *Harmony in Blue* and remarked that it was a different picture, the artist replied: "He doesn't understand a thing. It's not a different picture. I am seeking forces and a balance of forces."[6] On one occasion, as though he were considering a reverse transformation of *The Red Room*, Matisse observed that the red-green-blue-black surface could be overpainted in blue-white-red-green, and it would still be the same picture, the same feeling presented differently; only the rhythms would change. The difference between the two versions is like that between the black and white squares on a chess board during a game.[7]

2. Matisse archives, Paris. Reproduced in Flam, *Matisse. The Man and His Art*, p. 231.

3. Barr, p. 124.

4. Flam is thus undoubtedly correct when he insists (Flam, pp. 230, 493) that there were only two stages, and not three as claimed by Barr (Barr, pp. 124-126) and later by Schneider (Schneider, p. 312).

5. Questionnaire IV, 1950. Archives of The Museum of Modern Art, New York. This is one of the questionnaires to which Barr received replies from Matisse.

6. "Henri Matisse. Exposition du Centenaire." Paris, Grand Palais, 1970, cat. p. 74.

7. Matisse, "On Modernism and Tradition," p. 238.

LA SERVEUSE BRETONNE, 1896
(THE BRETON SERVANT GIRL)
PRIVATE COLLECTION

8. G. Jean-Aubry, *L'Art moderne*, 1 November, 1908, p. 345. This review was discovered by John Neff; see "Matisse and Decoration, 1906-1914. Studies of the Ceramics and the Commissions for Paintings and Stained Glass" (Ph. D. diss., Harvard University, 1974), p. 155.

9. Matisse, "Notes of a Painter," p. 37.

The reworking of the painting did not alter its fundamentally "melodic" nature, for the drawing remained unchanged with the exception of one small detail: the trees in the garden. Matisse told Barr that during the spring when he was working on the painting at the Hotel Byron in Paris (he had moved there from the quai Saint-Michel), the trees in the hotel's garden, which were in blossom, were made even whiter by a rare late snowfall. To judge from the slide, the trees in *Harmony in Blue* were bluish, with a bright crown of freshly opened blossoms. Matisse could not recall exactly when this snowfall had occurred, in 1908 or 1909. Barr maintained that it could only have been in the spring of 1909 and decided that this was when the painting became *Harmony in Red*. Flam has disputed this, pointing out with justice that the date 1908 was written over the red layer of paint. Flam has also cast doubt on the dominant opinion that Matisse reworked the painting and completed *The Red Room* just after the 1908 Salon d'Automne. Here he cites a review by the critic Jean-Aubry, published before the salon opened, which spoke about "this large composition, a kind of symphony in gum red and ultramarine."[8] Quite clearly the painting became *The Red Room* before the opening of the Salon d'Automne, and Matisse repainted the panel after it had been framed (since the edges concealed by the frame remained untouched).

The sequence of events can now be established clearly. On 6 August Matisse wrote a letter to Sergei Shchukin, which, like his other correspondence with the Russian collector, has been lost, probably destroyed in the excesses of the post-revolutionary period. However, the rough draft of this uniquely important document has survived and is kept in the Matisse Archives in Paris. "A month ago I decided that the G. N. M. [*grande nature morte*—A. K.] was finished and hung it on the wall of my studio in order to be able to judge it better. That was when Druet photographed it. Later I felt it was not decorative enough and could do nothing else but start work on it again, for which I am delighted today. Even those who thought that it was well done at first now find it considerably more beautiful. I myself am very pleased with the scheme. I will send you a photograph of its first state and try to give you some idea of its color in a watercolor sketch. Its price is 4,000 Fr. . . ." Unfortunately, the watercolor sketch enclosed with the letter or, more likely, actually painted on the letter, has also not survived.

A passing reference to the transformation of *Harmony in Blue* can be detected in "Notes of a Painter" (which was published, as we know, in 1908) when Matisse speaks of the various possible ways of transposing colors in painting: "I am forced to transpose until finally my picture may seem completely changed when, after successive modifications, the red has succeeded the green as the dominant color."[9]

The first thing that strikes the viewer about *The Red Room* is its posterlike vividness and simplicity, but it would be naive to think that the impact of Matisse's paintings is like that of a poster. The resemblance is superficial. The information contained in a poster must be capable of being "read" as quickly and conveniently as possible and usually amounts to what is in effect a cliché. Once the information is assimilated, there is no point in lingering over it. Matisse's paintings are quite a different matter. *The Red Room* provides initial information immediately—this is an interior with a female figure and a dessert table, a view of a garden. But this by no means exhausts the content of the picture. Despite its resemblance to a poster, one is drawn to study it more closely and thus to uncover the rhythmical principles of its structure that govern every detail. It becomes clear that a painting by Matisse cannot possibly be a literal likeness of nature because it is an autonomous organism. This is what makes it impossible to take a detail from one work by Matisse and insert it into another: it will always be out of place because the other picture is also a unique organism, another self-sufficient world.

The rhythmical structure on which a Matisse canvas is based is important, of course, not for itself, but only insofar as it serves to elicit the painting's color values. In *The Red Room* the rhythmic structure lends dynamism to the color statement. There are only a handful of tones, but their impact is quite different

from that of the machine-printed colors of a poster. The surface of the canvas is not mechanically uniform, and each patch of color is preserved from dismal monotony by the marks of the brush and the energy of the creative act itself. The color combination is so organically irrefutable that the magic of the colors draws the viewer back to them again and again.

The Red Room represented a turning point in European painting, not merely because it contained more red than had ever been used before, but because Matisse included these extreme notes of color without losing sight of the fact that the goal of art is harmony. The monumental compositions with a single dominant color may be compared to a musical form such as the concerto. Matisse began to make eager use of them because they provided the supreme test of color. A change in tonality such as that occurring from *Dinner Table* to *Harmony in Blue*, and then— even more important—to *The Red Room* was determined by the desire to amplify the symbolic significance of color in order to achieve "the transformation of an intimate interior . . . into an image with cosmic implications, of a genre scene into a resonant and complex meditation on time and becoming."[10]

In the same year that Matisse was working on *The Red Room*, Bonnard, the most original and profound heir of the discoveries of the impressionists, was painting his interior/still life *The Mirror over the Washstand*. Never had there been still lifes with such a complex program: the boundaries of the still life were pushed back so far that the composition included elements not only of an interior, but also of genre painting and the nude. Matisse was similarly unrestrained by the limitations of his genre in *The Red Room*. But Bonnard's painting remains a still life nonetheless: its status is determined by objects that tell a story about a person. The most important detail is the mirror that reflects the artist's wife and model at her unceremonious breakfast. The picture thus becomes more than a representation of toiletry articles: it is a narration of the life of an artist who has no home apart from his studio, for whom art is not a mere profession which takes up a certain number of hours a day. By introducing the mirror, Bonnard creates a situation in which the viewer does not seem to be standing in front of the picture but rather within it, in intimate contact with the artist's world. Banal objects serve as vehicles for the most subtle perceptions of color. In their lively, varied rhythms, there is nothing rigid about these objects.

The major movements of the early twentieth-century avant-garde, however, were not concerned with developing the ideas of the impressionists, but rather with opposing them—a stance that culminated in the work of Matisse, who sought to bring the power of color and the energy of line to an intensity unknown to previous generations.

In *Still Life with a Blue Tablecloth*, chiaroscuro is almost completely excluded.[11] The painting is dominated by pure color as intense as the artist's perception. His feel for the objects is firm and definite, and they can easily be read at any distance from the canvas, which is a worthy "afterword" to *The Red Room*. The tablecloth under the coffeepot, bowl of apples, and carafe stand is clearly not just a background; rather, it is the most important object, the one that dictates the choice of the other details in such a way that their forms echo its dynamic patterning. The painting's title is entirely justified. As in *The Red Room*, the floral garlands of the Jouy cloth determine the rhythmic foundation of the composition through the use of different viewpoints: whereas the objects are seen from the side, the tablecloth appears to be seen from above. But in making the surface of the canvas coincide with the surface of the table and the blue tablecloth, Matisse does not reject depth entirely. Everything in the painting is balanced on such a fine line that, even though Matisse avoids using atmospheric perspective, it is hard to tell whether there is any depth or not.

It is interesting to compare *The Red Room* and a Hans Purrmann *Still Life* (Staatliche Museen, Berlin) that was painted at about the same time, clearly in Matisse's school, where the German artist was responsible for collecting studio

10. Flam, p. 232.

11. In the scholarly literature, this work has often been dated to late 1909. According to Flam, it must have been painted at the beginning of the year, for it is mentioned in a letter from Matisse to Fénéon of 7 February, 1909 (Archives of the Bernheim-Jeune Gallery).

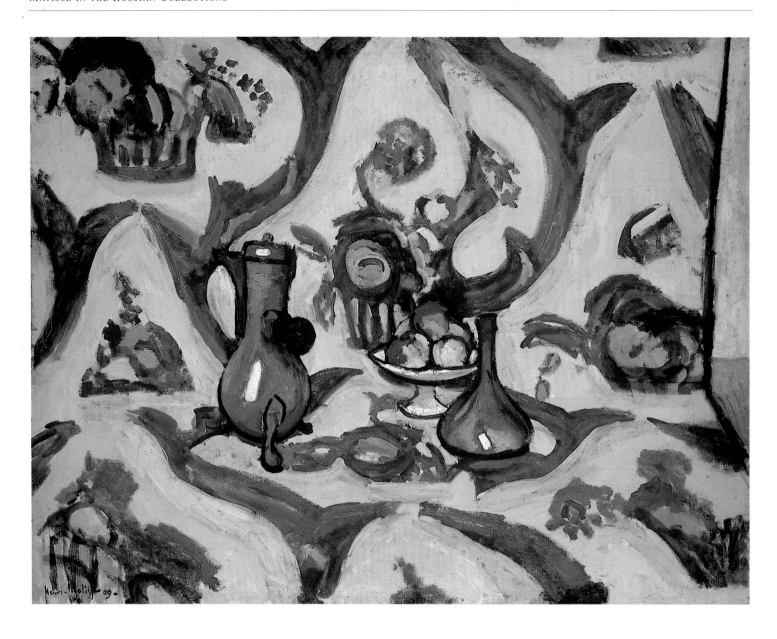

MATURE MORTE, CAMAÏEU BLEU, 1909
(STILL LIFE WITH A BLUE TABLECLOTH)
OIL ON CANVAS, 88 x 118 CM.
THE STATE HERMITAGE MUSEUM, ST. PETERSBURG
ACQUIRED BY SERGEI SHCHUKIN IN 1909 FROM
THE ARTIST

fees.[12] Purrmann also used Jouy cloth, and in a similar manner, allowing it to hang down from above onto the table. His painting, equally indebted to Matisse and to Carl Schuch, the leading Austro-German painter of realistic still lifes, is not the least bit phantasmagorical, for Purrmann's ideas of space are still determined by the nineteenth century, and the cloth here is no more than a background used for a rather traditional definition of space.

If Matisse painted the cloth in *Still Life with a Blue Tablecloth* in tones closer to the actual ones than he had done in *The Red Room*, he clearly approached the problem of color with the same freedom as before. The coffeepot that figured in *Dishes on a Table* (in a color close to its natural one) here ceases to be a metal object and is dominated by ochres that provide a precise contrast to the light-blue field of the tablecloth. While simplifying and intensifying his colors, Matisse does not forget for a moment about the organizing role of the arabesque. Since the improvised tablecloth covers the entire surface of the table and the objects standing on it are only intended as decorations complementing the mighty arabesque design, the cloth, in Aragon's words, "poses": it becomes the artist's model.[13] And every time, this model (which appears in three works in the Hermitage alone) arouses a new feeling in the artist.

The confident decorative approach introduced in *Still Life with a Blue Tablecloth* determines the tone of the works painted in the summer of 1909 in Cavalaire-sur-Mer, a town on the Mediterranean coast where Matisse had worked in 1906. It seems most likely that this was where he painted *Bouquet de fleurs dans un vase blanc* (Bouquet of Flowers in a White Vase), a work that he selected especially for Shchukin.[14] Such frontal bouquets were a great favorite of Odilon Redon, but he always "attached" them to vertical formats and, above all, endowed them with a special air of mystery. Matisse undoubtedly knew his work, just as he was evidently familiar with Gauguin's *Vase of Red Flowers* (1896), which was on display in Vollard's gallery before Degas acquired it. Unlike Redon and Gauguin, Matisse was not concerned with suggestive mood, and his *Bouquet,* while apparently a paraphrase of Gauguin's work, is filled with an openly antisymbolist intent. It is emblematically simple, clear, bright, resonant—one of his finest floral still lifes.

Matisse was probably also responsible for selecting another one of Shchukin's acquisitions, *La Dame en vert* (Woman in Green), which he stood in front of to be photographed when he was in Moscow. This portrait was also painted in Cavalaire-sur-Mer, at the time when Matisse once again turned his attention to a problem that had attracted him at the beginning of the fauvist period: the representation of the nude body in the open air. The model for the Cavalaire nudes, less impulsive than before, but decorative, with extensive use of bold arabesques, was Brouty (*Nu au bord de la mer* [Nude on the Seashore], *Seated Nude*). Brouty can also be recognized in *Woman in Green,* for the portrait is a very good likeness, but the most important thing for Matisse was, as always, the resolution of his painterly tasks in a decorative key: he was not interested in his model's psychology. There is an exceptionally soothing simplicity in the color scale based on a chord of white and green (which seems to echo the resonance of Near Eastern ceramics). By placing the brightest spot of color, the red carnation that is the woman's only adornment, at the precise center, where the diagonals intersect, Matisse emphasized the strictly centripetal character of his composition. The pose is extremely calm and traditional, and several details are arranged almost symmetrically. Could Matisse have been thinking of Hans Holbein, the god of portrait painting? In fact, *Woman in Green* is constructed in a manner very similar to Holbein's *Portrait of Jane Seymour.*

Matisse willingly made use of old, even hackneyed schemas, but he knew how to breathe new life into them, to fill them with a content that was new and absolutely contemporary. This painting, with the unobtrusive festivity of its colors and melodically repeated outlines, creates an atmosphere of sumptuous reserve.

Woman in Green and *L'Espagnole au tambourin* (Spanish Woman with a

MATISSE'S HOME. JOUY CLOTH
PHOTOGRAPH

12. This comparison was made at the exhibition "Das Stilleben und sein Gegenstand. Eine Gemeinschaftausstellung von Museen aus der UdSSR, der CSSR und der DDR," Dresden, Albertinum, 1983, cat. nos. 107, 134.

13. Aragon, vol. 1, p. 91.

14. In an August 1909 letter to Shchukin, Matisse informed the collector that he had reserved a "bouquet of flowers" for him. The letter has not survived.

BOUQUET DE FLEURS DANS UN VASE BLANC, c. 1909
(BOUQUET OF FLOWERS IN A WHITE VASE)
OIL ON CANVAS, 81 x 100.5 CM.
STATE PUSHKIN MUSEUM OF FINE ARTS, MOSCOW
ACQUIRED BY SERGEI SHCHUKIN IN 1909 FROM THE
ARTIST

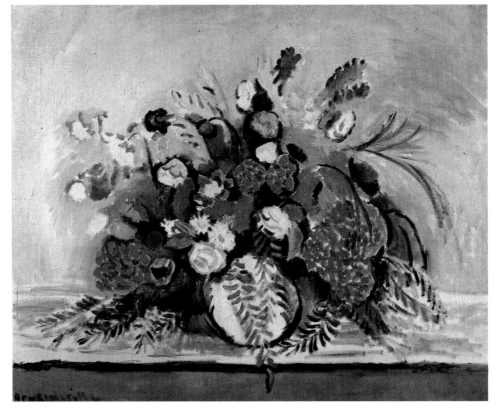

15. Matisse intended this work for the 1909 Salon des Indépendants, which opened on 25 March. Salon des Indépendants, Paris, 25 March—2 May 1909, cat. no. 1100, *L'Espagnole,* with a note, "for sale." Matisse had offered the picture to Shchukin before the exhibition.

16. In February 1910 *Girl with Tulips* was being prepared for the Salon des Indépendants, due to open in mid March. Salon des Indépendants, Paris, 1910, cat. no. 5445, *Jeune Fille aux tulipes,* with a note, "belongs to MM. Bernheim-Jeune."

Tambourine) belong to a special genre quite widespread in France during the Romantic period. They are not portraits in the literal sense of the word. For Matisse and Shchukin the models remained a nameless "woman" or "Spanish woman." Camille Corot worked in this genre, known as "figures" for a long time. Similar works became popular in avant-garde circles a few months after *Spanish Woman with a Tambourine* was painted, and the influence was seen in the work of Picasso and Braque, who were greatly impressed by an exhibition of Corot's work. It is quite possible that Matisse had drawn on this same source of inspiration somewhat earlier.

Spanish Woman with a Tambourine (also known as *Spanish Dancer*) was painted in early 1909.[15] The title is purely arbitrary, since the model was Italian. Matisse used to dress up his wife in a similar fashion when he painted her as a Japanese or Indian woman, and even as a Spanish guitarist. When he worked with models, he preferred to paint them either nude or in comparatively ordinary and familiar clothes. The seductive colors of Spanish costume, with the emphatically gaudy combination of black and red, had also attracted Edouard Manet. In accordance with the spirit of the new century, Matisse's "hispanism" is more incisive and simpler. The red skirt and the embroidered black jacket sit very well on the young brunette. Two large red flowers in her thick hair and a red tambourine in her right hand define the basis for the picture's unity of color. The tambourine is not only important as a detail of the subject; it is important for an understanding of the picture's formal structure: its oval shape is repeated in structures and rhythms in various parts of the composition (the head, the flowers, the skirt, the shape formed by the contour of the woman's shoulders and the hand on her hip).

Spanish Woman with Tambourine, Woman in Green, and the somewhat later *Jeune fille aux tulipes* (Girl with Tulips) are distinguished by the use of a unified silhouette produced by setting the figure on a monochrome background.[16] At this time Matisse was using quite different structures, in which the background was patterned and extremely "active" (*Portrait of Greta Moll, Jeune fille aux yeux verts* [Girl with Green Eyes], 1909, *L'Algérienne* [Algerian Woman], 1909). In the counterweight compositions painted with an "empty" background, no matter how decorative they might be, the human figure received greater emphasis; this

obviously impressed Shchukin, because he chose precisely these pictures.

Girl with Tulips recalls Aragon's report of a conversation with Matisse: "Henri Matisse confessed to me that every time he was seized by an instinctive desire to draw or paint some woman that could not be explained objectively by her beauty, the woman always had certain distinctive features that provoked his need: an exaggerated development of the base of the neck, a slight swelling of the thyroid, frequently accompanied by slightly bulging eyes. As though the instability of women's moods, their easy shift from tears to laughter, were the decisive elements of an attraction that in the final analysis must be regarded as beauty, a beauty for Matisse. And Matisse comments: 'All this is complicated by the attraction that I have always felt for Ingres's *Madame de Senonnes*. . . . Do you know *Madame de Senonnes* in the museum in Nantes? She also . . . she has a slight . . .' and Matisse points to his neck, with his fingers spread to indicate its distension."[17] The *Girl with Tulips* does in fact resemble Madame de Senonnes, although she is not as beautiful. The resemblance is less noticeable in the charcoal drawing in the New York Museum of Modern Art, which is clearly the first study from nature and still marked by a prosaic quality absent in the painting.

The painting shows Jeanne Vaderin, or Jeannette as the Matisses used to call her, a young woman who lived not far from them when they moved to the Paris suburb of Issy-les-Moulineaux in 1909. Jeanne Vaderin was recuperating from an illness. In 1910, in addition to *Girl with Tulips,* she posed for two bronze heads,

17. Aragon, vol. 1, p. 223.

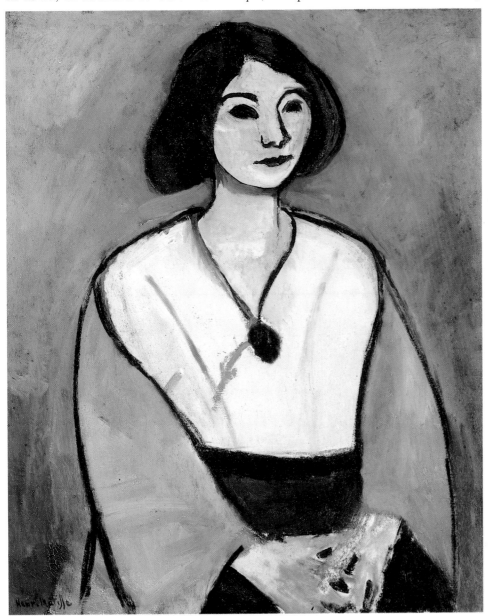

LA DAME EN VERT (LA DAME À L'ŒILLET), 1909
(WOMAN IN GREEN [WOMAN WITH A CARNATION])
OIL ON CANVAS, 65 x 54 CM.
THE STATE HERMITAGE MUSEUM, ST. PETERSBURG
ACQUIRED BY SERGEI SHCHUKIN IN 1909 FROM
BERNHEIM-JEUNE

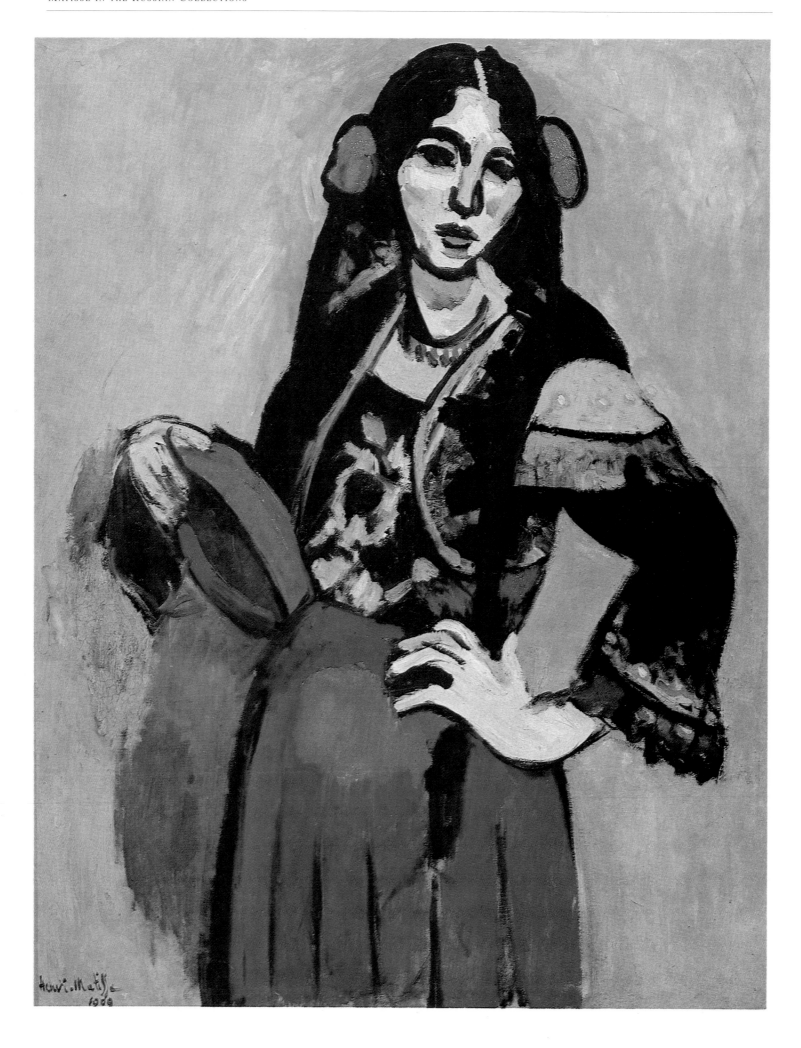

Jeannette I and *Jeannette II*, the first of which closely resembles her image in the picture. Three later sculptures of the period 1911-1913 were made without a live model and departed from an external likeness in order to resolve purely sculptural problems.

Although the colors of *Girl with Tulips* are more restrained than those of *Spanish Woman with a Tambourine,* the former also plays on the form of the oval, and with even more success. This is done so artfully and unobtrusively that Barr was not exaggerating in the least when he called this picture one of the great painter's most remarkable portraits.[18] When Matisse exhibited *Girl* in the Salon des Indépendants, he was warmly supported by Apollinaire.

"Let us speak first about Matisse," he wrote in *L'Intransigeant,* "one of the most abused painters of the present day. Only recently, did we not witness the entire press, including this newspaper, attacking him with rare fury? No man is a prophet in his own land, and while foreigners, in applauding him, applaud France, France herself is ready to stone one of the most captivating masters of the modern visual arts. I am happy once again to have been accorded an opportunity to render due homage to the honesty of this art. Matisse is one of those rare artists who have liberated themselves totally from impressionism. He strives not to imitate nature, but to express what he sees and feels through the very materials of art, just as a poet uses words from the dictionary in order to express the same nature and the same feelings.

"He possesses a genuine talent, and his lone canvas, exhibited among works that still reflect the influence of the impressionists, acquires greater significance. It is the one that is a genuine work of art."[19]

At Issy-les-Moulineaux Matisse painted *Bronze et fruits* (Fruit and Bronze) and *Nature morte au pot d'étain* (Still Life with a Pewter Jug), two works with very different compositions and coloring but linked by the fact that they both represent one of Matisse's other works. In *Fruit and Bronze,* as in *Still Life in Venetian Red,* a year and a half earlier, Matisse made use of a carpet as a "common denominator" but now set himself a more difficult task, since the new carpet had a rather distinctive design, based on a greater variety of colors.[20] Whereas in the earlier work the sculpture was emphasized so that it "stood out" as the most important feature among the series of objects, this time it retreats into the shadow and does not contrast with its surroundings. The statuette in *Fruit and Bronze* is an unusual piece of sculpture for Matisse: it is the only one to represent two figures. This more complex and dynamic combination of forms made *Two Negresses* more suitable for a "dialogue" with the blue and red carpet and the other objects in the still life. The 1908 statuette is a reminder of Matisse's lively interest in African sculpture, but he did not imitate any particular work; rather, one could say that he constructed his own "African" sculptural manner by employing emphatic formal articulations.

Like several of his other sculptures, *Two Negresses* was made from a magazine photograph. In this case, the photograph showed two naked Tuareg women (North Africa once again), whose poses were repeated in the sculpture, although the figures became more robust and stocky. In the still life, the statuette is presented frontally, using the same viewpoint as in the photograph.

The green bronze statuette is the key to a composition that involves a sophisticated interaction of forms and even has a certain ambiguity of spatial structure. The outlines of the statuette are rhythmically echoed in the designs of the carpet, the white vase, and the bottle, into which Matisse thrust a flower that could easily be taken for a detail of the carpet's design.

In the twenties, Matisse would often paint nude models against the colorful ornamental background of an oriental carpet, but long before that he introduced figures into his painting indirectly, in the form of sculpture, since it was easier at first for him to use such objectified figures rather than live models, in order to establish relations with other objects. [21]

18. Barr, p. 106.

19. Guillaume Apollinaire. "Prenez garde à la peinture. Le Salon des Artistes Indépendants. 6000 toiles sont exposées," *L'Intransigeant,* 18 March 1910.

20. The canvas was painted at the very beginning of 1910. In mid February it was already on show in an exhibition at the Bernheim-Jeune Gallery (no. 58), with an indication that it belonged to I. A. Morozov.

21. John Elderfield, *The Drawings of Henri Matisse* (New York, 1984), p. 90.

L'ESPAGNOLE AU TAMBOURIN, 1909
(SPANISH WOMAN WITH A TAMBOURINE)
OIL ON CANVAS, 92 x 73 CM.
STATE PUSHKIN MUSEUM OF FINE ARTS, MOSCOW
ACQUIRED BY SERGEI SHCHUKIN IN 1910 FROM
BERNHEIM-JEUNE

The unusual structure of *Fruit and Bronze* might also evoke Gauguin, starting from the fact that *Two Negresses* recreates the same situation as in *Two Tahitian Women on the Beach* (1892). The decorative features of the painting also echo the forms of some of Gauguin's canvases, such as *Mahana no atua* (Day of the God, 1894), which belonged to Degas. In *Day of the God,* the landscape and the figures become parts of a unified structure of ornament. Of course Matisse, an artist of the new century, does not repeat Gauguin; his colors acquire a resonance that could not be expected of painters in the nineteenth century.

In *Still Life with a Pewter Jug,* Matisse employs a substantially more simple arrangement, with several objects arrayed frontally along the paneled wall of his studio at Issy, which also figures in *Nature morte avec les géraniums* (Still Life with Geranium Plant, 1910) and later *L'Atelier rose* (The Pink Studio). The sideboard is shown in *L'Atelier rouge* (The Red Studio, 1911), where its color is extended throughout the interior.

The terracotta statuette of a reclining woman (1906-1907) was "quoted" by Matisse more often than any other of his own works, beginning with the *Nu bleu* (Blue Nude), a work for which it provided the "model." It occupies a central place in *Bronze aux œillets* (Sculpture and a Persian Vase, 1908). Several times it appeared in still lifes together with a goldfish bowl. The statuette, which is known primarily from bronze casts, reproduces the pose of one of the nudes in *La Joie de vivre*. The figures in this painting are pink, and by depicting the terracotta statuette in the canvas in the Hermitage, he returns to his starting point.

"The pose of this nude is in essence that which from the time of Dürer has signified Luxuria, or lust." [22] The reclining woman is a variation on the theme of a nymph: the sleeping nymph in the ceramic panel at Hagen is shown in a similar pose. Matisse's nymphs are sisters to the nymphs of Mallarmé, who was always one of the painter's favorite poets. Could Matisse have had Mallarmé's nymphs from "L'Après-midi d'un faune" in mind when he was working on his own embodiments of contentment and lust? "So clear their light incarnation, that it trembles in the air."

Whatever details of *Still Life with a Pewter Jug* we may turn our gaze to—the ornamental bronze cover of the sideboard, or the jug, or the twining plants—we detect echoes of the same motif: the langorous and captivating curves of the body of a nymph, the ancient symbol of an ideal world. Any other artist would have fallen into obtrusive affectation. But not Matisse.

He also quotes his own work in *Still Life with "La Danse."* In fact, this was the first time Matisse included one of his own paintings in another, paving the way for two highly important works of 1911, *The Pink Studio* and *The Red Studio*. To be sure, *The Dance* is the painting that has the most claim to serve as Matisse's "calling card," but this still life/interior is remarkable in its own right for the skill with which it is composed and painted.

The painting is simultaneously flat and three dimensional. The frontal boundary is marked in the manner of Cézanne—by a crumpled napkin, from which the surface of the table, covered by a tablecloth, recedes into the defined picture space. It is limited by another surface, formed by two canvases. One of them is *The Dance*. The other, not yet started, is turned face to the wall, a hint at the future decorative ensemble commissioned by Shchukin. Here we have the most vivid presentation, without any moderation, of the clash between static and dynamic, as the right-angled intersections of the slats of the stretcher seem to impede and slow the impetuous circular motion of *The Dance*. The vases of flowers link these two surfaces, and the very features of the Algerian vase, set precisely at the center of the composition, reflect the idea of harmony underlying the picture as a whole. The flowers echo the movement of the figures on the panel. Matisse even appears to confuse the spatial relations deliberately, so that the dark flowers and the black hair of a dancing woman merge together. The combination of flowers and dancing female figures, of nature and art, provides a powerful focus for that general

22. Lawrence Gowing, *Matisse* (London, 1979), p. 77.

LA JEUNE FILLE AUX TULIPES
(PORTRAIT DE JEANNE VADERIN), 1910
(GIRL WITH TULIPS [PORTRAIT OF JEANNE VADERIN])
OIL ON CANVAS, 92 x 73.5 CM.
THE STATE HERMITAGE MUSEUM, ST. PETERSBURG
ACQUIRED BY SERGEI SHCHUKIN IN 1910 FROM
BERNHEIM-JEUNE

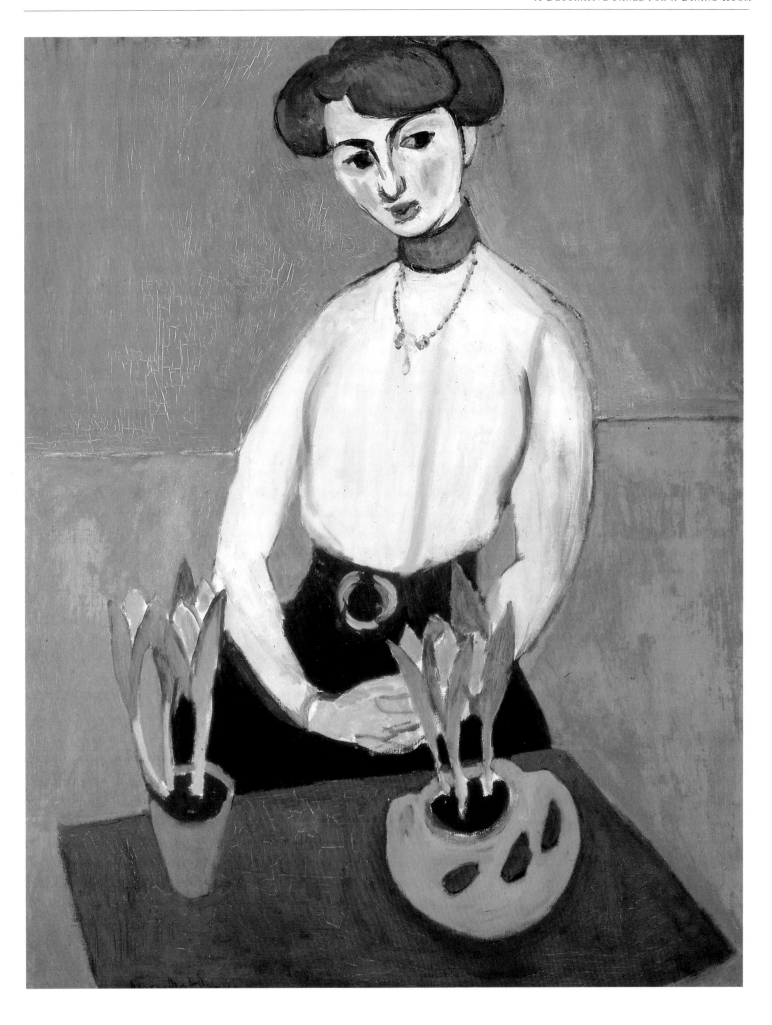

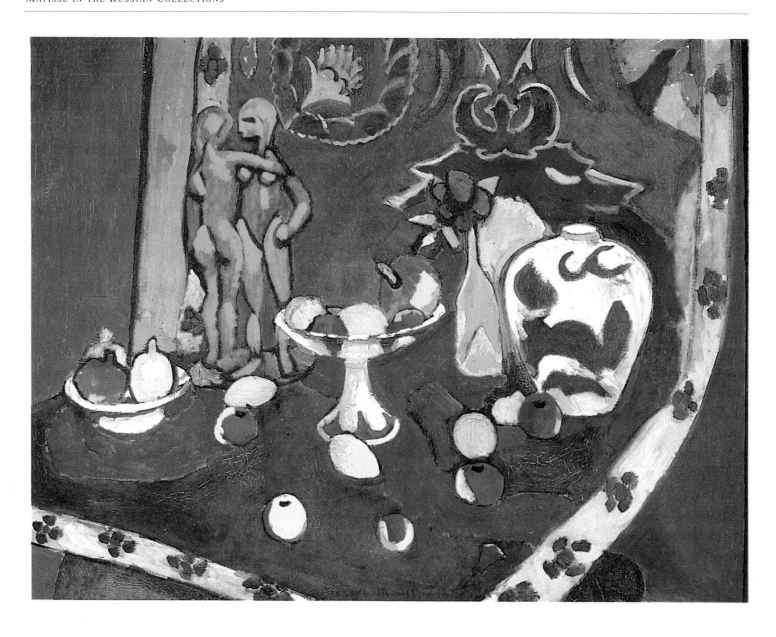

BRONZE ET FRUITS, 1910
(FRUIT AND BRONZE)
OIL ON CANVAS, 90 x 115 CM.
STATE PUSHKIN MUSEUM OF FINE ARTS, MOSCOW
ACQUIRED BY IVAN MOROZOV IN 1910 FROM
THE ARTIST

impulse of passion that symbolizes growth and vital élan. "The real and painted fruit and flowers on the table, the real flowers in the vase, and the painted women that rollick above them are compounded into a metaphor for the creation of life (echoed in the Michelangelesque convergence of the two hands)—a clear symbol of becoming." [23]

Since this canvas was one of the first records of work on Shchukin's ensemble, it is important to establish precisely when it was painted. Most scholars believe that this was the spring of 1909, an opinion disputed by Flam, who argues for autumn. The generally accepted point of view is based on the fact that the painting acquired by Ivan Morozov shows the first version of the panel, the so-called *Dance I,* which is now in the New York Museum of Modern Art. [24] Flam lacks adequate foundation for his assumption that it is the second version (the one in the Hermitage) that is shown, at an early stage. [25] Hans Purrmann, who lived in the same house as Matisse at the time, confirmed that *Dance I* was painted on the boulevard des Invalides, with amazing speed, in the space of one or two days. [26] Accordingly this must have been in the spring of 1909, and not at Issy. By that time Matisse must have already had a clear conception of the decorative ensemble commissioned by Sergei Shchukin.

4. *LA DANSE* AND *LA MUSIQUE*

If all of Matisse's oeuvre is divided into two parts, the boldest and most far-reaching undertaking in the first part would be the ensemble composed of *The Dance* and *Music.* Shchukin's part in its creation should not be underestimated. When asked if his father would have painted the panels on such a scale without Shchukin, Pierre Matisse replied, "But for whom?" [1] Every serious study of Matisse refers to the history of Shchukin's commission, which is not without dramatic aspects. [2]

When he came to Paris in late February 1909, Shchukin visited Matisse, who showed him the newly begun *Dance I,* then at the sketch stage, as seen in Steichen's photograph, before any color had been applied. [3] Shchukin was excited by the panel even in this state, and he was probably struck then and there by the idea that such a panel might look good on the staircase of his mansion. Matisse recalled that after the visit to the studio, Shchukin invited him to the restaurant Larue, where they discussed the new *Dance* and the price of the work. [4] It is not known whether the other panels were also discussed at this time, but most probably not, since Shchukin's first letter referring to *The Dance* speaks of it as an isolated work.

By this time, however, Matisse was probably developing a far broader concept. Indeed, he spoke about it to Charles Estienne, in an interview published in the newspaper *Les Nouvelles* on 12 April 1909. [5]

Matisse's letter to Shchukin of 23 March 1909 has not survived, but from the reply it is clear that the artist had offered the collector a three-part decorative ensemble, a proposal that Shchukin rejected, since he only had space to hang two panels. Matisse evidently gave the interview to Estienne at the end of the month, before he received Shchukin's reply of 27 March.

Shchukin had already expressed the hope of acquiring two panels, in his letter of 16 March, when he emphasized that they should contain no nudes, a condition on which he continued to insist. Having been obliged to accept the idea of a two-part ensemble, Matisse sent two watercolor sketches to Moscow: *Composition No. 1* and *Composition No. 2.* The first, of course, was *The Dance* and the second was "a recreational scene." Matisse was so enthused by the chance of painting the latter that when he received a notification of payment from Shchukin's firm dated

23. Flam, *Matisse. The Man and his Art,* p. 272.

24. Ivan Morozov bought *Still Life with "La Danse"* for 5,000 francs at the beginning of 1910, shortly before Matisse's exhibition in the Bernheim-Jeune Gallery. *The Dance* thus arrived in Moscow before Shchukin's version.

25. Flam, pp. 495-496. A simple comparison is sufficient to establish that the panel represented in Morozov's picture is undoubtedly *Dance I.* Unlike the figures in *Dance II,* the dancers in the first panel are all brunettes, and the dancers in Morozov's picture all have dark hair as well. In order to fit the facts to his argument, Flam has suggested that Matisse first copied *Dance I* onto a new canvas, which was supposedly depicted in Morozov's picture, and then reworked it afterward to produce *Dance II.* However, the version of *Dance* in the Hermitage shows no signs of having been reworked. And why should Matisse, whose copies of other artists were always painted with a free hand, copy himself? He could have simply used the first panel and reworked it.
Two photographs by the famous American photographer Edward Steichen, show Matisse in front of a small panel that bears only a drawing: this is clearly *Dance I.* Furthermore, one of the photographs shows a different canvas standing on an easel: this is the newly begun *Still Life with "La Danse."* Flam attempts to bolster his argument by pointing to the boots Matisse was wearing in the photographs as evidence that the picture was painted at Issy-les-Moulineaux. He thus concludes that the work was not done in the spring, when Matisse was still working on the boulevard des Invalides. These kinds of details hardly merit such decisive significance, however. Obviously the boots would not have been worn to the opening of an exhibition, but why should Matisse not wear them in his studio on the boulevard des Invalides, where it surely must have been rather cool in the spring?

26. John Elderfield, *Matisse in the Collection of the Museum of Modern Art* (New York, 1978), p. 55.

1. Kean, p. 193. I am reminded here of my own meeting with Pierre Matisse not long before his death. Standing in front of his father's wonderfully drawn portrait of Shchukin, he spoke about the Moscow collector with unfeigned admiration.

2. New details emerge from the letters of Shchukin included in this volume.

3. On 7 February Matisse was still in Cassis, and Shchukin wrote to him from Moscow on 4 March. The most likely time for them to have met is the final week of February.

4. Questionnaire VI (1951). Archives of The Museum of Modern Art, New York.

5. Charles Estienne. "Des tendances de la peinture moderne. Entretien avec M. Henri Matisse" (Some tendencies of modern painting. A conversation with M. Henri Matisse). *Les Nouvelles,* 12 April 1909, p. 40. English translation in Flam, *Matisse on Art,* pp. 47-49.

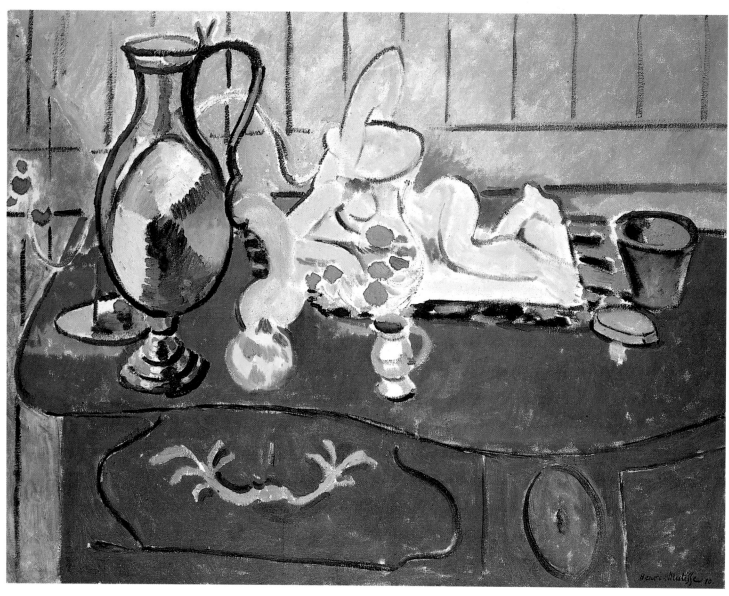

NATURE MORTE AU POT D'ÉTAIN, 1910
(STILL LIFE WITH A PEWTER JUG)
OIL ON CANVAS, 90 x 117 CM.
THE STATE HERMITAGE MUSEUM, ST. PETERSBURG
ACQUIRED BY SERGEI SHCHUKIN IN 1910 FROM
THE ARTIST

TERRE CUITE, GARGOULETTE ET FRUITS, 1915
(TERRACOTTA, WATER JUG, AND FRUIT)
OIL ON CANVAS, 80 x 100 CM.
TIKANDJAN TAIDEKOTI, VAASA (FINLANDE)

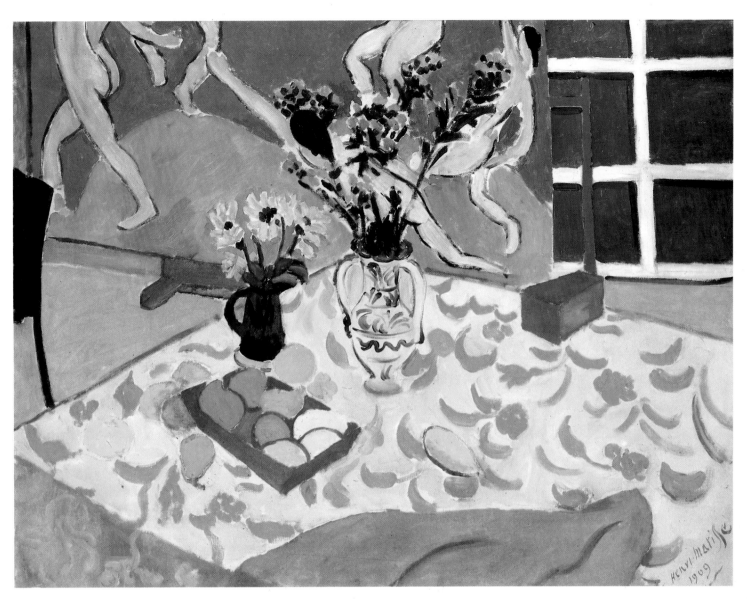

NATURE MORTE À "LA DANSE," 1909
(STILL LIFE WITH "LA DANSE")
OIL ON CANVAS, 89 x 116 CM.
THE STATE HERMITAGE MUSEUM, ST. PETERSBURG
ACQUIRED BY IVAN MOROZOV IN 1910 FROM
THE ARTIST

MATISSE AT WORK ON *STILL LIFE WITH "LA DANSE"* IN HIS
STUDIO AT ISSY-LES-MOULINEAUX, 1909
PHOTO: EDWARD STEICHEN
MATISSE ARCHIVES, PARIS

19 March (in those days letters from Moscow reached Paris in three to four days), he promptly used the document for a rough sketch of the composition, i.e. *Composition No. 2*. At first it included four figures, but in the sketch that Matisse sent to Shchukin there were already five, and he would maintain this five-figure formula through all the panels of this decorative series. Shchukin rejected the idea of *Composition No. 2*, which served as the basis of the composition for *Les Demoiselles à la rivière* (Bathers by a River) a panel the same size as *The Dance* and *Music* and which was clearly begun at the same time as them but finished considerably later, in about 1916. The female bathers in this "recreational scene" are cézannesque in mood, reminiscent of the three-figure composition that Matisse himself owned (now in the Petit Palais, Paris) and the five-figure composition (Arts Museum, Basel) that inspired several leading members of the avant-garde (Picasso, Derain, Dufy, Friesz) to paint their own versions.

In a letter of 31 March (first published by Barr, who mistakenly attached to it part of another letter, which served to confuse Matisse scholarship for a considerable time, until Beverly Whitney Kean set things right), Shchukin told Matisse: "I find so much nobility in your panel 'The Dance,' that I have decided to ignore our bourgeois opinion and hang a subject with nude figures on my staircase. At the same time I shall need a second panel, the theme of which could be music."[6]

In fact, Shchukin's rejection of Matisse's proposed "recreational scene" was quite unusual. The Moscow collector always demonstrated the greatest respect for any project undertaken by an artist, especially if that artist were Matisse. Pierre Matisse explained that Shchukin was the ideal client, precisely because he never attempted to influence the program of a work.[7] The only occasion on which Shchukin departed from this rule was in the case of *Music*. This exception has been explained by the fact that Shchukin was deeply impressed by the painting *Music* (1907) in the collection of Leo and Gertrude Stein (now in The Museum of Modern Art, New York). Shchukin must certainly have been familiar with this picture from his visits to the Steins, but we possess no information concerning his feelings about it.[8] At the time the commission was placed, he would not appear to have considered it superior to Matisse's other works. He was then buying bolder pieces on a grander scale, and we know that once he moved on, he never turned back.

6. Barr, p. 555; Kean, pp. 297-299 (letter XIV below).

7. Kean, p. 160.

8. Barr, and others following him, have considered that the version of *Music* now in New York served as the stimulus for the conversation in which Matisse and Shchukin discussed the commission (Barr, p. 78). But it remains a dubious assumption that they discussed the program of the composition, for this would have been out of keeping with Matisse's and Shchukin's understanding of the relationship between artist and collector. Furthermore, the request for a sketch indicates that the idea of *Music* was not clear to Shchukin at first, and indeed, it took time to crystallize for Matisse himself.

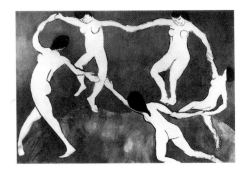

LA DANSE, FIRST VERSION, 1909
THE MUSEUM OF MODERN ART, NEW YORK

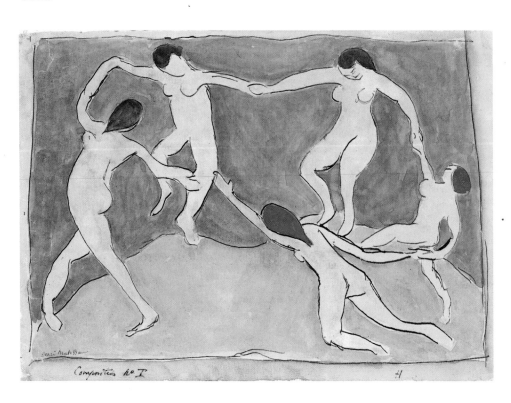

LA DANSE (COMPOSITION NO. 1), c. 1909
(THE DANCE [COMPOSITION NO. 1])
PEN AND INK, WATERCOLOR, 22 x 32.1 CM.
STATE PUSHKIN MUSEUM OF FINE ARTS, MOSCOW
GIFT FROM MATISSE TO SERGEI SHCHUKIN

Shchukin did not receive a sketch of the second panel along the lines of *Composition No. 1* and *Composition No. 2*. Perhaps Matisse found himself hesitating before "a musical scene with attentive listeners." We certainly know that *Music* cost him a lot more effort to produce than *The Dance*.

Just before Shchukin had placed the commission, some other decorations had arrived in Moscow—in 1908, large panels from Maurice Denis's "History of Psyche" series were installed in Ivan Morozov's house on Prechistenka Street, where Shchukin, of course, saw them very soon. He had not yet received *The Red Room,* so his own mansion could not boast any modern decorative painting. Only quite recently Shchukin had been fascinated by Denis, but now this kind of painting was not original enough for him. The success of "The History of Psyche" among the connoisseurs of Moscow could not help but spur on Shchukin, who enjoyed the passion of competition, and it seems quite reasonable to assume that the appearance of Denis's paintings in Moscow was one of the reasons why Shchukin commissioned decorative panels from his "own" artist, Matisse.

Once he had made his choice and agreed on the overall program with Matisse, Shchukin reminded him from time to time about his "decorations," but the artist did not start work on them straight away. He clearly had no intention of repeating *Dance I*. To judge from Shchukin's acquisitions of the time, the color range of the first version might not have suited him, a supposition supported by Matisse's own words about colors "to suit your taste" in a letter to which we shall return below. Before storming a fortress so unlike any he had conquered to date, Matisse required a break: real work on the panels could only begin after his return from Cavalaire-sur-Mer.

In August he wrote to Shchukin: "After two, almost three months by the sea I am returning to Paris satisfied with the health of all my family and the work I have done here. I have finished the model and am starting to work on documents that will be very useful—for your decorations. . . ." [9]

The "documents" referred to were probably material of some kind that Matisse was collecting—we must assume that it was in some way related to *Music*. Another rough draft, this time of a later letter, is relevant to the final stages of work on the panel: "I am sending you, as promised, a photograph of the *Music* panel, which is still in progress. It is a pity that you cannot see the harmony of color, which is very full and will, of course, suit your taste. Several days ago I drew back

LES DEMOISELLES À LA RIVIÈRE, 1910-1916
(BATHERS BY A RIVER)
OIL ON CANVAS, 261 x 391 CM.
ART INSTITUTE, CHICAGO

9. Matisse archives, Paris. This letter, obviously sent from Cavalaire-sur-Mer, has not survived. The date on the rough draft—August 1909—was added later, but there is no reason to doubt its accuracy. The existence of a rough draft indicates that Matisse thought this letter particularly important, presumably since he felt obliged to explain the delay in the work on the panels.

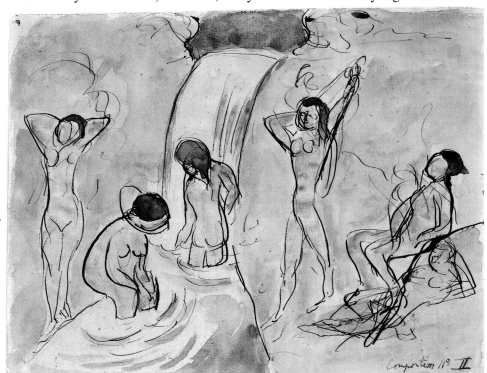

COMPOSITION NO. 2, 1909
INK, PEN, BRUSH, WATERCOLOR, 218 x 293 CM.
STATE PUSHKIN MUSEUM OF FINE ARTS, MOSCOW
GIFT FROM MATISSE TO SERGEI SHCHUKIN

10. Matisse archives, Paris. The dating of this rough draft to 1909 is clearly an error. The letter was sent to Shchukin in Italy, where he spent the summer of 1910, probably in mid August.

11. The photograph has not survived.

12. The pictures hung at right angles to each other on the staircase of Shchukin's mansion. Unfortunately they were not photographed at the time. The spatial relationship was maintained when the canvases were transferred to the Hermitage; in the late 1950s they were hung in a complicated fashion on the landing of the Wooden Staircase in the Winter Palace. See the reproduction in John Russell, *The World of Matisse* (New York, 1969), pp. 88-89. In the early 1970s considerations of conservation led to the transfer of the panels to one of the Matisse halls.

13. The bonding between the different layers of paint is so weak that the work cannot travel to exhibitions.

14. Diehl.

15. Barr, pp. 88-89. In his notes Barr specified that the Giorgione he had in mind was the *Fête champêtre* in the Louvre, but this painting is now believed to be the work of Titian.

from this panel in order to attack *Dance,* and I am already convinced that I shall achieve. . . [illegible] that I planned. After this panel I shall, of course, take up *Music* again [a few lines are crossed out here], in order to finish it. . . . I think that you will be completely satisfied. You will therefore find the photograph on your arrival in Moscow. In the meantime I hope that you will see *Music* before you return from Italy. Could you not come to Paris?

"Since this work has held me back a great deal during the winter and is taking up almost all the summer, I cannot do much outside the studio. A month ago I allowed myself to be so bold [several lines crossed out] of the fact that you mentioned to me the payment that you would like to make for the decorations in summer, in June. I therefore allow myself the liberty of asking you to pay part of the sum, which I require as a payment for the construction of my studio. . . ."[10]

Matisse worked on Shchukin's first panel within the framework of the composition defined in *Dance I,* but the painting became denser and the general color range shifted, as did certain individual details: the line of a hill, the positioning of limbs captured in swift movement. With *Music,* things were more complicated. We can see from photographs of the work in progress that Matisse entirely repainted this picture at least twice. The first photograph shows the outline drawing of the figures already in place, but the artist has scarcely applied any color, merely accenting the spatial positioning of the figures and the line of the twin-peaked hill (which was later almost completely straightened) In the other photograph, the entire canvas already has a substantial covering of paint, and there is actually more detail than in the final state—flowers growing on the hill, a dog at the violinist's feet, subtleties of shade in the treatment of the hill and the sky would all be eliminated. Most likely it was this second photograph that Matisse sent Shchukin.[11]

Since *Music* and *The Dance* were destined to hang side by side in Shchukin's house and not on separate floors, as in the original conception, Matisse had to do everything possible to unify the impact of the two panels.[12] This was a difficult task, for the last thing he wanted to do was sacrifice the magnificent, tightly sprung energy of *The Dance,* and in fact he strove to intensify its dynamism. *Music,* originally conceived as a counterbalance to *The Dance,* came to embody a calm that was anything but pacific and relaxing: it was an energetic and creative calm, the calm that is a match for motion. Matisse painted over the canvas again and again in the attempt to achieve this, even to the detriment of certain technical precautions.[13]

Shchukin's ensemble was preceded by the 1907 painting *Music* (now in The Museum of Modern Art, New York), which combined music-making (a violin), listening (a woman in the foreground with her head propped on her hand), and dance (a pair of girls in the middle ground). The wooden bas-relief *Dance* (Matisse Museum, Nice), made at the same time, shows nymphs in an ecstatic dance, a motif that also appeared on a painted vase of that year (Steinberg Collection, Los Angeles).

The "ancestor" of all of these works, including Shchukin's ensemble, was *La Joie de vivre* (1905-1906), with its circle of nude women (albeit six rather than five) dancing energetically in the background. "I have had this dance in me for a long time," Matisse told Gaston Diehl, "and I have already put it into 'La Joie de vivre,' my first large composition."[14]

La Joie de vivre is full of nude figures, mostly women. Barr was the first of several scholars to note that its theme is derived from the arcadian pastoral scenes and bacchanalia that the old masters used to paint. Among Matisse's precursors, Barr lists Bellini (*The Feast of the Gods* in Washington's National Gallery), Giorgione, Titian, Rubens, Poussin, Corot, Cézanne, Puvis de Chavannes, Gauguin, and the Nabis.[15] It is extremely tempting to compare *La Joie de vivre* with Titian's *Bacchanalia* in the Prado. In both cases the action unfolds in an ideal landscape. The pose of Matisse's nude in the bottom right corner corresponds to

that of Titian's sleeping nymph in the same location. In both paintings there is a woman playing a flute, and a dance in the background (in Titian's painting, there are five women dancing).

But there is more than the bacchanalia of the old masters to be considered in constructing a genealogy for *La Joie de vivre:* Matisse's picture is also a vision of paradise, and one that is tinged with many very personal notes. Thus it must also be compared with representations of paradise in earlier art, notably the Renaissance "gardens of love" that treated Christian themes in terms of pagan love motifs. This conception found its expression in allegories such as Lucas Cranach's *Golden Age* (National Gallery, Oslo, and other versions). The similarity between Cranach's composition and *La Joie de vivre* is so striking that it cannot be accidental. Matisse was probably familiar with engravings of the earlier work rather than the original painting, but in any case, the woman with raised arms, the reclining woman in the center, and the six dancing figures of *La Joie de vivre* can be seen as a restructured mirror image of *The Golden Age*.

The motifs of *La Joie de vivre,* especially the group of dancers and the reclining figures, in fact, everything that the old masters painted so freely, became commonplaces in the artistic iconography of the turn of the century. Even if Matisse was not directly inspired by Cranach's *Golden Age,* he would have been only too familiar with modern variations on the theme. These were favorite subjects in the 1890s, especially among artists subscribing to the Art Nouveau style.

Matisse was just starting out when Art Nouveau was in full bloom, and while he escaped its seductive allure, the points of contact in *La Joie de vivre* are obvious: the decorative quality, the linear structure based on flowing, closed contours, the flatness of the images. These are, of course, no more than passing encounters, for Matisse was no exponent of Art Nouveau. He simply drew freely on the iconography of this movement and others to which he can be linked through iconographic "bridges" in his major works of the pre-fauvist and fauvist periods: *Luxe, calme et volupté* (Luxury, Calm and Sensual Pleasure, 1904-1905), *La Joie de vivre,* or the different versions of *Luxe.*

It is interesting to compare these works by Matisse with various visions of the *Golden Age* that appeared in both the official and unofficial salons. One picture that immediately comes to mind is Henri Martin's *Sérénité* (Serenity), an immense canvas first exhibited at the 1889 Salon, and subsequently hung in the collection of the Musée du Luxembourg. Martin's monstrously huge work could not possibly have escaped Matisse's attention. It is even possible that he borrowed the title *Luxe, calme et volupté* from Baudelaire in order to counterpose his own painting to Martin's. In terms of emotion, Matisse and Martin are polar opposites, the full-blooded sensuality of one contrasting sharply with the anemic feelings of the other. Both paintings present a group of dancers in the background, but Martin's are draped in white robes. A similar group of five girls dancing appears in Alphonse Osbert's *Vision.* There are many similarities in turn between the works of Martin, Osbert, and other exhibitors at the Paris salons and the images of pastoral music-making and dancing to be found in European graphic art, especially in illustrations for books and magazines.[16]

The Dance and *Music* were ultimately rooted in an enduring tradition that had regenerated itself in the work of the symbolists.[17] The circle dance had become a rather hackneyed motif whose artistic possibilities were very impressive to fin-de-siècle sensibilities. It found a natural expression in the closed form dear to Art Nouveau artists, who also preferred female figures and complex, dynamic compositions. (Indeed, among the symbolists and practitioners of Art Nouveau, the circle dance was typically not represented with three figures, as in Carpeaux, or even with four, as in Daumier).

Dance was regarded as the primal and most vital embodiment of the dionysian principle. At the end of the nineteenth century, this eternal theme received an

16. For a more detailed discussion of Matisse's precursors in developing the iconography of *The Dance* and *Music,* and an interpretation of the conceptual content of the Shchukin panels, see Albert Kostenevich, "'La Dance' and 'La Musique' by Henri Matisse. A New Interpretation," *Apollo,* December 1974, pp. 504-513.

17. The sources for *The Dance* and *Music* listed by John Neff include a board for a trellis painted by Goya (1791). Neff's sources for *Music* also include Gauguin's *Arearea* (1892), which was in fact a variation of another musical composition by Gauguin, *Tahitian Pastorales* (1892).

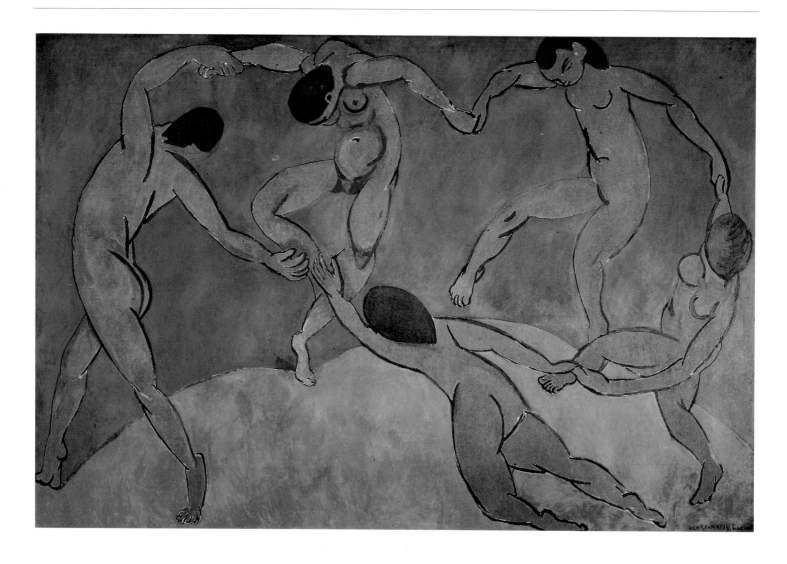

LA DANSE, DECORATIVE PANEL, 1910
(THE DANCE)
OIL ON CANVAS, 260 x 391 CM.
THE STATE HERMITAGE MUSEUM, ST. PETERSBURG
ACQUIRED BY SERGEI SHCHUKIN IN 1910 FROM
THE ARTIST

added stimulus through the growing influence of Nietzsche, who considered that music and dance contained "the eternal truths of Apollo and Dionysius." It would be an obvious exaggeration to claim that Matisse was influenced by Nietzsche, but he was caught up in that rising tide of European culture in which the German philosopher's ideas played so large a part. Nietzsche's comments can be applied more aptly to Shchukin's panels than to any other representation of dance and music in modern art.[18] In a book authorized by Matisse himself, Raymond Escholier speaks of the dionysian passion of dance and music.[19]

The figures in Matisse's panels do not create art simply because they dance, sing, and play but because they surrender themselves to dance and music as only an artist can. Thus the theme of the diptych could be formulated as man's relationship to life as mediated by art, a subject that was naturally of such immense importance for Matisse that it took him far beyond the solution of purely decorative tasks.

In the works of the old masters, and in those of the salon and demi-salon artists of the late nineteenth and early twentieth centuries, the musicians and dancers can usually be recognized as idealized portraits of their own contemporaries. By contrast, it would be strange indeed to describe the personae of *The Dance* and *Music* as contemporaries of Matisse, or even as embodiments of his ideas about his contemporaries. Not only do they wear no clothes, but, apart from the antique flute and the violin, which were added later, there are absolutely no indications of what era they belong to. They are unaware of their nakedness, which is to say, they behave like figures from myth rather than from historical time. Initially, the figures in *The Dance* and *Music* were sometimes taken for primitive people, but this was clearly the wrong track, for Matisse's painting had nothing in common with the "historical" works of the Paris salons that paraded an archaeological fancy-dress ball in front of the public as a reconstruction of the life of savages. Even if they had been told that Matisse's characters were not historical but symbolic, however, the public would have found it hard to come to terms with *The Dance* and *Music*. The symbolists had accustomed them to symbolism of a different kind.

Luxe, calme et volupté, La Joie de vivre, and *Luxe* are nourished by a dream of the primal Golden Age, a dream that has fired the imagination of many generations. But a great artist cannot dream for too long: consciously or unconsciously, his work will reflect the passions of the age, the pulse of his own time. The intense severity of the Shchukin ensemble, which seemed unaccountable in 1910, is now seen rather differently: the world-shaking events that followed closely upon its creation have set it in a different perspective.

The simple artistic structure of the Shchukin panels masks a content that is far from simple, including at once a certain sense of foreboding and a meditation on the prehistoric past, as well as a reflection of some of the artist's individual impressions. "I like dance very much," said Matisse. "Dance is an extraordinary thing: life and rhythm. It is easy for me to live with dance. When I had to compose a dance for Moscow, I had just gone to the Moulin de la Galette on a Sunday afternoon. And I watched the dancing. I especially watched the farandole This farandole was very gay. The dancers hold each other by the hands, they run across the room, and they wind around the people who are standing around. It is all extremely gay. . . . Back at home, I composed my dance on a canvas of four meters, singing the same tune that I had heard at the Moulin de la Galette, so that the entire composition and all the dancers are in harmony and dance to a single rhythm."[20]

It would be naive to explain *The Dance* as no more than an impression of the farandole at the Moulin de la Galette or the sardana at Collioure. The farandole set the necessary mood for the work, but the painting's message is deeper than it might appear at first sight. By transferring the action of his panels into the distant mythical dawn of humanity, Matisse created a structure of images endowed with profound symbolic meaning.

The first dances were an expression of magic, the primal act of creation,

18. Friedrich Nietzsche, *The Birth of Tragedy from the Spirit of Music* (London, 1965), pp. 23-24.

19. Escholier, op. cit.

20. Georges Charbonnier, "Entretien avec Henri Matisse," *Le Monologue du peintre,* vol. 2 (Paris, 1960). English translation in Flam, *Matisse on Art,* p. 138.

MATISSE AT WORK ON THE PANEL *THE DANCE,* 1909
PHOTO: EDWARD STEICHEN

LES JOUEURS DE PIPEAUX, 1909-1910
(PIPERS)
SKETCH FOR THE PANEL *MUSIC*
PEN AND INK, PENCIL
PRIVATE COLLECTION

21. Letter from Matisse to Romm, October 1934.
Archives of the State Pushkin Museum of Fine
Arts, archive 13, collection VI, no. 127/10.

embodying the victory of life over death. Scholars of the symbolism of ancient cultures have noted that dances performed with linked hands signify the union of earth and heaven. Art (be it dance or music) allows the human being to participate in this union.

For Matisse, the earth and the sky are more than a background: they are effectively protagonists in the action, and this is why he had to condense and simplify their colors. The tonal range of the Shchukin panels absorbed a voluminous symbolic content. It was not merely the desire for decorative unity that required such uniform tonality: the close matching of the colors in the two canvases elevates the theme of the earth and the heavens to cosmogony. In both panels the action takes place on a hill, which, like the mountains, is a traditional symbol of the junction of the earth and the sky, and by extension, the ascent to the realm of the spirit.

When painters have treated music symbolically, rather than as a theme for genre painting, it has often served—especially in medieval art—to embody the concept of universal harmony. Of course *Music* is far removed from the harmonious spirit of Christian art, but just like *The Dance*, it emphasizes the transcendental, mediating the cosmic through the human. It is surely no accident that although he took his inspiration from *La Joie de vivre*, Matisse reduced the number of dancing women from six to five. Five is a number that has always held a special meaning: the fact that we have five fingers, five bodily extremities, and so on has led us, from the most ancient of times through the Christian era, to regard this number as a cypher concealing some mystery. Matisse structured the composition of *Music* so that there would be five figures, and thus the total for the two panels would be ten—the number that signifies completeness and perfection.

Taken in isolation, neither *The Dance* nor *Music* express the full range of the artist's conception. Taken together, in powerful dialectical opposition, they say incomparably more. According to certain philosophical notions of the turn of the century, the woman brings the principle of unity to a group, while the man brings that of division and individualism, and the two antagonistic poles seek to unite. In the final analysis, *Music* is as static as *The Dance* is dynamic. Indeed, the final state of *Music* is remarkable for the miraculous immobility of the characters enchanted by the magic of sounds. Individual features have been simplified and reduced to common denominators. The same care has been taken to separate the figures in *Music* as to unite them in *The Dance*. Matisse worked stubbornly on *Music,* repositioning the figures in the process of painting. A close examination of the canvas reveals overpainted details showing through in several places. These modifications were partly intended to achieve a general economy of statement, but also to maximize the contrasts between the two panels. Thus, with the elimination of the woman in the upper right section of the composition and the substitution of a singing youth, *Music* became the embodiment of the male principle, while *The Dance* celebrated the female. The dog that initially lay at the feet of the violinist was probably a symbol of the power of music, a motif that goes back to antiquity—Orpheus charming the animals with his playing.

Matisse indicated that when he was working on *Music* and *The Dance*, he tried to saturate the canvas with the colors, in order to reveal their essence (absolute blue for the sky, for instance). He later wrote to Alexander Romm: "The intensity of the colors was what seemed most important to me. I felt that these colors, no matter how they were applied to the surface—fresco, gouache, watercolor, colored fabric—would be able to express the spirit of my composition. When I saw the panels in Moscow, I was astonished to see that I had varied the density of the colors with my brush, so that the whiteness of the canvas, showing through to different degrees, created the impression of a rather expensive moiré."[21]

When he spoke about *The Dance* and *Music* Matisse emphasized that their content and meaning went beyond the tasks of decorative art. "The Moscow panel," he wrote (referring to *The Dance*, which he was comparing with the Barnes

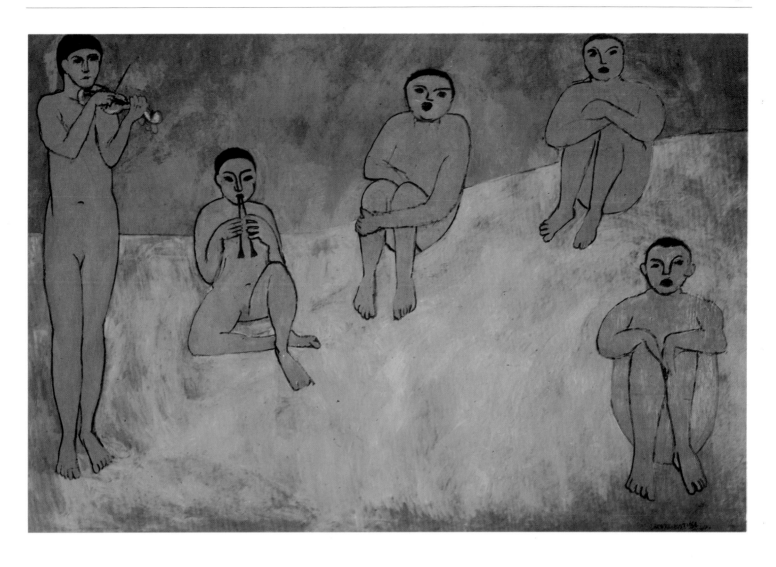

LA MUSIQUE, DECORATIVE PANEL, 1910
(MUSIC)
OIL ON CANVAS, 260 x 389 CM.
THE STATE HERMITAGE MUSEUM, ST. PETERSBURG
ACQUIRED BY SERGEI SHCHUKIN IN 1910 FROM
THE ARTIST

SÉVILLE I, 1910-1911
(SEVILLE STILL LIFE)
OIL ON CANVAS, 90 x 117 CM.
THE STATE HERMITAGE MUSEUM, ST. PETERSBURG
ACQUIRED BY SERGEI SHCHUKIN IN 1911 FROM
THE ARTIST

Foundation version), "still fulfills the requirements of a painting, that is, of a work that can be hung anywhere. This is only natural, since, not knowing the staircase where they were to be hung, I could not imagine how these panels would look in place. . . ."[22] In the end, the narrow, dark landing on Shchukin's staircase proved to be a less-than-ideal setting for the works, and yet even here they produced a powerful impression. The huge canvases look much better today, however, albeit in a place for which they were never intended: one of the halls of the Winter Palace in St. Petersburg.

When *The Dance* and *Music* were first exhibited, at the 1910 Salon d'Automne, the response was not good. The panels constituted such an insult to "good taste" that a large number of critics did not even comment on them.[23] However, André Fontainas and Charles Morice, influential writers of the symbolist camp, were not prepared to pass over the matter in silence. Fontainas found neither charm nor grandeur in what he termed Matisse's "wallpaper pictures"; Morice, meanwhile, situated Matisse at one pole of contemporary artistic life—with Vallotton at the other—and declared: "With his rich talent as a colorist, even in his worst errors he has frequently consoled us with beautiful color harmonies, as savory as rare phrases filled with hidden meanings. There is nothing of the kind in the two panels which he dares to consider 'decorative', and which he has called *The Dance* and *Music*. This is not even madness. There is genuinely nothing of any value left, nothing one could talk about, neither Painting, nor Music, nor Dance. Five naked men, pretending to play various instruments, five naked women, whose limbs trip over each other in furious disorder, and three broad bands of color—blue, green, red—that is all, and it is nothing."[24]

Morice's opinion was shared by the majority of Russian art-lovers and artists who visited the Salon d'Automne. Even that subtle painter Serov, who had only recently painted a portrait of Ivan Morozov against the background of Matisse's still life *Fruit and Bronze* and, while not accepting everything in Matisse's work, nonetheless acknowledged his talent, wrote to Morozov in Moscow: "Yesterday I was at the Salon—I very much liked one French painter, Chabaud. . . . He was also noted, in very positive terms, by several artists. Our Moscow Matisse— Mashkov—was not bad at all—seriously. His fruits are rendered extremely brightly and resonantly. Matisse himself I do not like—this is junk, and the little boys are really trash."[25]

The opinion first brought to the attention of the Russian public was quite different however. In his notes on the Salon d'Automne, Yakov Tugendhold, who had not yet grasped the innovative significance of the panels, nonetheless expressed several profound insights, and in any event, his comments were more intelligent than those published by the French critics: "Matisse's works—two huge panels—have roots that go further into the past than any others. *Music* and *The Dance*, painted for S. I. Shchukin, are the both the highlight and the bugbear of the Salon. Their deliberately crude drawing and garish colors may not necessarily please, but to dismiss them out of hand as 'nothing,' as the well-known critic Charles Morice has done, is simply not possible. Matisse's painting is no soap bubble; it is a complex phenomenon governed by its own laws. Matisse is a great talent, but a divided one: one half of his being belongs to our nervous, American reality; the other dreams of the naive monumentality of the primeval age, of the soul's lost harmony. Hence this voluntary descent into the depths of prehistory; hence this decorative ensemble, these harsh silhouettes, this brick-red color of the bodies, taken from antique vases in baked clay. Hence this bacchanalian frenzy of every element in the chain of a general circle dance. . . these werewolf boys hypnotized by the first sounds of the first instruments *(Music)*. But in transferring these primeval patches of color from the vases to a modern panel, Matisse "americanizes" the colors, transforming the panel into a gaudy poster that can be seen half a mile away. forgetting that mural painting has its own traditions. The modest Puvis de Chavannes remembered them; Matisse does not wish to understand them, and he has no time for them. But again, this is

22. Letter from Matisse to Romm,19 January 1934. Archives of the State Pushkin Museum of Fine Arts, archive 13, collection VI, no. 127/7.

23. cf. articles by Hamel in *Les Arts*, F. M. in *L'Art et les Artistes*, and Verneuil in *Art et Décoration*.

24. André Fontainas, "Le Salon d'Automne," *L'Art moderne,* 15 October 1910, p. 329; Charles Morice, "Le Salon d'Automne," *Mercure de France,* 1910, p. 88.

25. Letter from V. A. Serov to I. A. Morozov, 20 October 1910 (concerning the panels *The Dance* and *Music*), in *Valentin Serov v perepiske, dokoumentakh i interviou* (Valentin Serov in correspondence, documents and interview), vol. 2, pp. 237-238.

NATURE MORTE AVEC GÉRANIUMS, 1912
(STILL LIFE WITH GERANIUM PLANT)
NATIONAL GALLERY, WASHINGTON, D.C.

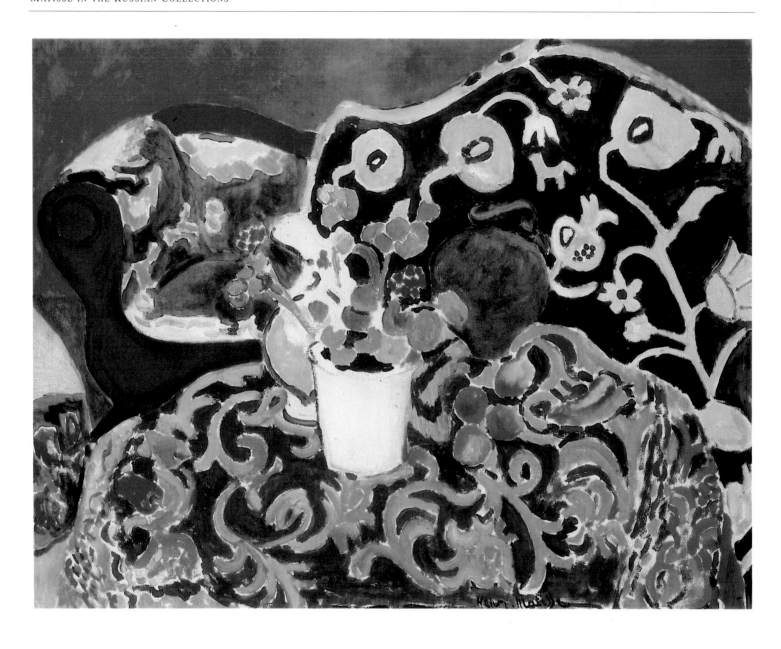

SÉVILLE II, 1910-1911
(SPANISH STILL LIFE)
OIL ON CANVAS, 89 x 116 CM.
THE STATE HERMITAGE MUSEUM, ST. PETERSBURG
ACQUIRED BY SERGEI SHCHUKIN IN 1911 FROM
THE ARTIST

typical of our era, this estrangement of talent from its material, this mingling of styles unknown in the past."[26]

Apollinaire was the only one to defend Matisse, in the few lines he devoted to the opening of the Salon. "The opening went off brilliantly. Crowds of people gathered in front of the decorative panels by Maurice Denis and Sert and enthused over the French furniture on the second floor. They discussed the decorative art from Munich. Matisse's pictures, as always, caused a scandal. . . . There were many Russians and Germans to be seen. As for painting, this year's Salon d'Automne offers few surprises. M. Henri Matisse's two panels make a powerful impression. The richness of the colors and the sober perfection of the drawing are indisputable this time, and one may hope that the French public will no longer be so standoffish with one of the most important painters of our era."[27] Unfortunately, this cheerful prognosis was not justified, and in another review of the Salon d'Automne, Apollinaire remarked: "I prefer the two panels that he has exhibited this year to all the other work done by this artist, whom I—and I say this without any posturing—have always defended."[28]

In the same article, however, Apollinaire praised Maurice Denis even more highly, calling his decorative compositions "the most remarkable works in the Salon."[29] His comments on the "exquisite music" of this ensemble were more than mere metaphorical compliment. Of Denis's eight canvases, inspired by Boccaccio's *Decameron* and entitled "Evenings in Florence," two—*Dance* and *Cantata*—dealt with themes similar to those of the panels painted for Shchukin, but in a totally different manner. This was the pleasant Art Nouveau of accessible, hackneyed symbolism and languid classical figures of beautiful women in an idealized Italian landscape: exactly what Matisse had challenged. Morice was wrong: it was not Vallotton who was Matisse's opposite, but Denis.

Even earlier, when Denis, with *La Joie de vivre* in mind, had described Matisse's art as abstraction, the fruit of theorizing, Matisse had taken it very badly. In early 1910 the influential Moscow critic P. P. Muratov, writing in the Moscow journal *Russkaya mysl* (Russian thought), used *The Dance* as an example to accuse Matisse of being intolerably limited and referred to Denis's similar opinion.[30] Denis called his own painting neotraditionalism, but as time passed it was dominated more and more by academic overtones.

In other circumstances Sergei Shchukin might have reacted more calmly to the way *The Dance* and *Music* were received, but the opposition was too unanimous. For all his independent spirit, he had to take some acount of the opinion of people such as Muratov and Tugendhold.[31] Shchukin almost refused to take the panels, and even made efforts to replace them with a large canvas by Puvis de Chavannes, The *Muses Greet Genius, the Herald of Light*, but eventually he managed to overcome his hesitation.[32]

Matisse himself was discouraged less by the hostile attitude of the critics (he was used to that) than by the fact that Shchukin's allegiance to him had almost been shaken. His disillusionment was so profound that he did not wish to continue working in Paris, and in mid November he went to Seville, where he soon painted two large still lifes, both in the mixed genre of the still life/interior now typical for him.[33] These pictures are sometimes regarded as a pair, but in fact they address different problems and do not form an ensemble. It is significant that Matisse himself did not position them as a pair when he hung Shchukin's collection. For the central motif of the *Séville I* (also known as *Interior with Spanish Shawls*), the artist collected the Spanish shawls that interested him so much. Their colorful patterns are contrasted with the designs of the upholstery of the sofa in Matisse's hotel room. The same objects appear in both pictures, expressing the different feelings they aroused in the artist at different times. The *Interior with Spanish Shawls* is more fragmentary and florid, whereas *Séville II* (also known as *Nature morte espagnole* [Spanish Still Life]) is more laconically drawn and its colors are stronger, which results in a different emotional key.

26. Yakov Tugendhold, "Osenny salon" (The Salon d'Automne), *Apollon,* 1910, no. 12, pp. 30-31.

27. Guillaume Apollinaire, "Vernissage d'Automne. Peu de surprises en peinture, presque pas de sculpture, mais beaucoup d'art décoratif" (Autumn salon opening. Few surprises in painting, almost no sculpture but a lot of decorative art), *L'Intransigeant,* 1 October 1910.

28. Guillaume Apollinaire, "Le Salon d'Automne," in *Chroniques d'art (1902-1918)* (Paris, 1960), p. 125.

29. Ibid.

30. P. P. Muratov, "Khudojestvennoye obozrenie" (Arts review), *Russkaya mysl* 1, 1910.

31. We know that Muratov and Shchukin were quite close from the fact that two years earlier Muratov had published a large essay devoted entirely to Shchukin's collection, which was the first serious attempt at a scholarly description. See P. P. Muratov, "Shchukinskaya galereia. Otsherk iz istorii noveishei jivopissi" (The Shchukin gallery. A study in the history of modern painting, *Russkaya mysl,* August 1908). In the period before and after 1910, Yakov Tugendhold, the most talented Russian art critic of his time, attracted the attention of many people, including Shchukin, with his commentaries from Paris. Somewhat later Tugendhold published a large article about Shchukin's collection: "Frantsusskoye sobranie S. I. Shchukina" (S. I. Shchukin's French Collection), *Apollon* 1914, no. 1-2.

32. Kean, pp. 197-199.

33. Previously the dating of the *Séville I* and *Séville II* still lifes was rather vaguely defined as 1910-1911. Sometimes they were even dated to early 1911. The similarity of titles and the themes has frequently led to the confusion of the two pictures.

5. SYMPHONIC INTERIORS

On his return from Spain Matisse once again immersed himself in intense work. The year 1911 was to be one of passionate involvement with large-scale compositions, a format he had not attempted more than once or twice a year since *La Joie de vivre.* This year he completed five large canvases (not counting *The Conversation,* which constitutes a separate problem): *The Painter's Family, The Pink Studio, The Red Studio, Intérieur aux aubergines* (Interior with Eggplants) and the *Grand Nu* (Large Nude) that was later destroyed and is known to us only from photographs and its reproduction in *The Red Studio.*

As far as we can tell, Matisse seems to have worked at the same time on *The Conversation,* one of his most unusual and enigmatic compositions. For some reason, he neither signed nor dated the canvas. Can we assume that he did not rate it very highly? According to Barr, "When asked about *The Conversation,* Matisse simply stated that he had wanted to try his hand at a large composition."[1] In 1912 the painting was sent to London for the prestigious Second Post-Impressionist Exhibition, which led to its renown.[2] That same year, it was purchased by Shchukin. In a well-known letter to Matisse, he wrote: "I am thinking a lot about your blue picture (with two figures). It seems to me like a Byzantine enamel, with such rich, deep colors. This is one of the most beautiful paintings that has remained in my memory."[3]

From this letter we may conclude that Shchukin was already familiar with the painting. Since he visited Matisse regularly, he knew what the artist was working on. Is it possible that a picture begun three or four years earlier was only shown to him in 1912? We cannot exclude the possibility: the huge canvas of *Bathers by a River,* which Matisse worked on from time to time, like several other pieces, remained unknown even to his closest associates.

The Conversation is variously dated between 1908 and 1912. Barr dates it to 1909.[4] Schneider, who has devoted an entire article to the painting and makes it a focus of his extensive monograph on Matisse, bases himself on the opinion of Matisse's daughter, Marguerite Duthuit, and insists on 1911.[5] Flam has proposed a compromise by dating the work between 1908 and c. 1910/1912.[6]

The Conversation was painted twice: it is quite clear even to the naked eye that the initial positions of the figures and the window were rather different, which provided Flam with his reason for extending the period of work on the picture over four years. He defines the end of the period on grounds of style and certain compositional elements that undoubtedly relate *The Conversation* to *The Red Room* and even more closely to *Harmony in Blue.* The paintings are all the same size and represent interiors with a window looking out on to a brightly lit garden. Each of them is dominated by a single color that occupies an unusally large and concentrated area of the picture surface.

In dating the beginning of work on *The Conversation* to 1908, Flam refers to several other paintings, including *Bathers with a Turtle,* in which the profile of the bather on the right prefigures the depiction of the woman in *The Conversation,* and in fact, the treatment of the head in both pictures is essentially the same. Even so, 1908 seems too early. Barr quite correctly links *The Conversation* with Issy-les-Moulineaux, where the artist moved the following year. Proof of this assertion is provided by the bars of the window in the painting, which resemble very closely the bars on the window of Matisse's house at Issy. As always, the artist drew his initial impulse from the real world. When he answered Barr's questionnaire, Matisse admitted that the characters in *The Conversation* were himself and his wife.[7]

In confirmation of the link with Issy, Schneider recalls the American journalist Clara MacChesney's account of her visit there in the summer of 1912. The gardener, she wrote, led her into "the studio built at one side, among trees, leading up to which were beds of flaming flowers."[8] The background of *The Conversation* includes a small section of the pink studio and its blue door, and we are invited, as

1. Barr, p. 126.

2. Second Post-Impressionist Exhibition, Grafton Galleries London, 1912, cat. no. 28.

3. Barr, p. 555 (letter XXXVII and note 1 below).

4. Ibid., p. 126

5. Pierre Schneider "The Striped Pajama Icon," *Art in America,* July-August 1975, pp. 76-82; *Matisse* (New York, 1984), pp. 16-25.

6. Flam, *Matisse. The Man and His Art,* pp. 249-251.

7. Questionnaire IV, 1950. Archives of The Museum of Modern Art, New York.

8. Clara T. MacChesney, "A Talk with Matisse," *New York Times,* 23 February 1913, reprinted in Flam, *Matisse on Art,* p. 50.

MATISSE'S HOUSE IN ISSY-LES-MOULINEAUX
PHOTOGRAPH
MATISSE ARCHIVES, PARIS

it were, to glance out at it and the garden through the second-floor window of Matisse's house.

Flam's other limiting date could also appropriately be "centered" by moving it to 1911, when Matisse was working on monumental compositions with one dominant color, including both the pink and red *Studios*.

Schneider explains his date of 1911 by the Byzantine influence.[9] There is no doubt that Matisse was genuinely interested in Byzantine art, but the phrase in Shchukin's letter has led Schneider to assume too much. At this time, Matisse was already a fully formed artist, and it would be an exaggeration to speak of some strong influence that only manifested itself in a single picture.

The magnificent simplicity of *The Conversation*'s structure is remniscent of not one but many sources known to Matisse. These are reflected in his work, not directly, through influence or borrowing, but on a different level, at which the ideas of other great artists are transmuted and totally integrated into the character of the modern work. Here it would be appropriate to mention not only Byzantium but Italy (in 1907 Matisse visited Padua, Florence, and Siena) and certain early Renaissance versions of the Annunciation, for *The Conversation* clearly repeats that iconographical image. The flat planar compositions of the early Florentine and Siennese masters, such as Simone Martini's *Annunciation* in the Uffizi Gallery show the figure of an angel in profile on the left and the Virgin dressed in black on the right. Giotto's Padua frescoes also come to mind, in particular, the *Annunciation with St. Anne,* where the setting is a modest and rather shady interior, while the center of the composition is occupied by the radiantly bright rectangle of a curtain. The rectangle of the window in *The Conversation* serves a similar function. In addition, there are Giotto's colors, especially his blue. In fact, Matisse actually mentioned Giotto in his "Notes of a Painter" a few months before he began work on *The Conversation*: "When I see the Giotto frescoes at Padua I do not trouble myself to recognize which scene of the life of Christ I have before me, but I understand the sentiment which emerges from it, for it is in the lines, the composition, the color. The title will only serve to confirm my impression." [10]

Yet another source that was very neatly picked up by Flam is the stele of Hammurabi in the Louvre, dated around 1760 B.C.[11] Its upper section is decorated with a relief in which King Hammurabi stands before the seated god Shamash, who is dictating the laws to him. The seated woman in Matisse's picture seems likewise to be giving instructions, which lends a certain irony to the title of the picture: the "conversation" is more of a monologue than a dialogue.

The hidden irony of Matisse's painting may perhaps be explained by comparing it with Bonnard's little-known work of the same name, which was painted almost

9. There is also the question of Matisse's knowledge of old Russian art, which is intimately related to the Byzantine tradition. Matisse's trip to Russia, where he saw a great many remarkable examples of icon painting, also took place in 1911 (see "The Visit to Russia, Autumn 1911" above). Matisse's high regard for the old Russian icon is a matter of record, but there are no grounds for seeking any specific influence from this quarter in *The Conversation*. The painting was in any case conceived and begun before the trip to Russia; when the final touches were made is a moot point.

10. Matisse, "Notes of a Painter," in Flam, *Matisse on Art*, p. 38.

11. Flam, *Matisse. The Man and His Art*, p. 252.

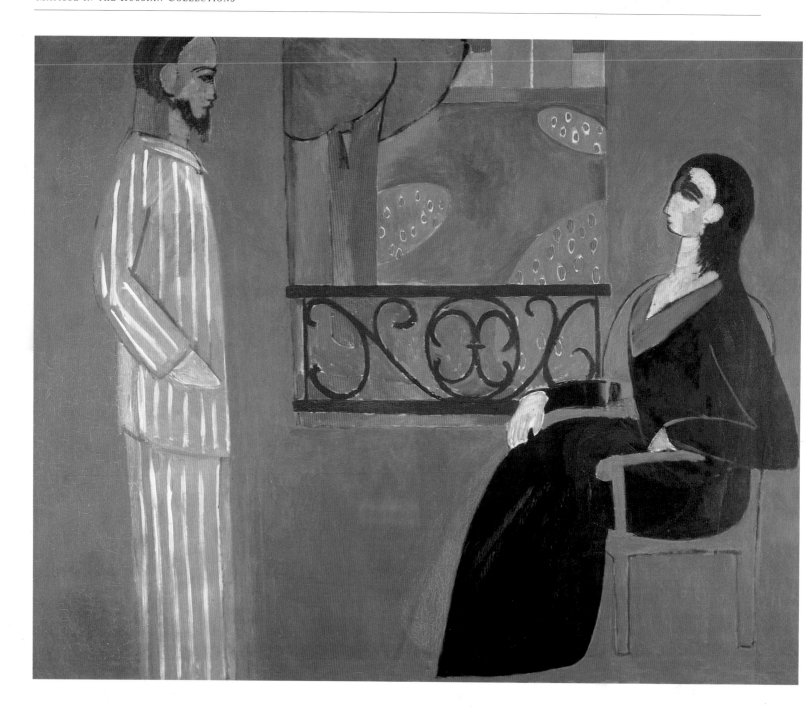

LA CONVERSATION, 1908-1912
(THE CONVERSATION)
OIL ON CANVAS, 177 x 217 CM.
THE STATE HERMITAGE MUSEUM, ST. PETERSBURG
ACQUIRED BY SERGEI SHCHUKIN IN 1912 FROM
THE ARTIST

two decades earlier, in 1890.[12] Bonnard's *Conversation* parodied the stereotype of Renaissance and academic Annunciations. It already combined irony and solemnity, the narrative structure of genre painting, and religious allusion, in short, all the elements that became part of Matisse's painting, which, in fact, repeats Bonnard's composition in reverse.

Barr has explained the basic impulse that resulted in the creation of *The Conversation* as a reaction against *The Red Room*. It seems highly unlikely that such a work could have been begun before *The Red Room* or at the same time. It is also logical to assume that after the transformation of *Harmony in Blue,* Matisse was bound to return sooner or later to a monumental composition in which the dominant color was blue. Barr, who admitted that *The Conversation* is not a pendant to *The Red Room,* nonetheless considered that it could well serve as such. It is hard to agree with this assertion however, because the different dynamics of the two paintings contradict the idea of such a relationship.

Just like *The Red Room, The Conversation* introduced into European art an unprecedented concentration of a single color, in this case blue. To be sure, this was five years after the end of Picasso's blue period, but even the "bluest" of Picasso's canvases are smaller than *The Conversation* and more important, they reflect a more simplified understanding of color. The deliberate application of a thick overlay of blue, so that objects appeared to be seen through blue glass, only signified that life was sad: the more miserable it was, the more palpable the spiritual potential of the characters becomes. In Picasso's blue works the significance of color remains purely symbolic. The blue of *The Conversation* is more organic, not only because of the contrast with other pure tones of green, black, and pink, but because of its dual nature: it has both a real and an ideal explanation, in contrast to the strictly ideal sphere of Picasso's blue.

The elemental blue that surrounds the two figures is in effect an ideal emanation of focused meditation, but also a specific property of the shadowy room, since both figures are shown against the light. The impressionists were the first to be fascinated by the blueness of shadows. A work such as *The Conversation* would have been impossible without them, but they would have been astonished at the conclusions drawn from their discoveries. Gauguin had already made color an absolute, endowing the nuances that the impressionists used in hopes of capturing momentary states with a timeless character. Matisse was even more radical, and this is why the blue shadow in *The Conversation* is not perceived as a shadow: it embodies the link between two worlds—the physical, where every object possesses a shadow if it is illuminated, and the spiritual, to which the artist's feelings belong.

Because Matisse did not strive to express things but the relationships between them, he did not allow them to cast real shadows, for these are appropriate only for creating illusions of real space. Matisse started from the fact that the canvas is a flat surface, and the sense of a flat surface should be preserved even in the finished work. He did not believe that the viewer needed a fragment of reality, a senseless mirror reflection: a work of art must serve higher goals than that of copying the objects of the external world. In *The Conversation,* the flat surface is not disrupted even by the gap of the window that opens out onto the garden, because Matisse has reduced the lawn to a simple flat surface and broken it up with spots of blue that reconcile it with the foreground (insofar as there is a "foreground" or a "background").

During the nineteenth century, the open window was one of the favorite motifs of the romantic painters, a particularly effective means for contrasting the prose of everyday existence, encircling them with household items and the narrow walls of their apartments, with the poetry of the infinite expressed in the mystical allure of distant spaces and the resounding promise of spiritual liberation. The motif of the open window provided the romantic aesthetic with its most tangible expression of the opposition between "here" and "there," and thus it was only natural that the

12. Pierre Bonnard, Exposition, Musée Rath, Geneva, 1981, cat. no. 1.

motif should not survive romanticism: a dream that was separated from the real "here" and transported to some illusory "there" could not maintain its fascination for very long. The old theme could only be resurrected once the antinomies of romanticism were overcome. An artist who is in love with the world around him discovers the spiritual in the everyday, or, more accurately, he endows the everyday world with his own spirituality. In contrast with the romantics of the nineteenth century, there is no schism within his soul.

What could be more banal than the almost anecdotal situation represented in *The Conversation*? Morning, a wife, either asking questions or explaining something to her husband, who has just appeared in his pajamas. But what monumental grandeur and depth of poetic meaning Matisse has imparted to this "coded Annunciation."[13] On the one hand, it is immensely specific, possessing the precision of the realist: if we compare the male figure in *The Conversation* with photographs and self-portraits, we can see that the painting has captured precisely the individual character of Matisse's pose. On the other hand, this level of specific reference is combined with an abstract, universal dimension that elevates the figures to near-mythological status. *The Conversation* is Matisse's only painting about the relationship between a man and a woman, and it is surely no accident that these heroes will never again gaze into each other's eyes. This "strange emotional tension. . . reconciled in the calm medium of the color" expresses an archetypal idea of the separation of the sexes similar to the idea that separates the figures of *The Dance* and *Music*.[14]

The center of this composition, and the key to its meaning, is the balustrade of the window. It is at once concrete, as an element to the house at Issy, and abstract, as a "code" within the painting. Two expressive principles, embodied separately in the male and female figures, coexist in the pattern of the balustrade: straight lines for the man (how useful the pajamas were here!) and curving lines, not without a certain harshness, for the woman. Two principles whose union is life-creating. The tree set between the two figures, and combining in itself the straight line and the curve, is simultaneously a tree in the garden at Issy and an ancient symbol, the tree of life. The meaning of such a detail is more complex and diverse here than, for instance, in *The Red Room,* where the entire composition follows the dictates of ornamentation, which is only one of the levels in *The Conversation*.

The painting's linear structure, which serves to maximize the autonomy of the color, is also symbolic. For centuries, the visual arts have traditionally sought inspiration in the juxtaposition of the male and female principles. Matisse renders this juxtaposition in almost schematic fashion through the primal symbolism of the straight (male) lines and the curved (female) lines. The black balustrade serves as a bridge from one figure to the other, from the insistently repeated verticals to the resilient arcs. The two expressive forms are deliberately combined in the green tree—the embodiment of nature—and the opposition of the male and female figures is deliberately submerged in the blue ambience of impenetrably profound silence, purity, and mystery. While this theme was more widespread in literature, it also left an indelible mark on the painting of the 1890s, as can be seen in Munch's *Eye to Eye* (1894), or Bonnard's *A Man and a Woman* (1900). Preserving its existential core, Matisse arrived at a powerful and profound expression of it for the last time in European art.

The transcendence of genre that Matisse achieved with the still life/interior *(The Red Room, The Conversation)* was soon extended to the portrait as well. In the spring and early summer of 1911, in response to a direct commission from Shchukin, Matisse painted his own family. On 26 May 1911 he wrote in a postcard to Michael Stein: "The picture is on the right road, but since it is not yet finished, I cannot say anything. It is not logical, but I am not certain of success. This all or nothing is very tiring."[15] The artist drew a quick sketch of the composition of *The Painter's Family* on the postcard.

In *The Painter's Family* Matisse addressed new painterly and compositional

13. Schneider, *Matisse,* p. 312.

14. Lawrence Gowing, *Henri Matisse: 64 Paintings* (New York, 1966), p. 17.

15. Barr, p. 152. In another postcard to Michael Stein, Matisse decribed the picture in considerable detail. He reported that the color was beautiful and lavish and expressed the hope that Stein would see it in September. It was envisaged that the painting would be exhibited at the 1911 Salon d'Automne, but Matisse subsequently changed his mind.

concerns. The two structural approaches tried separately in the Seville still lifes were now applied simultaneously, but the combination of monumental elements and intricate patterning posed tremendous problems. The theme of the group portrait, touched on in *The Conversation,* is dealt with here in a more complex fashion. The figures of the artist's wife, Amélie, at her sewing, his daughter, Marguerite, and his sons Pierre and Jean playing checkers are rendered in the manner of an interior genre painting, which was new for Matisse. In this banally narrative family scene, saturated to the extreme in color, the central motif of the checkered chess board sets the tone for the entire structure, linking together the oriental carpet, the sofa, the ornaments on the walls, and the fireplace. The figures, however, retain the dominant role, and they include the most striking patches of color in the painting: the boys' red shirts and the girl's black dress. The massed areas of black are one of the boldest strokes in modern painting. Only the dress of Matisse's wife does not stand out so much, since her figure is in the middle ground (although once again, with painting of this sort, one must be cautious when speaking of planes in general). It is clear that the artist was more concerned with questions of color than with producing a portrait piece.

P. P. Pertsov, a distinguished critic of the times, who might well have witnessed the inception and the growth of Shchukin's collection, wrote of *The Painter's Family:* "Here we see immediately what the artist's main interest is. The human figures are almost artist's mannequins, like wooden toys, and they play exactly the same ornamental role as the rest of the room's decor. Of course, this is not a 'family portrait,' but a portrait of this decor, of the whole room complete with its colors and patterns. The word 'carpet,' used by everyone who has ever spoken of Matisse, involuntarily comes to mind—and indeed it suggests the right approach for the viewer. These 'pictures' really are carpets: not only are they painted like carpets, but their function, although perhaps unconsciously, is the same. The roots of Matisse's art are the very same as those of oriental art—the ornamental and the decorative."[16]

The oriental quality of *The Painter's Family* is self-evident. More interesting is the fact that Matisse's work on such a large composition was inspired by Persian miniatures. "The East," he explained, "has always been a revelation to me. . . . Persian miniatures, for instance, showed me how to convey my sensations. The details of this art require a more extensive, genuinely plastic space. It helped me to move beyond the bounds of intimate painting."[17]

In early October 1910, Matisse, Marquet, and Purrmann visited the exhibition of

16. P. Pertsov, *Shchukinskoye sobranie frantsuzskoi jivopissi* (The Shchukin collection of French painting) (Moscow, 1922), pp. 88-89.

17. Henri Matisse, "Le chemin de la couleur. Propos recueillis par Gaston Diehl" (The way of color. Theses collected by Gaston Diehl), *Art présent,* 1947, no. 2.

POSTCARD WITH A SKETCH OF **LA FAMILLE DU PEINTRE** (THE PAINTER'S FAMILY), SENT BY MATISSE TO MICHAEL STEIN, 1911

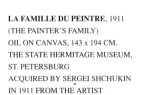

LA FAMILLE DU PEINTRE, 1911
(THE PAINTER'S FAMILY)
OIL ON CANVAS, 143 x 194 CM.
THE STATE HERMITAGE MUSEUM,
ST. PETERSBURG
ACQUIRED BY SERGEI SHCHUKIN
IN 1911 FROM THE ARTIST

JOUEURS DE DAMES, 1911
(GAME OF CHECKERS)
PENCIL
PRIVATE COLLECTION

Islamic art in Munich that had a vast impact throughout Europe.[18] Purrmann reported that Matisse studied the carpets, aquamaniles, and other metal utensils very closely, but that the miniatures also caught his attention. Matisse had of course discovered the art of the East long before, but his own art was evolving in such a way that after *The Dance* and *Music* he felt a fresh and more powerful attraction to the culture of the Near East.

A comparison of the final painting with the preparatory sketches showing the artist's sons playing checkers shows how the impressions of nature were subordinated to the requirements of decorative and ornamental spatial organization during the transition to canvas.[19] The central element is "stretched" so that the table will not mask the figures of the boys, and each detail is spread out on the surface. The structural logic of the ornamentation and color obliged Matisse to deviate from the real-life scene in certain details. Gertrude Stein indicated, for example, that Madame Matisse usually wore a black dress, but in the portrait she is dressed in a different color for the sake of harmony with her surroundings.

Matisse's painting is, once again, essentially a debunking of the traditional idea of the group portrait. Thirty years later Matisse would tell a radio interviewer, "As for portrait painters, they are outdone by good photographers. . ." What then becomes of the artists? Of what use are they? the interviewer asks. "They are useful because they can augment color and design through the richness of their imagination, intensified by their emotion and their reflection on the beauties of nature, just as poets or musicians do. Consequently we need only those painters who have the gift to translate their intimate feelings into color and design."[20]

Matisse makes no attempt to convey the individual personalities of his characters, although the painting does preserve something of their individuality. By means of color and the rhythms that organize it, a banal narrative theme is raised to the level of a solemn, almost hieratic image. The merits of *The Painter's Family* are not exclusively decorative: its festive mood encapsulates the finest and most lofty of human qualities.

The Painter's Family is one of a group of four large decorative interiors, or, as Alfred Barr dubbed them, "symphonic interiors"—a felicitous term for Matisse's new interest in more complex relationships between colors and all the plastic elements of a painting. The Greek word *symphonia* signifies harmony, but the symphony orchestra employs a wide range of different instruments, and consequently a musical composition has to be maintained in a single key. The symphonic interiors of 1911 should not be regarded as a single series composed of interrelated parts, for the canvases vary in size and their pictorial problematics are different. But stylistically they have a great deal in common, as if the principles of the Persian miniature were applied on a monumental scale.

The first of the symphonic interiors was *The Pink Studio* (also known as *The Artist's Studio*), painted at the beginning of the year. The other two works in the group are *Interior with Eggplants,* painted in Collioure during the summer, and *The Red Studio,* which was produced in the autumn.

The Pink Studio, like the later *Red Studio,* represents Matisse's studio in Issy. The pink tone, which is almost red on the floor and less intense on the walls, indicates the morning, the dawn that is just turning from a tint into a hue. The largest color areas in the painting are ochre, followed by yellow ochre and dark blue. The first defines the carpet on the floor, oriental, of course, which serves to mark the relative depth of the composition, leading the viewer into the picture, but also leading him out. The yellow ochre predominates in the fabric thrown over the green screen (a color balance tested in the *Spanish Still Life,* which could be described as the prologue to The Pink Studio). The placing of a dark blue rectangle in the center of the composition is the inverse of the device used in *The Conversation:* in that painting, a dark area is "gathered" around a bright focus, and here a bright area is gathered around a dark focus, in keeping with the painting's dominant chord. The dark blue fabric had already appeared with the green jug in

18. *Die Ausstellung von Meisterwerken Mohammedanischer Kunst in München,* 1910, 2 vols. (Munich, 1912).

19. One of these drawings is in the collection of the Pompidou Center in Paris; the other is in the Matisse Museum in Cateau.

20. "Matisse's radio interviews, 1942," in Barr, p. 562.

PIERRE MATISSE, THE ARTIST'S SON, c. 1916
PHOTOGRAPH
MATISSE ARCHIVES, PARIS

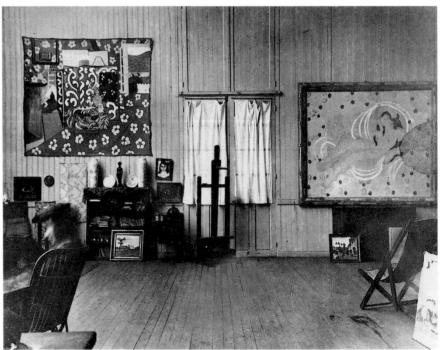

L'ATELIER ROSE, 1911
(THE PINK STUDIO)
OIL ON CANVAS, 180 x 221 CM.
STATE PUSHKIN MUSEUM OF FINE ARTS, MOSCOW
ACQUIRED BY SERGEI SHCHUKIN IN 1912 FROM
THE ARTIST

MATISSE'S STUDIO AT ISSY-LES-MOULINEAUX, 1911
PHOTOGRAPH
MATISSE ARCHIVES, PARIS

Spanish Still Life. Matisse had brought it back with him from Spain and continued to make enthusiastic use of it, no doubt attracted by its deep tone and the magnificently simple, large elements of its decorative design. In this work, he has given it pride of place over the paintings and sculptures in order to stabilize the center, thus giving the entire composition greater balance despite the presence of numerous and varied objects.

In contrast with *Spanish Still Life*, *The Pink Studio* does not counterpose animate and inanimate forms. It leads us into the world of artifice at its best: the world of art. At the top, there is a glimpse of greenery on the branches of a tree, an appropriate reminder of the world outside, but the studio and we who have entered it are screened off by the pink barrier of the wall. There are no real, living flowers here; their place is taken by the decorative abstractions on the fabrics. On a stool in the very center stands the jug, which, like the vase in *Still Life with "La Danse"* seems to pull the composition together around it, but in this case it is empty, and the flowers that appear to emerge from it are the conventional symbols on the fabrics. This unexpected substitution is a metaphor for art. Indeed, the whole of *The Pink Studio* is nothing other than a poem about art and the environment that the artist creates for himself.

At the same time, this work is a tribute to the applied art of the East, which Matisse appreciated as much as Shchukin. Indeed, one of the reasons prompting Shchukin to choose *The Pink Studio* may well have been the decorative fabrics used in the composition, a development of a motif in the Seville still lifes that the collector liked a great deal.[21] In this painting, applied art coexists with "fine" art in its basic forms, painting, sculpture, and graphics. With the exception of a plaster cast of the Borghese Mars (an antique replica of an original from the fifth century B.C.) all the works of art "quoted" here are by Matisse himself, and all of them had been made during the previous five years. On the left stands *Figure décorative* (Decorative Figure), one of his finest sculptures; on the right is *Le Dos* (The Back), a study for the monumental bronze relief of the same name. Most of the canvases represent nudes in various stages of completion. Above a quick sketch of a standing female nude there are the nude figures of the long-completed *Luxe II* (1907), and at the other side is the edge of the *Dance* panel in its first version. Beyond the screen there are two portraits standing on the floor, one of which, *Girl with Green Eyes*, has only just returned from an exhibition in London: the special packaging used to cushion the corners of the frame for shipping has not yet been removed. And complementing the canvases is the artist's palette, which provides not only an essential symbol but a patch of color balancing the red patch of *Luxe*.

The inventory of *The Pink Studio* does not seem premeditated, but these "pages" apparently torn out almost at random are held together by a deep inner logic. The way the objects naturally complement one another and the entire spirit of the composition testify to the personal, even intimate character of this studio, this spacious, far from secluded interior. Images of studios are usually autobiographical, and this canvas is no exception. But in comparison with similar works by Matisse's predecessors, from the miniaturists of the Middle Ages to Vermeer, Boucher, Chardin, Ingres, Courbet, and Bazille, this painting, for all its monumentality and extended color range, is more intimate and calm.[22] Like still lifes, Matisse's "studios" do not need the artist with a brush in his hand, or the nude model at one side, or rapt witnesses to the act of creation. "Still life/interior" is the name often used for the highly specific genre to which this painting belongs.[23] During this period, it will be recalled, Matisse generally gave greater emphasis to the elements of the interior than to those of the still life. A work such as *The Pink Studio* begins with the creation of the subject to be depicted, with the "contextualization" of the material objects.

Without the exceptionally clear linear structure of *The Pink Studio*, it might be difficult to recognize the sundry but sometimes similar details. The painting has quite appropriately been compared with a colored drawing or watercolor. There are

21. As an international textile dealer, Shchukin would have had a professional interest in fabrics, but as a collection of his firm's samples surviving in Moscow demonstrates, their artistic aspect also interested him.

22. Pierre Georgel et Jeannine Baticle, *Technique de la peinture* (Technique of painting) (Paris, 1976).

23. It is possible that *The Pink Studio* was in fact exhibited in the 1912 Salon d'Automne under the title *Intérieur* (Interior): see Salon d'Automne, Paris, 1912, cat. no. 770. Flam, however, believes that the work was *Coin d'atelier* (Corner of the Studio) (Flam, *Matisse. The Man and His Art*, p. 347).

L'ATELIER ROSE
(THE PINK STUDIO), FIRST STATE

24. Ibid., p. 303.

25. Henri Matisse, *Jazz* (Paris, 1947).

26. For a plan of the layout of Matisse's studio at Issy, see Elderfield, p. 198.

27. MacChesney, in Flam, *Matisse on Art*, p. 50.

28. Dominique Fourcade, "Autres propos de Matisse" (Other theses by Henri Matisse) *Macula*, 1976, no. 1, p. 92.

29. Flam, *Matisse. The Man and His Art*, p. 499.

30. Elderfield, p. 87.

31. Helen Franc, *An Invitation to See. 125 Paintings from The Museum of Modern Art* (New York, 1973), p. 74.

no impasto passages in the paint. A photograph taken when work on the canvas had just begun, before any paint had been applied, shows a drawing of exceptional completeness, with the precision of an etching, and there were almost no subsequent changes in the composition.[24]

The starting point for the pictorial structure was suggested by the studio itself, by its paneled wall and window transom. The artist has used the flat surface of the wall to block any eye movement into the picture space. The depth is minimal, purely conventional, and the surface of the wall is brought almost level with the picture plane. The repeated verticals of the wooden wall paneling provide basic stability for the whole structure, serving as a counterbalance to the whimsical arabesques of the fabric, the screen, the canvases, and the sculptures. This is a device of Japanese origin, first used in French painting by Manet and later by the Nabis. But while the Japanese influence is palpably present and sometimes even deliberately emphasized in the work of Bonnard and Vuillard, this is not the case with Matisse.

The theme of the studio concealed within itself so many possibilities that it was not soon exhausted. Matisse returned to it again and again, always settling on different aspects. The general transformation of his style affected the treatment of this theme as of every other, but Matisse remained faithful to its dual nature. On the one hand, the studio is a specific interior, the place where the artist lives, but on the other, it is the place where he creates, and therefore his shrine. Matisse's words in *Jazz* come to mind: "Do I believe in God? Yes, when I'm working."[25]

After *The Pink Studio*, the "red" version takes us back into the same setting (with an overlap of about one-third, so that certain details figure in both compositions: *Decorative Figure*, *Luxe*, and other paintings), but the theme has been totally transformed. *The Red Studio* is more subjective, and real space is defined far less authentically. There is not even a hint of the wooden wall paneling. The subjective element is reinforced by the choice of a section of the studio without a window, so that there is no link with the outside world.[26] In the new work, the entire space is flooded with a single color (sometimes called Pompeii red), and the other works are glittering islands in this sea of red, pictures within a picture.

The actual appearance of the studio was surely even less likely to have suggested this red than the preceding pink. The studio at Issy has been demolished, but a description of it has survived: "The studio, a good-sized square structure, was painted white, within and without, and had immense windows (both in the roof and at the side), thus giving a sense of out-of-doors and great heat. A large and simple workroom it was, its walls and easels covered with large, brilliant and extraordinary canvases. . . ."[27] Matisse explained to a visitor who was looking for a red wall in the studio that it did not exist and never had, that the very same furniture had initially been painted in blue-grey, that he did not know how he had hit on the idea of red, that all these objects, flowers, furniture, the sideboard had acquired a special meaning for him when he saw them with the color red.[28]

Matisse was particularly fond of red; it was his color. Flam has aptly remarked that Matisse painted himself in red in his self-portraits—the artist's ginger beard became red in the color system of his paintings.[29] Just as in the earlier case of *The Red Room*, Matisse changed one color for another in the transition from the impressions of the real world to certain profound, intuitively sensed personal meanings that he made no attempt to explain. Investigations have shown that *The Red Studio* really was blue-grey at the outset.[30] *The Red Studio*'s continuum is devoid of any link to a concrete time or place: in contrast with *The Pink Studio*, there is not even a hint of the time of day or the season of the year. In the imaginary environment of Matisse's painting, invented things seem more real than the setting in which they appear: "In this painting, the absence of Matisse himself from the scene may carry an implication that the artist lives most significantly through what he creates."[31] The light, almost spectral contours of the furniture emerge from the fantastic and powerfully bewitching atmosphere of this "studio":

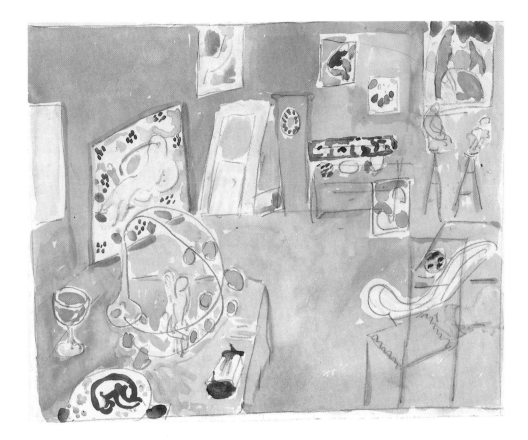

L'ATELIER DU PEINTRE, c. 1911
(THE ARTIST'S STUDIO)
PENCIL, WATERCOLOR, 21.8 x 26.9 CM.
STATE PUSHKIN MUSEUM OF FINE ARTS, MOSCOW
GIFT FROM MATISSE TO SERGEI SHCHUKIN

the lines of the table lead the eye to the studio's "products," its veritable treasures, while the chair at the other side seems to offer a concrete invitation to look, to meditate on these works and to take joy in them.

The Red Studio is generally dated to October 1911.[32] However, Shchukin's letters would suggest that Matisse was still working on it in December. It is possible that the painting was in fact begun in October and completed at the end of the year, that is, after Matisse's return from Moscow, although the early days of 1912 can also not be excluded.

As he worked on *The Red Studio*, Matisse was counting on Shchukin, for who else would appreciate such a bold conception, and who else would buy the large canvas without long deliberation? Shchukin had liked the Seville still lifes, which transformed the theme from one work to another. In this respect, the two *Studios* constituted an even more significant pair: not only did they share a common theme, but they had the same dimensions. At this stage, Shchukin had firmly staked his claim on the first of them and expressed interest in the second, which Matisse had described to him in one of his letters. What's more, Shchukin had asked for a sketch (the use of this word allows us to assume that work on *The Red Studio* was still in progress at New Year's). However, when he received the watercolor, Shchukin declined the artist's offer.[33]

It is hard to find an explanation for this refusal. The watercolor, lacking the intensity of the actual painting's color, could have given Shchukin a distorted impression.[34] In any case, the sketch clearly did not inspire him with enthusiasm, and he did not even hold on to it.[35]

In the summer of 1912, Matisse turned once again to the depiction of the studio at Issy, this time with a much more limited range of vision. The title given to one of these paintings, *Corner of the Studio*, accurately reflects the changed compositional approach in the works of this group: *Les Capucines à "La Danse"* (Nasturtiums and "La Danse") is a corner. The interiors with goldfish are "corners" too. This long, close look led Matisse to the fragmentary "microscopic sections" of these 1912 compositions, which made him the worthy successor to the great master of this approach, Degas (who was still alive at the time). *Nasturtiums*

32. Elderfield, pp. 88, 197.

33. It is difficult to tell for certain whether the watercolor was executed while Matisse was finishing the painting or after it was already completed. I tend toward the latter opinion, although a few small details of the watercolor are different from the actual painting.

34. Although the watercolor was painted in order to give Shchukin an impression of the canvas, it can hardly be considered even an approximate "reproduction." Its comparatively pale colors effectively match the size of the paper and the medium in which it was painted: transparent watercolor on white paper. The colors inevitably lack the density and intensity of the large painting, which rivals *The Red Room* in its chromatic impact. I can judge the difference in the impressions produced by the watercolor and the painting from my own experience: having known the watercolor very well, but having seen the painting only in reproductions, when I finally saw the painting in real life, I was quite astonished at how much stronger its impact was.

35. In 1917 Shchukin donated the watercolor to a charity auction in aid of war victims. In 1920 it became national property and was returned to the Shchukin collection, also nationalized at that time.

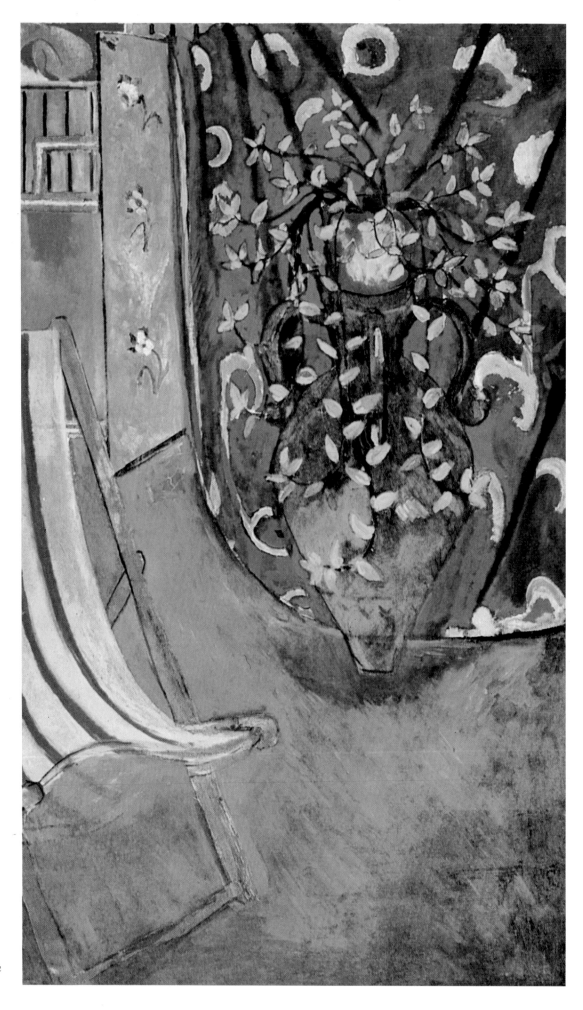

COIN D'ATELIER, 1912
(CORNER OF THE STUDIO)
OIL ON CANVAS, 192 x 115 CM.
STATE PUSHKIN MUSEUM OF FINE ARTS,
MOSCOW
ACQUIRED BY SERGEI SHCHUKIN IN 1912
FROM THE ARTIST

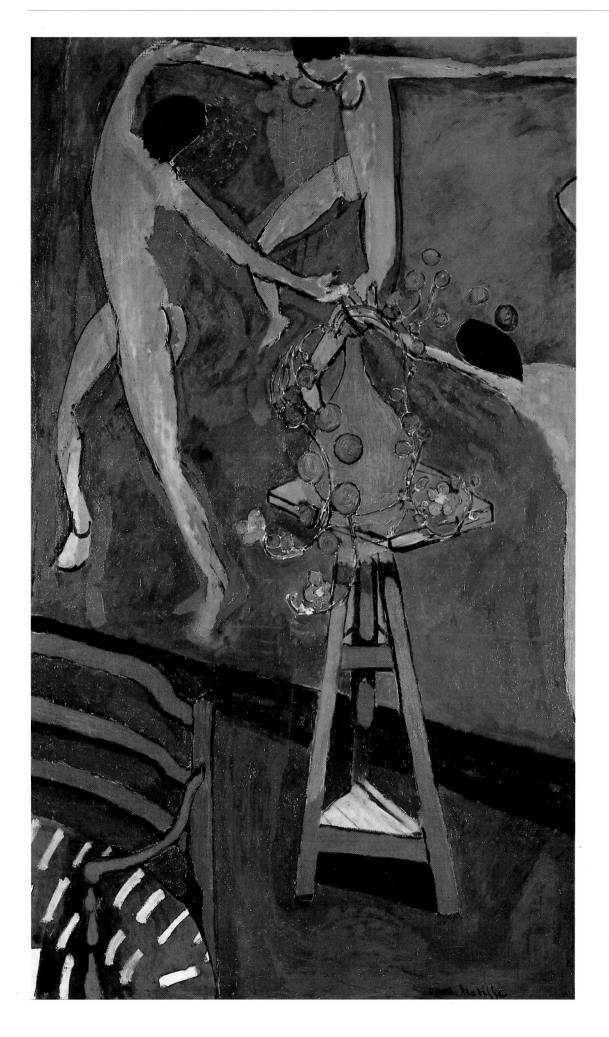

LES CAPUCINES À "LA DANSE", 1912
(NASTURTIUMS AND "LA DANSE")
OIL ON CANVAS, 193 x 114 CM.
STATE PUSHKIN MUSEUM OF FINE ARTS,
MOSCOW

131

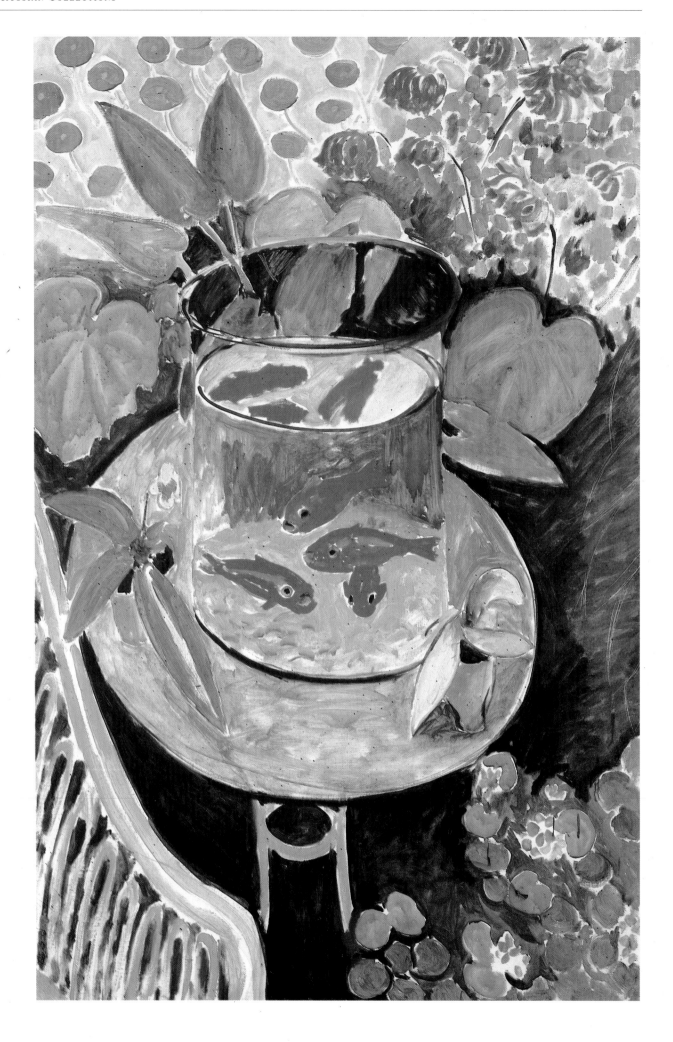

and "La Danse" shows only fragments of two of the three objects depicted (the panel and the sofa), and *Corner of the Studio* takes the same approach.

These two works form a pair that marks Matisse's renewed interest in the motifs of *The Pink Studio*.[36] *Corner of the Studio* includes the familiar screen, which has become blue instead of green, in line with the color range of the new work. The blue fabric is here too, but the designs on it are now pink. Matisse does not reproduce it literally; he offers his own version (he could have been a superb textile designer had he considered such work worthy of his talent).

The harmony of blue and pink, which determines the color range of both canvases, is particularly enhanced by the inclusion of emerald hues. This color range shows the influence of new impressions of oriental art, received during the first trip to Morocco. Matisse probably also took Shchukin's wishes into account in defining the color range: the Moscow collector had told him how he loved his "blue and green with dark pink."

The two paintings are constructed in a rather similar fashion, the similarity being less a matter of a common format than of general "constitution": the same laws govern the life of both works. Each has two planes with little spatial separation between them, and each "grows" upward (a feature clearly derived from the lessons of the East). In both works, the point of departure for the composition is provided by an article of furniture for sitting on—a folding chair in one case and a sofa in the other. They seem to invite us to stay a while and make ourselves comfortable. These details perform a double function, semantic and compositional. The sagging cloth of the chair is echoed by the the curvature of the blue fabric, while the back of the sofa seems to guide the panel standing behind it into depths. It is interesting to note that when Matisse later listed the best works in Shchukin's collection that had not been reproduced in France, he included "the green Arab vase with nasturtiums," a clear confusion of two pieces, for *Corner of the Studio* does not include the nasturtiums shown in the earlier painting.[37]

The device of combining living flowers with their pictorial or symbolic representations, already seen in the Seville still lifes and *The Pink Studio*, is applied to even greater effect in *Corner of the Studio*, where this floral duet affords a glance into one of art's greatest mysteries—the creation of the symbol. In *Nasturtiums and "La Danse,"* nature and art are once again balanced against each other, but this time the terms of the equation are different: the frenzied female dancers move to the same rhythm as the whimsically sinuous plants, a rhythm that is more than merely biological, elicited solely by living matter's fundamental need for movement, the cosmic rhythm that rules everything. As Flam remarks: "Matisse's desire to animate and to bring together different forms of being in a single image is nowhere more powerfully embodied than in [*Nasturtiums and 'La Danse'*]."[38]

Matisse had used a similar device before when he introduced *The Dance* into the composition of *Still Life with "La Danse."* In *Nasturtiums*, however, the panel is presented quite differently, on a larger and more dynamic scale and establishing a sense of movement that engulfs the entire picture space. In Moscow the work became known as *Dance Around the Nasturtiums*, and if this title (which even found its way into catalogues) was a poor one as far as describing the subject is concerned, it certainly reflects the dynamic nature of the work. This time Matisse has quoted *The Dance* so extensively that it has "overwhelmed" the greater part of the picture. Even so, he has not simply inserted a ready-made painting: he has made a free copy corresponding to the needs of the new composition. The version of *The Dance* shown here is the first, but its cosmic dynamism allies it more closely with Shchukin's version. This is not simply because the painting was intended for Shchukin, but because the entire spirit of the work demanded it. The colors here have been heightened, and the basis of the symbolic narrative has been shifted: the hill has disappeared, and the figures are literally soaring in the air. Cézanne loved to paint blue air, but Matisse goes even further in condensing his

36. Shchukin was to hang these paintings on the end wall of the large dining room, on either side of *The Conversation*, which he purchased at the same time. The very way Shchukin hung them emphasized their decorative qualities.

37. Letter from Matisse to Romm, 19 July 1935. Archives of the State Pushkin Museum of Fine Arts, archive 13, collection VI, no. 127/19.

38. Flam, *Matisse. The Man and His Art*, p. 345.

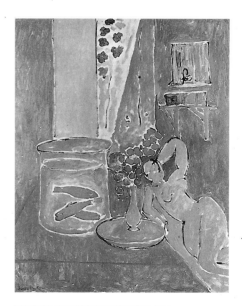

POISSONS ROUGES ET SCULPTURE, 1911
(GOLDFISH AND SCULPTURE), OIL ON CANVAS
THE MUSEUM OF MODERN ART, NEW YORK

LES POISSONS ROUGES, 1911
(GOLDFISH), OIL ON CANVAS, 147 x 98 CM.
STATE PUSHKIN MUSEUM OF FINE ARTS
ACQUIRED BY SERGEI SHCHUKIN IN 1912 FROM
THE ARTIST

39. At this time Matisse's former comrade-in-arms Derain had abandoned pure colors such as Matisse used and was painting pictures in his "gothic" style, the finest example of which is *Portrait of an Unknown Man Reading a Newspaper (Chevalier X)*, 1911-1914, The Hermitage, St. Petersburg.

40. Barr, pp. 156-157; Elderfield, "Matisse in Morocco. An Interpretative guide," in *Matisse in Morocco*, National Gallery of Art, Washington, D.C. et al. (Washington, D.C., 1990), p. 218.

41. MacChesney, in Flam, *Matisse on Art*, p. 51.

blue. The general dynamism of the picture is supported by its "gothic" vertical format and the fact that *The Dance* is seen from an angle and thus foreshortened.[39]

There is another version of *Nasturtiums and "La Danse,"* known in the literature as *Nasturtiums and "La Danse" II* (1912, Metropolitan Museum, New York). This time there is no perspective foreshortening, and the viewer faces the panel squarely, whereas in the incomparably more dynamic Moscow version, the movement of the figures and the horizontals of the back of the sofa create a perspectival vector that draws the eye off to the left. The scholars originally followed Barr in believing that the Moscow version was painted before the one in New York, but Elderfield has reversed this order on the basis of MacChesney's evidence.[40] During his interview with her in the summer of 1912, Matisse pointed to the ceramic vase of nasturtiums standing on the table and said: "I do not literally paint that table, but the emotion it produces upon me. . . ." As for his method of using two canvases when he worked on a subject, he explained: "I always use a preliminary canvas the same size for a sketch as for a finished picture, and I always begin with color. With large canvases this is more fatiguing, but more logical. I may have the same sentiment I obtained in the first, but this lacks solidity, and decorative sense. I never retouch a sketch: I take a new canvas the same size, as I may change the composition somewhat. But I always strive to give the same feeling, while carrying it on further. A picture should, for me, always be decorative. While working I never try to think, only to feel. . . ." MacChesney then commented: "The sketch hung on the wall at my left, and the finished canvas was on an easel before me. They represented nude figures in action, boldly, flatly and simply laid in broad sweeps of vivid local color, and I saw very little difference between the two." [41]

It takes no great scholarship to note the considerable difference between these two descriptions: quite clearly, the unnamed sketch is *Nasturtiums and "La Danse" II*, and the finished painting is *Nasturtiums and "La Danse" I*. The New York canvas was painted quickly—the paint is applied thinly, with no alterations—whereas the Moscow canvas is thickly painted with a complex texture betraying a whole series of alterations where the old paint had been scraped away and reworked.

Matisse's various "Goldfish" canvases are closely related to the pictures of the artist's studio. An aquarium of fish became a natural accessory in the still lifes made in the Issy studio in 1911 and 1912. In *L'Intérieur aux poissons rouges* (Interior with Goldfish, 1912), an aquarium and an easel flank a composition with the familiar statuette of a reclining nude in the center. The statuette is simultaneously a symbol of art and of living human beauty, and the easel, a studio accessory, is a natural symbol for the studio as a whole. The aquarium with the red goldfish, meanwhile, is a personal symbol, given the special meaning that the color red always had for Matisse. The fish gleam like jewels in the green-tinted aquariums that he painted again and again, as though they held some important and mysterious meaning for him.

The best of the many works showing goldfish, and the most joyous of the entire group, is in Moscow. *Les Poissons rouges* (Goldfish) serves as a very fine demonstration of the unusual and unexpected tasks faced by the still life at the beginning of the twentieth century. It would seem that by its very nature, the still life was least of all suited to the representation of movement, and yet movement, in the form of the fishes' constant circling in the water of the aquarium, is the main motif of this picture. This is why Matisse has made the maximum use of rounded and elliptical forms in its composition. Most strikingly, he has turned the top of the table toward the viewer, a transgression of the laws of perspective that is entirely justified by the artist's magical fascination with the smooth, hypnotic movement of the fish.

The lines of the painting are subordinated to a single rhythm, composing a pattern that harmonizes with the movement of the fish. Matisse repeats the oval

and circular forms as many times as he can, abandoning in the process that fundamental principle of European art, the unified point of view. He views the aquarium from the side, the tabletop from above, and then the leg of the table from the side once more. The banisters of the staircase are not viewed from the same position as the aquarium, and the distance between the staircase and the aquarium has almost disappeared.[42] The table and the glass vessel clearly protrude too much in defiance of the law of perspective. The lacy pattern of the banisters harmonizes with the oval forms of the aquarium and the leaves of the flowers. The circles and ovals in the center are repeated in the leaves, which grow smaller as they approach the edges of the picture: the movement gradually dies away, like a melody. Matisse has captured a specific, self-contained movement that does not lead beyond the edges of the canvas, for that would undermine the very foundations of the still life. This dance, involving not only the fish but everything in the painting, this smooth, eternal waltz, is a simple and powerful expression of "the quiet life."

The distribution of the colors reinforces the mood. If the interaction of these extremely bright hues were not strictly controlled, the effect would be disturbing. The fish gleam because the picture contains a lot of green complementary tones, but nowhere are they placed directly beside the red. Such an intimate combination would have created a tension in conflict with the smooth circling motion of the fish and the meaning of the painting. In order to retain its richness, the green, in turn, needs to be reinforced with black and pink. The aquarium's pink halo is absolutely essential to the picture's miraculous visual quality.

This painting by Matisse is so unusual that one would think he actually discovered the theme. In actual fact, by the time this work was produced, goldfish had already "surfaced" in French painting.[43] In his ironical review of the 1911 French Artists' Salon, Apollinaire noted two such works.[44] By the time Matisse took up his brush to paint an aquarium of goldfish, the motif had already lost the charm of freshness. But he was never afraid of banal or hackneyed subjects: he did not paint objects, but the feelings they aroused.

42. The staircase leading upward proves that the painting shows the house at Issy, not the garden, as Elderfield assumes (*Matisse in Morocco*, p. 221).

43. The painting dates from the summer of 1912, and not, as Barr thought, from 1911 (Barr, p. 144).

44. Of Fernand Toussaint's *Goldfish*, Apollinaire wrote: "They say that carp are fashionable now as a result of this year's Chinese exhibitions." When he subsequently encountered Eulet's *Goldfish* he exclaimed: "This really is some kind of obsession!" (Apollinaire, "Aux artistes français. Vernissage du Salon" [To the French artists. The opening of the Salon), *Chroniques d'art* [1902-1918], p. 176-177).

6. MOROCCAN REVELATIONS

Matisse did not stay in France for long following his return from Moscow, for Marquet persuaded him to spend the winter in Morocco. On 29 January 1912, the steamship from Marseilles delivered Matisse to Tangier, and a week later he wrote a postcard to his daughter from the Hotel Villa de France: "I have begun a bouquet of blue flowers."[1] Irises could be found easily enough in France; Matisse did not go to Morocco to paint the scenery or even to capture the exotic atmosphere of a foreign country. What he was seeking in the East was a "revelation," and he found it.

Vase d'iris (Vase of Irises) was his first Moroccan painting, a return to the still life, though admittedly a forced one: "We got caught in the rain here, a real flood. It seems it could go on for a whole month."[2] Locked away in his hotel, Matisse began to paint the pot of flowers standing in his room. In the painting the blue irises became a different color. Was the reason for this the quality of the light during the bad weather, or some subconscious desire to see the flowers as a reflection of Morocco? In any case, the color range of the canvas certainly includes references to Moroccan costume and local decorative tiles.

The combination of motifs in *Vase of Irises* is very unusual for Matisse. He never sought to paint mirrors, but in this painting the neo-rococo mirror plays a very important role. It was not included to provide the traditional juxtaposition of object and reflection, nor to allow the artist to play with the dimensions of space. Rather, it contains the brightest and the darkest spots in the composition and thus defines the limits of the tonal range. During this period Matisse was frequently attracted to the

1. Postcard from Matisse to his daughter, Marguerite, of 6 February 1912. Matisse archives, Paris.

2. Letter from Matisse to his daughter of 31 January 1912. Matisse archives, Paris.

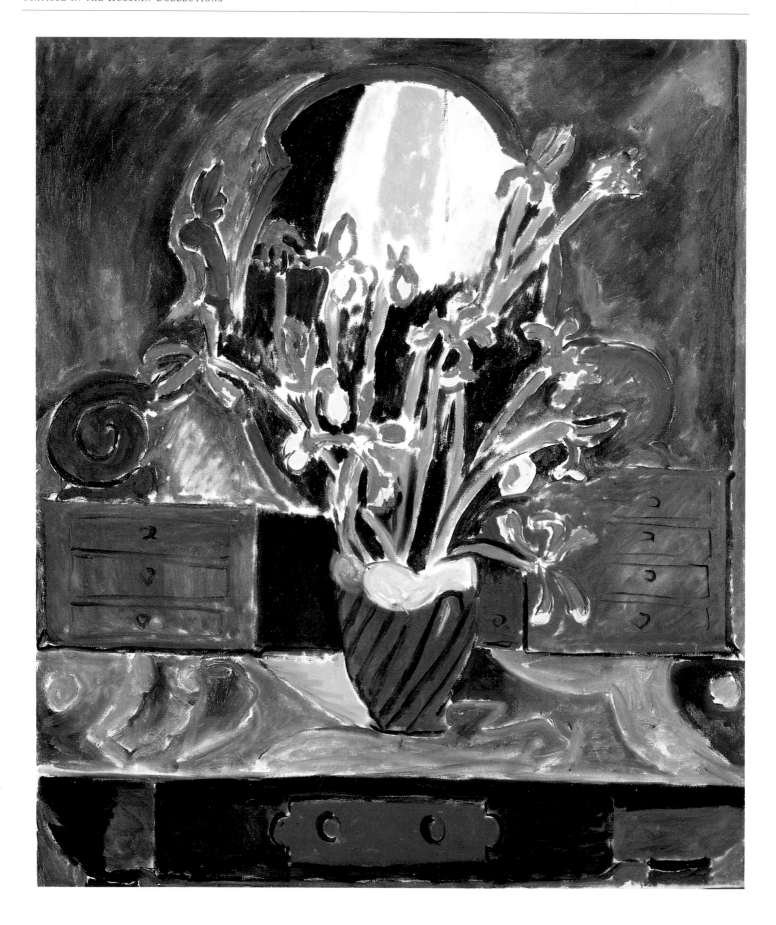

VASE D'IRIS, 1912
(VASE OF IRISES)
OIL ON CANVAS, 118 x 100 CM.
THE STATE HERMITAGE MUSEUM, ST. PETERSBURG
ACQUIRED BY SERGEI SHCHUKIN IN 1912 FROM
THE ARTIST

motif of potted plants, which allowed him to introduce the black of the soil as a contrast with the other pure colors. He used this device in various still lifes, including the two painted in Seville. Sometimes he chose a vantage point from above, in order to expose more of the soil to view. In *Vase of Irises*, however, Matisse abandoned this approach to find the black he required not in the earth, but in the mysterious shadowy depths of the mirror, which provided a fine contrast with the flowers protruding from the pot in disarray.

The window of the Tangier hotel room offered a magnificent view of the city, with the Anglican Church of St. Andrew in the foreground. This panorama of the "white city" went some way to reconciling Matisse to the inconvenience of the endless rain. He made several sketches, and in the spring he began painting his most poetic cityscape, *Vue de la fenêtre* (View from a Window), for Ivan Morozov.[3] The painting was not finished during this first trip to Morocco. Matisse left Tangier on 14 April and returned on 8 October, when he stayed until mid February of the following year.

The rain came to an end, and after the somewhat somber, but nonetheless beautiful *Vase of Irises*, he painted themes that he discovered in the city. The paintings contain no references to city life, however, for Matisse was attracted by the gardens of Tangier. One of these works, *Les Pervenches (Jardin marocain)* (Periwinkles [Moroccan Garden]), was also originally intended for Morozov, but the artist subsequently found a better pendant for *View from a Window*. In Matisse's rendering, the trees of the Tangier gardens look like fantastic paradisaical flowers. Indeed, paradise is a word often used in association with the Moroccan paintings, the majority of which possess a miraculous lightness and ease. They give no hint that any hard work was involved in their creation.

Amido le marocain (Amido the Moor) is quite a large work, but it was painted with swift ease, like a watercolor sketch. The impression of lightness is conveyed by the way the paint was applied, the bright tones (there are almost no shadows), the vertically elongated format and even the unstable pose of the youthful model, who seems about to soar into the air. His face, like the other Moroccan faces in Matisse's paintings, is devoid of expression—everything is expressed through the colors. In painting this delightfully sophisticated, colorful "bouquet," Matisse wittily exploited the formula of the full-length portrait. When he invited Amido to pose, he clearly discussed with him the details of the traditional costume of a white shirt, turquoise vest, violet pantaloons, light orange scarf, and a bag on a gold ribbon.[4]

The picture was painted in the spring of 1912, and it became the "souvenir of Tangier" that Shchukin had requested from Matisse.[5] In August Shchukin insisted that the painting be sent to him as soon as possible.[6] In October it was Matisse who mentioned the work in a letter: "I have begun a Moorish girl on the terrace, in order to make a pendant to last year's little Moroccan. . . ."[7] It is not quite clear what Matisse meant, for *Amido the Moor* and *Zorah sur la terrasse* (Zorah on the Terrace) are not a genuine pair. On the other hand, apart from *Amido* (now in the Hermitage), we know of no other "little Moroccan."[8]

The natural pendant to *Amido the Moor* is *Zorah debout* (Zorah Standing). The red background of this painting is, of course, the purest invention, stimulated by Zorah's green dress. Perhaps she also posed on the terrace, but there is no indication of this in the picture. Confusion has arisen because the title *Zorah on the Terrace* has long been accepted as the name of a painting that is quite different in shape, almost a square, and even here the setting of the terrace is indicated rather indistinctly.

The "Moorish girl" mentioned by Matisse is *Fatmah la mulâtresse* (Fatmah the Mulatto). The physical dimensions of Fatmah, Zorah, and Amido are the same. The compositional approach is also the same in each case, but there are no grounds for regarding them as a triptych, as several scholars have done. Barr warns against this, and there is no documentary evidence of any such intention on Matisse's part.[9] The colors of the three pictures harmonize well enough, but not so closely that one can speak of a unique ensemble.

The almost hieratic solemnity of the pose in *Zorah Standing* has led several

3. It is still not known exactly when Matisse accepted Ivan Morozov's commission for the two pictures. In any case, in the summer of 1911, Matisse already considered himself obliged to fulfill the commission. The trip to Moscow, during which the artist viewed Morozov's collection, served to increase his respect for the collector. Before he returned to Paris from Collioure, Matisse had written to Shchukin about the works (the letter itself has not survived, and the rough draft is undated, but it was probably written in early September): "Mr. Morozov has written to me that he is counting on seeing my still lifes in the Salon d'Automne, but I truly have not been able to do them; I hope to start on them when I return to Paris, but since submissions close on 15 September, they cannot be included there. . . ." (Matisse archives, Paris).

4. Amidou or Hamido is a diminutive form of the name Mohammad. Amido was a groom in another hotel in Tangier, the Villa Valentina. Matisse loved riding, and he could have met Amido while engaged in this pursuit in Tangier.

5. A label on the reverse indicates that it was dispatched from Marseilles to Paris in April: "Marseille (20 avr. 12 P.L.M.) Paris."

6. "And I ask you to send the other two pictures (the Moroccan and the goldfish) to Moscow by express delivery" (Barr, p. 555).

7. Letter from Matisse to Camoin of late October, 1912. "Last year" is a mistake; Matisse meant "last season." See Daniel Giraudy. "Correspondance Henri Matisse—Charles Camoin," *Revue de l'art*, 12 (1971), p. 13.

8. In an attempt to unravel this contradiction, Giraudy made up his "own" Moroccan triptych of *Amido the Moor*, *Zorah on the Terrace*, and *Fatmah the Mulatto*, but compositional considerations make this entirely unconvincing. In any case, *Zorah on the Terrace* was included by Matisse in his own Moroccan triptych.

9. Barr, p. 155. The paintings were first exhibited as a triptych in the exhibition "Matisse in Morocco" held in 1990-1991 in the National Gallery in Washington, D.C., the Museum of Modern Art in New York, the State Pushkin Museum of Fine Arts in Moscow, and the Hermitage in St. Petersburg. In the exhibition of Matisse's Moroccan paintings and drawings held in the Bernheim-Jeune Gallery in 1913, the three works *Zorah*, *Fatmah*, and *The Standing Riffian* were shown as a group (*Amido* was already in Moscow at the time).

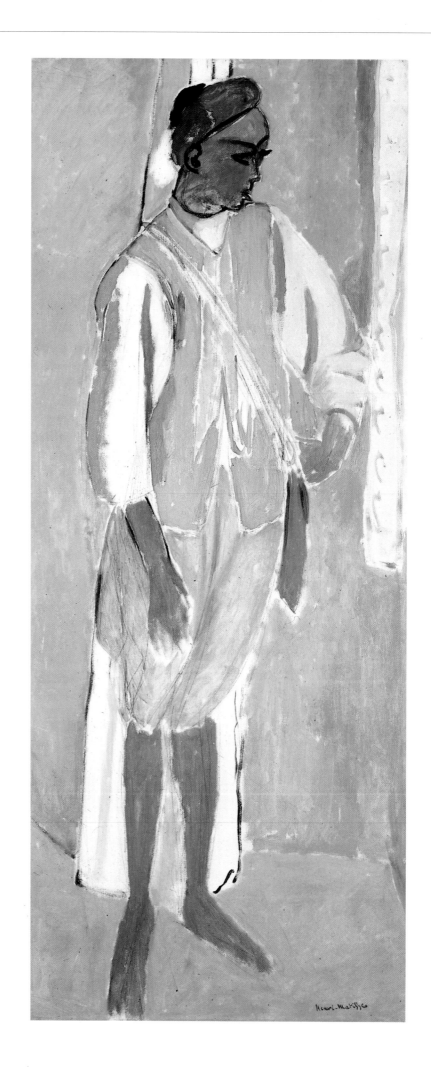

AMIDO LE MAROCAIN, 1912
(AMIDO THE MOOR)
OIL ON CANVAS, 146 x 62 CM.
THE STATE HERMITAGE MUSEUM, ST. PETERSBURG
ACQUIRED BY SERGEI SHCHUKIN IN 1912 FROM
THE ARTIST

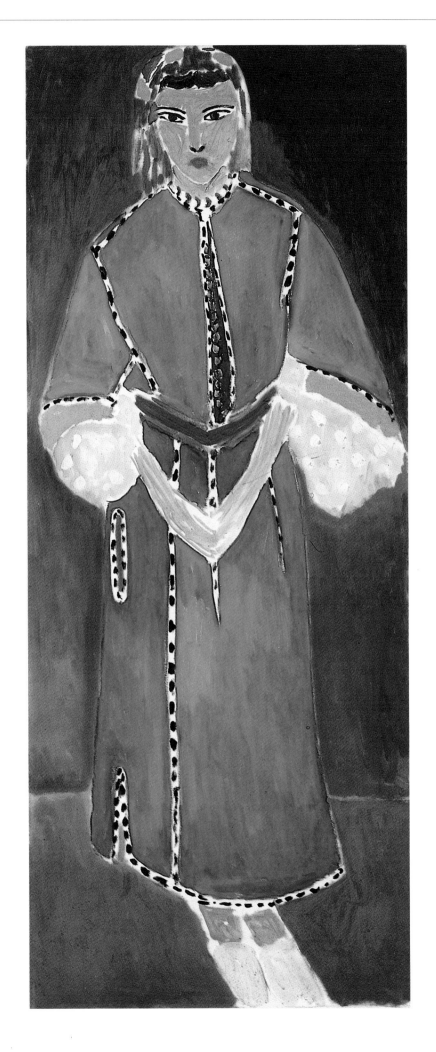

ZORAH DEBOUT, 1912
(ZORAH STANDING)
OIL ON CANVAS, 146 x 61 CM.
THE STATE HERMITAGE MUSEUM, ST. PETERSBURG
ACQUIRED BY SERGEI SHCHUKIN IN 1913 FROM
THE ARTIST

Matisse scholars, beginning with Barr, to compare the picture with Hans Holbein's *Christina of Denmark*. While not rejecting the validity of this comparison, we should not forget the Persian miniatures that were an even more likely source of inspiration along with—and even more important in this context—the art of ancient Russia. While in Moscow, in the churches of the Kremlin, the Rogozhskoe cemetery, and the Monastery of the Unified Faith, Matisse had seen many full-length, frontal images of saints in the rows of the iconostases. He was astounded by the pure, resonant colors of the old Russian icons, some of which, especially those from Novgorod, used the device of an abstract crimson background (there were icons of the Novgorod school in the Old Believer churches and in Ilya Ostroukhov's collection).

Zorah appeared later than the other members of this threesome, *Amido* and *Fatmah*. Initially Matisse had *Fatmah* in mind as a counterweight to the "little Moroccan" *Amido*, and her pose is almost a mirror reflection of his.[10] It is hard to say whether Matisse was intending to produce another pendant to *Amido* when he started work on *Zorah*. In any case, *Zorah* is the most successful work in the three-part suite, and one of the reasons is clearly the fact that Matisse had painted this model before. Shchukin proved to be more attracted to *Zorah*, partly because he was moved by her resemblance to the images of old Russian painting, and partly because as a decoration she fit better into the scheme of the Matisse hall in his mansion.[11]

Matisse painted Zorah much more often than his other Moroccan models. During his first trip to Morocco he painted *Zorah en jaune* (Zorah in Yellow) and *Zorah assise* (Zorah Sitting), and it also seems clear that at this time he drew a sheet of pen and ink studies of Zorah's head (Isabella Stewart Gardner Museum, Boston). Of the three drawings of Zorah, the sketch of her head on the upper right is similar enough to the treatment in *Zorah Standing* to be taken for a study for the picture. Matisse wrote to his family that in early April he had received permission from the owner of his hotel to use a room where he could paint an Arab girl.[12] No names were mentioned, but in all probability this girl was Zorah. Local customs forbade a woman to show her face—a problem that Delacroix also encountered, and things had changed little since his time. Matisse liked working with Zorah, but he had to act carefully, and in the end Zorah's brother halted the sessions. When he came back to Tangier in the autumn, Matisse decided to paint Zorah again, but for a long time he could not find her, until he learned that she was in a brothel. Muslim strictures did not extend to prostitutes, and the artist was able once again to use Zorah as a model. But there is nothing in *Zorah Standing* and *Zorah on the Terrace* to indicate that the model for these wonderful images was a prostitute.

After *Zorah Standing*, Matisse apparently began work on *Zorah on the Terrace*, which gave him much more difficulty. The canvas has quite evidently been reworked, for the original colors show through the upper layer of paint, and the initial relationship between the figure and the interior was different.[13] Matisse maintained his decorative manner here but used it to express a different mood.

Camoin, Matisse's friend from his days at the Ecole des Beaux-Arts, arrived in Tangier in November, and they went to the brothel together to paint from live models. "In Tangier," Camoin recalled, "he and I worked at the same time; the prostitutes posed for us in their rooms. Matisse said to me: 'Be careful, now. We have to go inside as though we were doctors.'"[14] It was probably at this time, in late 1912 and early 1913, that Matisse painted *Zorah on the Terrace*.

This painting must have served as the link between two landscapes, *View from a Window* and *La Porte de la Casbah* (Entrance to the Casbah, referring to the old part of the city, where the sultan's palace was located). Matisse worked longer on the second than on the first: he reworked the painting several times in the attempt to make it as concise as possible. At an early stage, there was a standing figure (visible in X-ray photographs) to the right of the entrance gate. The figure on the left was more distinct and accompanied by a child. In the finished work, the solitary, spectral figure, hardly noticeable at first, only emphasizes the drowsiness of the deserted town. With its blue shadow and the opening in the center, the composition is like

10. On 16 October 1912, Matisse wrote to his wife that he had painted a "Moorish girl" for Shchukin. However, Shchukin did not take the painting, which remained in the Bernheim-Jeune Gallery for several years.

11. Exactly when Shchukin bought *Zorah* is not known, but it was probably at the very end of 1912. On 10 January 1913, Shchukin wrote to Matisse that he was impatient to receive his latest painting (it was mentioned quite clearly in previous letters, which confirmed Shchukin's interest). This letter (XXXIX below) also confirmed a price of 6,000 francs, the same amount that Shchukin paid for Amido. The "latest painting" is, of course, *Zorah Standing*. Shchukin's impatience to receive the work to go with Amido is quite understandable, especially as the Moscow collector was at this time concerned with the best way to hang the paintings in the Matisse hall. On 5 April Matisse wrote to Shchukin that he had brought back from Morocco "four pictures for your drawing room: a Moroccan girl, so that you will have a pendant for the little Moroccan. . . ." (Only the rough draft of the letter has survived; it is in the Matisse archives in Paris.)

12. Letter of 1 April 1912. Matisse archives, Paris.

13. X-ray photographs indicated that in the early stages the figure was significantly smaller, closer to the size of the seated Moroccan in the right section (*Entrance to the Casbah*) of the Moroccan triptych.

14. Giraudy, p. 12.

some eastern reminiscence of *The Conversation*, covered in large part with a blue haze. Blue was likewise dominant in *View from a Window*, and Matisse undoubtedly intended *Entrance to the Casbah* as its pendant, which explains the various correspondences between the two works. In addition to the foreground plane defined in both cases, the red bouquet in *View from a Window* is paralleled by the dark pink path in *Entrance to the Casbah*. The spatial relationships in the two paintings are also close: in both, the artist has set himself the task of painting the distance without any sharp contrast between the front and back plane, not simply because every detail must be subordinated to the decorative whole, but because in spiritual terms "here" and "there" cannot be antitheses.

The Matisse archives contain a photograph of the Casbah gate that Matisse had bought and might even have used for his work on the painting. A comparison of the two shows what he was trying to achieve: he retained only one of the many buildings, and he totally ignored details such as the cobbled surface of the roadway and the stones of the walls. These are excluded in order to amplify the role played by color and reinforce its unity, which was based on the dominance of blue. (If it were possible to speak about Matisse's "blue period," then it would be the Moroccan years, and its finest expressions would be *Le Café arabe* [The Arab Café] and the Moroccan triptych. Matisse, however, avoided the sadness and tragedy typical of Picasso's blue period).

With smooth and subtle modulations, this blue is alternately used for the azure of the southern sky, for shadowy trees and walls, for a windowsill or a carpet, all of them redolent of the invigorating blue coolness so longed for under the burning southern sun. The blue is so powerful in *Zorah on the Terrace* that it obliges Matisse to omit lines that would seem absolutely essential. The juncture of floor and wall, for example, remains unmarked, with the result that the wall becomes almost unreal, and the woman appears to be floating in some incredibly miraculous medium. But in fact, what could have been so miraculous in the bare whitewashed walls of the Moroccan room, or in Zorah herself, this poor young prostitute whom the artist's brush transformed into a character out of a fairy tale?

Matisse himself did not regard these paintings as a triptych, and although they look better together, they are each autonomous works in their own right. It would thus be more correct to speak of a suite in three movements, unified by variations on common tones. Matisse's preference for painting such ensembles, however, led him to consider various ways of organizing his painting in cycles, sometimes in two parts, more often in three. He did not adhere to the rigid trinitarian concept of medieval Christian art, but he was inclined to the use of triads, especially during his Moroccan period, when he was more obsessed than ever by the search for harmony. Nonetheless, there was always a certain degree of variation in the composition of any particular trio.[15]

The way in which Matisse came to create the Moroccan triptych is of interest in itself. Initially, he had promised two landscapes to Morozov, who was himself an amateur landscape painter and passionately fond of the genre. (In January 1910, the Moscow collector gave Bonnard a similar commission, which resulted in *Morning in Paris* and *Evening in Paris*). On 19 September 1911, Matisse wrote to Morozov from Collioure: "I have been thinking about your landscapes since I arrived in Collioure, but I am really afraid that I shall not be able to do them this summer. Most likely I shall work on them in Sicily, where I intend to spend the winter. . . ."[16] Instead of Sicily, Matisse found himself in Morocco. Morozov's commission was evidently one of the reasons why Matisse quickly set out to work in the open air, in the gardens of Tangier. At this stage he had also accepted another commmission, from Morozov's wife, for a still life. In a letter of 1 April 1912, Matisse reported to his wife: "This morning I wrote Shchukin a nicely phrased letter. I added a sketch of Morozov's still life and two landscapes, the blue one and the periwinkles, and that made a fine sketch, a triptych."[17] Schneider has convincingly suggested that the still life mentioned in the letter is *Vase of Irises*, which eventually went to Shchukin, that

ZORAH DE PROFIL, 1912
(ZORAH IN PROFILE)
PEN AND INK
WHEREABOUTS UNKNOWN

15. Pierre Schneider, William John Cowart, and Laura Coyle, "Triptychs, Triads, and Trios: Groups of Three in Matisse's Paintings of the Moroccan Period," *Matisse in Morocco*, pp. 270-274.

16. Letter from Matisse to Ivan Morozov, 19 September 1911. Archives of the State Pushkin Museum of Fine Arts, archive 13, collection VI, no. 127/1 (letter IX below).

17. Matisse archives, Paris. Unfortunately neither the letter to Shchukin nor the sketch of the triptych has survived.

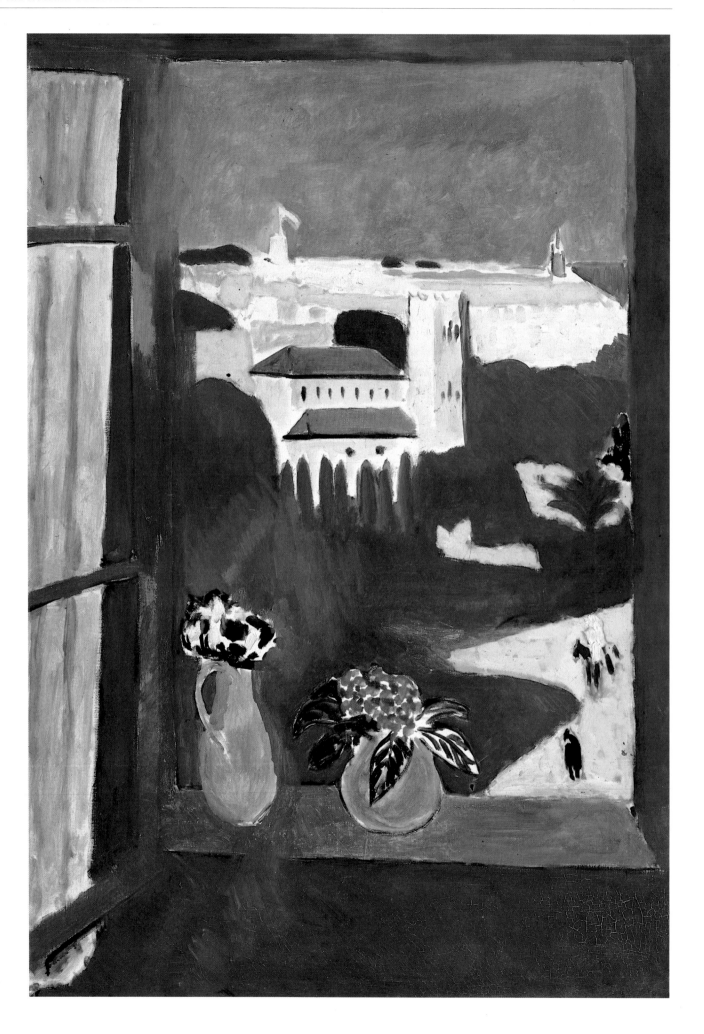

the blue landscape is *Acanthes. Paysage marocain, Tanger* (Moroccan Landscape [Acanthus]), and "periwinkles" is the work known as *Periwinkles (Moroccan Garden)*.[18] It remains possible, however, that the blue landscape Matisse mentions was *View from a Window*.

In a photograph of Matisse and his wife taken in the second half of November 1912, *View from a Window* can be seen hanging on the wall without a frame.[19] It was probably at this time that Matisse began work on his new triad: the Moroccan triptych. On 19 April 1913, the final day of the exhibition of his Moroccan paintings at the Bernheim-Jeune Gallery, Matisse wrote to Morozov about the triptych: "These three paintings have been combined with the intention that they should be hung together in a particular order—that is, that the view from the window should be on the left, the Casbah gate on the right, and the terrace in the middle, as the sketch shows."[20]

We do not know exactly when the still life was replaced by the terrace. The easiest assumption is that Matisse was not satisfied by the first plan for the triptych. He soon sold *Vase of Irises*, just as he sold *Corbeille d'oranges* (Basket of Oranges), yet another still life from his first Moroccan trip, and one that would have been even more difficult to combine with landscapes.

Matisse was obliged to rethink the conception of the triptych on the basis of *View from a Window*. This composition with two vases of flowers on a windowsill is almost as much a still life as a landscape. Could the artist have felt that another still life beside it would be too much? Beyond the window, in the blinding sunlight on the square, there are two small figures of Arabs that are not immediately noticeable, just like the shadow-cloaked figure in *Entrance to the Casbah*. They play an essential role, however, for they introduce the human theme, like music that is first heard at a distance, then draws closer until it resounds, not loudly perhaps, but with utter clarity. Such is the center of the scene, the focus, the culmination, which Matisse was to keep for Zorah. That he met her again just as the program for the triptych was taking shape was a stroke of luck that allowed him to complete his ensemble with the figure of a Moroccan woman personifying the life of the East.

Another stroke of luck was the idea of the terrace, essentially a transitional space between interior and landscape. Take one step forward and you are in the open air. Or take a step back and you approach the intimacy of the household. It is here, at the entrance to the house, that the Arabs leave their shoes behind to enter a realm where different rules apply; it is here that people come to sit and take the air, to

18. Pierre Schneider, "The Moroccan Hinge," *Matisse in Morocco*, p. 42.

19. Charles Camoin archives, Paris.

20. Letter from Matisse to Morozov, 19 April, 1913. Archives of the State Pushkin Museum of Fine Arts, archive 13, collection VI, no. 127/5 (letter XIV below).

AMÉLIE AND HENRI MATISSE IN FRONT OF *VIEW FROM A WINDOW*, TANGIER, 1913
PHOTOGRAPH

VUE DE LA FENÊTRE, TANGER, 1912
(VIEW FROM A WINDOW)
OIL ON CANVAS, 115 x 79 CM.
STATE PUSHKIN MUSEUM OF FINE ARTS, MOSCOW
ACQUIRED BY IVAN MOROZOV IN 1913 FROM
THE ARTIST

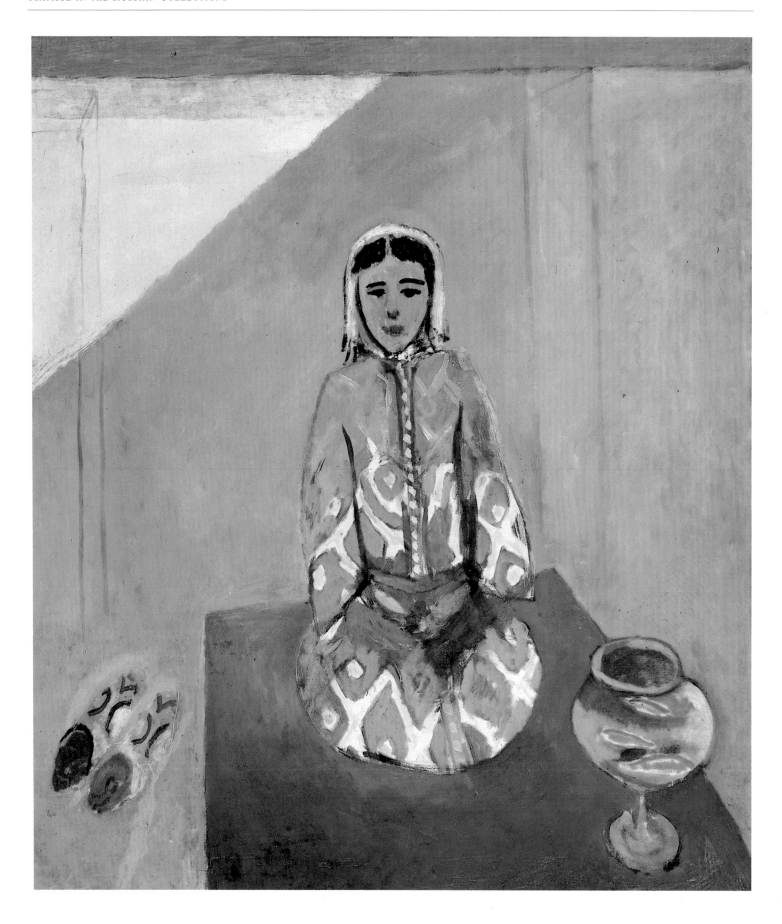

ZORAH SUR LA TERRASSE, 1912
(ZORAH ON THE TERRACE)
OIL ON CANVAS, 116 X 106 CM.
STATE PUSHKIN MUSEUM OF FINE ARTS, MOSCOW
ACQUIRED BY IVAN MOROZOV IN 1913 FROM
THE ARTIST

survey the drowsy neighborhood. Zorah, seated on a rug, seems at the same time to float in some miraculous space populated less by real objects than by symbols from the land of make-believe. This is why the shoes clearly invite comparison with fish in an aquarium.

Since Matisse had no need to record the details of the landscape, whether local curiosities or typical street corners of an Arab city, there was nothing to prevent him from resorting to the ancient philosophical underpinnings of landscape painting. Indeed, as John Elderfield has very aptly remarked, when viewed from left to right, the triptych represents the three major times of day: morning, noon, and evening.[21]

Reminiscing in his old age about the trips to Morocco, Matisse indicated, "I found the landscapes of Morocco just as they had been described in the paintings of Delacroix and in Pierre Loti's novels. One morning in Tangier I was riding in a meadow; the flowers came up to the horse's muzzle."[22] If we compare Matisse's landscapes with Delacroix's sketches, however, they seem to represent a quite different country. This is not a matter of natural stylistic differences: Matisse thought very highly of the great romantic's work, but his use of the word described is not accidental. His own landscapes go beyond description in order to express. Matisse never painted anything like the horse rides in the meadows that made such an impression on him: a scene of that sort would require description; it would involve a certain risk (or temptation) of anecdote, to which Matisse was, mercifully, immune. He loved to paint flowers (as proven by two decades of work before his Moroccan trip), but like Cézanne, he did not attempt to render meadows carpeted in fragrant blossoms (the unsurpassed achievement of the impressionists). He preferred to paint flowers in the solitude of his studio, for his dialogue with them required a certain level of concentration.

This concentration is clearly visible in the two large floral still lifes painted during the final phase of the Moroccan period: *Arums, iris et mimosas* (Arum, Iris, and Mimosa) and *Bouquet d'arums sur la véranda* (Bouquet of Arum Lilies on the Verandah).[23]

Irises and callas (arum lilies) seem to be the two kinds of flowers that most attracted Matisse in Morocco. Callas dominate these two still lifes, and they appear in the only flower drawing Matisse made during the Moroccan period, *Arum et liserons, Tanger* (Arum and Bindweed). Matisse was fascinated by these distinctive white flowers with their spiraling petals and leaves like the tongues of large animals. Very similar motifs (in the first case, a mix of arums, irises, and mimosa, and in the second, only the arum) are presented quite differently in the two floral still lifes. *Bouquet of Arum Lilies* is treated in Matisse's graphic manner, to such an extent that there are even white patches of unpainted ground that "act" in much the same way as unpainted areas of paper in watercolors. The painting of *Arum, Iris, and Mimosa*, in contrast, is dense and saturated.

It has been suggested that *Bouquet of Arum Lilies* was a sketch for *Arum, Iris, and Mimosa*, in the same sense that *Nasturtiums with "La Danse"* in the Metropolitan Museum was a sketch, or rather, a preliminary version of the work with the same title in Moscow's State Pushkin Museum of Fine Arts.[24] There is even a certain bewilderment over why Shchukin bought both phases, which would certainly have been an exception to his usual rule.[25] In this case, however, the collector did not select the works. Having placed a commission by letter, Shchukin relied on the artist's judgment, as is confirmed by a phrase in Matisse's letter to Shchukin of 5 April 1913 concerning "the two paintings with flowers . . . for your drawing room."[26]

Matisse quite clearly regarded these two works as equal in status. There are even grounds for assuming that he intended to include them in a triad.[27] On the other hand, the idea that *Bouquet of Arum Lilies* was painted before *Arum, Iris, and Mimosa* is open to debate and lacks substantive proof. The logic of Matisse's art is frequently based on successive stages of simplification. Seen in this light, then *Bouquet of Arum Lilies* might well have been painted after *Arum, Iris, and Mimosa*.

21. *Matisse in Morocco*, p. 230. Elderfield's other conjecture, concerning a symbolic opposition between the church in the left section and the mosque in the right section, seems more questionable.

22. "Matisse Speaks," *Art News Annual* 21 (1952), reprinted in Flam, *Matisse on Art*, p. 133.

23. The latter title is traditional but somewhat inaccurate, since the bouquet is not on the verandah but in the hotel room. It has been dated rather indefinitely in the literature as 1912-1913. In all probability, both works were painted in the room whith the curtain and the bedside table bearing the vase of callas, which was evidently in the Villa de France. The landscape in *Bouquet of Arum Lilies* is quite different from the panorama of the old city in *View from a Window.*

24. *Matisse in Morocco*, cat. no. 21, p. 100. In this article in the same catalogue, Elderfield characterizes *Bouquet of Arum Lilies* as a "preparation" (p. 218).

25. Ibid., p. 96.

26. This letter has not survived. The rough draft is in the Matisse archives in Paris.

27. Schneider, Cowart, and Coyle proposed three versions of the triptych that included both "floral" pictures. In each case they are the side panels, with the center occupied by either *The Standing Riffian* or *Goldfish* or *Open Window at Tangier* (*Matisse in Moscow*, pp. 273, 274).

TANGER, L'ÉGLISE ANGLAISE, 1913
(TANGIER, ENGLISH CHURCH)
PEN AND INK
PRIVATE COLLECTION

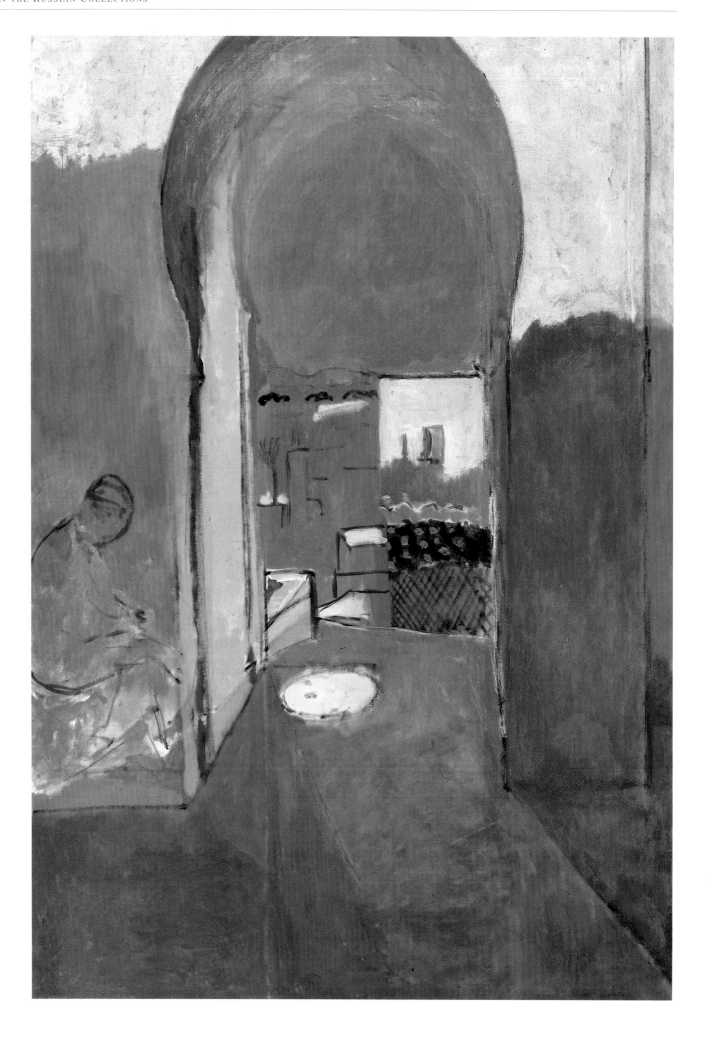

Comparison, which is always interesting in the case of the large floral still lifes, is more fruitful when like is compared with like. The main color effect in *Arum, Iris, and Mimosa* is produced by the combination of dark blue and green. The improbably large arum lily leaf "presented" in the center has a malachite-green color that is repeated in the background and resonates densely with the composition. The irises here are painted differently from those in *Vase of Irises*: they have recovered their blue tone, which is echoed in the shawl underneath the bouquet. Green and blue thus appear in two distinct registers, with the bright tones occupying the upper part of the painting and the dark tones the lower part. In this way, the composition is stabilized by the inventive combination of two pyramids, above (inverted) and below. By omitting all the fine details, Matisse produces an effect of conventional decoration, which is immediately contrasted with another conventional treatment of flowers: that of floral designs on fabrics. In juxtaposing these two representations of plant life, the living flower and the imitation, Matisse is not trying to seduce us with the verisimilitude of the bouquet he has composed, but to draw us into communion with art itself, to force us into an awareness of its nature. For an artist like Matisse, intuition follows the same route as that of the folk craftsmen who decorate their fabric with patterns.

The task attempted in *Bouquet of Arum Lilies* is apparently more simple. The motif of a contrast between living flowers and printed ones is here so understated (the agitation of the white callas is echoed in the wavy border of the curtain) as to be scarcely perceptible. The curtain is pulled aside, and the silhouettes of trees are visible through the window, as animated as the callas on the table (which, in passing, is the same bedside table that figures in *Arum, Iris, and Mimosa*). A memorial to something that is past, *Arum, Iris, and Mimosa* preserves the fullness and taut precision of a drawing. *Bouquet*, on the other hand, is a picture of becoming, a poem of the early morning, in which many things have yet to be defined and languish in waiting for their realization.[28]

At the beginning of November 1912, Matisse wrote to his family that he intended to paint a picture of a young Moroccan from the Rif mountains, and on 21 November he informed Marguerite that he had taken "a canvas of the same size as Shchukin's *Goldfish*. This is a portrait of a Riffian, a magnificent fellow, a mountaineer as wild as a jackal."[29]

In the early years of the century, the men of the Rif, mainly Berbers, had a reputation as fearless warriors who would go to any lengths to defend their independence. They would sometimes even kidnap Europeans who went to Morocco. When he met a Riffian in Tangier, Matisse began to draw him with great excitement, and he did two paintings of him.[30] One of these, *Le Rifain assis* (The Seated Riffian), is very large (200 x 160 cm) and presents the figure on a heroic scale, larger than life. The other, *Le Rifain debout* (The Standing Riffian), is smaller in size, but more energetic in color. Green can be gentle and soothing, but here it is energy incarnate, flooding almost the entire surface of the canvas. It has been suggested that *The Standing Riffian* could easily be taken for a preparatory study.[31] However, the two compositions are quite different, and a certain similarity in the use of color (the background of *The Seated Riffian* consists of green and yellow stripes) cannot obscure the differences in emotional register.

Matisse's color is capable of many things, including psychological characterization. Take Amido: the little Moroccan does not look at us, inveterate servant that he is, but this task is not onerous to him, and we have the impression that if he begins to move, it will be with a dancing gait. The colors are correspondingly light and joyful, without the slightest tension. The Riffian presents a very different case. This man will not lower his eyes, and his gaze is keen. There is even a feeling of aggressiveness in the way his steely figure presses forward. Matisse had every right to call the work a portrait, because this is an individual, not some ethnographical type.

"And this Riffian," wrote Marcel Sembat, one of the first visitors to Matisse's Moroccan exhibition in 1913, "is he not capital, this devil with the angular face and

28. If the triad is composed of still lifes from the second trip to Morocco, then *Arum, Iris, and Mimosa* must be set in the center, not on the right. *Bouquet of Arum Lilies* would then signify morning, *Arum, Iris, and Mimosa*, noon, and *Open Window at Tangier*, evening.

29. Both letters are in the Matisse archives in Paris.

30. For the drawings, see *Matisse in Morocco*, cat. nos. 45-51.

31. A. Humbert, notes to Diehl, p. 140. The traditional title of this painting, retained at the Hermitage, is *Marocain debout en vêtement vert* (Moroccan Standing in Green Robes).

VUE DE LA CASBAH, 1911-1913
(VIEW OF THE CASBAH)
PENCIL, PRIVATE COLLECTION

LA PORTE DE LA CASBAH, 1912-1913
(ENTRANCE TO THE CASBAH)
OIL ON CANVAS, 116 x 80 CM.
STATE PUSHKIN MUSEUM OF FINE ARTS, MOSCOW
ACQUIRED BY IVAN MOROZOV IN 1913 FROM
THE ARTIST

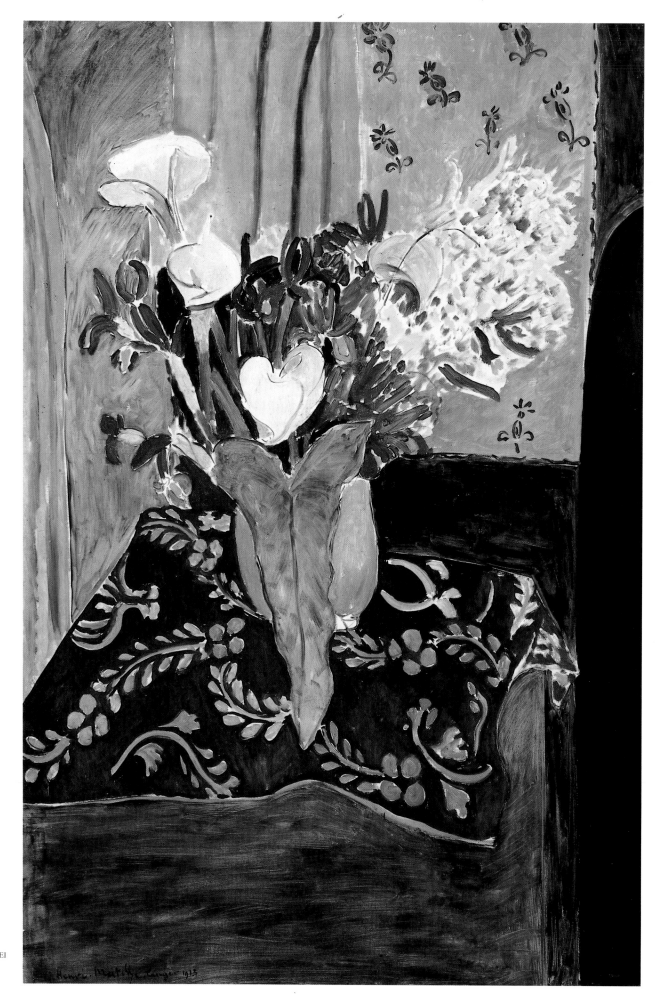

ARUMS, IRIS ET MIMOSAS, 1913
(ARUM, IRIS, AND MIMOSA)
OIL ON CANVAS,
147 x 98 CM.
STATE PUSHKIN
MUSEUM OF FINE
ARTS, MOSCOW
ACQUIRED BY SERGEI
SHCHUKIN IN 1913
FROM THE ARTIST

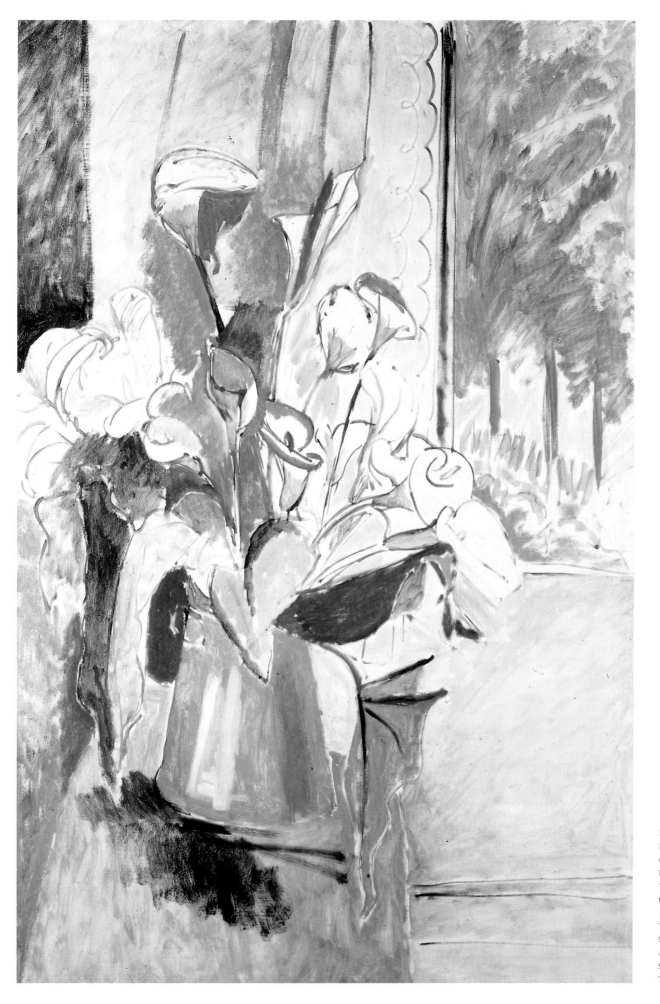

**BOUQUET D'ARUMS SUR
LA VÉRANDA,** 1912-1913
(BOUQUET OF ARUM
LILIES ON THE
VERANDAH)
OIL ON CANVAS,
145 x 97 CM.
THE STATE HERMITAGE
MUSEUM, ST. PETERSBURG
ACQUIRED BY SERGEI
SHCHUKIN IN 1913 FROM
THE ARTIST

32. Sembat, p. 194.

33. The title *The Arab Café* retained at the Hermitage, was coined by Shchukin. In the 1913 exhibition of Matisse's Moroccan works at the Bernheim-Jeune Gallery the work bore the title *Moroccan Café*. It is also referred to occasionally as *The Moorish Café* (e.g., Schneider, *Matisse*, pp. 467-471 and passim).

34. The drawings (*Matisse in Morocco*, figs. 79, 80) are in a private collection.

35. *Matisse in Morocco*, fig. 138.

MAROCAIN, 1912
(MOROCCAN), PENCIL, PRIVATE COLLECTION

LE RIFAIN DEBOUT (MAROCAIN DEBOUT EN
VÊTEMENT VERT), 1913
(THE STANDING RIFFIAN [MOROCCAN STANDING IN
GREEN ROBES]), OIL ON CANVAS, 145 X 96.5 CM.
THE STATE HERMITAGE MUSEUM, ST. PETERSBURG
ACQUIRED BY SERGEI SHCHUKIN IN 1913 FROM
THE ARTIST

the sturdy figure! Can you gaze on this magnificent barbarian without thinking of the warriors of ancient times? The Moors of the *Song of Roland* had this same severe mien."[32]

The Standing Riffian and *Le Café arabe* (The Arab Café) define the two poles of Matisse's Moroccan painting.[33] The resonant color of the first contrasts with the soothing gentleness of the second. The face and the robes in *The Standing Riffian* are depicted concretely, whereas *The Arab Café* tends towards abstraction. The Riffian is individualized to the same degree that the figures in the *The Arab Café* remain impersonal: the artist has not even given any of them eyes, ears, a mouth, or a nose.

The simplicity and abstraction of *The Arab Café*, which is both the largest and the most significant picture of the Moroccan period, only came about through a gradual process of assimilating the theme. Despite the fact the preparatory drawings, *Café I* and *Café II,* were hastily dashed down from real life, they portray the scene in the café in a very concrete manner that defines the space of a specific interior and captures in a few pencil strokes details such as the pose of a dozing Arab, the way a man's head is thrown back to drink, the Moroccans seated on their little carpets with their shoes removed and set down next to them.[34] This row of shoes originally formed the lower border of *The Arab Café*, but they were painted over, as we can clearly see in the X-ray photos, and their outlines can still be made out with the naked eye.

The Arab Café invites comparison with a painting by Camoin, *Le Marocain dans un café* (Moroccan in a Café, 1912-1913), that may show the same café since the old friends went for walks together around Tangier.[35] Camoin's work renders a very similar scene in a more realistic manner. There are two planes of depth: in the shaded foreground, an Arab about to go inside stands before the step on which the men usually leave their shoes; inside the café, there are the customers in white robes (Matisse transformed the white into light grey).

For Camoin, the café in Tangier offered a fairly exotic spectacle that he sought to convey as precisely as possible. But that was not enough for Matisse, who, seeking to recast the concrete details of life into an exalted poetic reality, preferred to sacrifice the details that were so important to Camoin to the gentle blue enchantment of his magic kingdom.

Matisse himself said that he was astounded by the Arabs' ability to spend hours in the contemplation of flowers or goldfish. Anybody else, a businessman, for instance, would have only laughed or been astonished at such a useless waste of time, but for Matisse such scenes represented a different universe, a semifantastic world for which he felt total respect. The romantic movement had long since disintegrated, but the artist had preserved a romantic view of the East.

It is the exalted poetic mood of the painting that truly distinguishes it from the preparatory sketches, especially from *Café maure* (Moorish Café), a drawing that nonetheless shows Matisse moving toward the conception of *The Arab Café*. An Arab with a pipe sits in the foreground of this interior with eight figures; the fact that hashish was frequently smoked in the cafés of Tangier might explain the relaxed poses of the figures. However, the impressions that prompt a drawing from nature are not worthy of a work of art. Thus Matisse completely abandoned every element of naturalism, and the somnolent poses of the figures in *The Arab Café* call to mind the poses in his paradisaical canvases, especially the reclining women in *La Joie de vivre*. The musical motif seems as integral to *The Arab Café* as to the earlier work. The violinist in the upper section of the composition is easily overlooked at first, but the theme of music is important, because it helps to account for the atmosphere of calm and the static poses of the characters. They are just as isolated here as in the version of *Music* painted for Shchukin. The seated Arab in the foreground plane, one of the most important characters, is actually shown in the same pose as three of the youths in *Music*.

By virtue of its pictorial and compositional qualities alike, *The Arab Café* is almost unique among Matisse's work. The explanation for this has been sought in oriental

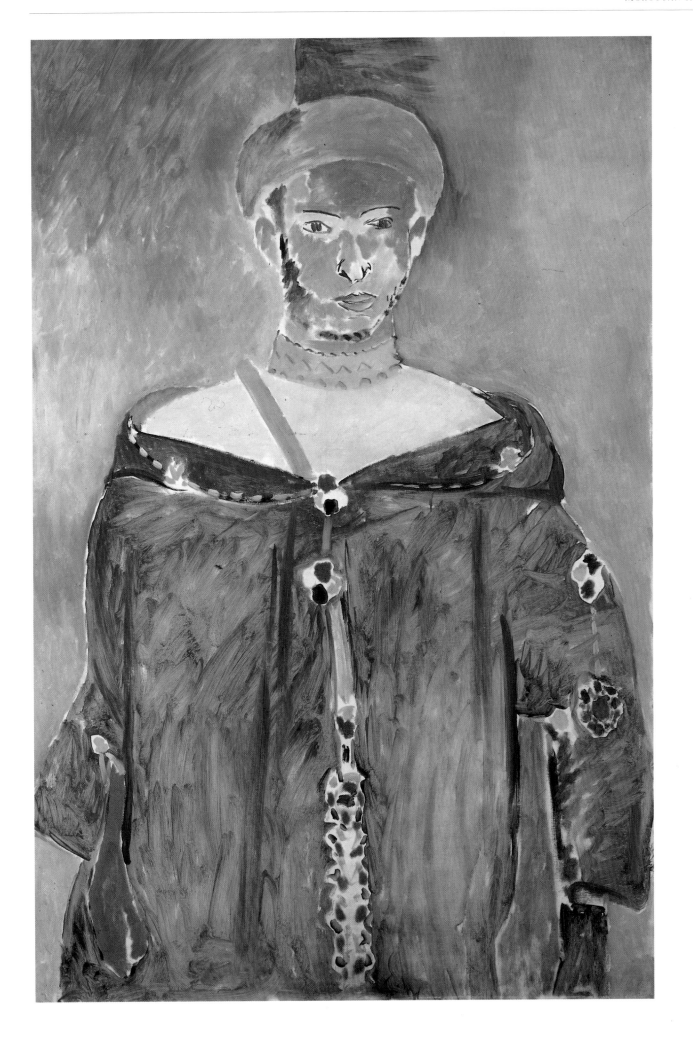

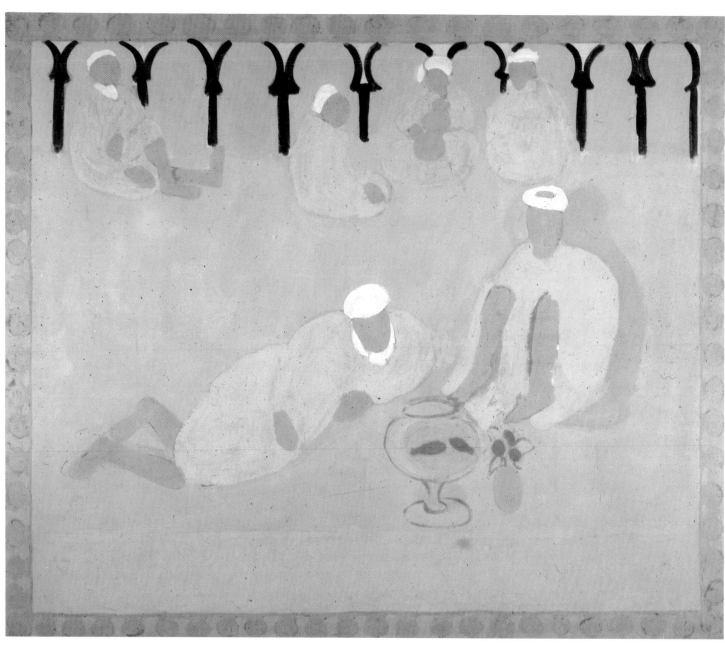

CAFÉ ARABE, 1912-1913
(ARAB CAFÉ)
OIL ON CANVAS, 176 x 210 CM.
THE STATE HERMITAGE MUSEUM, ST. PETERSBURG
ACQUIRED BY SERGEI SHCHUKIN IN 1913 FROM
THE ARTIST

CAFÉ MAURE, 1912-1913
(MOORISH CAFÉ)
PENCIL
PRIVATE COLLECTION

influences. Barr, for example, cited as one possible source the Aqa Riza miniature *The Prince and His Tutor* (1532) that had been shown at the exhibition of Persian miniatures in Paris in 1912.[36]

Account should probably also be taken of European sources for *The Arab Café*, such as Ingres's *Odalisque and Slave-Girl* (1839-1840). Matisse was quite familiar with this painting, but to mention it in this context is to cloud the issue somewhat, since it is well known that Matisse's bronze statuettes of 1906-1907 were variations on Ingres's odalisque, as was the *Blue Nude* of the same period. In *The Arab Café*, the place of the odalisque is taken by a reclining man in an oriental robe. An "eastern still life" is similarly placed in the foreground (it is worth noting in passing that the entire picture has the character of a still life). The musical motif is removed to the rear plane, and the balustrade in the background is replaced by an arcade

The arcade has a dual function. It is "empowered" to complete and crown the composition (in the original version Matisse was clearly playing on the rhythmic echo between the shoes below and the arcade above). Furthermore, the arcade marks the far plane in a paradoxical fashion, in that its black is the most intense color in the painting, whereas the laws of color perspective would require that in the depths of a composition the colors should become weaker. In this instance, however, such gradation is not necessary since the entire scene is presented in softened tones.

Black, white, yellow ochre, a sprinkling of red—these provide the necessary contrasts to the pale blue-green, like a retinue. Not even *The Conversation* was dominated to such an extent by a single color, since the blue was intended to balance all the others. In *The Arab Café*, however, the light grey of the robes is intended to reinforce the basic color. Only the pale ochre, which is the "flesh tone," has relative autonomy, and Matisse also used it for the frame painted around the composition.

The device of painting a frame onto the canvas of a work was suggested to Matisse by the neo-impressionists, in the first instance by Seurat. In this case, however, there was also an oriental influence—an illustration to a recent Paris edition of *A Thousand and One Nights*.[37] Matisse always laid great emphasis on the frame of a painting and tried to find nonstandard solutions to this problem. In the case of his three most significant compositions of this period he resorted to painting decorative frames himself. The only example still extant is *The Arab Café*, in which the frame not only serves as the boundary of the composition and sets off its colors, but by symbolizing the Arabs through the swarthy color of their skin, draws our attention back to the figures, the people of that color, and thus encourages lengthy meditation of the work.[38]

Shchukin felt the hypnotic effect of the painting before anyone else, and he wrote to Matisse that he looked at it for at least an hour every day. Matisse himself undoubtedly felt that *The Arab Café* occupied a special place among his Moroccan pictures as well.[39] At first, however, the work had very few admirers. It is worth noting the rather cool response of even such a bold and penetrating critic as Apollinaire, expressed during the period of the exhibition at the Bernheim-Jeune Gallery: "The works inspired by contemporary North Africa that are more or less tolerable include *The Turkish Café* [Apollinaire's error] and *Entrance to the Casbah*."[40]

The extreme laconicism and economy of means would seem to favor a more austere painting, but in Matisse's work these qualities are associated with genuine and even, one might say, tender emotions. The attempt to simplify while retaining the distinctive quality of Matisse's innate delicacy underlies the entire structure of *The Arab Café*, although it is perhaps more pronounced in *Goldfish* and other "fishbowl" paintings. The stubborn, repeated reworkings of *The Arab Café* were directed toward the most lapidary artistic statement possible. Some details were excluded, others were altered. One can still see that the position of the figure in the foreground was changed twice. The chromatic structure of the work was also changed, as Marcel Sembat mentioned in an article published in the spring of 1913: ". . . At the top, the fellow on the left was red! The other one, beside him, was blue,

36. Barr, p. 160.

37. This publication (Fasquelle, 1908-1912, 8 vols.) was referred to at the time by Willard Hantington Wright, *Modern Painting, Its Tendencies and Meaning* (New York-London, 1915), p. 231. Wright knew several of Matisse's acquaintances. Flam has developed this reference in relation to the *Large Nude* and *Interior with Eggplants* (Flam, *Matisse. The Man and His Art*, pp. 312-313).

38. *Large Nude* was destroyed, while *Interior with Eggplants* was quickly, and to Matisse's chagrin, relieved of its frame at the Grenoble museum.

39. In a letter of April 1913, he invited Morozov to look at *The Seated Riffian* and *The Arab Café* (letter XIV below). On 15 September Matisse wrote to Camoin that *Café* had been sold to Shchukin: "The picture should already have arrived in Moscow" (Giraudy, p. 16).

40. Apollinaire, "La Vie artistique. Henri Matisse" in *L'Intransigeant*, 17 April 1913.

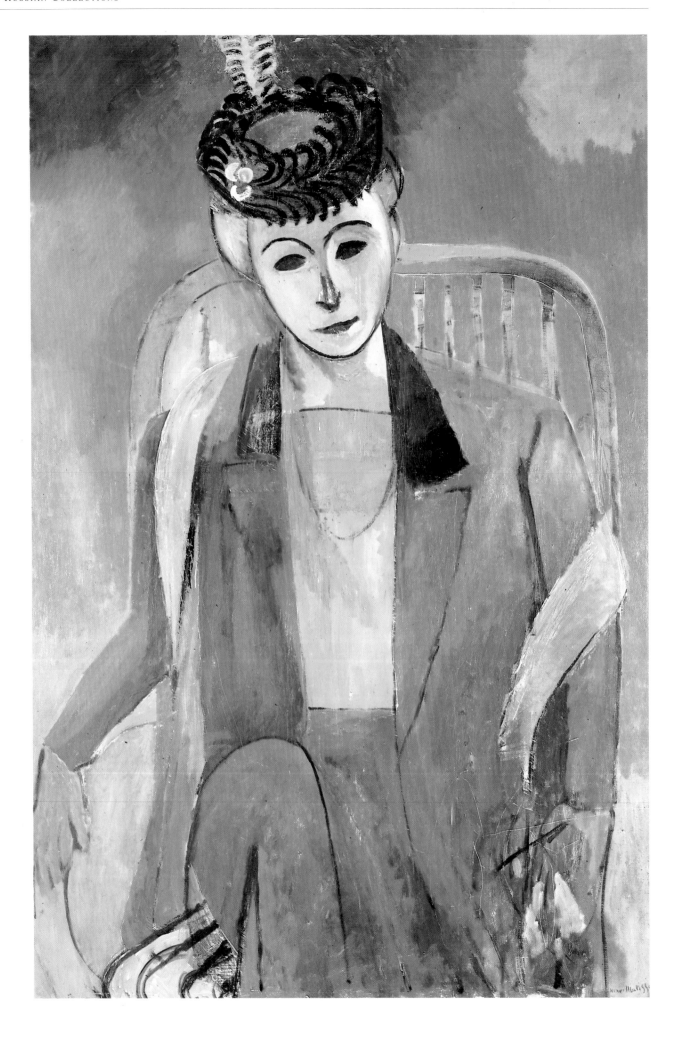

and the third, yellow. Their faces had features—eyes and mouth. The uppermost figure was smoking a pipe,"[41] Sembat also recorded a statement by Matisse that provides an excellent insight into the painterly logic of *The Arab Café*: "I have my jar of fish and my pink flower. That's what struck me! These big devils who stay for hours contemplating a flower and goldfish. OK, if I paint them red, this vermilion will make my flower purple. What then? I want my flower pink and nothing else. So my fish could be yellow; I don't care, they'll be yellow!"[42]

There is no reason to doubt Sembat's words simply because he was not in Morocco when Matisse made his painting.[43] The artist himself thought very highly of his article and clearly perceived no contradictions in it (he even sent a copy of the magazine to Shchukin). Furthermore, it could well be that Matisse finished the painting in France and that Sembat was able to witness the final reworkings.

It must be assumed that sufficient time elapsed between the picture's initial and final states for the first layer of paint to dry. In this case Matisse did not use oils, but tempera, no doubt to achieve a matte effect, but the already fragile materials have become even more brittle with the passage of time.[44]

Several attempts have been made to work out which cafe in Tangier Matisse depicted.[45] This is probably not all that important, since in the course of his work on the painting, the artist eliminated the specific details. As Sembat wrote, apropos of *The Arab Café*: ". . . For Matisse, to improve himself means to simplify, because consciously or not, deliberately or in spite of himself, every time he has attempted to improve something he has done, he has moved in the direction of simplicity. A psychologist would make no mistake about it: Matisse instinctively moves from the concrete to the abstract and the general. I tell him this. 'I move,' he answers me, 'toward my feeling, toward ecstasy.' . . . 'And then,' Matisse continues, 'I find peace there.'"[46]

Matisse also indicated that his trips to Morocco helped him accomplish the "transition" from fauvism and develop new contacts with nature.[47] A great painter like Matisse always needs contact with nature, and its renewal is a vitally important condition for his art. The act of creation requires that familiar faces and objects be seen afresh with new eyes.

A remarkable series of paintings, immensely varied in style and spirit, is made up of images of one and the same woman, his wife, Amélie, who frequently posed for her painter husband. *Dame japonaise* (Japanese Woman, 1901), *La Guitariste* (Guitarist, 1903), *La Femme au chapeau* (Woman in a Hat, 1905), *Madame Matisse* ("*La Raie verte*") (Madame Matisse ["The Green Line," 1906], *Madame Matisse en madras rouge* (Red Madras Headdress, 1908), *Madame Matisse au châle de Manille* (Manila Shawl, 1911). The most significant work in this series is The *Portrait de Madame Matisse* in the Hermitage, a fitting finale to this succession of landmarks in Matisse's art. As the list of titles indicates, Amélie Matisse appeared every time in a different headdress or costume— frequently exotic—which stimulated a fresh and unexpected approach to a familiar face.

The *Portrait of Madame Matisse* depicts Amélie Matisse not as a housewife, as in *The Painter's Family*, but as a lady of fashion smartly attired in a feather hat, a stylish jacket, and a scarf casually flung across her shoulder—all of which is conveyed with great precision, but schematically, for such details are not the artist's main interest.

The work was painted in Matisse's garden at Issy-les-Moulineaux in the summer of 1913.[48] Matisse did not produce many paintings that year, because the *Portrait* (the title used in the 1913 Salon d'Automne, where it was the only canvas Matisse exhibited) took up too much of his time. When the critic Walter Pach suggested that the painting's natural freedom of execution was the result of speed, Matisse replied that the *Portrait* had required more than a hundred sittings.[49] On 15 September he wrote to Camoin: "I am very tired now and I should free my mind of all preoccupation. While I have not done a great deal this summer, I have advanced my

41. Sembat, p. 191.

42. Ibid., p. 192.

43. *Matisse in Morocco*, p. 106.

44. The paint layer on this picture was never very secure, first of all because the canvas was not adequately primed, and second, because of the binder in the water-soluble tempera paints. Matisse's reworking made the paint layer still more fragile and even subject to flaking. The condition of the work deteriorated further when it was evacuated with the rest of the collection of the Moscow Museum of Modern Western Art to Novosibirsk, where it was stored for several years, until the war ended, without a stretcher. The upper layer had become friable in the extreme and was already flaking away, and the painting was extensively restored between 1956 and 1963 using a method specially developed by the Hermitage restorers L. N. Iltsen and T. D. Chizhova, who reinforced the paint with solutions of artificial resins. Time has proven the restoration to be a success, but the work cannot be transported and is never sent to exhibitions.

45. Flam and several others believe that the picture shows the Café Baba (Flam, p. 350). It is not possible to be entirely certain about this matter because the degree of abstraction is too great.

46. Sembat, p. 192.

47. "Matisse Speaks," *Art News Annual 21* (1952), reprinted in Flam, *Matisse on Art*, p. 133.

48. Giraudy even felt that the portrait was begun in 1912 (Giraudy, pp. 15-16).

49. Barr, p. 183.

PORTRAIT DE MADAME MATISSE, 1913
(PORTRAIT OF MADAME MATISSE)
OIL ON CANVAS, 145 x 97 CM.
THE STATE HERMITAGE MUSEUM, ST. PETERSBURG
ACQUIRED BY SERGEI SHCHUKIN IN 1913 FROM
THE ARTIST

PORTRAIT DE MADAME MATISSE, 1915
(PORTRAIT OF MADAME MATISSE)
PENCIL
MUSÉE MATISSE, NICE

50. Giraudy, p. 15.

51. Ibid., p. 16.

52. MacChesney, in Flam, *Matisse on Art,* p. 52.

53. The majority of these works are now in St. Petersburg, where Matisse's paintings occupy three halls in the permanent exhibition at the Hermitage.

large picture with the bathers, the portrait of my wife, and also the bas-relief."[50] And in another letter to Camoin, Matisse commented: "By the way, my picture (the portrait of my wife) is a great success among the progressives. But it hardly satisfies me: it is the beginning of a very great effort."[51]

The portrait of his wife was indeed a success. In Apollinaire's opinion it was the finest painting in the Salon d'Automne, a living embodiment of Parisian elegance that possessed the charm so lacking in modern art. Many years later Louis Aragon recalled the enchanting impression the portrait had made on him in his adolescence, and the young André Breton experienced its influence no less powerfully.

The exceptionally subtle color range of the portrait permits the unusual combination of a character study with emphatically decorative qualities. While it was actually in progress, Matisse told Clara MacChesney that he rarely painted portraits, and when he did, it was "only in a decorative manner."[52] The woman's face is a mask, reminiscent of the enigmatic theatrical masks of antiquity. The harshness of the facial features and the sense of mystery produced by the tremulous color transitions interact with each other to produce an atmosphere that is almost phantasmagorical.

The *Portrait of Madame Matisse* arrived in Moscow in mid March 1914; it was the last of Matisse's paintings to become part of Sergei Shchukin's collection. The so-called Great War that later became the First World War soon halted the activities of the Russian collectors, and in 1917 the October Revolution put an end to them forever. First Shchukin and then Morozov were forced to leave Russia, but in just a few years they had managed to assemble an extraordinary group of works by Matisse in Moscow.[53]

MATISSE'S CORRESPONDENCE
WITH HIS RUSSIAN COLLECTORS

Issy 92 route de Clamart
29 sept 1912

Cher Monsieur,

Je suis tout confus en vous
écrivant que je n'ai pu
faire vos 2 paysages, qu'il
ne seront pas au salon par
conséquent comme je vous
l'avais écrit ; mais que
je pars demain au Maroc
où je compte les peindre.

En vous présentant mes
excuses, je vous prie de faire
part à Madame de mes respec-
tueux hommages et de me
croire
 Votre dévoué
 Henri Matisse

MATISSE'S CORRESPONDENCE
WITH HIS RUSSIAN COLLECTORS

CATALOGUED AND ANNOTATED BY ALBERT KOSTENEVICH

The correspondence between Matisse and the first owners of his finest works sheds light on his relations with people who supported him at a very difficult time, when buying his canvases, far from being a profitable investment, was an extremely risky business. In addition, Matisse's letters provide us with important details of the history of certain works: when and where they were was painted, their origins, and so on.

Matisse's correspondence with Shchukin and Morozov naturally differs significantly from that with Marquet and Camoin, or later, with Bonnard. In the former instance, the element of commerce is almost always present, and the letters are written in a fundamentally different tone, preserving a certain distance that would be out of place in exchanges between friends: they are, in effect, "documents," and this is what gives them their particular value.

Unfortunately, we do not have all of Matisse's correspondence with his Moscow collectors. The six letters from Matisse to Morozov in the State Pushkin Museum of Fine Arts are well known to all Matisse scholars, but Morozov's letters have not been published previously.[1] The two men wrote to each other, with long intervals between letters, for a period of less than two years, beginning shortly before Matisse's visit to Moscow; in every exchange it was Matisse who took the initiative, always writing to Morozov for some specific reason.

Matisse's relations with Shchukin were quite different. They were equal partners in correspondence who maintained constant contact with each other. In the present volume, in addition to three of Shchukin's letters that appear in Barr's monograph on Matisse, Claude Duthuit, the director of the Matisse archives, has kindly allowed us to include thirty-five previously unpublished letters written by Shchukin to the artist.[2]

All attempts to locate Matisse's letters to Shchukin have proved unsuccessful, although we must assume that he wrote no less frequently than his correspondent. Matisse's letters were still in Moscow prior to Shchukin's departure from Russia in 1918, and it is unlikely that the Russian collector took them with him. Most probably he entrusted his personal papers to someone's safekeeping.

We can, however, glean some impression of the contents of Matisse's letters from Shchukin's replies, which, for all their brisk, businesslike tone, give occasional echoes of the artist's voice. Certain words are clearly quoted from Matisse's letters, occasionally cited merely to maintain the flow of the "conversation," but more often because they are words in which Matisse managed

1. Archives of the State Pushkin Museum of Fine Arts, archive 13, d. 38. These letters were first published in the exhibition catalogue *Matisse. Painting. Sculpture. Graphics. Letters,* State Pushkin Museum of Fine Arts, Hermitage (Leningrad), 1969, pp. 128-129.

2. Barr, pp. 147, 555.

3. Searches undertaken at various times in the Moscow archives have all proved fruitless. The final hope remaining to us is the archives of the former KGB, which it may now be possible to consult. They have informed us, however, that they have no documents relating to Sergei Shchukin.

4. Sergei Shchukin's heirs have no information concerning the whereabouts of Matisse's letters.

LETTER TO MOROZOV FROM MATISSE,
29 SEPTEMBER, 1912.
ARCHIVES OF THE STATE PUSHKIN
MUSEUM OF FINE ARTS, MOSCOW

to capture the very essence of the matter in hand. Matisse regarded his correspondence with Shchukin as so important that he often made rough drafts of his letters (we even know of one case in which there were two drafts). Several of these have been preserved, together with Shchukin's letters, in the Matisse archives in Paris. They were written in cases when the letters concerned key works such as *La Desserte rouge* (The Red Room) or *La Danse* (The Dance). It is tempting to compare these almost illegible, hastily written drafts with Matisse's paintings, in particular with the spontaneous works of the fauvist period. They have been dashed out almost in a single stroke, in an urgent attempt to capture the most vitally expressive train of thought. Matisse writes almost in shorthand, occasionally cutting words short or using abbreviations, crossing things out, starting anew, then crossing them out again.

Apart from the genteel formalities of polite correspondence, Shchukin's letters are in general rather laconic, written in the businesslike tone of a concerned collector addressing an artist whose work he genuinely loves. Their recurrent theme is the question of how Shchukin can obtain the paintings he likes and the ones he himself has commissioned: the letters published here make it clear that not only were *The Dance* and *La Musique* (Music) produced in response to commissions from Moscow, but several other crucially important works were also painted with Shchukin in mind.

Letters, no matter what their purpose, always tell us something about their author's personality, and Shchukin's letters are no exception. They will be essential source material for all who wish to gain a fuller understanding of this quite remarkable figure and his role in the culture of the early twentieth century.

A. K.

1. SERGEI SHCHUKIN'S LETTERS TO HENRI MATISSE

I

Moscow, 23 May 1908

Dear Sir,

Thank you very much for your letter of 18 May. I am sorry to hear that the still life with the pottery[1] has fallen into other hands[2] and would like to ask you now if you could kindly ask Mlle Weill, the picture dealer,[3] for what price she would agree to sell me this picture.

I am sure that your bathers[4] will be reunited[5] and impatiently await their appearance in Moscow. Be assured that the old wives' tales of the dealers will not in any way affect our good relations.

My regards to Mme Matisse.

I wish you good health and success in your work and I remain yours faithfully,

Sergei Shchukin

1. *Poterie et fruits* (Pottery and Fruit, 1901, Hermitage).

2. Obviously, during one of his meetings with Matisse in 1908, Shchukin had expressed interest in *Pottery and Fruit*, but the artist let the dealer Berthe Weill have it.

3. Matisse's relations with Berthe Weill had a long history. She was his first dealer, and the first to sell one of his works, as early as April 1902, when they were not yet in demand. Matisse and his colleagues from Moreau's studio exhibited in her gallery on the rue Victor Masset from 1902 to 1904.

4. The reference is to *Joueurs de boules* (Game of Bowls, 1908, Hermitage).

5. In Matisse's letter of 18 May 1908 (which has not survived), he clearly must have informed Shchukin, to whom he had promised *Game of Bowls*, of the compositional difficulties he was encountering with it.

II

Moscow, 2 June 1908

Dear Sir,

I am most grateful to you for your efforts concerning the "Pottery" still life.[1] Yesterday, via Crédit Lyonnais, I sent you 900 francs, the price set by Mlle Weill. Would you please be so kind as to pay this amount to Mlle Weill and inform my forwarding agent Monsieur Schroeder (rue Sèze, 2) that this painting should be sent to my Moscow address by express delivery (insured for 900 francs).

Mr. Druet[2] is offering me another of your still lifes,[3] the one belonging to Mr. Fénéon.[4] I wish to take it.

As for "The Bathers," I am glad to learn that you are thinking of starting them again.[5] I am always thinking of your ravishing "Sea", and constantly see the painting before me.[6] I can feel that freshness, that majesty of the ocean, that sense of sadness and melancholy.

I should be very glad to have something of this kind.[7]

Perhaps you could send me a photograph of "The Bathers."

My regards to Mme Matisse. I hope that she is in good health, and your children also.

Your devoted Sergei Shchukin

1. *Pottery and Fruit.*

2. Emile Druet (1868-1916), a Paris art dealer.

3. *Plats et fruits sur un tapis rouge et noir* (Dishes and Fruit on a Red and Black Carpet, 1906, Hermitage).

4. Félix Fénéon (1861-1947), a literary and art critic, writer, and friend of Seurat, Signac, and Pissarro. He was closely involved with the neo-impressionists and symbolists, and founded the *Revue indépendante* in 1884 and served as director of the *Revue blanche* from 1895 to 1904. He managed the affairs of the Galerie Bernheim-Jeune for several years; it was Fénéon who persuaded the gallery's owners to sign a contract with Matisse in 1909.

5. *Game of Bowls.*

6. Shchukin clearly had in mind *Les Baigneuses à la tortue* (Bathers with a Turtle, 1908, City Art Museum, Saint-Louis).

7. *Game of Bowls* was indeed a development of the motifs and themes of *Bathers with a Turtle*, from the very close landscape background and the number of figures to the drastically simplified style.

III

TELEGRAM
25 June 08
Addressed to: Paris, 33 bd. des Invalides

Please telegraph if Crédit Lyonnais paid you 900 francs for Still Life[1] at Weill's.

Shchukin

1. *Pottery and Fruit.*

IV

Telegram
30 June 08
Addressed to: Paris, 33 bd. des Invalides

Received photograph bathers[1] find picture very interesting please send Moscow express delivery insure 1,500.

1. *Game of Bowls,* 1908 (Hermitage).

V

Moscow, 17-30 July 1908

Dear Sir,

Yesterday I received your painting "The Bathers". I am quite pleased with it and extremely grateful to you. I very much like the freshness and nobility of your work.

Mr. Druet has also sold me your still life from Fénéon.[1] It is very beautiful.

Could you please let me know now how much I owe you for the large still life that you are doing for me,[2] and for the medium-sized one[3] (similar to the one Mme Stein has).[4]

Perhaps you could send me a photograph of the large still life.

My regards to Madame Matisse.

Please accept my very warmest wishes,

Your devoted Sergei Shchukin

N.B. Small sketch of Fénéon's still life

1. *Bowl of Fruit on a Red and Black Carpet.* Shchukin drew a small sketch of the still life at this point in his letter.
2. A decorative panel for Shchukin's dining room. It later became *The Red Room,* 1908 (Hermitage).
3. *Nature morte en rouge de Venise* (Still Life in Venetian Red, 1908, State Pushkin Museum).
4. It was clearly through Matisse that Shchukin made the acquaintance of Michael Stein (1865-1938) and his wife, Sarah (1870-1953). Matisse was friends with the couple, and he gave lessons in painting and drawing to Sarah Stein, who may be considered his pupil. It was for her that Matisse painted *Bronze et œillets* (Sculpture and a Persian Vase, 1908, Nasjonalgalleriet, Oslo), the "medium-sized" still life (60 x 73 cm.) that Shchukin saw in the Steins' apartment on the rue Madame in Paris.

VI

Nizhny Novgorod, 19 August 1908

Dear Sir,

Yesterday I arrived in Nizhny Novgorod,[1] where I found your letter of 6 August.[2] I am very glad that the large still life is finished.[3] I shall be in Moscow in 2-3 days and shall send you the 6,000 francs[4] (4,000 for the large work and 2,000 for the medium-sized one[5] similar to Mme Stein's).[6]

Could you please send the large still life to Moscow by express delivery (insuring it for 4,000 francs). And the same with the small still life, when it is finished.

I hope that you will finish several other works for the Salon d'Automne.[7]

My regards to Madame Matisse.

Please accept, my dear sir, the very warmest wishes of your devoted

Sergei Shchukin

1. Shchukin was a regular visitor to the annual fair at Nizhny Novgorod, where the most important commercial deals were concluded, particularly in the textile trade. This was the largest of all the Russian fairs; it usually lasted from 15 July to 25 August.
2. The draft of this letter is in the collection of the Matisse archives in Paris. See p. 92 above.
3. *The Red Room.*
4. This was the price proposed by Matisse himself.
5. *Still Life in Venetian Red.*
6. *Sculpture and a Persian Vase.*
7. Matisse showed thirty works in the Salon d'Automne of 1908. These included both of the pictures that Shchukin was anxious to receive immediately. The fact that they belonged to the Moscow collector was clearly indicated: no. 897, *Nature morte tapis d'Orient* (Appartient à M. Sch.), i.e., *Still Life in Venetian Red*; no. 898, *Panneau décoratif pour salle à manger* (Appartient à M. Sch.), i.e., *The Red Room.*

VII

Telegram
7 November 08
Addressed to: Paris, 33 bd. des Invalides

Please telegraph if large picture[1] and still life[2] sent Moscow reply paid.

Shchukin

1. *The Red Room.*
2. *Still Life in Venetian Red.*

VIII

Telegram
20.12.08
Addressed to: Cassirer, Berlin, Violoviastrasse

Agree leave Matisse paintings.[1]

Shchukin

1. The telegram concerns the proposed exhibition at Paul Cassirer's gallery in Berlin. See note 2 to Shchukin's letter of 21 February 1909 below.

IX

Moscow, 13-26 January 1909

Dear Sir,

Allow me to be so bold as to recommend to you the young Russian artist Mr. Léopold Stürzwage.[1] In Moscow he was one of the first to admire your paintings.[2] He is now going to Paris in order to enter your school.[3] I am sure that your advice can be very useful to this young artist.

My regards to Mme Matisse.

I hope that you are in good health.

In anticipation of news from you, I remain your devoted

Sergei Shchukin

X

Moscow, 21 February-4 March 1909

Dear Sir,

It was only this morning that I received the two paintings from Paris (the blue still life and the fauvist one).[1] They are ravishing!

The paintings from Berlin were also delayed (in view of the heavy snows in Russia).[2]

I like the red room tremendously. And the Turkestan carpet too.[3]

Could you please write and tell me whether you have done any more easel paintings. You promised to keep me informed of every painting you are working on. I think a lot about the large painting.[4]

Perhaps you might be able to send me a color sketch.[5] I feel that it will be very beautiful! and that I must take it.

In any case I have complete confidence in you, and I am sure that the large painting will make a fine decoration for my staircase.

My regards to Mme Matisse and Mr and Mme Stein.

Your devoted

Sergei Shchukin

XI

Moscow, 3-16 March 1909

Dear Sir,

I have received both of your letters of 11 and 12 March with the sketches of the large paintings.[1] They are very fine indeed, and their color and line are very noble, But alas! I can no longer hang *nudes* on my staircase.[2] Following the death of one of my relatives,[3] I have taken three young girls (8, 9 and 10 years old) into my house, and here in Russia (we are somewhat oriental here) one cannot show nudes to young girls.[4] Make the same circle, but with girls in dresses. And the same with composition no. 2. The staircase has two walls for large paintings.

In Russia we are like Italy in the seventeenth century, where nudes were forbidden.[5]

If I did not have young girls in the house, I would risk ignoring public opinion, but now I am obliged to conform with Russian customs. Perhaps you will find some way of painting the same dance, but with girls in dresses?

I like the "Spanish Woman"[6] very much, and I am impatient to receive Mr Fénéon's letter with the price.[7]

I hope that you will find a way to decorate my staircase with two large panels (4 meters), but without any nudes. One or two small nude figures at the [illegible] would be acceptable.

1. Léopold Stürzwage (1879-1968), better known by his pseudonym of Survage, was Finnish in origin. He studied at the Moscow College of Painting, Sculpture, and Architecture under Leonid Pasternak and Konstantin Korovin. After moving to Paris he took part in various avant-garde movements and later became a French citizen. It was as a French painter that he was included in the collection of the State Pushkin Museum of Modern Western Art.

2. In addition to the works in Shchukin's collection, Survage could have seen five canvases by Matisse that were exhibited in Moscow in the spring of 1908, at the first Salon of the Golden Fleece: *La Coiffure* (Coiffure), *La Terrasse, Saint-Tropez* (The Terrace, St. Tropez), *La Malade* (The Sick Woman), *Le Pot de géranium* (Geranium Plant), and *Le Môle de Collioure* (The Pier at Collioure).

3. It was generally thought that Survage settled in Paris in 1908, but this letter obliges us to revise the date to 1909.

1. *Nature morte, camaïeu bleu* (Still Life with a Blue Tablecloth, 1909, Hermitage) and *Nature morte, vaisselle à table* (Dishes on a Table, 1906, Hermitage).

2. Shchukin is referring to Matisse's brief and unsuccessful exhibition at Paul Cassirer's gallery. The catalogue is no longer extant, but since the paintings were selected in December, after the 1908 Salon d'Automne had closed, it is reasonable to assume that "the paintings from Berlin" were *The Red Room* and *Still Life in Venetian Red*, exhibited while en route from Paris to Moscow.

3. *Still Life in Venetian Red*.

4. *The Dance*.

5. Matisse actually did send Shchukin a sketch of *The Dance*, which he called *Composition No. 1* (State Pushkin Museum). See the following letter.

1. *Composition No. 1 (Danse)* and *Composition No. 2 (Demoiselles à la rivière)* (Bathers by a River), both 1909 (State Pushkin Museum).

2. The emphases here and below are Shchukin's.

3. Shchukin is referring to the death of his brother Ivan, who had committed suicide in Paris on 2 January.

4. Shchukin took three young peasant girls into his own home for upbringing. A short while later, only two of them, Anya and Varya, were still there.

5. Shchukin's comment properly applies not to the seventeenth century, but to the preceding Counter-Reformation period. He most likely had in mind the attacks on the frescoes of "The Last Judgment" by Michelangelo, who was accused of lewdness. In 1565, on the orders of Pope Pius IV, Daniele da Volterra began covering the hips of the nude figures with drapery.

6. *L'Espagnole au tambourin* (Spanish Woman with a Tambourine, 1909, State Pushkin Museum).

7. This letter from Fénéon has not survived. The price proposed to Shchukin by the Bernheim-Jeune Gallery was 5,000 francs. See the following letter.

My regards to Mme Matisse.

Awaiting the pleasure of reading your reply, I remain your devoted

Sergei Shchukin

XII

Moscow, 27 March 1909

Dear Sir,

I have received your letter of 23 March and am very touched that you have kept three paintings for me.[1] I am quite definitely taking them (subject to your choice and price).

For my staircase I need only two large decorations.[2] But concerning the subject, I would like to avoid nudes. This way you can do them when you have finished that important matter you mentioned in your letter.

But I have another proposal for you. I liked your sketch of "The Dance" tremendously.[3] What noble movement it has!

Can you make this sketch into a painting the same size as "The Red Room" or "The Sea"?[4] I am prepared to pay the same price of 15,000 (fifteen) francs that you set for the large canvas of 4 or 5 meters.

This painting will be hung in my private room. The canvas can even be slightly larger than the "The Red Room" (1/3 or 1/4 of a meter larger), but even so it is intended for a room.

I have taken your "Spanish Woman" from Bernheim for 5,000 francs.

My regards to Mme Matisse.

In anticipation of your speedy reply, I remain your devoted

Sergei Shchukin

P.S. Mr. Morozov will be at the Salon des Indépendants.[5] He wishes to talk with you about the decoration of his dining room. As yet he has not decided anything.[6]

XIII

TELEGRAM
28 March 09
Addressed to: Paris 33 bd. des Invalides

Received your letter found panel there cancel[1] all reservations expressed in my letters[2] request priority for two panels on staircase telegraph if accept firm order panel Dance for fifteen thousand for second panel please take music as subject write price second panel[3]

Sergei Shchukin

XIV

Moscow, 31 March 1909[1]

Dear Sir,

I find so much nobility in your panel "The Dance," that I have decided to ignore our bourgeois opinion and hang a subject with nude figures on my staircase. At the same time I shall need a second panel, the theme of which could be music.

I was very glad to have your advice: please accept my firm order for the panel "The Dance" for 15,000 francs, and the panel "Music" for 12,000 francs, price confidential. I thank you very much and hope to receive a sketch of the second panel soon.[2]

There is a great deal of music-making in my house. Every winter there are about ten concerts of classical music (Bach, Beethoven, Mozart). The panel "Music" should to some extent express the character of the house. I trust you completely, and am convinced that "Music" will be as successful as "The Dance."

Please send me news of your works.

1. To judge from the following sentence, Matisse had not indicated which paintings he had "reserved" for Shchukin. By a process of elimination we can establish that the three were most probably *Nu, or et noir* (Black and Gold, 1908, Hermitage), *La Nymphe et le Satyre* (Nymph and Satyr, 1908-1909, Hermitage), and one of two earlier works, either *Vue de Collioure* (View of Collioure, 1905, Hermitage) or *Le Bois de Boulogne* (The Forest of Boulogne, 1902, State Pushkin Museum).

2. In his letter of 23 March, Matisse probably described the plan for a triptych of large panels that he later mentioned to Charles Estienne. cf. p. 17.

3. *Composition No. 1*.

4. *Bathers with a Turtle*, which is almost exactly the same size as *The Red Room* (178.8 x 216.9 cm.).

5. In fact Morozov was not able to visit Paris in April 1909.

6. Morozov's idea of decorating the dining room of his mansion with Matisse's paintings, which was prompted by Shchukin's acquisition of *The Red Room*, was never realized. It is possible that on reflection Morozov felt it was too bold an undertaking. In addition, the success of Denis's first canvases from the "History of Psyche" series prompted Morozov to commission a continuation, and the "Matisse project" was postponed.

1. The sketch of *The Dance (Composition No. 1)*, State Pushkin Museum.

2. See Shchukin's letters of 3 and 27 March 1909.

3. Matisse set a price of 12,000 francs for the *Music* panel.

1. This letter, which has been preserved in the archives of Pierre Matisse, was first published in Alfred H. Barr, Jr., *Matisse, His Art and His Public* (New York 1951), p. 555. However, Barr mistakenly combined the texts of two letters: the second (see letter no. XXXVII below) was written in 1912. Barr's mistake was corrected by Beverly Whitney Kean.

2. Nothing is known of this commission. In view of the difficulties encountered with *Music*—the composition was revised several times—it must be assumed that no initial sketch of this panel for Shchukin ever existed.

All of my reservations in the two previous letters are canceled by my telegram of last Sunday.[3] You now have a firm order for both panels.
My regards to Mme Matisse.
Awaiting news from you, I remain your devoted

Sergei Shchukin

3. This telegram has not survived.

XV

Moscow, 30 May 1909

Dear Sir,
I have received your letter of the 19th and was very glad to learn that you are feeling well and working a great deal.
Your two new paintings must be very interesting.[1] Here in Moscow everything is calm. Mr. Morozov has given Mr. Denis a new commission for six panels, in view of the great success of his first decoration.[2]
I hope that when they see your decorations,[3] the panoply of admiring cries that are heard at present will be muted a little. At present they talk of it as a great masterpiece. They laugh at me a little, but I always reply: "He who laughs last, laughs best." I trust you always and hope that you will find a composition worthy of you for "Music."
My regards to Mme Matisse.
Hoping to receive good news from you, I remain your devoted

Sergei Shchukin

1. It is hard to say which paintings are meant here. Shchukin could hardly be referring to *La Conversation* (The Conversation): Matisse had apparently already begun the work at this time, but it came as a revelation to Shchukin in 1912. We cannot consider the "two new paintings" to be *The Dance* and *Music*. Most probably Matisse had written about some portraits on which he was working at the time.
2. Maurice Denis came to Moscow at Morozov's invitation in 1909, when agreement was reached concerning an additional six panels and two borders; these were finished by the autumn and dispatched to Moscow from Paris in October. Denis's visit, during which he overpainted the first five panels somewhat, in order to tone down the harsh colors, contributed significantly to the success of "The History of Psyche."
3. *The Dance* and *Music*.

XVI

TELEGRAM
28 May 1909
Addressed to: 42 route de Clamart à Issy-les-Moulineaux

Mr. Sergei Shchukin in Italy will return June third.

Shchukin (son)

XVII

POSTCARD (postmarked June 1909)
Addressed to: 42 route de Clamart, Issy-les-Moulineaux

Dear Sir,
I have reached Venice after a grand tour of Italy and I hope to arrive in Moscow in two weeks. On about 27 or 28 June I shall send you 30,000 frs (20,000 for the decorations[1] and 10,000 for the flowers[2]). My health is restored. I wish you good health; my regards to Madame Matisse.
Your devoted

Sergei Shchukin

1. *The Dance* and *Music*.
2. *Bouquet de fleurs dans un vase blanc* (Flowers in a White Vase, 1909, State Pushkin Museum), which Shchukin received in 1910, after the 1909 Salon.

XVIII

POSTCARD (postmarked 5.7.09)
with the letterhead: "Grand Hôtel des Bains, Lido-Venice"
Addressed to: Issy-les-Moulineaux

Dear Sir,
I have sent you via Crédit Lyonnais (in Moscow) 30,000 frs (20,000 for the decorative panels and 10,000 for the flowers. I owe you another 800 frs for the

flowers). My health is good. I should be very glad to have some news from you. Write a few words to me here in Venice (Lido - Grand Hôtel des Bains). My best wishes to Mme Matisse. I am staying in Italy. Your devoted

Sergei Shchukin

XIX

Moscow, 20 August-3 September 1909

Dear Sir,

It was a great pleasure for me to receive your letter, and I am very grateful to you for having saved "Bouquet of Flowers"[1] (canvas no. 40)[2] for me. By all means do exhibit this painting in the Salon d'Automne.[3] Please be so kind as to let me know the price; I will send you the money.

I am very interested in my decorations "The Dance" and "Music." I am sure this will be a great victory.

I am counting on coming to Paris for the Salon d'Automne.[4]

I should be most grateful if you could please send me small color sketches of your other easel paintings.

In any case I am very much counting on your promise to reserve for me the canvases that you consider important.

In anticipation of your swift reply, I remain your devoted

Sergei Shchukin

1. *Flowers in a White Vase*, 1909 (State Pushkin Museum).
2. In the French system of standard canvas sizes, no. 40 for still lifes and figure compositions measured 80 x 100 cm.
3. The painting was shown as no. 735 at the 1909 Salon d'Automne.
4. The Salon d'Automne opened on 1 October.

XX

Moscow, 1-14 March 1910

Dear Sir,

Your letter of 6 March gave me great pleasure. I was very glad to receive good news concerning yourself and your family. You know very well that I am concerned for you. I shall do everything possible in order to come to Paris this spring, but I do not know whether my business will allow me to leave Moscow.

My health and my eyes are in good condition, and I am able to work once again. Yesterday I saw Mr. Morozov; he is impatiently awaiting your 2 still lifes.[1]

Life in Moscow is very calm.

Perhaps you could send me a few articles about your exhibition and the catalogue.[2] My regards to Madame Matisse.

Goodbye, my dear Mr. Matisse, keep well, and work well.

Your devoted

Sergei Shchukin

1. In all probability, the still lifes mentioned here did not become part of Morozov's collection, because he bought from various dealers rather than from the artist himself.
2. It is not known whether Matisse sent Shchukin a catalogue of his large retrospective exhibition, which was held at the Bernheim-Jeune Gallery from 14 to 22 February 1910, or any articles about it. For the most part, such articles were hostile.

XXI

Moscow, 23 August-5 September 1910

Dear Sir,

It is a few days now since I returned from Italy. I was mostly in Venice, from time to time I visited Padua, Vicenza, Verona, Mantua, etc.

My health is completely restored, and I hope to come to Paris for the Salon d'Automne.

I shall be very glad to have news of yourself and your family.

Your devoted

Sergei Shchukin

XXII

TELEGRAM
10.11.10

Considered while traveling decided take your panels please send Dance and Music express delivery greetings

Sergei Shchukin

XXIII

Moscow, 11 November 1910

Dear Sir,

While traveling (two days and two nights) I pondered a great deal and came to feel ashamed of my weakness and lack of courage. One should not quit the field of battle without attempting combat.[1]

For this reason I have decided to exhibit your panels. People will make a clamor and laugh, but since I am convinced that you are on the right path, time will perhaps be on my side, and in the end I shall emerge victorious.

I have sent you a telegram asking for the panels to be dispatched to Moscow by express train delivery.

As for the panels [sic] of Puvis, I am in a more difficult situation.[2] I cannot fit a single one of the panels into my room. Here are the measurements of my walls:

[sketch]

To alter the walls would require radical reconstruction, which, in my architect's opinion, would cost 100-120,000 francs (because of the vaults and the doors). In that case I prefer to lose 15,000 francs rather than incur such heavy expenditure. I have offered the panel to the Moscow Museum of Painting, but they have rejected my donation for lack of space.[3]

You can see that the panels have no value for me at all. I ask you please, as a friend, to suggest to Messrs Bernheim an exchange of some other work for the Puvis panel.[4]

I understand that its current value is very low, and I shall be happy to receive in exchange a painting worth 5,000 francs (thus I lose 10,000 francs). But if the Bernheims find this too much to ask, let them make an offer, and I shall agree to lower my terms. I shall, of course, regret the loss of 15,000 francs, but at the same time it is a lesson to me. It is so difficult to find a place for large paintings, and their value is so low.

Now I shall be cured of my weakness for large works. In exchange I request the Bernheims to give me your painting "Girl with Tulips".

In Paris, when I bought the Puvis panel, I was too much under the influence of reminiscences of my youth, when I was so infatuated with Puvis.

Here, in different surroundings, I can see that the panel, although it is very beautiful, is rather weakly drawn and even a little (a very, very little) in the "pompier" style.[5] I therefore have nothing to regret except the loss of the money. I hope to earn back the amount lost by working. If the Bernheims reject every offer, then I ask you to leave the Puvis panel in your studio until I die.

In Moscow the weather is sad and misty. I hope that you are in good health, likewise Madame and your children. I wish you a pleasant journey and complete rest.[6]

Your devoted

Sergei Shchukin

XXIV

Moscow, 14-27 November 1910

Dear Sir,

Your letter from Madrid gave me great pleasure. I am very happy that you have gone to Spain. You need rest, and I am sure that the trip will do you a great deal of good.

1. Having arrived in Paris only to witness the furious attacks on *The Dance* and *Music* (these two panels, in which Matisse placed his greatest hopes, were the only works he exhibited in the Salon d'Automne), Shchukin began to hesitate once again about whether or not to hang them on the staircase of his mansion.

2. In fact one panel The Muses Greet Genius, the Herald of Light.

3. The Rumyantsev Museum in Moscow. Only three rooms in the museum's picture gallery were devoted to western painting.

4. The brothers Gaston (1870-1953) and Josse (1870-1941) Bernheim-Jeune, at that time the owners of the Bernheim-Jeune Gallery.

5. "Pompier," the French word for a fireman, is used here as a disdainful term, current in avant-garde artistic circles, for academic salon painting. It arose because the protagonists of academic art were so partial to historical subjects that the antique headgear in their pictures came to be referred to as firemen's helmets. The term implies banality and conventional conformity: *pompierisme* was synonymous with academic art.

6. Matisse left for Spain in mid November.

1. Matisse had taken up negotiations with the Bernheims to have Puvis de Chavannes's *Muses* exchanged for *Girl with Tulips*. See the preceding letter.

2. *Nature morte au géranium* (Still Life with Geraniums, 1910, Neue Pinakothek, Munich).

3. Matisse took note of Shchukin's request. For his next two still lifes, the so-called *Séville I* (Interior with Spanish Shawls) and *Séville II* (Spanish Still Life), he chose approximately the same dimensions as *Still Life with Geraniums* and, more important, he developed a similar theme, depicting a potted geranium plant with decorative fabrics.

4. Vassily Vassilievich Kandinsky (1866-1944).

5. *Still Life with Geraniums.*

6 Hugo von Tschudi (1851-1912), director of the Neue Pinakothek in Munich, and formerly director of the Kaiser Friedrich Museum in Berlin. After visiting Paris in 1910, Tschudi commissioned a still life for his own collection from Matisse.

7. Matisse painted two still lifes for Shchukin in Seville, thus fulfilling the request even before he returned to France.

I am very grateful to you for the trouble you have taken over the Puvis, and I am very pleased that the Bernheims have agreed to this exchange.[1] I become more and more convinced that you are on the right path. In the three weeks since I left Paris, the only thing I can remember clearly are your paintings, which seem to be engraved on my memory. The other things have been forgotten.

Could you please now do two still lifes the same size as the Munich piece[2] and somewhat in the same vein?[3] Could you please set the price for each picture at 5,000 francs. At the same time I ask you to give me priority over other commissions.

I shall have to endure a great struggle with the two large panels, and the two still lifes should help me to win greater acceptance for you.

Yesterday I saw Mr. Kandinsky, the painter from Munich;[4] he passionately admires your still life[5] at Tschudi's.[6] Paintings of that sort are easy to understand. I therefore ask you please to give me the first two still lifes you do on returning to France.[7] At least give me one as soon as possible. I hope to receive confirmation that you are not only strong, but also charitable.

The weather here is very bad.

Your panels should arrive in a month.

I hope for good news from you, dear sir, and remain your devoted

Sergei Shchukin

XXV

Undated[1]

Dear Sir,

I brought back a photograph of Cézanne's "Card Players" (a large painting at Vollard's).[2] While looking at it, I thought that perhaps some day you will also paint a composition with clothed figures. Perhaps a portrait of your family (Madame Matisse and your three children).[3] What do you think? I should be so glad to have such composed paintings from you. Please do write a few words to me on this matter.

Do not forget that you promised me "Sails."[4] You see, I enjoy thinking about your paintings and hope to have many of them.

My very best wishes to Mme Matisse.

Your large panels have still not arrived.[5]

I remain your devoted

Sergei Shchukin

1. The letter was most likely written during the first half of December 1910.

2. Cézanne's *Card Players* (1890-1892) is now in the Barnes Foundation in Merion, Pennsylvania.

3. The original idea for *La Famille du peintre* (The Painter's Family, 1911, Hermitage).

4. *Femme à la terrasse* (Woman on a Terrace, 1907, Hermitage).

5. *The Dance* and *Music* arrived in Moscow on 17 December (4 December old style).

XXVI

Moscow, 20 December 1910

Dear Sir,

Your panels have arrived and been hung. The effect is not bad. Unfortunately in the evening, by electric light, the blue changes greatly. It becomes almost murky, almost black. But overall I find the panels interesting and hope to come to love them some day. I have complete confidence in you.

The public is against you, but the future is yours.

I would like now to suggest a certain matter to you. I am thinking of making up a room with your decorations. It is not a large room,[1] but it could hold three paintings of the same size as "The Red Room." Perhaps you could do them? And what would be your price?

They will have to be viewed from close up (the distance in the room is less than 5 square meters).[2]

What subject? Not nudes. Clothed figures. Think it over and let me know your opinion.

1. The reference is to the room that Shchukin had sketched in his letter on 11 November 1910. Its area is actually 27.5 square meters.

2. Clearly a slip of the pen: it should be 5 linear meters or a little less, taking into account the stove.

The room is badly lit and pierced above by a vault.

I hope that you have returned from Spain,[3] that your health is sound and that soon I shall receive the two still lifes from you.[4]

My regards to Mme Matisse.

Your devoted Sergei Shchukin

P.S. People mistreat me a little because of you. They say that I am doing harm to Russia and the young people of Russia by buying your paintings. I hope to emerge victorious some day, but I shall have to fight on for a few more years.

The choice of subject for the three panels depends on you. What do you think of youth, maturity, and old age? Or spring, summer, and autumn?

3. Matisse left Spain during the second half of January. His final postcard from Toledo was sent on 17 January.

4. *Séville I* and *Séville II*.

XXVII
Moscow, 23 December 1910-5 January 1911

Dear Sir,

Yesterday I received your letter from Seville, and it brought me great pleasure. I am happy that I shall have your two still lifes. Do send them immediately to Moscow by express delivery, insured for 10,000 frs. Only please write and tell me to what address I should send these 10,000 frs.

I like the family painting very much now; the dimensions could be 2 m. by 1.5 m. or 2 m. But I ask you please, if possible, first to do the panels with the flowers.[1] The big job that I am now offering you is to decorate an entire room in my house (it is the room in which I wanted to hang the Puvis).[2] But it seems to me that it would probably be more sensible to come to Moscow in the spring and see the place itself.[3] Otherwise, I could send you the precise measurements.

I am impatiently awaiting your reply concerning the price for the full decoration of this room. As for the family painting, I want to have that as well, for I find the composition very beautiful.[4]

You see, my dear sir, I have complete confidence in you and am certain of your victory. I was happy to learn that your health is better, and I consider it very wise on your part to work for a little while in Spain. Perhaps you will be able to do the family portrait or the flowers there.[5]

I am beginning to enjoy looking at your panel "The Dance," and as for "Music," that will come in time. In spring I want to change the color of the wall and the carpet (to match the frames).[6]

You can take any subject you want for the decorations of the room (figures, landscapes, still lifes), even a few nudes.

My health is excellent.

I am rereading your letter and examining with great interest your sketch of the family painting.[7] It has a noble feeling to it, and I ask you please to do this painting for me.

Once again I wish you sound health and courage. The victory is yours!

Druet has not sent the photographs of the panels.[8] He is constantly angry with me.

I ask you please to send the Paris still life (like the stained-glass windows at Chartres), which I bought from you in November.[9]

I await news from you and remain your devoted

 Sergei Shchukin

1. No details are known of this commission from Shchukin, but we may assume that the panels with flowers were eventually painted as the two large floral still lifes of the Moroccan period: *Bouquet d'arums sur la véranda* (Bouquet of Arum Lilies on the Verandah, 1912-1913, Hermitage) and *Arums, iris et mimosas* (Arum, Iris, and Mimosa, 1913, State Pushkin Museum).

2. See the letter of 11 November 1910.

3. This visit took place in October-November 1911.

4. Shchukin formed his opinion of the future work from a sketch that Matisse sent him.

5. Matisse must have informed Shchukin that he intended to stay on in Spain.

6. The reference is to the staircase in Shchukin's mansion. The frames of the panels have unfortunately long been lost.

7. The initial sketch of *The Painter's Family* (the painting is now in the Hermitage) was not drawn on a separate sheet of paper like the sketch of *The Dance*, but included as part of the letter. It has therefore been lost, together with Matisse's other letters to Shchukin.

8. Photographs of *The Dance* and *Music*: evidently Shchukin had hoped to receive photographs of the panels painted for the Salon d'Automne.

9. The work concerned is *Nature morte au pot d'étain* (Still Life with a Pewter Jug). In the catalogue of Shchukin's collection, it is described as follows: "105. Still life: table with vases (1910)" and then in French, "Nature morte [still life] (Chartres)." This letter proves that Shchukin visited Matisse at Issy-les-Moulineaux in November, which is why he described the painting as the "Paris still life": it shows the wooden wall paneling of the studio at Issy.

XXVIII
Moscow, 2-15 February 1911

Dear Sir,

I hope you have returned to Issy in sound health and completely recovered from your bouts of fatigue.

I am very grateful to you for accepting my proposal to do three decorations, and I

1. Sarah Stein.

2. The *Séville I* and *Séville II* still lifes, together with *Still Life with a Pewter Jug*.

think a price of 30,000 frs is fair. But I ask you please to set the price of the family portrait at 10,000 frs.

I am very grateful to you for forwarding Mme Stein's letter.[1] I enjoyed it greatly. I have a high regard for Mme Stein's opinion.

I am now waiting impatiently for the still lifes (from Seville and Paris).[2] I hope you have received the 10,000 frs sent to Crédit Lyonnais.

Do write with news of yourself and your family. Here in Moscow we are having a very cold winter (25-30 degrees Réaumur), but I am feeling very well.

I think I shall be in Paris in spring.

My regards to Mme Matisse.

Your devoted

Sergei Shchukin

P.S. Mme Stein's letter enclosed.

XXIX

(Letter undated. Postmarked 26 March 1911)

Dear Sir,

I was very glad to have news of you.

Your two Seville still lifes arrived four weeks ago. I find them quite magnificent and am very grateful to you. I like your light blue and green with dark pink tremendously.

I hope that the family portrait and the floral panels will be finished for the Salon d'Automne.[1] As for the large decorative panels, I would very much like to know if you have had any ideas yet.[2]

I shall only be in Paris in July for two or three days. I shall spend May and June in Venice.

My health is excellent.

My very best wishes to Mme Matisse.

In eager anticipation of the pleasure of news from you, I remain your devoted

Sergei Shchukin

1. Although *The Painter's Family* was finished in good time, Matisse did not keep it for the 1911 Salon d'Automne. As though he needed a respite following the harsh shocks of the previous Salon d'Automne, he exhibited only two sketchily executed landscapes under the title of "esquisses décoratives" (decorative sketches): they contained not a hint of the daring that distinguished *The Dance* and *Music*, and they went almost unnoticed. At this time Matisse had not actually begun to work on the floral panels.

2. We must assume that Matisse had already formulated, or was in the process of formulating, the idea of "symphonic interiors," a series where *The Painter's Family* would be followed by "The Artist's Studio" (*L'Atelier rose* [The Pink Studio, 1911]).

XXX

Moscow, 3 September 1911

Dear Sir,

This morning I received your letter of 29 August and was extremely pleased to learn that you are feeling well and working full speed ahead.[1] Please do stay in the peace of Collioure until your work is finished. You can send me the paintings when you return.[2] I would not wish to disturb your creative impulse for anything in the world. Your art is too dear to me. Your paintings bring me tremendous joy. Every day I look at them and I love them all. I am sure that you will make beautiful things in Collioure too.

I also think a great deal about your painting with the boats,[3] and I hope that you will come to Paris with 3 works (2 for Morozov[4] and 1 for me).

I very much like your idea of visiting Ravenna.[5] It is a wonderful town for the art of mosaics and wall decoration. Please write to tell me when you are thinking of going back to Paris. I wish to set out from Moscow at the same time (for the Salon d'Automne).[6] I am feeling extremely well.

My regards to Mme Matisse.

In anticipation of news from you I remain your devoted

Sergei Shchukin

1. During the summer of 1911 Matisse worked on several pictures in Collioure, including landscapes, still lifes, and the *Portrait d'Olga Merson* (Portrait of Olga Merson, 1911, Museum of Fine Arts, Houston), but he was mostly occupied with the large *Intérieur aux aubergines* (Interior with Eggplants, 1911, Musée de la Peinture et de Sculpture, Grenoble).

2. The paintings in question are most probably *The Painter's Family* and *The Pink Studio*.

3. Shchukin was clearly thinking of *Woman on a Terrace*, which he had referred to as "Sails" several months earlier (see letter XXV).

4. Matisse put off painting the works commissioned by Morozov several times (this commission eventually resulted in the creation of the "Moroccan triptych"). The painter had probably informed Shchukin that he intended to work on the commission in Collioure.

5. Matisse had already visited Ravenna in 1907. It was probably the work on Shchukin's "decorations" that gave the artist the idea of returning there. However, he was unable to carry out his plan.

6. The 1911 Salon d'Automne opened on 1 October.

XXXI

Moscow, 3-15 January 1912

Dear Sir,

I have spent several weeks resting in the country. This morning I returned to

Moscow and found the telegram with your New Year's greeting and your letter. I am very grateful to you. I am most sorry that Mme Matisse is still not feeling well, and I hope that the south will do her good.[1]

Your new large canvas of 2.20 x 1.80 should prove very interesting.[2] Perhaps you could send me a watercolor sketch and the price of the painting.

We are having very cold weather here. A lot of snow, but a lot of sunshine too. It was very beautiful in the country. I hope that you will have a pleasant time in Tangier and will also think a little about my red drawing room.[3]

My regards to Mme Matisse and Mr and Mme Stein (she will have the photos in a few days).

I remain your devoted and sincere Sergei Shchukin

XXXII

Moscow, 1-14 February 1912

Dear Sir,

Yesterday I received your letter of 1 February from Tangier, and also the watercolor[1] for the red painting.[2] I am sure it must be very interesting, but I prefer your figure paintings now,[3] above all the portrait of your family. This painting is a tremendous success here: it is regarded as the most beautiful work of yours that I have.

Mr. Ostroukhov has received your painting of the nude and is very pleased with it; he finds it very beautiful.[4]

The winter is very cold here in Moscow at present and there is a lot of snow. Life goes on as usual, and I am very busy all the time. In spring I hope to go to Italy again, to Rome and Venice. In July I shall come to Paris for a few days to see you. Perhaps you will have something for me.

My regards to Mme Matisse.

I wish you good health, fine weather, and fruitful work, and I remain your devoted

Sergei Shchukin

P.S. I am sending this letter to Issy-les-Moulineaux; it's safer.

XXXIII

Moscow, 13 March 1912

Dear Sir,

I was very pleased to receive your letter of 1 March from Tangier, as well as the letter from Japan, and I entirely agree with your Japanese friend's opinion that your art has a certain precious and essential quality, which is its principal charm. I hope that you and Mme Matisse are in good health, that your work is going well, and that you will not forget to make a souvenir of Tangier for me too.

At the beginning of July I am thinking of coming to Paris for a few days to catch you there. At the end of April I leave for Italy (Rome and Venice).

My health is good; the weather here is very bad, damp and cold.

My family all send you their greetings; they think of you very often, and all of them hope that they will see more of your beautiful works in my house.

Perhaps you will do a painting with figures in Tangier?

I remain your devoted

Sergei Shchukin

XXXIV

Grand Hôtel des Bains
Lido - Venice
19 June 1912

Dear Sir,

In the last few months I have made a grand tour of Italy, primarily in Tuscany and Umbria. I should be very glad to receive news of yourself and your family.

Do write me a few words about your health and your works.

1. On 29 January 1912, Matisse and his wife set sail from Marseilles for Tangier. He must certainly have informed Shchukin of his plans to go to Morocco.
2. *L'Atelier rouge* (The Red Studio, 1911, Museum of Modern Art, New York).
3. While he was in Moscow, Matisse rehung his works in the "pink drawing room" of Shchukin's mansion.

1. *L'Atelier du Peintre* (The Artist's Studio, 1912, State Pushkin Museum). This watercolor was painted at Shchukin's request after *The Red Studio* was already completed. It differs in a few minor respects and thus cannot be regarded as a sketch for the large work.
2. *The Red Studio*.
3. Even from the watercolor Shchukin evidently sensed that *The Red Studio* would not suit the room that he had chosen for his "decorations."
4. *Nu* (Nude, 1908, Hermitage).

I shall stay here until 15 or 16 July and am thinking of coming to Paris about 20 July.

Hoping for the pleasure of reading your letter soon, I remain your devoted

Sergei Shchukin

XXXV

Grand Hôtel des Bains
Lido - Venice
2 July 1912

Dear Sir,

I was very glad to receive good news from you, and I am very glad to learn that you have been thinking about me and have saved me several paintings for the large drawing room and one for the dining room.[1]

I hope to be in Paris in two weeks and to see you on about 16 or 17 July.

My regards to Mme Matisse.

Your absolutely devoted

Sergei Shchukin

XXXVI

Moscow, 6 August 1912

Dear Sir,

Yesterday I sent you 19,000 francs via the Banque d'Escompte in Moscow (Crédit Lyonnais) to the address that you gave me (18,000 frs for the paintings[1] and 1,000 frs for the frames). Could you please have a beautiful frame made for your large blue painting?[2]

At the same same time I ask you please to send the three paintings for my drawing room as soon as possible by express delivery (insured for 18,000 frs).[3]

I hope that you are in good health and that the work is going well. Do not forget to do a few pieces for me.

I am feeling very well, despite the tropical heat here in Moscow.

My regards to Mme Matisse.

In anticipation of news from you I remain your devoted

S. Shchukin

XXXVII

Moscow, 22 August 1912[1]

Dear Sir,

Yesterday I received your letter of 17 August and I am only too happy to allow you to exhibit "Nasturtiums and 'La Danse'" at the Salon d'Automne.[2] But I ask you please to send the other two paintings ("The Moor" and "Goldfish") to Moscow by express delivery. I am thinking a lot about your blue painting (with two figures).[3] It seems to me like a Byzantine enamel, with such rich, deep colors. This is one of the most beautiful paintings that has remained in my memory.

The weather in Moscow is very bad, very cold and it is raining all the time. My health is good.

I hope that you are feeling well and that the work is going ahead.

Don't forget about the pendant for my fish.[4]

My regards to Mme Matisse.

Assuring you of my absolute devotion,

Sergei Shchukin

1. The painting for the dining room mentioned here is *The Conversation* (1909-1912, Hermitage). The three works for the large drawing room are *Amido le marocain* (Amido the Moor, 1912, Hermitage)—the "souvenir of Tangier" that Shchukin mentioned in his letter of 13 March 1912—*Les Poissons rouges* (Goldfish,1912, State Pushkin Museum) and *Les Capucines à "La Danse"* (Nasturtiums and "La Danse," 1912, State Pushkin Museum).

1. Each of the three paintings had been priced at 6,000 frs.
2. *The Conversation*. The frame has not survived, but it can be seen in a 1913 photograph of the main dining room in Shchukin's mansion.
3. The pictures for the pink drawing room were *Amido the Moor*, *Goldfish*, and *Nasturtiums and "La Danse."*

1. This letter was incorrectly published by Barr. See letter XIV, note 1.
2. The painting was exhibited at the Salon d'Automne (no. 769), but the ownership was indicated incorrectly.
3. *The Conversation*.
4. Matisse promised Shchukin that he would paint him a work that could serve as a "pendant" to *Goldfish*, but this never materialized. On 21 November 1912, Matisse wrote to his family that he had begun a painting of a young man from the Rif (*Le Rifain debout* [The Standing Riffian], Hermitage) with the same measurements as Shchukin's *Goldfish* (Matisse archives, Paris). This does not mean, however, that they formed a pair or were parts of a triptych. Pierre Schneider, Jack Cowart, and Laura Coyle have attempted to construct such a triptych by combining *Goldfish*, *The Standing Riffian*, and *Fenêtre ouverte à Tanger* (Open Window at Tangier, 1912-1913, private collection, United States of America), but the argument is unconvincing for reasons of both coloring and content, as well as the fact that the third painting was not intended for Shchukin (*Matisse in Morocco* [Washington, D.C., 1990], p. 273).

XXXVIII

Moscow, 2-5 November 1912

Dear Sir,

I had hoped to see you in Paris during the Salon d'Automne, but the sudden death of my elder brother, Pyotr, has changed all my plans.[1] I should be very pleased to have news of you. I also ask you please to let me know to what address I can send the 10,000 frs that I owe for the blue painting (which is in London).[2] I intend to settle my account this month. Perhaps I could have the illustrated catalogue of your exhibition in London? I also hope that you have been thinking of my drawing room and that I shall be able to receive a few pieces during the winter.

My health is good, but I am very busy putting my late brother's affairs in order.

I hope that Mme Matisse and your children are in good health, and also yourself, my dear sir.

In anticipation of good news from you, I remain your devoted

S. Shchukin

1. Sergei Shchukin's elder brother, Pyotr, died on 12 October 1912.

2. *The Conversation* (Hermitage) was shown at the Second Post-Impressionist Exhibition, Grafton Gallery, London, cat. no. 28 from 5 October to 31 December 1912.

XXXIX

Moscow, 10 January 1913

Dear Sir,

Thank you very much for your last letter, and also for the two issues of *Soirées de Paris*.[1] I was very glad to receive good news.

To my great regret, my affairs did not allow me to come to Paris for the Salon d'Automne, but I hope to get there in the spring.

Mr. Ostroukhov requests you to write an article on your impressions of holy images in Russia. He works with an art journal called *Sophia*, which is producing a special issue on Russian icons.[2] There will be several articles by foreigners, among them one by Mr. E. Verhaeren (the Belgian poet), who spent two weeks in Moscow at the end of the year.[3]

Mr. Verhaeren has seen my collection and greatly admired your works.

I am impatiently awaiting your latest painting.[4] I shall only be able to send you the 6,000 frs that I owe you for this piece in spring or summer of this year. I always receive my dividends in the summer (in June or July). I hope that by then you will do a few more works for my drawing room (I am short three ptgs for the upper row).

Mr. Morozov is under the constant influence of other artists who do not understand the way your work has evolved recently. He wanted to have you decorate a room, and now, under the influence of these gentlemen, he has bought a large panel by Bonnard for the room in question.[5]

My health has been good all this time, but I am very busy.

My best wishes to Mme Matisse.

Hoping for more good news from you, I remain your absolutely devoted

S. Shchukin

1. *Les Soirées de Paris*, published from February 1912 to August 1914, immediately became one of the leading avant-garde publications. Apollinaire was one of its contributors: the April and May issues of 1912 included his notes on the new painting, which also appeared in his book *Les Peintres cubistes* (Paris, 1913) shortly afterward. We do not know which issues of the journal were sent to Shchukin.

2. *Sophia*, literary and art magazine published in Moscow in 1914. The project Shchukin refers to didn't come to fruition.

3. The Belgian poet and art critic Emile Verhaeren visited Morozov as well as Shchukin and also viewed the collection of the Tretyakov Gallery.

4. This painting is most probably *Vase d'iris* (Vase of Irises, 1912, Hermitage).

5. Bonnard's *Summer. Dance* (1912, State Pushkin Museum).

XL

Moscow, 15 January 1913

Dear Sir,

I was delighted to receive good news from you, and I am most grateful to you for your latest letters. I have been very concerned recently about your painting "Nasturtiums and 'La Danse'." You sent it to Moscow by express delivery on 15 November, and there is still absolutely no sign of it. I am thinking of changing my spediter [sic] in Paris.

I am also very much afraid that the painting from London was not properly dispatched.[1] I ask you please to find out for me who was used to forward the painting to Moscow.

At the beginning of January you were sent 10,000 frs from my account (for the blue painting "The Conversation"), I hope that you have received the money (at

1. See letter XXXVIII, note 2.

2. Shchukin is referring to Matisse's Moroccan paintings. In a November 1912 letter to his family from Tangier, the artist wrote about three pictures, including initial sketches and indicating that one of the pictures was intended as a pendant to Shchukin's Moor, Amido. (The letter is in the Matisse archives in Paris.) This pendant was *Zorah debout* (Zorah Standing, 1912, Hermitage). In another letter to his family (1 November 1912, also in the Matisse archives), the artist informed them that he had begun a portrait of a young man from the Rif that was the same size as Shchukin's *Goldfish*. (See letter XXXVII, note 4, above). In his desire to see the decoration of the pink drawing room completed, Shchukin returned again and again to the idea of linked and paired paintings, which accounts for the phrase that follows about being "afraid of having to wait too long." The third painting intended for Shchukin was *Bouquet of Arum Lilies on the Verandah*. This work has been dated 1912-1913 although this letter proves it was painted in 1912.

3. Matthew Prichard, an English aesthetic theorist and specialist in Greek archaeology, worked at the Boston Museum of Fine Arts from 1900 to 1907, then moved to Paris, where he often discussed matters of art and aesthetics with Matisse. Shchukin was clearly returning to Matisse a letter that Prichard had written to the artist in Tangier. We can glean some idea of the letter's contents from Matisse's reply to Prichard of 4 January 1913: "Your letter gave real pleasure, above all the passage where you say that my works emanate a sense of health and hopefulness, which consoles me for their imperfection. My sojourn here is very pleasant after the winters at Issy which for me were a bit dreary. Here the weather is fine almost every day, and already the countryside is in flower" (Archives of the Isabella Stewart Gardner Museum, published in Barr, p. 145).

1. These are the works painted in Morocco: *Arum, Iris, and Mimosa, Bouquet of Arum Lilies on the Verandah, Zorah Standing*, and *The Standing Riffian*.
2. Shchukin was one of the directors of the Emil Zindel cotton print factory in Moscow.
3. One of these "large paintings" is definitely *Le Café arabe* (The Arab Café, 1913, Hermitage), and the other is most probably *The Standing Riffian* (Barnes Foundation, Merion).
4. The "Moroccan triptych."

1. The paintings of the so-called Moroccan triptych were finished no later that the beginning of February 1913. Matisse took them with him when he left Morocco in mid February. See Matisse's letter to Morozov of 19 April 1913 below.
2. The Bernheim-Jeune exhibition, featuring "paintings from Morocco and sculpture," was held 14-19 April 1913.
3. The Moroccan paintings were shown in Fritz Gurlitt's art gallery in Berlin during the first week of May 1913.
4. See note 1 to the preceding letter.

1. The reference is to Gauguin's *Where Do We Come From? Who Are We? Where Are We Going?* (1898-1899, Museum of Fine Arts, Boston). The dealer Levesque had asked Matisse to inform Shchukin that the painting was for sale. Following Shchukin's refusal, Matisse wrote to Morozov with the same offer. See letter XV of the Morozov-Matisse correspondence (25 May 1913).

the Comptoir d'Escompte on the rue de Rennes).

My health is good, but I have a lot of work to do in order to settle my late brother's affairs.

I am very glad that you have done some paintings for my drawing room.[2] At my age one is afraid of having to wait too long. I hope that you continue to be in good health, and Mme Matisse also, and that the work is going well.

My best wishes to Mme Matisse.

I include Mr. Prichard's letter;[3] it is very interesting and very accurate.

In hopes of receiving more good news from you, I remain your devoted

Shchukin

XLI

Moscow, 11 April 1913

Dear Sir,

Yesterday I received your letter of 5 April, which gave me great pleasure. I was very glad to learn that you have been thinking about my drawing room and that four paintings for me are finished.[1]

I shall send you the 24,000 frs that I owe you in July (after dividends are paid by the Zindel Company, of which I am a director).[2] Just at the moment I do not have any funds available.

I find your two large paintings enormously interesting; I hope to see them in Paris in July.[3]

I am also very pleased that you have finished the landscapes for Mr. Morozov and the still life for Mme Morozov.[4] I shall see them some day soon.

My health is good, but I am very busy all the time.

My regards to Mme Matisse.

Your devoted

Sergei Shchukin

XLII

Moscow, 16 April 1913

Dear Sir,

After receiving your second letter, I went to see Mr. Morozov. He is very glad that the two landscapes and the painting for Mme Morozov (he knows about this commission) are finished,[1] and he asks you to send them to Moscow through his spediter [*sic*] Mr. Sharshovsky (Mr. A. Vollard at rue Laffitte 6 has his address). I told him that you were intending to show it in Paris at Bernheim's gallery[2] and in Berlin at Gurlitt's.[3] He has nothing against this exhibition, but please ask Mr. Sharshovsky for the name of his colleague in Berlin.

My four paintings[4] can be sent by Mr. Schroeder's colleague in Berlin (to my spediter in Moscow, Pavel Forostovsky) for delivery to Mr. Sergei Shchukin.

I hope to be in Paris for several days on about 20-25 May.

My health remains good, but I am very busy.

I was very glad to have good news from you.

My regards to Mme Matisse.

I remain your devoted

Sergei Shchukin

XLIII

Moscow, 14 May 1913

Dear Sir,

I have received your letter of 10 May, and I am most grateful to you for all your news.

Gauguin's paintings no longer interest me, and the dealer is free to offer them to other art lovers.[1]

I shall leave Moscow on 17 May and go first of all to Italy for a month to rest for a while beside the sea; I'm thinking of spending a month at Sorento, not far from

Naples. This means that I shall only arrive in Paris toward the end of June, and I hope to find you still at Issy-les-Moulineaux.

Thank you very much for *Les Cahiers d'aujourd'hui*. Mr. Marcel Sembat's article is very fine and quite correct.[2]

I hope that your Morocco exhibition was a success in Paris and also in Berlin.[3]

My regards to Mme Matisse.

Wishing you good health and success in your work, I remain your devoted

Sergei Shchukin

XLIV

Moscow, 10 October 1913[1]

Dear Sir,

It is two weeks since I returned to Moscow, and during that time I have had the pleasure of a visit from Mr. Osthaus,[2] founder of the museum at Hagen,[3] and then visits from many museum directors (Dr. Peter Tessen from Berlin, Dr. H. von Trenkmold from Frankfurt, Dr. Hampe from Nuremberg, Dr. Polaczek from Strasbourg, Dr. Sauerman from Flensburg, Dr. Stettiner from Hamburg, Dr. Back from Darmstadt, Max Sauerlandt from Halle, and Jens Thiis from Christiania). All of these gentlemen viewed your pictures with the greatest of interest, and everybody called you a great master ("ein grosser Meister"). Mr. Osthaus has been here twice (on one occasion for luncheon). I observed that your pictures impressed him deeply. I spoke of your blue still life that you did for him,[4] which I find very beautiful, and of the tremendous development I sense in your recent works ("Arab Café," "Blue Still Life," Mr. Morozov's "Fatma").[5] Jens Thiis, director of the Museum of Fine Arts at Christiania (in Norway), spent two days in my house, for the most part studying your pictures (the second day he stayed from ten o'clock in the morning till six in the evening). He is so taken that he hopes to buy a picture for his museum.[6]

The other gentlemen also asked where your pictures could be bought, and I replied in Paris at Bernheim's or directly from you. Mr. Osthaus will write to you about his impressions of your works.

The "Arab Café" arrived in good condition, and I have placed it in my dressing room.[7] It's a painting that I now like more than the others, and I spend at least an hour every day looking at it.

Mr. Morozov is quite enchanted by your Moroccan pictures. I have seen them, and I share his admiration. All three are quite magnificent. He is now thinking of commissioning three large panels for one of his rooms.[8] He is returning to Paris on 20 October and will speak to you about this.

I hope that the portrait of Madame Matisse will also be an important work.[9]

You will receive the 10,000 francs which I owe you for the "Arab Café" in December.

My health is good, and all of my family's too, but I am very busy.

When you have time, write me a word about your work and projects for the winter. Also, please do not forget my drawing room. It is becoming a genuine museum of your art.

My regards to Mme Matisse.

Your devoted

Sergei Shchukin

P.S. When will the Salon d'Automne open? Are you going to exhibit?[10]

XLV

Moscow, 4-17 October 1913

Dear Sir!

I should be most grateful if you could give me some information concerning the blue painting ("The Conversation") that was in London.[1]

2. Marcel Sembat, "Henri Matisse," *Les Cahiers d'aujourd'hui* 4 (April 1913), pp. 185-194.

3. The exhibition was a success in Paris: enthusiastic articles were written by, among others, Sembat and Apollinaire. It did not attract much attention in Berlin however.

1. The French original of this letter is lost; the English translation was previously published in Barr, p. 147.

2. Karl-Ernst Osthaus (1874-1921), an outstanding collector and museum director, who acquired a number of Matisse's most important works for the museum he founded in Hagen. According to Matisse's pupil Greta Moll, Osthaus's purchase of *Bathers with a Turtle* made a deep impression on Shchukin. The painting was subsequently auctioned by the Nazis and turned up in the United States. In the spring of 1907 Matisse created a ceramic triptych for Osthaus's villa in Hagen. In late 1908 Matisse visited Osthaus there and viewed his museum.

3. The Volkwang Museum, founded in 1902 (the same building now houses the Karl-Ernst Osthaus Hagen Municipal Museum). Following the death of Osthaus, its major collections were transferred to Essen. The Essen Volkwang Museum suffered badly after the Nazis came to power, with many of its pictures declared to be "degenerate art" and either sold abroad or destroyed.

4. *La Fenêtre bleue* (The Blue Window, 1911). This painting was acquired by Osthaus for the Volkwang Museum in late 1911. The canvas was confiscated on Hitler's orders, and in 1938 it was sold to The Museum of Modern Art in New York.

5. Shchukin's error: the painting in question was *Zorah sur la terrasse* (Zorah on the Terrace, 1912).

6. Thiis was not able to carry out this plan.

7. Since the French original of this letter is no longer extant, we cannot be sure that "dressing room" is the actual term used by Shchukin. In previous letters he does not refer to the room in question in this way (see, for example, letter XXIII of 11 November 1910).

8. This idea was never realized.

9. *Portrait de Mme Matisse* (Portrait of Mme Matisse, Hermitage), which Matisse worked on during the summer and autumn of 1913. It was completed at the start of November, as we know from Prichard's letter of 4 November to Isabella Stewart Gardner: ". . . Matisse is very lively. I was in his studio yesterday where there were as many as twelve people. He has finished a great portrait of his wife and two other pictures lately" (Jack Flam, *Matisse. The Man and His Art*, 1869-1918, London, 1986, pp. 40-41).

10. The 1913 Salon d'Automne opened a month and a half later than usual, on November 15. Matisse exhibited only his *Portrait of Mme Matisse*, under the short title *Portrait*.

1. See letter XXXVIII, note 2 and letter XL.

The exhibition ended on 30 December 1912, and so far I had have no news of the painting. Was it dispatched to Moscow? By what spediter [*sic*], to what name? Express or standard delivery?

Some time ago I received the "Nasturtiums and 'La Danse'" with a delay of more than two months.

As always, I am hoping that you and your family are in good health and the work is going well. If my affairs will permit I hope to come to Paris for a few days in May, but not earlier.

My health is quite good, and so is my children's.

The winter is very severe here, more than 25 degrees Réaumur below freezing today.

I find the "Nasturtiums and 'La Danse'" very beautiful, and I take great pleasure in looking at them every day.

In hopes of receiving good news from you, I remain your devoted

Sergei Shchukin

XLVI

Moscow, 10 March 1914

Dear Sir,

Today I received your letter of 6 March and was very pleased to have good news from you.

I also hope to receive the portrait soon, the spediter [*sic*] has informed me that it has already crossed the border.[1]

My health is good, but I am always very busy.

I was very interested by the Bearskin.[2] It is most agreeable that the demand for your paintings and Picasso's has increased so much. Mr. Michel Stein must be very pleased.

I am sure that the demand for your paintings must continue to increase. The directors of various museums have viewed my collection and were full of enthusiasm for your works.[3] "A great master," "ein grosser Meister," was what they all said.

The museums must buy your paintings.

I hope to be in Paris in May and find a few pieces for my drawing room.

My account will be settled in full in summer. At this moment I owe you 6,000 frs for the portrait.

My regards to Mme Matisse.

Your devoted

Sergei Shchukin

XLVII

Grand Hôtel des Bains
Lido - Venice
18 June 1914

Dear Sir,

On 15 June I sent you the 6,000 frs that I owed you for the beautiful painting (the portrait of Mme Matisse) via the Banque Commerciale Italienne in Venice, and I apologize for the delay in payment. But I normally receive my business dividends in July and August. I hope that you have already received the money (at the Comptoir d'Escompte National, boulevard Montparnasse 71).

I should be very glad to have some news of you and your family. And also of your works, I hope that you have not forgotten my drawing room and that I shall have a few paintings (I am still short of three to complete the first row).

Write a brief word to me at the Lido, Hôtel des Bains.

1. *Portrait of Madame Matisse.*

2. The Bearskin (La Peau de l'Ours) was a project undertaken in 1904 by several artists, who decided that they would jointly acquire works by young painters and offer them for sale ten years later. Each member of the association contributed 250 francs. All the purchases were approved by a committee. The success of the Bearskin auction, held on 2 March 1914, exceeded all expectations: with a total sales of over 100,000 francs. Ten of Matisse's paintings were among the works sold.

3. See letter of 10 October 1913.

During the spring I had a visit from an art lover from Paris, Mr. Strauss,[1] who appeared to have a very fine collection of Renoir and Degas.[2] He admired your paintings and is thinking of buying some from you or from Bernheim.

My health is good: I have been in Italy for six weeks now.

I am thinking of coming to Paris between 15 and 20 July. Write to say if you will be at Issy-les-Moulineaux or in Paris at quai St. Michel 19.

In anticipation of good news from you, I remain your devoted

Sergei Shchukin

P.S. My regards to Mme Matisse.

1. Emile Strauss. His wife, the former Geneviève Halévy, had a salon that was well known in the Parisian high society.

2. Degas had close ties with the family of the composer Halévy, and he painted Halévy's daughter Geneviève, who was first married to Georges Bizet, and then, after his death, became Emile Strauss's wife.

XLVIII

Moscow, 25 July-7 August 1914

Dear Sir,

Today I received your letter from Collioure and sent 20,000 frs to your account at the Comptoir d'Escompte, Paris, place de Rennes office.[1]

I am very glad to have good news of you, and I hope that in Collioure you will make me the boat painting that I am so keen to have.[2] I arrived in Moscow yesterday and greatly enjoyed looking at your paintings once again. Even my ideas about your nudes are beginning to change.

I think that one day I shall prefer your nudes to your other subjects. The lines are so beautiful and at the same time so chaste.

It is very hot here in Moscow too. I have to go to the fair at Nizhny, and I am leaving this evening.

When you are back in Paris please do write me a brief word. I hope to have good news of your paintings with the boats.

My regards to Mme Matisse.

Your devoted

Sergei Shchukin

1. It is difficult to determine the works for which this sum was due. One of the unpaid paintings was possibly *La Femme au tabouret* (Woman on a High Stool, Museum of Modern Art, New York), which was intended for Shchukin, but never reached him because of the outbreak of World War I.

2. The definite tone of Shchukin's references to a picture of a boat obliges us to assume that there was already a sketch or the first stages of a painting. The general conception, however, must have remained unrealized, for we know of no paintings of boats from this period. The outbreak of war (German troops crossed the French border on 2 August) changed all of Matisse's plans: his mother and brother were stranded in occupied territory. Matisse immediately returned to Paris in order to send his children to his wife's parents in Toulouse, and he joined them there shortly afterward.

XLIX

TELEGRAM
2 November 1914

Impossible send [money] Moscow exchange closed bank and post office refuse transfer money France hope send when contacts restored greetings,

Sergei Shchukin

IVAN SHCHUKIN'S EX-LIBRIS, 1911
PEN AND INK, WATERCOLOR, 22.5 x 16.3 CM.
PUSHKIN STATE MUSEUM OF FINE ARTS, MOSCOW
GIFT FROM MATISSE TO SHCHUKIN

MIKHAIL KELLER'S EX-LIBRIS, 1911
PEN AND INK, WATERCOLOR, 12.2 x 10.1 CM.
PUSHKIN STATE MUSEUM OF FINE ARTS, MOSCOW
GIFT FROM MATISSE TO SHCHUKIN

A LETTER FROM IVAN SERGEIEVICH SHCHUKIN TO HENRI MATISSE

8, Bolshoi Znamensky Pereulok, Moscow
4 February 1912

Cher Maître,

Thank you very much for the "ex-libris" that you sent me.[1] I am genuinely touched by your consideration. I find one of these "ex-libris" very beautiful (the same one that you yourself prefer),[2] and I am sure it will ornament my library.[3]

As for the small "ex-libris," I do not like it, because I feel that it does not adequately express the character of the great artist who drew it.

A thousand apologies for not having replied to you sooner: my military service has taken up all my time this week, because I was taking the entrance examination for engineering.

Please accept, cher Maître, my profound gratitude and my sincere admiration.

Ivan Shchukin

1. It was formerly believed that Matisse had created the ex-libris for Ivan Shchukin in Moscow (*Matiss. Jivopiss. Skulptura. Grafika. Pisma. Katalog* [Matisse. Painting. Sculpture, Graphics. Letters. A catalogue] [Leningrad, 1969], p. 121). Both of the ex-libris bore the words "Ex libris Ivane Schoukine." Shchukin's son chose the larger of the two, and the other became the ex-libris of Count Keller, Sergei Shchukin's future son-in-law, who was at that time a student at Moscow University.

2. At the bottom edge of the large ex-libris Matisse wrote in pencil: "Celui que je préfère" (The one I prefer).

3. No books containing Ivan Shchukin's ex-libris have survived.

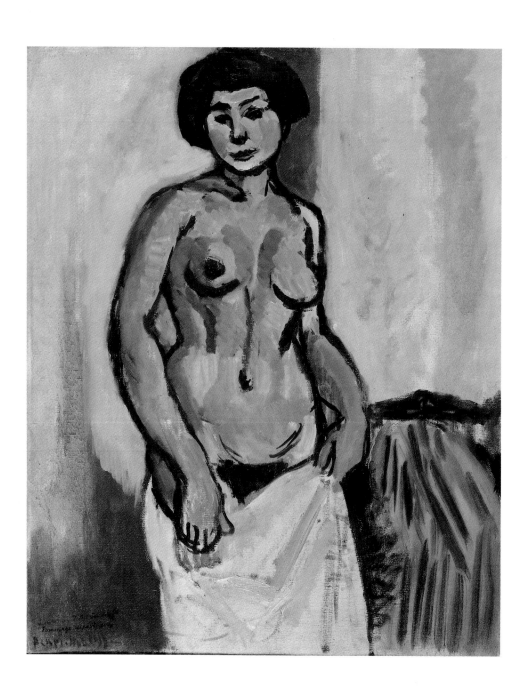

NU, 1908
(NUDE)
OIL ON CANVAS, 60 x 50 CM.
THE STATE HERMITAGE MUSEUM, ST. PETERSBURG
GIFT FROM MATISSE TO ILYA OSTROUKHOV

A LETTER FROM SERGEI SHCHUKIN
TO ILYA SEMYONOVICH OSTROUKHOV[1]

10 November 1909, Cairo

Dear Ilya Semyonovich,

The director of the Munich Pinakothek, Professor Tschudi (formerly the director in Berlin)[2] saw Matisse in Paris. He was very interested in his works, viewed Matisse's paintings in private collections, and commissioned one similar to my red room for the Munich museum.[3] Tschudi told me himself that Matisse is one of the most remarkable artists of our century.

I enclose herewith Bendemann's article, in which Matisse is described as continuing the movement initiated by Manet.

Forgive me for writing all this to you from faraway Egypt, but I wish to convince you that my enthusiasm for Matisse is shared by people who are genuinely devoted to art.

In Paris I spoke with Berenson, one of the finest connoisseurs of older art. He called Matisse "the artist of the epoch."[5]

With my sincere respects, I remain your profoundly devoted

Sergei Shchukin

1. Department of Maunuscripts, Tretyakov State Gallery, archive 10, d. 7276.

2. See letter XXIV, note 6.

3. This work, *Still Life with Geraniums*, although quite different in character from *The Red Room*, includes the same Jouy cloth.

4. Bernard Berenson (1865-1959), a major American historian of Italian Renaissance art. Shchukin evidently made Berenson's acquaintance through his friend Leo Stein, with whom he used to stay in Paris. Berenson was one of Matisse's most energetic and uncompromising supporters in the early years. In 1907 he bought Matisse's landscape *Arbres près de Melun* (Trees near Melun, 1901, National Museum, Belgrade). The next year, precisely one year before Shchukin wrote this letter, he defended Matisse in the New York weekly *The Nation* (12 November 1908), pointing out that the artist was a follower of the traditions of ancient art, including that of the Egyptians (Shchukin also had strong feelings on this point). ". . . I have the conviction," Berenson wrote, "that he has, after twenty years of very earnest searching, at last found the great highroad traveled by all the best masters of the visual arts for the last sixty centuries at least." Shchukin was probably aware of this article, or had at least heard of it from others, since it mentions him indirectly: "Fifty years ago, Mr. Quincy Shaw and other countrymen of ours were the first to appreciate and patronize Corot, Rousseau, and the stupendous Millet. Quantum mutatis ab illo! It is now the Russians and, to a lesser extent, the Germans, who are buying the work of the worthiest successors of those first mighty ones" (cited in Barr, p. 114).

2. HENRI MATISSE AND IVAN ABRAMOVICH MOROZOV

I
MOROZOV TO MATISSE

Moscow, 12 May 1909
Monsieur Henri Matisse
Paris, 33 bd. des Invalides

Dear Sir,

I very much regret that Mrs. Morozov's indisposition has prevented me from coming to Paris.[1] Please inform me whether the two Still Lifes I commissioned from you are ready,[2] and if they are, please be so kind as to have them delivered to:

Mr. N. Sharshevsky
46 rue des Petites-Ecuries, Paris

and I will forward to you immediately the remaining 4,000 (four thousand) francs.

In hopes of seeing you in Paris during the Salon d'Automne, and in anticipation of reading your letter, I offer you, dear sir, my respectful regards.

Ivan Morozov

Address:
Ivan Morozov
Tver Manufacturing Association
Varvarka St., Morozov House
Moscow

1. Morozov had intended to visit the Salon des Indépendants.

2. The details of Morozov's commission for two still lifes are unknown. He was obviously attracted by the latest works in this genre that Matisse had painted for Shchukin, in particular by the *Still Life with a Blue Tablecloth*. In any case, Matisse intended to produce works of the same size. He was, however, fully occupied with his monumental canvases, primarily those intended for Shchukin, and he kept putting off the commission for Morozov.

II
MOROZOV TO MATISSE

Moscow, 25 May 1909
Monsieur Henri Matisse
Paris
33 bd. des Invalides

Dear Sir,

I have received your letter of 19 [May][1] and have noted that the two still lifes will be finished in the autumn.[2] I should be very glad to see these two paintings exhibited at the Salon d'Automne.

Please accept, my dear sir, my respectful regards.

Ivan Morozov

1. This letter from Matisse has not survived.
2. In promising Morozov that he would keep his word, Matisse undoubtedly counted on showing both still lifes at the Salon d'Automne.

III
MOROZOV TO MATISSE

Moscow, 3 September 1909
Monsieur Henri Matisse
Paris
33 bd. des Invalides

Dear Sir,

I have received your letter of 29 August.[1] I had very much hoped to see the still lifes at the Salon d'Automne, but since this is not possible, I ask you please not to hurry too much, for I shall be equally glad to see them completed in your studio during my next stay in Paris, where I shall arrive on 27 September.
I shall stay in Paris for three weeks.
In anticipation of the pleasure of seeing you, I offer you, my dear sir, my respectful regards.

Ivan Morozov

1. This letter from Matisse has not survived.

IV
MOROZOV TO MATISSE

Moscow, 24 November 1909
Monsieur Henri Matisse
at Issy-les-Moulineaux (Seine)
42, route de Clamart

Sir,

In hopes that the still lifes will be finished shortly, I ask you to be so kind as to inform me of their dimensions, height and width, and also the approximate date when these paintings will be able to be dispatched, and in anticipation I offer you, dear sir, my respectful regards.

Ivan Morozov

Tver Manufacturing Association
Varvarka St., Morozov House
Moscow, Russia

V
MOROZOV TO MATISSE

Moscow, 10 December 1909
Monsieur Henri Matisse
Issy-les-Moulineaux (Seine)
42, route de Clamart

Dear Sir,
With reference to my letter of 24 November, I wish to inform you that I am
presently occupied with the hanging of my paintings. Please be so good as to
inform me of the dimensions, height and width, of the still lifes, so that I might be
able to leave space for them, and also to let me know approximately when these
paintings will be ready to be dispatched.
Please accept, dear sir, my respectful regards.

Ivan Morozov

Address:
Ivan Morozov
Tver Manufacturing Association
Varvarka St., Morozov House
Moscow

VI
MOROZOV TO MATISSE

Moscow, 4 March 1910
Monsieur Henri Matisse
at Issy-les-Moulineaux (Seine)
42, route de Clamart

Dear Sir,
Being now in possession of your letter of 24 February,[1] I send you my most sincere
thanks for completing the two still lifes[2] and also for selecting the frames, of which
I approve completely. I enclose a cheque drawable on the Comptoir Nationale
d'Escompte de Paris for 4,300 frs (four thousand three hundred francs), receipt of
which I ask you to confirm.
Please accept, dear sir, my most respectful regards.

Ivan Morozov

1. This letter has not survived.
2. One of these two still lifes was undoubtedly *Bronze et fruits* (Fruit and Bronze, 1910, State Pushkin Museum), which this letter allows us to date to early 1910. The other, *Nature morte à "La Danse" (Still Life with "La Danse,"* 1909, Hermitage), was completed considerably earlier. In all probability, Matisse did not paint it for a specific commission, but in view of Morozov's insistence, he took advantage of the similarity of size (an important factor for the hanging of the paintings) and added this canvas to *Fruit and Bronze.*

VII
MOROZOV TO MATISSE

Moscow, 23 March 1910
Monsieur Henri Matisse
Issy-les-Moulineaux (Seine)
42 route de Clamart

Dear Sir,
I have just received the 2 paintings, which I find quite ravishing.[1] The frames are
also very lovely.
Thank you once again for the splendid way in which you have fulfilled my order.
Please accept, my dear sir, my respectful regards.

Ivan Morozov

1. See the preceding letter.

VIII
MOROZOV TO MATISSE

Moscow, 12 September 1911
Monsieur Henri Matisse
Issy-les-Moulineaux
42, route de Clamart
Seine

Dear Sir,

You would oblige me greatly if you could please inform me of the present state of the two landscapes that I commissioned from you.[1] As I told you when we met in person, cracks have appeared in the paint of one of your still lifes,[2] which is causing me considerable concern, and it would please me greatly if you would allow me to return it to you in order to have the cracks repaired. In anticipation of the pleasure of receiving your letter, I offer you, my dear sir, my most respectful regards.

Ivan Morozov

Ivan Morozov
Tver Manufacturing Association
9, Varvarka St., Moscow

1. See the following letter for Matisse's reply.
2. Morozov owned several still lifes by Matisse. In all likelihood, the reference here is to one of the two canvases that Morozov had added to his collection quite recently, in 1910. Both works, *Nature morte, fruits et cafetière* (Still Life with Fruit and Coffeepot, 1897, Hermitage) and *Fruit and Bronze*, were rendered in thick impasto, which would account for the collector's concern for their well-being.

IX
MATISSE TO MOROZOV

Collioure, 19 September 1911[1]

Dear Sir,

I have been thinking of your landscapes[2] since I arrived in Collioure,[3] but I am really afraid that I shall not be able to do them this summer. I shall work on them in Sicily, where I intend to spend the winter.[4]

At the Salon d'Automne you will see a landscape that was intended for you, but which never got beyond the stage of a sketch.[5] I am very busy at present with an important decorative piece.[6] I hope you will not take offence if you do not have the promised landscapes in time for the Salon d'Automne, since I warned you at the time of your order that it was not certain when they would be completed. Please be assured, my dear Sir, that I will do them as soon as possible, and I ask you to take this in the best sense.

As for the still life that you mention, I think there is no point in putting you to the trouble of sending it to me, since I have to go to Moscow at the end of October. When I am there I can see what the problem is and will repair it if necessary.

I assure you, my dear sir, of my most sincere best wishes.

Henri Matisse
at Collioure P.V.

1. Archives of the State Pushkin Museum of Fine Arts, archive 13, collection VI, no. 127/I.
2. See letter XXX, note 4 of the Shchukin-Matisse correspondence (3 September 1911).
3. The precise date of Matisse's arrival in Collioure is not known, but he certainly arrived in June and stayed until the end of September.
4. Matisse actually went to Morocco instead of Sicily.
5. Matisse exhibited only two paintings in the Salon d'Automne, both with the same title, *Esquisse décorative* (Decorative Sketch). The landscape referred to in the letter was exhibited as no. 678.
6. Matisse is apparently referring to the large decorative composition *Interior with Eggplants*.

X
MATISSE TO MOROZOV

Tuesday, 191...[1]

Dear Sir,

I have just learned that you have acquired from Bernheim[2] a still life which, although it is very old,[3] is one of my favorites, but I am a little perturbed to see it sent to you in such an ordinary frame. If you intend to frame it in a manner more in keeping with its quality, I am willing to assist you in finding an old frame for a price of about 150 f. (100 to 150), which would be the accompaniment the picture requires.

In hopes that you will forgive this liberty, I ask you, my dear sir, to accept my most sincere best wishes.

Henri Matisse
92 Route de Clamart à Issy

1. Archives of the State Pushkin Museum of Fine Arts, archive 13, collection VI, no. 127/4. The letter was written on the notepaper of the Grand Hotel, 12 boulevard des Capucines in Paris, although Matisse was living at Issy and noted his address at the end of the letter. The date is incomplete, but the letter was undoubtedly written in 1911.
2. The Bernheim-Jeune Gallery held the exclusive rights to sell Matisse's work.
3. *La Bouteille de Schiedam* (Still Life with Gin Bottle, 1896).

XI
MOROZOV TO MATISSE

Moscow, 23 July 1912
Monsieur Henri Matisse
Issy-les-Moulineaux
92 route de Clamart
Seine

Dear Sir,
I have received your kind letter of the 17th and was delighted to learn that both of the paintings that I commissioned from you will be finished in the autumn.[1]
I thank you for this promise and offer you, dear sir, my respectful regards.

Ivan Morozov

Address:
Ivan Morozov
21, Prechistenka St.
Moscow (Russia)

1. *Vue de la fenêtre* (View from a Window) and *La Porte de la Casbah* (Entrance to the Casbah).

XII
MATISSE TO MOROZOV

Issy, 92 Route de Clamart
29 Sept. 1912[1]

Dear Sir,
I feel extremely awkward having to write to you that I have not been able to do your two landscapes and as a result they will not be in the salon[2] as I wrote to you before,[3] but I am leaving tomorrow for Morocco, where I am counting on painting them.
I ask you please to accept my apologies and to convey my respectful greetings to Madame. With my sincere best wishes, your devoted

Henri Matisse

1. Archives of the State Pushkin Museum of Fine Arts, archive 13, collection VI, no.127/3.
2. The Salon d'Automne.
3. See letter IX, Matisse to Morozov, 19 September 1911. Bearing in mind that the two letters are separated by an interval of a year, we may assume the existence of another letter from Matisse that is not available to us.

LETTER FROM MATISSE TO MOROZOV, 19 APRIL 1913
ARCHIVES OF THE STATE PUSHKIN MUSEUM
OF FINE ARTS, MOSCOW

XIII
MOROZOV TO MATISSE

Moscow, 15 April 1913
Monsieur Henri Matisse
Issy-les-Moulineaux
92 route de Clamart
(Seine)

Dear Sir,

I was pleased to learn from Mr. Shchukin[1] that the two pictures that I comissioned from you, as well as the canvas ordered by Mrs. Morozov,[2] have been finished and are at present in an exhibition at MM. Bernheim's. After the exhibition,[3] please be so kind as to have these three paintings delivered to Mr. Sharshevsky, 45 rue des Petites-Ecuries, Paris, who has been instructed to dispatch them to Moscow. Please be so good as to let me know the amount that I owe you, and also the precise address to which I can send you a check. Awaiting the pleasure of a letter from you, I assure you, dear sir, of my respectful regards.

Ivan Morozov

Address:
Ivan Morozov
Tver Manufacturing Association
Varvarka St. n° 9
Moscow, Russia

1. See letter XLII of the Shchukin-Matisse correspondence (16 April 1913).
2. *Zorah on the Terrace.*
3. The exhibition of the Moroccan paintings in the Bernheim-Jeune Gallery, 14-19 April, 1913.

XIV
MATISSE TO MOROZOV

Issy-les-Moulineaux, 19 April 1913[1]

Dear Sir,

The three paintings in question[2] are still on show at Bernheim's until today.[3] They have been a great success, and I feel sure that you will be satisfied, even though you have waited for so long. I also feel that Madame Morozov will be pleased.[4]

The three paintings have been combined with the intention that they should be hung together in a particular order–that is, that the view from the window should be on the left, the Casbah gate on the right, and the terrace in the middle, as the sketch indicates.

The frames were intended for the works, and they are grey, painted with glue.[5] If there should be any finger marks on them, one can remove the spots by rubbing with a damp sponge (slightly moistened): the surface of the paint comes off as it is rubbed with the sponge; if this should not be possible, any decorator will repaint it for you after the grey paint on the frame has been stripped to the white ground with water.

The grey is made with Spanish white or any other white pigment, a small amount of black and ultramarine, and some gelatine to bind it.

I have given in to my friends' pleas and also the need to show my canvases before sending them to Moscow, by promising that they will be exhibited in Berlin for eight days on their way to Moscow,[6] along with Mr. Shchukin's paintings.[7] I have made the following arrangements: the transport and insurance costs from Paris to Berlin are to be borne by the dealer who is organizing the exhibition, the forwarding agents are Mr. Sharshevsky for you and Mr. Schreter for Mr Shchukin, plus their representatives in Berlin. I am even thinking of going myself to make sure that the canvases are satisfactorily forwarded.[8] They will leave Berlin about 8 May.

1. Archives of the State Pushkin Museum of Fine Arts, archive 13, collection VI, no. 127/5.
2. The so-called Moroccan triptych.
3. The Moroccan triptych was included in the Bernheim-Jeune Gallery exhibition of 14-19 April (cat. nos. 6-8).
4. Despite widespread belief to the contrary, the three parts of the Moroccan triptych were not all painted in response to Morozov's commission. He commissioned two landscapes, and his wife added a commission for a still life. Matisse gradually abandoned the second idea, however, and instead of a still life, he painted *Zorah on the Terrace* (see above, p. 137).
5. The initial frames that Matisse mentions here were later lost, as were the other frames from the 1913 Moroccan exhibition, with the exception of *Fatmah la mulâtresse* (Fatmah the Mulatto, J. Muller collection).
6. At Gurlitt's gallery. See letter XLII of the Shchukin-Matisse correspondence (16 April 1913), note 3.
7. Four of the paintings shown at the Bernheim-Jeune exhibition already belonged to Shchukin: *The Standing Riffian, Zorah Standing, Bouquet of Arums,* and *Arum, Iris, and Mimosas.*
8. Matisse never carried out his intention of going to Berlin.

Their price, as was agreed, is 24,000 f. (8,000 f. each), which you can have transferred to my account at the Comptoir National d'Escompte de Paris, Agence 0, Place de Rennes 7.

I hope that these three canvases will make you want to visit my studio if you come to Paris this summer, in order to see two large canvases of about two meters by 1.7, which show a tall man from the Rif[9] and an Arab café.[10] I could you send you photographs of them if you are interested.

Please convey my respectful regards to Madame Morozov, and be assured that I remain your devoted

<div align="right">Henri Matisse</div>

9. *Le Rifain assis* (The Seated Riffian, 1912-1913, Barnes Foundation, Merion).
10. *Arab Café*, subsequently acquired by Shchukin.

XV

MATISSE TO MOROZOV

<div align="right">Issy, 25 May 1913[1]</div>

Dear Sir,

Mr. Levesque, the art dealer of rue Faubourg St. Honoré, requested me to forward to you the photograph of a Gauguin measuring four meters that he has for sale.[2] I accepted, thinking that the piece might be of interest to you: you will receive it with this post. The asking price is 120,000 f. You have probably received or will receive some day soon the 3 paintings that have just been exhibited successfully in Berlin;[3] the frames will certainly be soiled, and I therefore ask you to have them refurbished as I indicated in my previous letter.

May I hope to have a visit from you on your next trip to Paris; two important paintings from Morocco that I have here might interest you; I would rather not send you the photograph.

Please convey my greetings to Madame. Your devoted

<div align="right">Henri Matisse
92 Route de Clamart, Issy</div>

P.S. I have arranged for you to be sent a copy of a magazine, *Les Cahiers d'aujourd'hui*, which contains Marcel Sembat's article, the best that has been written about me.

1. Archives of the State Pushkin Museum of Fine Arts, archive 13, collection VI, no. 127/6.
2. Gauguin's *Where Do We Come from? Who Are We? Where Are We Going?* See also letter XLIII of the Shchukin-Matisse correspondence (14 May 1913), note 1.
3. The Moroccan triptych, which was shown in Fritz Gurlitt's gallery during the first week of May 1913.
4. See notes 9 and 10 of the preceding letter.

XVI

MOROZOV TO MATISSE

<div align="right">Moscow, 29 May 1913
Monsieur Henri Matisse
Issy-les-Moulineaux
92 route de Clamart
(Seine)</div>

Dear Sir,

Only today, on my return from a journey, did I receive your kind letter of 19 April, the contents of which I have noted. I hasten to reply that I am not yet in possession of the three paintings, and I have therefore today telegraphed Mr. Gurlitt in Berlin today in order to learn when they will be forwarded.[1] On the day that I receive the canvases, I will forward you the cheque. Please accept, dear sir, my respectful regards.

<div align="right">Ivan Morozov</div>

1. See note 3 of the preceding letter.

XVII
MOROZOV TO MATISSE

Moscow, 14 June 1913
Monsieur Henri Matisse
Issy-les-Moulineaux
92, route de Clamart
Dpt. de Seine

Dear Sir,
I have just received your three paintings, and I hasten to inform you that Madame Morozov and I think they are splendid, and we thank you very much for this fine achievement.
I enclose a check drawable on Paris: 24,000 frs (twenty-four thousand francs), which I ask you please to accept in payment for the above-mentioned paintings.
Please confirm receipt of the check.
Please accept, dear sir, my respectful regards.

Ivan Morozov

XVIII
MATISSE TO MOROZOV

[1913][1]

Dear Sir,
Monsieur Osthaus[2] is in Moscow,[3] and once again I ask you please to allow him to visit your gallery, which he regards as one of the major attractions of his trip.
Please accept the warmest gratitude of your devoted

Henri Matisse

1. Archives of the State Pushkin Museum of Fine Arts, archive 13, collection VI, no. 127/2. The letter is not dated.
2. See letter XLIV of the Shchukin-Matisse correspondence (10 October 1913), note 2.
3. Shchukin's letter of 10 October 1913 indicates that Osthaus was in Moscow at that time, which allows us to date this letter from Matisse to Morozov to October. When the letter was first published *(Matiss. Jivopiss. Skulptura. Grafika. Pisma*, p.129), it was incorrectly dated to 1911.